THEORIES OF ART, 3

From Impressionism to Kandinsky

MOSHE BARASCH

Routledge

NEW YORK AND LONDON

Routledge edition published in 2000
Routledge
29 West 35th Street
New York, NY 10001
www.routledge-ny.com

Routledge is an imprint of the Taylor & Francis Group.

This edition published by arrangement with New York University Press.
Copyright © 1998 by New York University.

Printed in the United States of America on acid-free paper.

Library of Congress Cataloging-in-Publication Data

Barasch, Moshe.
 Theories of art / Moshe Barasch.
 p. cm.
 Rev. ed. of: Modern theories of art. 1990–c1998.
 Includes bibliographical references and indexes.
 Contents: v. 1. From Plato to Winckelmann—v. 2. From Winckelmann to Baudelaire—v. 3. From Impressionism to Kandinsky.
 ISBN 0-415-92625-4 (pbk. : v. 1)—ISBN 0-415-92626-2 (pbk. : v. 2)—ISBN 0-415-92627-0 (pbk. : v. 3)
 1. Art—Philosophy. 2. Aesthetics—History. I. Barasch, Moshe. Modern theories of art. II. Title.

N70 .B2 2000
701—dc21 00-042461

10 9 8 7 6 5 4 3 2 1

For Berta—once again

Contents

Preface

Since this is the final volume in a series of three dealing with art theory I take the opportunity to record some of the debts I incurred in the course of studying the subject and writing its history. My main debt of gratitude goes to the libraries and to the librarians in many universities who unfailingly helped in sometimes difficult searches. I cannot list all of these, but I should not fail to mention the National and University Library in Jerusalem and its devoted staff. Shlomo Goldberg earns my special thanks for continual assistance.

In the course of writing the volumes and preparing them for publication I enjoyed the stimulating interest of Colin Jones, the former director of New York University Press. Our many lively talks over many years helped to concentrate my attention on this work, when other projects often seemed very tempting. Closer home, I should like to thank Mira Reich for continuing intelligent help in many respects. My questions, I am afraid, were not always easy ones, but she always did her utmost to find what I was looking for. I am also grateful to Luba Freedman, colleague in my department and former student, for continuous assistance in many ways.

It is now more than two decades since I began to work with New York University Press, and it is a pleasure to record my gratitude to the staff of the Press, first of all to Despina Papazoglou Gimbel, managing editor, for steady cooperation, combining prudent responsibility for the quality of the book with friendly care for its author.

My most profound gratitude I owe to my wife. Without her encouragement, strict criticism, and patience this book, as well as my other studies, could not have been written.

Introduction

In the present volume I shall discuss theories of art that emerged and flourished over the relatively short period of roughly four decades. In general, a marked continuity is characteristic of the theory of art; the heritage of the past lives for a long time. The demarcation of such a brief period in the field's history, therefore, calls for an explanation.

Since the mid-nineteenth century, artists and critics, now largely detached from their traditional social and cultural frameworks, have been fully exposed to the quickening pace of general intellectual change. Moreover, as other intellectual disciplines became increasingly concerned with art, they discovered, and often shed light on, new and often surprising aspects of artifacts created in many periods and cultures. Because of the diversification of the interests of artists and critics, their interaction with scientists and scholars in other disciplines, if indirect, increased sharply. One of the results of this versatile and complex process was that art theory, in earlier stages of history perceived as a more or less distinct discipline with a common structure and well defined subject matter, became obscured, its outlines were blurred, and its structure equivocal. On the other hand, however, reflection on the problems of art witnessed an outburst of original creativity which often broke up the time-honored patterns of thinking on the subject. In surveying these decades we necessarily ask ourselves what, in the late nineteenth and early twentieth centuries, can still be perceived as art theory? To whom would such a theory be addressed, and whom was it meant to serve?

This apparently chaotic appearance of reflection on art does not surprise the student. Not only has the quickening of pace, so characteristic of the modern world in general, contributed to this development, but there were also more specific reasons that should be outlined. Differing from what we know from earlier ages, these reasons perhaps also warrant us in distinguishing a "period" that extends over merely a few decades. The basic conditions within which art theory evolved (and within which we can fol-

low its development) changed dramatically in the second half of the nineteenth century. The old institutions (such as workshops and art schools) in which styles were crystallized and in which aesthetic norms of art were sanctified and upheld for faithful imitation, either completely disappeared or lost whatever significance they may have had in the first half of the nineteenth century.

Already in the first half of the nineteenth century the artist's workshop, the traditional framework for articulating and transmitting style in the Renaissance and Baroque periods, was a thing of the past. Though it was occasionally romanticized (as in German Romanticism), it so obviously belonged to the past that nobody even felt the need to polemicize against it. These historic workshops were now the stuff of legend. But after the 1870s the more modern and more prestigious form of art education, that is, the art schools and influential academies of art where styles were forged, also came under attack. By the end of the decades discussed here the academies of art were not only regarded as the embodiment of "reaction," but they had in fact hardly any active contribution to make.

At that time the conditions under which art was presented to wide audiences, and painting and sculpture, judged and explained, also underwent profound change. The great exhibitions, the famous Salons, that had earlier presented normative models of established taste to both artists and audiences, completely lost their significance within less than a generation, while the exhibitions that made a real and lasting impact on both artists and audiences did not present the established norms. Increasingly it was the work of dissenting artists that evoked lively reaction. Exhibitions such as that of the impressionists (1873, 1874), of Cezanne's paintings (1904), and of the German Expressionists (1906) became the major cultural and artistic "events"; it was they, rather than the academics, that made a profound impact on the imagination of artists and shaped the expectations of audiences. These unorthodox exhibitions were discussed and remembered, and remained influential in the life of art.

Even more profound and drastic was the transformation of the literary discussion of painting and the other visual arts. In the course of many centuries two major forms for the presentation of the visual arts had emerged and became traditional. The first, which had crystallized in the Renaissance, was the art theoretical treatise. Although this type of treatise had many variations, all of them, throughout the centuries, retained the essential character of original art theory. The purpose of such treatises was to offer a systematic and comprehensive doctrine of what was often called the

"elements" of the visual arts. To be sure, sometimes these treatises seem quite lacking in systematic structure, and also seem far from comprehensive. Yet from Alberti in the fifteenth to, say, Richardson in the eighteenth and even Carus in the early nineteenth centuries, the desire to treat art, or part of it (as in Carus's discussion of landscape painting), in a comprehensive, systematic, and "objective" way, remained unchanged. Art theory was a doctrine.

The other important form in the discussion of art was established mainly in the eighteenth century. It was the criticism of art, particularly of new and contemporary works. Beginning with Diderot's famous Salons, that is, reviews of then recent exhibitions in Paris, art criticism became a separate literary category for dealing with works of art. For better or for worse, it became a mediating link between the public visiting exhibitions and the artists whose works were shown in them. Soon enough, it became one of the main functions of art criticism to pass judgment on newly exhibited work. Certain critical attitudes and elements of judgment were of course present in the art literature of all ages, but as a rule these were implicit, and were not the main purpose of literary composition. As a more or less independent field of writing on the arts, judgment on individual works emerged mainly in the eighteenth century. The critical review, though a new form of statement, must have satisfied a widely felt need; it was received with a great deal of approval, and within a very short period it became an established function in art literature. Already in the late eighteenth century Lessing, in his *Laocoön*, referred to the "judge of art" as one of the central figures in the theoretical consideration of painting and sculpture; he represented one of the principal approaches to art. Sometimes, as we shall see in the following chapters, art criticism yielded important evidence both with regard to the aims of different groups of artists (including avant-garde groups) and the taste prevailing in different strata of society. But since art criticism became increasingly devoted to the actual passing of judgment, it could only to a limited extent fulfill the functions that were traditionally those of art theory, namely, to reveal and analyze the rich and structured world of art, particularly as the artist experienced it, both to the artist himself and to the public that sought to respond to it.

In sum, we can conclude that the traditional patterns for explaining art were broken up, some modern forms only inadequately doing the job once performed by the old-fashioned treatise. What happened in the late nineteenth and early twentieth centuries to the core functions of art theory? In aesthetic reflection during the few decades to which the present volume is

devoted, these tasks were in part taken over by workers in other, partly new, fields of intellectual effort. Some students in these new fields were now contributing to the task of explaining art, and what they had to say became, as we shall see, increasing important. On the other hand, the literary form, and to a certain extent the essence of artists' presentation of their insights and aims, also changed profoundly. The writings of painters at the turn of the century were very different in form as well as in outlook, from writings in the seventeenth, eighteenth, and even early nineteenth centuries. By way of introduction it may be useful to outline briefly the overall character of these different new factors and forms.

One characteristic feature of the modern age that immediately comes to mind is the increasing significance of science in attempts to understand art. Nobody following the story of art theory needs to be told that at several crucial periods of history, close and profound ties linked the visual arts and the sciences. Thus, during the Renaissance the two domains, art and science, were closely linked in making new discoveries, in scientific illustration, and in the precise presentation of new insights in anatomy, botany, and zoology. Perspective, the doctrine and practice of the representation of space so crucial for many centuries of painting, was always understood as hovering between optics and art. In the decades with which we are concerned, however, the relationship between art and science changed. While artistic representation ceased to be of any real significance for scientific investigation or teaching, and the scientific illustration became a photograph rather than a woodcut or an engraving, art for the first time explicitly became the object of scientific investigation. In the past while some scientists had interested themselves in the arts from time to time, and occasionally made some surprising observations, there was no scientific concern with art on the scale experienced in the late nineteenth and early twentieth centuries. The range of questions asked by scientists about the arts became surprisingly wide.

A whole group of disciplines, many of them grouped in the nineteenth century under the common label of "psychology," concerned themselves with exploring different aspects of art, or questions that had a bearing on art. The interests of the "psychologists" were often quite different from one another, as were their points of departure. Yet, in one way or another they all made an impact on the art that was being created, on the trends that were being articulated in those decades, and on the theoretical interpretation of art in general. Beginning with the perception of light intensities in nature and the question of whether or not it was feasible for the painter to

translate the bright sunlight of a summer day into the color patches on his canvas, to the fascinating problem of how we perceive and correctly understand the emotional character of a work of art created in a distant period and alien culture—these were problems that the different "psychological" disciplines approached from their particular viewpoints. In nineteenth-century culture it was commonly believed that psychology held the key to solving these problems. In the following chapters these themes will appear time and again, as they were seen from different points of view and treated by different branches of learning. In the course of these intellectual efforts significant aspects of art, hitherto not sufficiently studied and not at the center of awareness for artists and scholars, were discovered and explored. They were among the core questions continuously discussed in reflection on the arts throughout the twentieth century. Looking back from a distance of almost a hundred years, there can be little doubt that what the "psychologists" presented in the late nineteenth and early twentieth centuries had a profound and lasting effect. Contemporary approaches to art would be unthinkable without these historical contributions.

Other great complexes of themes and images that emerged in the decades considered here made a lasting imprint on twentieth-century culture and art as a whole. They, too, were the result of an interaction between art and science. Prominent among them was the rise of "the primitive" as a new model for art (and not only for art). The primitive came to be considered by avant-garde groups as well as by large audiences both as an ideal art form and as a source of culture in general. Anthropologists brought to the consciousness of the western mind the very existence of cultures that were highly articulate yet radically different from our own. At the same time archaeologists excavated and studied the famous prehistoric sites, and students of religion discovered in these sites clues to highly developed systems of belief and ritual.

It was in this intellectual and emotional atmosphere that artists, searching for radically new forms of expression, found in the artifacts of prehistoric times and of the "primitive" cultures in our own time aesthetic and expressive patterns of art. With the advantage of hindsight we are now able to see that these different interests and trends converged. The participants in these historical developments were not aware of these interactions. Some of the critics who were conscious of the profound crisis of traditional models and inherited ideal types in European art did not necessarily realize the crucial role the primitive was about to assume. But looking back from the distance of a full century we can clearly see that all these phenomena were

aspects of a powerful common trend. The primitive became a central feature in twentieth-century art; it was also a focal theme in the attempts of our time to solve what has often been called "the secret of art."

The part played by the sciences in the profound changes in art was accompanied by another feature, or another process, that was characteristic of the modern age. This second process is less easily measured and described. What I have in mind is the change in the spiritual world of the artists themselves, and in the ways in which they articulated their views. The decades studied here abound in statements in which artists reflected on their work. These consist not only of fragmentary utterances made in specific contexts, but also of whole treatises written by painters and sculptors, as well as articles and books composed by critics close to the new movements that crystallized in the art of the period.

Reading these statements, mainly those written by artists, one is struck by their distinctly subjective character, their "confessional" tone. This kind of written statement was often employed with full awareness, with the explicit desire to reflect the artist's personal world. To a contemporary reader this seems almost natural. In fact, however, it was a novel feature, particularly in art theory. For centuries it was typical for artists to lay claim to a doctrinal "objectivity" in their craft and to aver that they were motivated by the desire to formulate a doctrine valid beyond mere individual taste and preference. This was true not only for the theories of the Renaissance and Baroque periods, but also for the teachings of the academies of art in the nineteenth century. Even if in the later centuries, mainly in the nineteenth, the "objective" character of the doctrine of art was less closely knit, the aspiration of artists and critics to formulate, and to follow, a supraindividual, suprapersonal doctrine was a guiding motive. This changed dramatically in the late nineteenth century.

To the historian following the shifting emphases in what the artists said about their work, impressionism seems to mark a distinct caesura. Painters now explicitly made their personal visual experience, the way *they* saw what was around them, the basis and criterion of pictorial representation. As I shall try to show in the next chapter, what the impressionists proclaimed to be their personal experience was in fact often influenced by comprehensive intellectual, particularly scientific, trends. Nevertheless they intended to depict their individual, direct, and immediate experience, and believed that such personal experience could be the ultimate basis for pictorial rendering.

Considering the developments just outlined, we can conclude that between the early 1870s and, say, 1912, the theory of art as a separate disci-

pline did not have a common form, nor a common framework. What in earlier stages had been called "the elements" of the doctrine of painting disappeared, the methods of teaching disintegrated, and the normative models faded. Given these developments, one wonders whether the modern reflection on art has any common core. Are there any links, overt or hidden, between the different concerns with art which lend them unity? And if there is such a unity, open or obscured, how can it be discerned, and in what does it actually consist?

One recalls, of course, that the theories of art from impressionism to abstract painting have a common background. All the opinions and doctrines we are about to discuss in the present volume occurred not only in a limited period of time, but also in the same cultural atmosphere. We are dealing with phenomena in western and central Europe. Most of the artists, critics, and thinkers who produced this body of revolutionary thought on art originated and worked in western or central Europe. Even if some of the artist-thinkers who played an important role in the emergence of the new art theory came from a more distant region (Wassily Kandinsky coming from Russia is, of course, the most obvious example), their theories were developed in western Europe, and they grew from, and took a position against some of, the intellectual traditions in the culture of central and western Europe. The very complex but closely knit fabric of western European culture at the turn of the century is the matrix of the doctrines to be presented. This highly developed culture, permeated by abstract concepts and the desire for scientific understanding, formed the frame of reference for all the theories of art that flourished in the late nineteenth and early twentieth centuries. Even the attraction that the primitive, the alien, and the exotic exerted on painters and critics between impressionism and abstract painting bears witness to the dominant position of western concepts in the reflection on painting and sculpture.

If this common cultural framework lends to the theories of art of these four decades a hidden unity, what makes them even more manifestly an interlocked pattern, a more or less organic body of thought, are the problems they were concerned with. The time span in which all theories we are about to discuss in this volume was a very short one—merely four decades, or roughly the period of a single generation. Even considering the accelerated pace of the modern world, four decades are too short a period to allow a historian, particularly a historian of aesthetic reflection, to speak of a historical development. While in the following chapters I shall occasionally have to indicate, however incompletely, a certain growth in time, that is,

progression from a "beginning" to a fuller, more developed articulation, that is, something recalling history, the historical narrative cannot be applied here. It is primarily the problems with which the theories are concerned that show their underlying unity.

The most obvious example of this is the intense concern with sense perception, beginning with impressionism's desire to be true to sense perception to the transcending of regular sense perception in abstract painting. These two attitudes to the same problem—the desire to fully immerse painting in sense perception and the urge to transcend the domain of sense impression—do indeed mark a beginning and an end, the first and the last phases of a process that lasted only a short time. Yet though occasionally some processual developments can be discerned, the characteristic structure of art theory in the decades considered here is that the great trends of thought—impressionistic theory, psychologic reflection on empathy, the concern with the primitive—existed simultaneously, alongside each other, and sometimes even influenced each other. It is for this reason that in the present volume the art theories are presented and analyzed in terms of problems rather than as stages.

The issues discussed, the themes or what we have called the "problems," also overshadowed the doctrine of the individual artist or critic. Significant as the single artist's individual experience may have been in the thought of artists and critics at the turn of the century, theoretical reflection on art in the decades considered here cannot be limited to the doctrine of a single figure. Insofar as we can tell from the distance of a century, the doctrine of a single thinker, whether artist or critic, cannot be properly considered as a unit unto itself. Transpersonal issues which go beyond the borders of the merely subjective form the conceptual framework of all art theory in the four crucial decades that mark the limits of this period. For this reason, too, the discussion of art theory between impressionism and abstract painting has to follow theoretical issues rather than any other framework.

Impressionism

1

Introduction

The Crisis of Realism

In May 1867 Edouard Manet made a kind of programmatic statement when he wrote: "The artist does not say today, 'Come and see faultless works,' but 'Come and see sincere works.'" Later in this part (in the chapter on style) I shall come back to the specific meaning of these words. Here we shall only say that when it was made, this programmatic statement that brought up a central problem in the theory of art, was unusual and differed from the issues commonly raised in discussions of art. Does it mark the beginning of a new theory of art? When, and in what context, did modern reflection on art begin? Periodization is always a peculiar matter. While we usually cannot trace a precise demarcation line between the old and the new, we also cannot help but divide up the continuous history we are studying into periods. Hence we cannot stop asking for beginnings. This question also imposes itself upon the student of modern thought on art.

The doctrines to be considered in the present volume emerged within four crucial decades: the late sixties or early seventies of the nineteenth century to the first decade of the twentieth. Replacing anonymous dates by terms denoting well-known art movements, we would say this was the period from the emergence of impressionism to the full crystallization of the principles of abstract art. The ideas that characterized the emergence and impact of what is called "abstract art" so profoundly stirred the minds of artists, critics, and audiences throughout the twentieth century that they came to overshadow the theoretical significance of impressionism, its spiritual and cultural sources, and the disturbing and revolutionizing effects that this movement had on critical reflection on the art of image making in later decades.

In the critical literature, impressionism is frequently treated as a "painter's art," an art that embodies specific pictorial values, and is devoted to them alone. This means, in fact that, on the one hand impressionism is considered to be largely detached from other, nonpictorial domains, such as literature, philosophy, and science, and on the other, that the impres-

sionist's work concentrated on the painter's actual performance, and was thus detached from any theoretical reflection even on itself.

In the present section I shall try to show that these assumptions, while they may seem justified in view of the artists' almost exclusive concern with visual phenomena and their rendering in painting, do not reveal the comprehensive breadth of impressionism as a trend in its own right. I shall, therefore, try to show first that some of the problems that result from impressionistic painting arose also in various other fields of intellectual and cultural activity. In philosophy and literature, in social doctrines and even in the natural sciences, ideas and attitudes emerged that had a basic affinity to the principles of impressionism in painting. Seen in this broad context, the pictorial movement of impressionism seems to be the expression, perhaps the climax, of a many-sided historical process that encompassed most of late-nineteenth-century culture in western Europe. With all its exquisite pictorial values, impressionistic painting was not an isolated phenomenon. To be properly understood, the cultural movements around it must be taken into consideration.

Nor is impressionistic art as antagonistic, or even outright hostile, to theoretical reflection as some later critics, and mainly popular presentations, have made it out to be. To be sure, unlike some other trends of art, impressionism is not a systematically formulated theory; there is no "treatise" representative of the ideas of the painters belonging to this movement. But from a careful reading of fragments of personal statements and short critical reviews, a consistent body of thought emerges. It should be noted that impressionistic thought has themes and emphases. Suffice it to recall the concern with the effects of sunlight and atmosphere, the fascination with the phenomenon of reflection (in water and other materials), and the development of a particular technique of painting in perceptible, sometimes contrasting brush strokes and dabs of color. Impressionistic doctrines, whether articulated openly or only implicitly suggestive, make some specific assumptions with regard both to what we see and experience in the world around us, and to how these visual experiences should be represented in painting. None of this attests to a detachment from theoretical reflection; rather it shows a particular and distinct theory of painting, calling for a study in its own right. To this the second part of the present part is devoted.

Only when we see these two sides—the intrinsic links of impressionism in painting with related trends in other fields, and the immanent theory of painting in this movement—can we understand how impressionism formed the beginning of a new age in the theory of art.

2

Aesthetic Culture in the Literature of the Time

In the second half of the nineteenth century both philosophy and science contributed, and, as we have seen, formed a comprehensive background to, what might be called the crisis of Realism. The solid world, made of a tangible material substance, seemed to crumble, to slip away, or simply to disintegrate. What remained, it seemed to writers and artists, were only appearances, sensations, something which you could look at for a fleeting moment, but which you could not grasp, hold, or rely on. How did the arts, or culture as a whole, reflect this state of affairs, or this intellectual trend? Philosophy, one could say, has some inherent links to the abstraction of science. How did the arts linked to real life approach a world in which there were only appearances? To answer these questions, we turn first to literature and to the literary criticism of the time.

In 1868, the year in which impressionistic painting was crystallizing, Walter Pater composed the "Conclusions" to what became his best-known work, *The Renaissance: Studies in Art and Poetry*. In the few pages of the "Conclusions" Pater gave concise expression to an important intellectual and artistic trend of his time. "To regard all things and principles of things as inconstant modes or fashions has more and more become the tendency of modern thought."[1] Walter Pater, as we know, was the principal representative of the movement we call Aestheticism. To this movement we shall return in another part of this volume. Here I shall mention only one of its characteristics, the concern with a contemplative attitude.

"At first sight," Pater said in the Conclusions, "experience seems to bury us under a flood of external objects, pressing upon us with a sharp and importunate reality. . . ." But, he continued, "when reflexion begins to play upon these objects they are dissipated under its influence: the cohesive force seems suspended like some trick of magic: each object is loosed into a group of impressions—color, odor, texture—in the mind of the ob-

server."[2] Impression, or sensation, as it was later called, was the initial (and the last) place where contact was established between ourselves and the world surrounding us.

In French letters of the late nineteenth century, the main proponents for the attitude of mere contemplation were the brothers Edmond and Jules Goncourt. They were not painters (though originally both brothers intended to become artists), but the visual arts played an important part in their writings. Painting was a significant influence in their work and a constant source of inspiration, for the attitude they considered the most appropriate to man was most fully realized in painting. This was the attitude of mere contemplation, of passive looking. In this sense they spoke of "optique intellectuelle."[3] It is characteristic that Jules Goncourt should have coined the term.

What is "optique intellectuelle"? A concise answer is not easily given. The Goncourts were not philosophers. They did conceive of general, abstract ideas, but as a rule they did not invest great effort in conceptual clarifications. At a late stage in their lives they regretted that they had not formulated a theory of art. "What a misfortune," we read in the *Journal* (IV, p. 72), "that we did not have time to formulate our revolutionary doctrine of art." But the Goncourts did not define their term "optique intellectuelle." Moreover, the words "optique" and "intellectuelle" suggest a theoretical discourse, as they have a scientific ring. Scientific and theoretical discourse, however, does not fit the spirit and style of the Goncourts. What they had in mind, and probably denoted by Jules Goncourt's term, was the kind of pure contemplation that leads to, or is based upon, complete detachment from cognitive as well as emotional purposes and involvements. This type of contemplation became a kind of ideal. Such an attitude of detached, pure contemplation, as I shall try to show, lay behind all that may be called "impressionistic culture." It was a culture that played a major part in the last third of the nineteenth century, and paved the way for some of the radical, revolutionary movements in aesthetic thought.

Mere contemplation, mere looking, was the Goncourts' central attitude, at least insofar as their views of art were concerned. Since they nowhere defined what such contemplation was, we have to rely on different allusions scattered in their works. Both in their entries in the *Journal* and in some of their novels, they suggested, at least vaguely and in fragmentary comments, what they understood by such looking and watching. To be sure, when they conjured up the image of mere looking, they did not have looking at pictures or other works of art in mind; usually they were referring to looking

at nature, social reality, or at people. From these descriptions, however, we also learn in some detail how, in the Goncourts' view, the spectator looks at pictures and statues.

Why did the Goncourts strive for pure contemplation? Critics have looked for what might have motivated the Goncourts in their search for a perfect attitude. It has been said that the brothers' views of mere contemplation were informed by an "aesthetic hedonism," by a drive for pleasure and satisfaction achieved by looking alone. The Goncourts did indeed frequently, and in various contexts, speak of the "pleasures of the eye." They said one is concerned with "shaping one's environment artistically, so as to give pleasures to the eye."[4] The "joy of the eye" was a significant and recurring theme in their consideration of both art and visual experience in general.

Nevertheless, it seems to me it would be a mistake to try to derive the Goncourts' aesthetic doctrines from a drive for pleasure, satisfied by the eye. This would suit some twentieth-century trends in psychology that make the "pleasure principle" and the desire for pleasure the main motivating force. It is not valid, I believe, for late-nineteenth-century culture. While the concern with the "pleasures of the eye," or, in theoretical terminology, the hedonistic motivation for aesthetic visual experience, is indeed a continuous thread in the Goncourts' reflections on art, it is not the central motif in their doctrine. Were we to present a comprehensive system of the Goncourts' aesthetics, the desire for visual pleasure would be marginal and would not be sufficient to account for an attitude of mere contemplation.

Mere looking is a basic existential situation, and this is particularly true for the arts. "To see, to feel, to express, this is the whole of art" (II, p. 251)—this is how the Goncourts defined art. Terms such as "feeling" and "expression" should not mislead us; they should not be taken in the sense they have acquired in the twentieth century. We should understand "to feel" (*sentir*) as "to sense," to become aware. The concept of "sensation" became a central notion in impressionism. When we come back to it in greater detail, the difference between the impressionistic reading of this term and the one common in expressionistic trends will become even more obvious.[5] Nor does "expression" have the emotional meaning it acquired early in the twentieth century. When the Goncourts said that art should "express" something, they did not think of expressing our inner experiences, but of showing what we perceive.

The suggestive descriptions the Goncourts often gave in their literary works indicate what they meant by these crucial concepts—pure contem-

plation or mere looking. Thus Edmond Goncourt wrote that Faustin, the heroine of one of his novels, "received from her contacts with objects and people particular impressions . . . in a manner unexpected, unusual. . . ."[6] Note that the impressions received from inanimate objects were of the same nature as those derived from people. The Goncourts looked at the world around them without empathy for particular parts or components; their gaze was detached. Passions, emotional involvement, and empathy have been taken out of the whole domain of the visible, from the vast sphere from which impressions are received.

How far removed from any emotional involvement the spectator's experience can be, may be seen from a description in *Manette Salomon*, a novel originally published in 1867, a crucial date in the crystallization of impressionistic painting and thought. Just listen to the Goncourts' description of one of the personages looking at Manette. "When he was outside, he sat in sunny places, letting his eye rest for quarters of an hour on a piece of the neck, a bit of Manette's arm, a spot on her body on which a sunray fell."[7] Reading such observations one cannot help but think of impressionist paintings, say by Renoir or Monet, representing a nude in a landscape. Not only do the individual optical effects remind us of these famous paintings, but so does the general atmosphere of emotional detachment.

Finally, in the Goncourts' thinking visual impressions were not permanent and stable, nor did they reflect the unchanging features of reality; their temporary nature was emphasized. On the contrary, what they saw in their mind's eye was "a succession of extraordinarily rapid and fugitive sensations."[8]

These characteristics of mere contemplation, selected, as I have said, from observations scattered in the Goncourts' writings, do not sustain the "hedonistic" thesis: the purpose of pure looking was not to give pleasure to the eye. On the contrary, contemplation seems altogether detached from any psychologistic orientation. Mere looking is an original condition of man.

The novelty, perhaps even uniqueness, of the Goncourts' approach to art in general can be seen with particular clarity when we concentrate on a detail, and compare what they said about it to what earlier generations had said. Such a detail is the eye. In the writings of the Goncourts the reader often finds lengthy praise of this organ. Indeed, such praise of the eye was characteristic of their reflections on art. The historian of painting, and of artists' reflections on their metier, remembers, of course, the praise of the eye as a recurring literary topos. Who would not think of Leonardo? (One

should perhaps recall that the great editions of Leonardo's notes were being prepared and published in the very years that the Goncourts were reflecting on painting.)[9] The Goncourts, cultivated and well read, were certainly aware that they were moving on traditional ground here. Yet what they said about the eye often departed radically from established tradition.

Throughout the history of European culture, the eye was praised mainly for two reasons. One type of praise is associated with the Neoplatonist writings of late Antiquity, and transmitted by a variety of media, from philosophy and erudite literature to various kinds of popular psychology and common beliefs: here it was claimed that the eye was "the window to the soul." The unique value of the eye, it was believed in this widely diffused tradition, consists in what it reveals of our inner self. Were it not for the eye, we would have no insight into another's soul. However, the intellectual and emotional world of impressionistic philosophy and art had no affinity with such views, and this kind of praise for the eye left no trace at all in its work.

Another traditional type of praise is of more significance in our present context. Here the eye was valued because it is the organ of cognition. The best formulation of this approach is found in Leonardo da Vinci's famous statements. The eye, Leonardo said, makes it possible for us to attain objective cognition of the world around us, and to record the knowledge gained by visual observation. The eye, he said in the exalted style of laudations, "is the prince of mathematics, its sciences are most certain, it has measured the heights and dimensions of the stars, it has found the elements and their locations."[10] What we see is the most "correct," most truthful cognition of reality (although Leonardo was well aware of optical illusions). Briefly summarized, the central value of the eye is that vision makes possible, and leads to, cognition.

The impressionists, too, praised the eye. But the spirit that informed their acclamations differed radically from Leonardo's as well as the Neoplatonists' praise. The unique nature and value of the eye, the Goncourts' writings as well as those of lesser critics suggested, do not consist in the ability to measure the objects around us precisely and to represent them truthfully (so that the pictorial representation may serve as a scientific illustration); nor do they follow from the fact that the eye is a window to the soul. Looking and contemplation are not a means to something; they are a kind of primordial experience, sufficient unto themselves, and not in need of justification by a different end to be served (cognition or revelation of the soul). When we immerse ourselves in pure contemplation and are detached from everything else, we do not aim at cognition, nor do we wish to

reveal our inner being. Such contemplation is an immediate, irreducible experience. Pure visual experience is not a means to an end, it is an end in itself.

The views of artists, writers, and critics belonging to the impressionistic trend about the eye and about visual experience in general has a profound affinity to what we call the "aesthetic." Indeed, mere contemplation has often been characterized by its affinity to the aesthetic realm. The term "aesthetic," especially as used in the language of nineteenth-century criticism, is not free from a certain ambiguity. Thus the term "Aestheticism" is used to describe artistic or critical movements and attitudes that make the "Beautiful" (whatever that may mean in a given case or context) a characteristic feature, as distinguished from other movements or attitudes. With the Goncourts, and with impressionism in general, it was not "Beauty" that counted; what allows one to use the term "aesthetic" in speaking of them was their emphasis on mere contemplation, on just looking.

The Goncourts were well aware of the conceptual difficulties, perhaps even contradictions, inherent in the notion of aesthetic experience, particularly when coupled with that of pure contemplation. The eye, they said, searches for "joys." Here complications arise. To savor all the delicacies of visual experience, the eye must be educated. The demand for the education of the senses, particularly of sight, appears time and again in the Goncourts' writings. But this demand implies an intrinsic contradiction in the impressionists' philosophy of aesthetic experience and of art. On the one hand, the impressionists wanted to reach the level of "sensation," which they believed to be an aboriginal, primordial layer of our human experience preceding culture and education, and hence available to every human being. On the other hand, however, they knew that in practice it is acquired taste, shaped by social conditions and collective memory, that enables the eye to enjoy much of what it perceives, or that prevents it from enjoying other sights. The Goncourts' awareness of the social and historical conditioning of the pleasures of the eye found succinct expression in their famous dictum: "The beautiful is that which appears abominable to eyes without education." But though the Goncourts were aware that education can make a difference, social and cultural elements remained marginal in their concept of contemplation. They were not primitivists in the sense that they did not as a matter of principle deny the significance of culture. But what mattered to them—this is what the student of cultural tendencies concludes—was detached contemplation as a unique activity that in principle is common to every human being.

Detached contemplation, as we have seen in several cases, is not primarily concerned with singling out the figures and objects we perceive and lifting them up from their surroundings, but with their appearance only. This acceptance of appearances leaves figures and objects fully embedded in, and merged with, their environment. This is also true of the Goncourts. One of the many manifestations of this attitude can be seen in their preference for the sensation of color to the significance of line within visual experience.[11] In art theory, at least since the Renaissance, a well-known competition has been going on between line and color. In the conceptual developments and literary records that accompanied this competition it was accepted as a matter of course that the preference for line or color indicated different, even opposing, artistic aims: the adherence to line was understood as an expression of the desire to make an objective statement about the reality portrayed; the predilection for color, on the other hand, was understood as indicating the wish to reproduce physical reality as it appeared to the senses, without the intermediacy of inquisitive, discriminating observation. The Goncourts, concerned as they were with art and widely read in the literature dealing with it, must have been well acquainted with this traditional competition.

The Goncourts' preference for color was noticed and commented on by other critics and writers even during their lifetimes. Let me quote Paul Bourget, a well-known novelist and influential literary critic of the period, mainly in the 1880s. Juxtaposing the Goncourts' views concerning the elements composing painting with those held by more traditional critics, he said that "the Brothers Goncourt do not prefer plastic forms in the manner of Theophile Gautier. They have quickly grasped that the form is nothing but a particular case of color, and that the salience of objects results from a degradation of shades; it is thus the color one should strive to reproduce."[12]

Reading the Goncourts' literary prose one is struck by their frequent attempts to describe subtle effects of color and shade in nature. The colors so evocatively described usually appear as patches of hue, as bits of shaded extension rather than as hard, tangible objects having a special color. This kind of description invokes impressionistic painting, and indeed has an intrinsic affinity to it. The brothers themselves may have felt that in describing the colors we perceive in nature, they were thinking of painting. Sometimes such a submerged feeling is even expressed. Thus, in an entry in the *Journal* describing the sun in the sky suspended over a pearl-gray sea, they noted that "It was only the Japanese who in their color prints venture to depict such strange effects" (II, p. 213).

More than other critics, and more perhaps than most artists, the Goncourts were aware of the intimate, if subtle and subdued, interaction between the art we remember, the paintings that have impressed us and that we store in our memory, and the immediate impressions of the nature we are looking at. Their writings yield fine examples of such interplay. The brothers' sensitivity to color in their descriptions of natural sights often betrays the eye's education through art, the wealth and interiorization of artistic memories, and the way they tinge what we perceive, seemingly directly and immediately, in nature. Take, for instance, the description of the pearl-gray shade of the sea over which the sun descends (*Journal*, VIII, p. 99). What has this hue in nature to do with the symbolic shades of gray in the pictures by Eugène Carrière whom the Goncourts so admired? Whatever one may think about the interaction of artistic memories and natural views, by making color the primary element in looking at both nature and art the Goncourts revealed their intellectual proximity to impressionism, and also indicated their general attitude to art.

The significance the Goncourts accorded to color formed part of a comprehensive view on art and life. Particularly in what they said about painting, the Goncourts have come to be considered the representatives of what is termed "aesthetic culture." It was precisely in contributing to this culture that they shaped the conceptual framework for impressionistic thought and art.

"Aesthetic culture" is an ill-defined concept that would not bear careful logical analysis; it is suggestive rather than clearly outlined. And yet we know what it suggests: namely, the extension of an aesthetic attitude to matters of life itself. Oversimplifying, we might say: it is a culture in which the attitude of detached contemplation is maintained not only with regard to works of art, but with regard to everything, all the realities surrounding us. If such an attitude were maintained, people and events in actual life would assume a certain remoteness that is characteristic of works of art.

An aesthetic attitude to life, demanding total dedication to art alone— so it appeared to the Goncourts and to some of their readers—fosters a psychological detachment from the active life and from any involvement in the problems of society. The Goncourts were indeed extreme in this respect. Few authors would have been ready to claim what the brothers recorded in their *Journal*: "One should not die for any cause, one should live with every government, whatever the aversion you feel to it; one should not believe in anything but in art, and one should not admit anything but literature. All the rest is a lie and a booby-trap" (II, p. 84).

The brothers Goncourt testified that they lived up to this ideal of art as the only reliable, permanent value that counted, the only reality that could be fully trusted. "I believe that since the beginning of the world one has not seen living beings so swallowed up by, so engulfed in, matters of art and matters of intelligence as we are. Books, drawings, engravings are the landmarks on the horizon of our eyes. Perusing, looking—with this we pass our existence" (II, p. 6).

A comprehensive attitude of this kind necessarily affected their approach to literature and to the literary masterpiece. What the Goncourts said about literature does indeed shed light on their thinking in general. In their judgment, the ethical meaning of a literary work of art, its general human subject matter, tends to recede into the background; the admiration for perfect configurations becomes the dominant factor. In other words, for them the central value of a literary work lay in its application of aesthetic norms to the subject matter it described.

It was this attitude of detachment, of total restriction to the world of appearances, that brought the Goncourts' worldview so close to the frame of mind of the impressionists. The crystallization of their concepts of aesthetic culture (and hence also their affinity to impressionistic painting) evolved in a continuous discussion with the art of the past. They felt the need to set themselves off from the classical heritage. Their treatment of Greek literature, and mainly of Homer, is particularly illuminating in this context; it bears witness to their approach to the general problems of literature and art. Their low opinion of Homer is particularly striking; it is a judgment they proclaimed several times. A derogatory attitude to Homer, openly stated, was in their time and world something of a heresy. Though the brothers did not say so explicitly, in their mind Homer clearly stood for the whole of Greek culture. In the *Journal*, Edmond Goncourt expressed the reasons for their disparagement of Homer as follows: "Your Homer paints only physical suffering. To paint moral suffering, this is more arduous. . . . The most modest psychological novel moves me more than all your Homer. Yes, I take more pleasure in reading *Adolphe* [by Benjamin Constant] than the *Iliad*" (II, p. 112). What they found so attractive in Benjamin Constant's *Adolphe* was the author's inclination to transform what went on in his own soul into some kind of object, and to look at it from the outside, as it were.

Contemporaries of the Goncourts were quick to note the brothers' critical attitude to Greek literature and art. As early as 1866 Sainte-Beuve discussed in an article still worth reading the brothers' lack of respect for clas-

sical Antiquity; *their* Antiquity, he said, is the eighteenth century.[13] Though the Goncourts' attitude to Antiquity was perhaps not as consistently negative as it was later made out to be,[14] their rejection of the Greek and Roman cultural and artistic heritage was far-reaching. In their view, this rejection was part of their affirmation of modernity, a condition of belonging to the world of today. Sainte-Beuve understood this motive. The "Querelle des anciens et des modernes," that great dispute between traditionalism and modernity that nourished the literary and artistic debate of former centuries,[15] is not yet over, he wrote in his article.

The Goncourts' critical attitude to, perhaps even outright repudiation of, the Greek tradition in literature and art, whatever the motives that inspired them, made it imperative for them to indicate what should replace the classical model. The question was, of course, crucial at the time; even today, reading the criticism of those years, one senses its urgency. But if the Goncourts did not intend to replace the classical tradition by another specific tradition as coherent and self-contained as the Greek, they did want to supplant one "organic" culture by another. In this they were pioneering a new attitude, one that was rare even in the great trends of modern times. For example, when around the turn of the century the trend known as primitivism also rejected the Greek tradition, its advocates offered what they called the "primitive" model instead. This model, they believed, though spread over many periods and dispersed over many continents, was in spirit and form no less coherent and articulate than the Greek one.

The brothers Goncourt did not present a new systematic philosophy, but they did offer another principle. What they were concerned with was the individual art object. The aesthetic object, the work of art, was considered by itself, totally detached from its cultural and historical context. Therefore objects belonging to altogether different cultures could be seen (and shown) next to each other, without losing their inner completeness and beauty. It was in this form, as isolated objects, that they could inspire the modern artist. In *Manette Salomon*, a novel written jointly by the brothers, they described an artist's *atelier*. It was an embodiment of the Goncourts' eclectic ideal, and resembled a strange museum. "Everywhere astonishing vicinities, the confusing promiscuity of curiosities and relics: a Chinese fan issuing from an earthen lamp from Pompei."[16]

Such "confusing promiscuity" was the result of detaching what you see from all that is linked with it, and valuing only what the eye sees. It is a principle quite close to the one that, as we will see in the next couple of chap-

ters, dominated philosophical and scientific thinking. And it had an inherent affinity to the attitude of impressionistic art.

NOTES

1. Walter Pater, *Three Major Texts (The Renaissance, Appreciations, and Imaginary Portraits)*, edited by William E. Buckler (New York and London, 1986), p. 217.
2. Pater, *Three Major Texts*, p. 218.
3. Edmond and Jules Goncourt, *Journal des Goncourt. Mémoires de la vie littéraire*, II (Monaco, 1956), p. 294. The entry was written in 1865. Further references to entries in the *Journal* will be given in parentheses (by volume and page number) in the text.
4. Some quotations are collected by Erich Koehler, *Edmond und Jules de Goncourt: Die Begründer des Impressionismus* (Leipzig, 1912), especially pp. 183 ff. See also the still fundamental work by Pierre Sabatier, *L'esthétique des Goncourts* (Geneva, 1970; original edition: Paris, 1920).
5. See below, the part on empathy.
6. Edmond de Goncourt, *La Faustin* (Paris, 1907), p. 233.
7. Edmond and Jules Goncourt, *Manette Salomon* (Paris, 1906), p. 210.
8. E. Goncourt, *La Faustin*, p. 237.
9. The six monumental volumes of Leonardo's manuscripts, edited by Charles Ravaisson-Mollien, *Les Manuscrits de Leonard de Vinci. Manuscrits de la Bibliothèque de l'Institut*, appeared in Paris between 1881 and 1891.
10. Leonardo da Vinci, *Treatise on Painting*, translated by Philip MacMahon (Princeton, 1956), p. 34. See Moshe Barasch, *Theories of Art: From Plato to Winckelmann* (New York, 1985), pp. 134 ff. For Leonardo's views on the eye in science, see V. P. Zubov, *Leonardo da Vinci* (Cambridge, Mass., 1968), chapter 4, pp. 124–68.
11. See Sabatier, *L'esthétique des Goncourts*, pp. 98 ff., 296 ff.
12. Paul Bourget, *Nouveaux essais de Psychologie Contemporaine* (Paris, 1894), p. 186.
13. Sainte-Beuve's article, called *"Idées et sensations,"* that appeared originally on May 14, 1866, and was reprinted in *Les grands écrivains français* (Paris, 1927), pp. 258–78.
14. See François Fosca, *De Diderot à Valery: Les écrivains et les arts visuels* (Paris, 1960), chapter 16, in which he shows that in the Goncourts' judgment of Antiquity there were also positive elements.
15. For the significance of the *Querelle* for the theory of the visual arts, see Moshe Barasch, *Modern Theories of Art, 1: From Plato to Winckelmann* (New York, 1985), pp. 360 ff.
16. E. and J. Goncourt, *Manette Salomon*, p. 131.

3

Impressionism and the
Philosophical Culture of the Time

The utterances of the impressionistic painters and of the roughly contemporary art critics I quoted in the previous chapter have a seemingly narrow, "professional" ring; they seldom refer to comprehensive problems lying outside the work of the painter. One thus easily gets the impression that these artists were intent on stressing the specific, unique nature of the artistic, pictorial domain, detaching it from other domains of experience, reflection, and life. We read of light and color, of tones and brush strokes, and thus of art as isolated from thought and culture as a whole. Considerable contemporary criticism and interpretation of art still vividly reflects this attitude. It goes without saying that the characteristics of impressionistic painting are unique, and that they pose issues that cannot be fully compared to the specific characteristics of contemporary science, literature, or philosophy. Nevertheless, impressionistic painting has much in common with trends prevailing, or developing, in these other domains, and these common attitudes or problems bear investigation.

The intellectual attitudes characterizing the culture that produced impressionism as an artistic trend were not inherently conducive to strict philosophical reasoning or the building of philosophical systems. To build a philosophical system one has to strive for completeness of presentation, for a full and reasoned connection between the system's distinct parts, and for a fully and evenly articulated argument, requirements seemingly in direct opposition to the leanings that shaped impressionistic art. Nevertheless, the emphasis on certain philosophical notions both in France and in other parts of Europe, as well as the explanations offered for them in late-nineteenth-century reflection, show a remarkable, more than accidental similarity with tendencies in impressionistic painting. A glance at these theoretical speculations will shed some light on the spiritual world of impressionism.

The student of modern culture may be familiar with the central significance accorded to immediate experience and the empirical ideal in the thought of the second half of the nineteenth century. But notions like "experience" are complex, and may be understood in different, even contradictory, ways. What did western philosophers of the late nineteenth century mean when they evoked this notion? One of the meanings the notion of "experience" had in the philosophical reflection of the time was that of a continuous flow of impressions, rather than an encounter with some real, independent object "out there" in the world.

Here it may be useful to adduce Henri Bergson as a witness to this intricate trend of thought. Although Bergson belongs to a somewhat later generation than the impressionist painters, he sums up the impressionistic trend of thought more profoundly than other thinkers. Right at the beginning of one of his great works, *Matter and Memory (Matière et mémoire)*, which appeared in Paris as early as 1896, he offered his theory of the real world as consisting of the presentations of everyday experience. Characteristically he called these presentations "images." The term is not employed by chance. By making what we would otherwise call an "object" or a "thing" into an "image" he in a sense emptied the object of its full material reality. True, Bergson did not want to be seen as a "subjectivist," that is, as one who conceived of objects as mere "appearances." Without denying the existence of an outside world, Bergson in fact concentrated on what we perceive in our experience as the contents of our consciousness. He very powerfully conveyed the feeling that we are surrounded by a web of immaterial images. "Here I am in the presence of images," he wrote in the opening sentences of *Matter and Memory*, images "perceived when my senses are opened to them, unperceived when they are closed. All these images act and react upon one another. . . ."[1] Representation, he said, is "the totality of perceived images" (p. 64).

The truth or philosophical validity of Bergson's doctrines does not concern us in the present study. However, philosophical doctrines often expressed the social trends of their time, and were of great consequence in shaping their culture. Seen from this point of view, Bergson's ideas are important for our understanding of the intellectual and emotional character of impressionism, and the attitudes it articulated in the domain of the visual arts.

One of the central problems in Bergson's philosophy is the relationship between experience and memory. Disregarding the philosophical implications of Bergson's discussion, we will look at what a painter or an art critic

may have derived from this theoretical reflection (even if the philosopher himself wished to emphasize different aspects). Painting, it was generally accepted, is based on, and reflects, visual experience. "We paint what we see" became a slogan, repeated countless times by artists and critics. But artists always felt (though the degree of their awareness greatly varied) that visual experience is not as naive and direct as this concise sentence suggests. In fact, human vision is not naive; it is tinged, blurred, some would say "distorted," by the accumulated memories we carry in our minds. It is this accumulation that Bergson called "memory." There could hardly be a subject of more profound concern to the impressionists than this juxtaposition of experience and memory.

Bergson had much to say about the nature of memory, and particularly about the functions it fulfills in our experience of the world around us. In fact no experience of present reality is unmixed with memory. The question is, which of the two factors, perception or memory, determines the overall character of experience? According to Bergson, memory is often so powerful that it in fact replaces perception; actual perception may become the occasion that triggers a memory (p. 162 ff.). It has correctly been concluded that memory may thus become not so much an augmentation of, as a hindrance to, perception.[2]

Given the cultural mood of Bergson's reflections and theories it is no surprise to encounter the notion of "pure perception" here. Of course, Bergson was aware that "pure" perception exists only in theory. Our real perception, "concrete and complex" as it is, is never pure; it is "never a mere contact of the mind with the object present; it is impregnated with memory-images which complete it as they interpret it" (p. 170). Already, earlier in his work he said that actual perception is "enlarged by memories and offers always a certain breadth of duration." Bergson introduced the concept of "pure" perception in order to understand what perception is in general.

From this we understand what "pure perception" may be. It is an altogether instantaneous grasping, totally freed from memory. Such a perception would be "absorbed in the present and capable, by giving up every form of memory, of obtaining a vision of matter both immediate and instantaneous" (p. 26). Pure perception would mean the immediate apprehension of an "uninterrupted series of instantaneous visions." And it necessarily implies that the person doing the perceiving is totally immersed in what he or she experiences.

Bergson the philosopher knew that "pure perception" and "pure intuition" cannot be achieved in reality. Such perception would presuppose that

we are able to experience the world around us without our views and impressions being shaped, at least in part, by the accumulated treasure of crystallized images that make up our human world; Bergson himself called them "memory images." In other words, "pure perception" would require us to shed the impact of the accumulated culture that is part and parcel of our human existence. We need not follow the philosophical problems that arise here. We need only say that, from the vantage point of the historian, the very appearance of the notion of "pure perception" was a significant development in the thought of the time. That the subject attracted attention and became topical indicates that it touched on one of the central themes of the period.

Here we have to turn from Bergson the philosopher to his role as a herald of the culture of his time, and from what he said to how he was perceived, at least in certain circles (and regardless of whether or not the reception of him was "correct" in a scholarly sense). As a philosopher, it goes without saying, Bergson did not attach any value judgment to the two elements, perception and memory; he did not in any way suggest that the one was better than the other, that it belonged to a more basic layer of human existence, or that it was more desirable. But one can well understand how a generation that was tired of its inherited culture, that longed for a direct, "immediate" experience of reality (and made the primitive an ideal figure), imbued Bergson's "pure perception" with high value, even as a kind of paradisiac land which people longed to reach.

The theory of thought that shaped Bergson's interpretation of experience culminated in his view of time. His treatment of time is not only among the most characteristic and influential elements in his philosophy; it also sheds some light on an intellectual and cultural attitude that was central to what may be called the impressionistic worldview, and may even have had a more direct relation to the impressionistic painter's approach to his experience of "nature." The core of this Bergsonian contemplation is the notion of *durée*. The concept of duration (*durée*) was a persistent theme in his philosophy, which had played a central part in his first major work, the *Essai sur les données immédiates de la conscience* (Essay on the Immediate Data of the Consciousness). The *Essai*, a short book, appeared in print in 1889,[3] but it was composed several years earlier, mainly in 1886. It is worth recalling that the mid-1880s were years in which impressionistic painting became better known among, and was taken more seriously by, some progressive circles in Paris, the city where young Henri Bergson lived and composed his philosophical discussion.

Duration (*durée*), and time in general, continued to occupy Bergson's interest. In a later work, *Introduction to Metaphysics* (Paris, 1903), he approached the subject from another angle, one that may be of interest to the student of art. There are two ways of knowing, relative and absolute, he said here. Relative knowledge is achieved by piecing together fragmentary views, while absolute knowledge is achieved by experiencing something from within, that is, by intuition. Intuition is "the kind of intellectual sympathy by which one places oneself within an object in order to coincide with what is unique in it and consequently inexpressible" (1.6). Now, *durée*, Bergson believed, can be grasped by intuition only. The real experience of duration is altogether distorted by our attempt to make the flow of time measurable. What is measurable is the projection of time onto space, or surface, and we tend to mistake the projection for the movement itself. "A quarter of an hour *becomes* the 90-degree arc of the circle that is transversed by the minute hand."[4]

In his attempt to show that the uninterrupted flow that is the nature of time cannot be measured, that is, cut into pieces and projected onto space, Bergson took up the classical formulation of a problem in Greek thought, Zeno's paradox. Arguing against Zeno's famous paradox (the ancient philosopher's "proof" that movement is impossible) Bergson stressed the unfortunate consequences of projecting time onto space. Zeno concluded that if an arrow in flight passes through the different points on its trajectory, it must be at rest when at them, and therefore can never move at all. The mistake, said Bergson, was to assume that the arrow can be *at* any point. The line may be divided, but the movement may not. It is the same with time. Time is a great flux that cannot be divided, counted, and summed up; it can be understood properly only by means of intuition.

How then, if at all, does Bergson's discussion of time and movement tell us something about the spiritual world of impressionistic painting? Painting, after all, is an art of space. The fact that the picture is grounded in spatial perception was distinctly part of the cultural awareness of many periods, especially in the modern world. The early Italian Renaissance already conceived of geometrical and stereometrical figuration as the essential framework for the art of painting. Thus Alberti began his treatise on painting—the birth certificate of the "modern" theory of art—with what the painter takes from the mathematician[5]—and what he takes is geometry. For centuries painting and sculpture were considered the "arts of space," while music and poetry were seen as the "arts of time."[6] Why, then, should we look at Bergson's theory of time in the context of impressionistic painting?

The answer is that Bergson's theory of time is important for our understanding of the impressionistic approach because he discovered, or articulated, a new principle for seeing the world around us. This principle also dominated the art of impressionism. If one accepts Bergson's thought one has to abandon our view of painting as an art of space. For centuries it was firmly believed that the reality, or "nature," we see around us and that our painters represent in their pictures is made up of discrete, material figures or other bodies placed within empty space. That space is altogether unrelated and indifferent to the objects it contains. Objects are tangible bodies, space is a mere extension. But as we have seen, Bergson believed that in our actual experience both can become parts of a continuous flow. Reality, perceived in a highly intuitive way, is "mobile and continuous" rather than static and discrete. This doctrine of *durée*, Bergson felt, has an inherent affinity to art. He did not write a special treatise on art, but the concern with art permeates his whole work. A few examples will make this clear, I hope.

When Bergson wished to show that intuition, as he understood that notion, was not merely a conceptual construction but a reality of life, something that can be observed and experienced, the artist was his main witness. In one of his most famous works, *L'Evolution créatrice*,[7] he tried to show that intuition can to some extent, be initiated intentionally. Again it is the artist who proves this. That intuition is not impossible in real life, Bergson said, "is proved by the existence in man of an aesthetic faculty along with regular perception." The artist is the embodiment of this faculty. The artist achieves this aim of expanding our faculty of perception by way of intuition, "by placing himself within the object with a kind of sympathy." Thus he succeeds "in breaking down, by an effort of intuition, the barrier that space puts up between him and his model" (p. 641).

A few years later Bergson presented the essence of his philosophy before an Oxford audience, under the significant title "The Perception of Change."[8] Here he came back once more to what the artist's existence and work told him. Those who claimed that the intuition that enlarges the reach of our sensual experience is not possible in the world we actually inhabit were disproved by facts. Their claim "is refuted, we believe, by experience. The fact is that there have been for centuries men whose function it has been to see what we should not perceive under natural conditions. These are the artists" (p. 1370). Moreover, such extension of our perceptual faculties was the very goal of art. "What is the object of art if not to make us discover ... outside and within ourselves, a vast number of things which did not clearly strike our senses...?"

Bergson articulated some tendencies innate in impressionism in still another respect, namely, in what he said about aesthetic experience in general, and quite particularly about the effect the work of art had on the spectator. His views were revolutionary in historical perspective, and radical in the conclusions he drew from his original assumptions. They also show how radical impressionism was in the ideas it implied.

In earlier periods there were of course different explanations of how the work of art affects the beholder, and what it conveys to him or her. Essentially two types of effect occupied the minds of thinkers on art. In earlier periods the work of art was seen primarily as an appeal for a certain cause (true religion, a social movement, the greatness of a ruler), or as a semiscientific record of physical reality. In modern times it was seen mainly as an autonomous object, isolated from anything outside it, and capable of giving a unique kind of gratification, what philosophers have called "aesthetic pleasure." Bergson seems to have drawn his final conclusions from the modern view.

Already in his first major study, the *Essai sur les données immédiates de la conscience*, Bergson presented his views on what we call the aesthetic experience; they did not change in the works he wrote in the following decades. The first part of the *Essai* deals with the "intensity of psychological states." Here Bergson devoted much effort to rejecting the quantitative approach, especially as employed by the science of psychology. This science is concerned mainly with measurements. The spectator experiencing a work of art, said Bergson, is in a psychological state that is not quantitative, and that cannot be measured. Its essence is altogether different.

Bergson's explanation of the aesthetic experience was intimately linked with a theory of art. This is not as self-evident as it may seem in the late twentieth century. Exactly a century before Bergson wrote the *Essai*, Kant defined the essence of the aesthetic experience as "disinterested pleasure," a particular kind of psychological reality. In his *Critique of Judgment* Kant did not refer to art at all. The aesthetic experiences he noted are those that emerge in our contemplation of nature. The sunset, not a painting or a piece of sculpture, was his example. In Bergson's *Essai*, a hundred years after Kant's *Critique of Judgment*, it was precisely the opposite. For Bergson, only the work of art, a beauty produced by conscious effort, showed what beauty is. To understand and appreciate beauty, he suggested, we must experience the effort of intuition embodied in the work of art. But the effort of intuition exists only in art. Therefore only after we have experienced and understood beauty in a work of art may we "descend to [beauty in] nature."

The relationship between art and nature—both seen as they appear in our aesthetic experience—played an important part in Bergson's art theory. The difficulty of defining beauty may well have arisen from our belief that the beauty of nature precedes that of art (p. 13). Moreover, he even suggested that we conceive of nature as beautiful only because we compare it, albeit unconsciously, with what we have experienced in the work of art (pp. 12 ff.). What Bergson was suggesting here was a full inversion of the concepts developed in the Renaissance, and maintained ever since: not nature as the origin of all forms and harmonies, but rather art.

Now, how did Bergson treat aesthetic experience? Was there anything new in what he said about the subject, and do his views reveal something of the spirit of impressionism? To answer these questions it may be best to consider his approach in historical perspective.

It was Kant, as we know, who had sorted out aesthetic experience from all other kinds of experience. He did this in comparative terms, as it were: the hallmark of aesthetic experience is that it remains within itself. "Disinterested pleasure" does not seek a result in the outside world, and it is this characteristic that is its defining feature. This definition describes the category of experience, it does not even attempt to say anything about the emotional contents and character of aesthetic experience, of what is going on within us while we undergo it. Bergson did precisely this. He was not so concerned with a comparison of aesthetic and other experiences. The core of his doctrine (insofar as our subject is concerned) was an attempt to describe aesthetic experience as a psychological state.

What was this psychological state? The page or two in the *Essai* that Bergson devoted to describing this state are of a suggestive power rarely found in the theoretical literature. He wrote that it is the aim of art to lull to sleep (*d'endormir*) the active and resistant powers of our personality, and to induce in us a state of perfect docility. This aim is achieved in the aesthetic experience in the presence of a work of art. "In the procedures of art we shall rediscover, though in attenuated form, more refined and more spiritualized, as it were, the procedures one normally obtains in a state of hypnosis" (p. 13). This comparison suggests a very radical conclusion. In the last decades of the nineteenth century hypnosis was topical in some sense; it was even put to therapeutical use. The attempts made in the very years of Bergson's early writings to employ hypnosis in treating hysteria are well known from the history of psychoanalysis. Bergson must therefore have been aware of the far-reaching implications of his comparison. Now, in hypnosis, it was believed, certain control mechanisms break down or are

temporarily put out of action. What did Bergson believe breaks down in the aesthetic experience he likened to the state of hypnosis?

Bergson does not give an explicit answer. But we shall probably not be mistaken in assuming that what is excluded in aesthetic experience, as in hypnosis, is any outside control of the work of art we are contemplating, or experiencing in any other fashion. The question asked in countless ways since the Renaissance was, Is the representation correct? To answer it you have to compare what you see in the picture to something outside it (a piece of physical reality, a cultural code of painting, etc.). It was this outside factor that he excluded.

A kind of free-floating existence, detached from any constraints—external, or even internal—this is where art, by its very nature, leads us. This holds true even for the most subjective aspect of art, the manifestation of emotions. It is the intention of art, said Bergson, to give us "an impression of the emotions rather to give them an expression." Following Bergson's thought through to its logical conclusion (though Bergson himself did not use these words with regard to art), in nature the expression of emotions is not a matter of free will or decision; in art it is a detached suggestion. Art, he said, "suggests to us [the emotions], and it can do without the imitation of nature when it finds a more efficient means" (p. 14).

In the few pages of the *Essai* devoted to art, Bergson seems to have juxtaposed the notions of "expression" and of "suggestion." Without analyzing the details (his formulation is not always clear) we can say that he conceived of expression more as a forceful imposition upon us than as a mild stimulus. This was indeed the belief of great masters of art and thought ever since the Renaissance. A convincing representation of crying, they believed, should make us cry.[9] But art, as we have just seen, prefers the suggestion of emotion. In other words, the emotions expressed (as we say) do not overwhelm us, they do not force us to accept or relive them; they remain a free-floating suggestion.

Of course, our concern here is not with Bergson's philosophy as a whole; we are only looking for those of his views that express, or shed light on, the main intellectual leanings of impressionism. In this respect, I believe, his ideas are rather revealing. As far as our subject is concerned, Bergson's ideas culminate in the notion of detachment. His notion of detachment, and the emphasis he placed on it, should be seen on two levels. First it meant the detachment of the image from nature. Here, as I have briefly indicated, Bergson in fact revolted against a centuries-old tradition that ruled supreme for many generations. At another level, the detachment he was

speaking about was primarily emotional. The image was not only detached from a tangible, material basis, but it was also without any link to strong emotional foundations. The notion of suggestion replacing that of expression, the concept of the spectator lulled into sleep or in a kind of hypnotic trance, all spoke of an emotional detachment no less than a physical one. This ideal of detachment, I shall try to show, was a profound expression of the essential attitude of impressionism.

NOTES

1. See Henri Bergson, *Matter and Memory*, translated by Nancy Margaret Paul and W. Scott Palmer (London, 1911), p. 1.

2. Arthur Szathmary, *The Aesthetic Theory of Bergson* (Cambridge, Mass., 1937), p. 8.

3. Henri Bergson, *Essai sur les données immédiates de la conscience* (Paris, 1889). I quote here from Henri Bergson, *An Introduction to Metaphysics*, translated by T. H. Hueme (London, 1913). Page numbers, given in the text, refer to the French edition: See Henri Bergson, *Ouevres* (Paris, 1963).

4. See Stephen Kern, *The Culture of Time and Space, 1880–1918* (Cambridge, Mass., 1983), p. 26.

5. Leone Battista Alberti, *On Painting*, translated by John R. Spencer (New Haven and London, 1966), pp. 43 ff. And see Barasch, *Theories of Art*, pp. 152 ff.

6. For a survey of these trends, see Barasch, *Modern Theories of Art, 1*, pp. 213.

7. Henri Bergson, *L'Evolution créatrice* (Paris, 1907). I use the reprint in *Oeuvres*, pp. 489 ff. Page references, given in the text, refer to this edition.

8. Henri Bergson, *Conférences faites a l'Université d'Oxford les 26 et 27 mai 1911: Par perception du changement* (Oxford, 1911); reprinted in *Oeuvres*, pp. 1365–92. Page references in the text follow the latter edition.

9. A famous passage to this effect is found in Leon Battista Alberti, *On Painting*, p. 77.

4

Science and Painting

In surveying the horizon of late-nineteenth-century intellectual life for developments that may shed some light on the emergence of the impressionists' views, we shall now briefly turn to science. The evocation of science in a discussion of impressionism necessarily causes one to wonder. How can science, a reader might ask, be relevant to the creation, or even to the explanation, of art? Did the artists, the critics, and the general public who were looking at impressionistic pictures, have any real understanding of the problems and procedures of science?

We must quite frankly admit that neither the impressionistic artists nor their original audiences possessed a professional grasp of science. To be sure, some of the Neoimpressionists may have had a certain amount of scientific training, and occasionally their work and thought may have been influenced, or inspired, by scientific doctrines. But these were individual cases, to which we shall return later in our discussion. At the present moment, however, we are not speaking of individual artists or critics, but of the impressionistic movement as a whole and of its public at large, at least in the first decades of impressionistic painting. Taken as a whole, these artists and audiences, we should repeat, had little insight or training in the sciences. How, then, can a survey of contemporary scientific developments help throw light on the problems of art?

Of course, in certain historical periods science and art were not separated by a chasm of mutual ignorance. There were even times, as in the Renaissance, when certain sciences (like anatomy) and some arts (like painting and drawing) were perceived as closely linked to each other. Suffice it to recall Leonardo da Vinci, or the unusual type of the *pittore notomista*, or the illustrators of botanical and zoological works, to be convinced that painting could well fulfill an important function in scientific investigations, and in the articulation and transmission of their results, just as science could play an important part as a corrective criterion of art. Modern scholars have studied the symbiosis of art and the natural sciences in the Renais-

sance, and have shown how deeply rooted were the links between both fields.

Nevertheless, a symbiosis such as that found in the Renaissance was limited to a few short phases. They were the exception rather than the rule. Moreover, more important for our present purpose, the link between science and painting was limited to a certain type of science. It was, one dare say, a rather primitive science, primarily concerned with the faithful recording of what the naked eye can see in nature. This was why art was so important in the early stages of anatomy in particular, and at the beginning of botanical science. At this point, these were descriptive sciences primarily concerned with the recording and classification according to visual criteria of their materials. But is such a link possible in an age when science was becoming increasingly sophisticated and abstract, and when the simple recording, by means of drawing and pictorial representation, of what meets the naked eye was no longer meaningful or needed? In the late nineteenth, as in the twentieth, century the links between art and science, if they exist at all, must be of a nature different from what we know of Renaissance Florence.

We should remember, however, that the functions science fulfills are manifold and variegated. While the cognitive function of science remains its central concern, the findings of the natural sciences often have a wide influence on the thought and image of whole periods. Without in any way limiting its purely cognitive function, in history science often also served to articulate important cultural issues, and to build support for the view of the world that answered to the needs of a time or a society. For science to articulate such issues, audiences do not have to grasp the results of technical investigations. This may also explicitly apply to the arts. To take an example familiar to many of us from our own experience, students of twentieth-century art remember how often both artists and critics of cubism invoked time as a "fourth dimension" of space, repeatedly mentioning, and even clinging to, Einstein's theory of relativity. Nobody has to be told that the artists and audiences who used these concepts and terms are not likely to have had a proper scientific understanding of the role of time in Einstein's view of the world. Yet their incompetence in matters scientific did not prevent Einstein's theory, interpreted or misinterpreted as it may have been, from becoming a means of crystallizing crucial concepts in the theoretical and critical reflection on cubist art; at certain stages of the debate Einstein's theory almost became a slogan, a catchword that helped to popularize cubism. It is in a somewhat analogous sense that we have to consider the sig-

nificance and impact of late-nineteenth-century science as a factor shaping the intellectual world of impressionism.

Several of the themes current in scientific investigations during the late nineteenth century reached a broader public, were energetically discussed at the time (if not always with the precision required of proper scientific work), and thus became part of the spiritual background of the period. Some of them seem to have had an intrinsic affinity to the central concerns of painting. Issues such as light, color, and the perception of space easily illustrate this affinity. Not surprisingly, not only did artists often refer to science when discussing these issues, but occasionally even scientists felt compelled to consider seriously some of the seemingly specific problems posed by the arts. In the following pages we shall, of course, be concerned only with what lay audiences, lacking scientific training, derived from what filtered down to them from the scientist's investigation. We want to know what some of the great scientific discussions that took place during the second half of the nineteenth century can tell us about the intellectual world of impressionism, and how, in fact, they may have helped foster the attitudes characteristic of this artistic trend.

Let us begin by recognizing that human perception of the natural reality surrounding us may be radically different from what that reality itself is. That perception is a means of, perhaps the principal road to, the cognition of physical reality is, of course, an old and firmly established belief, well known to the student of the history of scientific investigation and of philosophical reflection. Long before the nineteenth century people also realized that the world we try to know by direct empirical experience may, in fact, be different from our perception of it. Optical illusions, known as such, were often recorded, among others by Leonardo da Vinci.

There is, however, a profound difference between knowing that visual experience may mislead, and even using this fact in certain ways (as in foreshortening) and the awareness that physical reality as such is altogether different from our sensual experience of it. This chasm opened up in the cultural awareness of the nineteenth century. The sensory qualities that loom so large in our everyday "natural" perception simply do not exist in the world "out there"; they are products of the process of human perception. The leaf itself, said one writer at the turn of the century in what is one of the earliest comprehensive discussions of impressionism, *is* not green; we only *see* it as such.[1] While this insight had been known to scientists for a long time, it was in the second half of the nineteenth century that it also

penetrated popular awareness and became a factor in the thought of a wider audience.

An interesting study of the breaking apart of "objective" and perceived reality, and at the same time also a significant document of the intellectual struggle to clarify our views of the nature of the world around us, can be found in a lecture by Ernst Mach (1838–1916), a well-known and versatile scientist of the late nineteenth and early twentieth centuries. Mach's central theme here—space—is of crucial significance for the painter, it is his very medium. In a lecture entitled "Space and Geometry," Mach attempts to separate geometrical space from physiological space. "The sensible space of our immediate perception, which we find ready at hand on awakening to full consciousness, is considerably different from geometrical space," he said as he opened the lecture.[2] He juxtaposed the two types of space. The space of Euclidian geometry is "everywhere and in all directions constituted alike; it is unbounded and infinite in extent." In short, we could say it is an abstract space. The space of our visual experience, on the other hand, "is found to be neither constituted everywhere and in all directions alike, nor infinite in extent, nor unbounded."

This view of space was quite different from the one that the Renaissance upheld. In the Renaissance, at the beginning of what is often called modern times, the intention was to lump together, perhaps even to unify, geometrical space and the space of human experience. The system of rendering perspective, considered by the Renaissance an ultimate achievement of art, was in fact the superimposition of a (more or less) Euclidian space over what we actually experience when we open our eyes. By the end of the nineteenth century, intellectual development had reached the opposite pole: there could be no harmony between the space of geometry and the space of sensual experience. "Physiological space," said Mach in the same study, "has but few qualities in common with geometrical space" (p. 11). The examples that he mentioned, though obviously without thinking of painting, have for centuries been the problems of painters. They are, in Mach's words, "rightness" and "leftness," "aboveness" and "belowness," "nearness" and "farness." These, he said, "must be distinguished by a sensational quality." Once again let us recall that Renaissance art tried to fuse these very "sensational" qualities with the abstract nature of an infinitely extended space. No better example for this fusion can be found than in some of Leonardo's paintings.

Space, one might say, is an abstract notion. But light is the primary datum of every visual experience. Yet even light itself is not what we see. In

his public lectures, given years before the rise of impressionism, Hermann von Helmholtz (1821–94), the towering figure of nineteenth-century research on vision, emphasized the discrepancy between crude reality (as it is in itself, or as we can imagine it) and our perception of it. The quality of our sensations, he said, whether they relate to light or warmth, tone or taste, do not depend on the external object we perceive, but rather on the specific nerves that mediate the individual sensation. "If you like paradoxical expressions," he continued, "you could say: light becomes light [only] when it meets a seeing eye; without that it is merely a movement of aether."[3]

In a lecture series delivered in 1878, Helmholtz drew what seemed to be some final conclusions from his researches for the lay public. Our sensations, he said, are the result of certain external factors that affect our perceptive apparatus. As we know, however, the nature of our sensations does not depend on ultimate, external causes, it follows from the perceptive apparatus itself. The sensation that we perceive, Helmholtz concluded, is therefore no more than a "sign" of the cause; by no means can it be considered its "image" (*Abbild*).[4]

The reason for this far-reaching conclusion is of immediate bearing on our subject. Of an image, he said, we demand some kind of "sameness" (*Gleichheit*) with the object portrayed, "of a statue [we demand] a sameness of form, of a drawing the sameness of perspective projection in the field of vision, of a painting also the sameness of colors." Of a sign we do not demand all that. A sign does not need any kind of sameness with what it stands for.

It is easy to see, I believe, at least some of the effects this approach must have had on a domain seemingly so far removed from science as is the art of painting. Separating objective reality in itself, on the one hand, and the sensory appearance in our perception, on the other, must have strengthened and lent further support to the tendency to altogether detach painting from the "objective" reality of tangible things. The demand for "sameness" between the pictorial representation and the thing depicted—a central idea in any theory of mimesis—could no longer be maintained if reality and appearance broke apart. "Appearance," it turned out, was the only layer that the painter should observe.

The natural sciences and the humanities (including the arts) now seem worlds apart; in fact, it was mainly in the nineteenth century that the gap between what we now call "two cultures" became manifest and dominant. In spite of this process, we occasionally come across some direct interaction between them. An interesting and instructive example, provided by

Helmholtz, deals with a central problem in the foundations of art. In several respects Helmholtz's discussion is unusual. It is not common to find a great scientist seriously discussing, from his point of view, what the painter does. Helmholtz was attracted by the question of whether and how problems of scientific optics are reflected in and influence art. In his youth he was even a professor at an academy of art (in Konigsberg), though only for a short period. In his popular lectures he later came back several times to specific questions of art. Most important in this respect are the lectures he delivered between 1871 and 1873, and published under the title *On the Relations between Optics and Painting*.[5]

Helmholtz approached the problem of art not by the regular way; it was not aesthetic experience that occupied the center of his attention. He himself described his approach as follows: "I have arrived at my artistic studies by a path which is but little trod, that is, the physiology of the senses. . . . I may compare myself to a traveller who has entered upon them by a steep and stony mountain path, but who, in doing so, has passed many a stage from which a good point of view is obtained" (pp. 73–74). What was this "point of view" that the traveler had discovered?

The four lectures that make up this series deal with "form," "shade," "color," and the "harmony of colors." For our present purpose the second lecture is probably the most illuminating one, though all lead to the same conclusion. The English translator, probably wishing to give it a concise title, called it "Shade." However, this not an altogether precise rendering into English of what Helmholtz said. In the original German version, the second lecture was called "Helligkeitsstufen," which should read, "Degrees of Brightness." This was indeed Helmholtz's subject. Degrees of brightness, not shade or shadows cast by objects, are the central problem any scientific explanation of painting should discuss.

At the beginning of his lectures Helmholtz emphasized that "We have not here to do with a discussion of the ultimate objects and aims of art, but only with an examination of the action of the elementary means with which it works" (p. 76). Perhaps for this reason he gave the traditional formulation of what painting aims to do: "The painter seeks to produce in his picture an image of external objects" (p. 78). Helmholtz also explained what he meant by "imitation." The artist who imitates nature does not aim at some kind of duplication of the natural object, as naive realism may assume. By "imitation" Helmholtz understood the painter's attempt at "producing, under the given limitations, the *same* effect that is produced by the object itself" (p. 95).

But here the scientist's doubts and questions arise. "If the artist is to imitate exactly the impressions which the object produces on our eye, he ought to be able to dispose of brightness and darkness equal to that which nature offers" (p. 95). Is this feasible? Can the "same" optical effect that something in nature has on us be achieved by a work of art? Helmholtz emphatically stressed that this was utterly and completely beyond the painter's reach.

To give an example, Helmholtz asked his listeners and readers to imagine two paintings hanging next to each other on the wall of a museum. One picture represents a bedouin clad in white garments, moving in the desert during the hours of glaring daylight; the other picture represents a night scene, showing the moon reflected in water. Now, in actual nature the difference in the degree of brightness between these two scenes is enormous; the intensity of light reflected from the white garments of the bedouin in the sun-filled desert is thousands of times stronger than the brightness of the moon's reflection in the river. The artist's means of rendering these differences are extremely limited. In fact, he will use the same (or almost the same) white color to render the bedouin's garments and the moon's reflection. Under these conditions, Helmholtz concluded, it would be absurd to believe that the artist can give a "transcript" of the object in nature; all he can give is "a translation of his impression into another scale of sensitiveness" (pp. 100–101). In the concluding remarks that summed up all four lectures, Helmholtz used the same formulation. "The artist cannot transcribe Nature; he must translate her" (pp. 135–136).

What could all this have meant to the artist, the critic, and the student of art in the last decades of the nineteenth century? The answer seems clear, at least in its general outlines. Helmholtz had provided a scientific foundation for the final break with the traditional belief that art *can* faithfully represent nature, or even our impressions of the reality around us. If art can*not* represent the natural object as it is, it is meaningless to compare the picture representing a scene from nature with that natural scene itself, to compare the painting and the "model." This was, of course, the final break with a great tradition that, at least in principle, had remained unchallenged since the Renaissance.

So far I have tried to indicate, in some summary remarks, what the natural sciences may have contributed to the great cultural process that shook the foundations of a world that seemed stable, and was fully available to the observer. What went on in the sciences, and particularly what became known to the general public, helped to articulate tendencies that were to be

found in all fields of study and reflection. These tendencies may have exerted some influence, no matter how indirect, on the aesthetic thought of those decades. But scientific development in the second half of the nineteenth century had still another aspect that could have had a bearing on the concepts and vocabulary of impressionistic art theory and criticism. What I have in mind is the analysis of the process of perception itself, particularly of visual experience, and the distinguishing of different layers in that experience.

Research in vision, consisting not only of optics (the propagation of light rays), but also of the physiological processes taking place in the eye and mind of the viewer, was perceived as a new field, one that cut across long-established boundaries. In 1868 Helmholtz said that "The physiology of the senses is a border land of the two great divisions of human knowledge, natural and mental science. . . ."[6] It was mainly in this newly established field that the perceptual process was analyzed.

Wilhelm Wundt was among those who made important contributions to the analysis of the perceptual process (which may also have some bearing on our subject). A student of Müller and Helmholtz, Wundt (1832–1924) was considered one of the founders of experimental psychology in the nineteenth century. His first major work was a comprehensive study of sensual perception.[7] A proper analysis of Wundt's view of the perceptual process, and the formulation of a balanced judgment of his achievements, is a matter for historians of science. Here it is sufficient to note that Wundt dissected the perceptual process into distinct elements or stages. What is significant in our context is his assumption that there is a stage, or an "act," as he called it, that precedes perception proper. This is the stage he called "sensation." Sensation, Wundt said, is "the first psychic act" (p. 423). It represents an elemental stage, one that cannot be further broken down into constituent parts. It is on this elemental level that the meeting of the subject and the objective world occurs, and that physical, outside reality is transformed into primary psychic experience (p. 446). As compared to sensation, perception is a composite reality, not only grouping together many sensations, but also including other factors, mainly consciousness.

Whether or not later scientific developments supported Wundt's thesis of an initial layer of experience, one preceding conscious identification of what we call experience, the very idea of such a "pure" layer had deep roots in the culture of the late nineteenth century, and it was certain to find a lively response among the audiences of the time. I shall try to suggest that the concept of "pure vision" that had such a magic appeal for artists and art

lovers of the late nineteenth century, derived from the same origins as the psychological concepts we have just mentioned.

The urge to break perception down into its constituent elements, and particularly to distinguish between perception and mere sensation, was a widespread concern of intellectual life in the later nineteenth century. We should note particularly that the idea of "pure sensation" haunted intellectual life—and as I shall try to show, also the artists—of the time and left an imprint on the culture of the generation. I shall briefly discuss only one further example, the psychological theory of William James.

William James (1842–1910) was a philosopher and analytical thinker; he knew that in real life no pure sensations ever occur. "A pure sensation" is "an abstraction, never realized in adult life," he wrote in his great work, *Principles of Psychology*.[8] An "absolutely pure sensation," he thought, is feasible only "in a new-born brain" (p. 25), that is, at a stage at which experience and reflection have not yet accumulated. We cannot experience pure sensation because we are not able to eliminate, or exclude, the accumulation of former experiences and thoughts. Experience as we know it is a "compound," while sensation as such, were it ever attainable, would be of ultimate simplicity.

It is interesting to follow the hypothetical experiments, carried out only in our minds, that William James and his contemporaries suggested, in order to imagine what such a simple sensation might be. When, for instance, "we look at a landscape with our head upside-down," our "perception is to a certain extent baffled, ... gradations of distance and other space-determination are made uncertain" (p. 320). In our context it is particularly noteworthy that William James extended his mental experiments to the field of painting. The effect we experience in seeing a landscape with our heads upside down similarly "occurs when we turn a painting bottom-upward. We lose much of its meaning, but, to compensate for the loss, we feel more freshly the value of the mere tints and shadings, and become aware of any lack of purely sensible harmony or balance which they may show" (p. 321).

This observation has a decidedly modern ring. These are ideas with which now, more than a century later, we are thoroughly familiar. William James obviously did not intend to make a contribution to the theory of art with this observation; all he wished to do was to explain what pure sensation is. It is important to note that he believed that this concept can be approached only by way of exclusion. Were we able to remove from our experience and regular perception all elements of knowledge and all residues of memory and consciousness, we would arrive at pure sensation.

It goes without saying that Wundt and James, as well as all the other physiologists who concerned themselves with these subjects, considered sensation to be devoid of any emotional character. In the impressionists' thought, as I shall try to show in a later chapter, the concept of sensation, derived from the science of the time, was endowed with a half-articulate emotional character, and became a core notion in their theory of art.

We can now sum up our brief observations, which have ranged over several fields, in a few simple points. (1) Not only scientists, but also lay audiences became increasingly aware of the profound difference between reality as it is in itself, and our perception of it. Reality in itself will never be grasped by human perception. With this insight the foundations of any naive realism were finally shaken. (2) A comparison of reality as perceived by our senses and as represented by art clearly shows that pictorial rendering, no matter how much of an illusion it produces, can never even approach nature. Even the most realistic representation of reality is nothing but a "translation," an analogy of nature in an altogether different medium and on an altogether different scale. (3) As it became increasingly obvious that perception, far from being simple, is in fact a complex process, scientists looked for an original layer of sensual experience, a layer in which our immediate meeting with encompassing nature takes place. They called this layer, which in principle is free from the impact of former experiences and knowledge, sensation.

NOTES

1. Camille Mauclaire (pseudonym Faust), *L'Impressionisme, son histoire, son esthétique, ses maîtres*, 2d ed. (Paris, 1904), p. 30. To be sure, it is not clear what Mauclaire meant precisely here: is the world itself without color, or do the reflections of colors obscure the "true" tone? Whatever the case may be, he was obviously influenced by contemporary science.

2. Ernst Mach, *Space and Geometry in the Light of Physiological, Psychological and Physical Inquiry* (La Salle, Ill., 1960), p. 5. The English translation originally appeared in 1906.

3. Hermann von Helmholtz, *Vorträge und Reden*, I (Braunschweig, 1884), pp. 365 ff. For the passage quoted, see p. 378. The lecture was originally delivered in 1855. The edition I refer to is the third edition of Helmholtz's popular lectures on science.

4. Helmholtz, *Vorträge und Reden*, II, pp. 217–71. The passage quoted may be found on p. 226.

5. The original German title was *Optisches über die Malerei*. It was soon translated into English. See H. Helmholtz, *Popular Lectures on Scientific Subjects*, translated by A. Atkinson (New York, 1881). I shall give page references in the text (in parentheses) which refer to this edition.

6. In his lecture series on "The Recent Progress of the Theory of Vision," reprinted in English translation in H. Helmholtz, *Popular Lectures on Scientific Subjects*, pp. 197 ff. The sentence quoted is the opening sentence of the first lecture.

7. Wilhelm Wundt, *Beiträge zu Theorie der Sinneswahrnehmung* (Leipzig and Heidelberg, 1862).

8. William James, *Principles of Psychology* (Cambridge, Mass., 1890). I am using the abridged edition, *Psychology (Briefer Course)* (London, 1969). See especially chapter 20, entitled "Perception," pp. 318 ff.

5

Impressionism

Reflections on Style

In the preceding chapters of this part I have attempted to trace some of the central intellectual developments—philosophical, scientific, and literary—that form the broad background to what we call impressionism in painting. We now come closer to the painters themselves. Here the question arises: can we speak of a theory of impressionistic painting in a narrow sense, that is, a theory that deals with the specific problems of impressionistic painting and sculpture? Artistic movements at earlier stages of history, from the fifteenth-century Renaissance to nineteenth-century Classicism and Realism, developed doctrines that were intended to help artists solve the problems that were prominent or new in the art of their own time and world. Renaissance perspective is one famous example that immediately comes to mind, while the Baroque study of how to express passions in face and gesture (and the models of such solutions) is another. Often these doctrines were developed by artists, were primarily addressed to artists, and were meant to guide and assist artists in their work. Such theories therefore dealt with problems that painters and sculptors were actually encountering. Did impressionism formulate a doctrine that would parallel the theories of art in former ages? Is there a theory of impressionistic painting?

The question is not easily answered. Impressionist painting, it need scarcely be said, has a very distinct physiognomy that could hardly have come about without thought and reflection. The very fact that the subject matter of impressionistic painting is so consistent—giving pride of place to landscape and to certain specific segments of modern urban life, such as the café and the spectator in a theater box—would indicate some reflection. The treatment of color and the brushwork that remains visible in the paintings, are based at least in part, as we shall shortly discuss in some detail, on theoretical considerations. They diverge too strongly and abruptly from established and accepted models of art to have come about without the artists

being aware of some general principles of their own approach. Clearly, then, there is a kind of theory underlying impressionistic painting.

On the other hand, however, impressionist painters did not formulate a "theory" in the simple sense of that term. Unlike Renaissance artists, they did not write treatises, nor did they compose long cohesive statements about their art. For impressionism we have nothing like Alberti's treatises on painting and architecture or even, to choose a more recent example, Philip Otto Runge's *Hinterlassene Schriften*. Yet the impressionist painters were not illiterate craftsmen living in a workshop environment. They were literate, often highly sophisticated urban artists, and the original group at least consisted of painters living in Paris, clearly the intellectual capital of Europe in the late nineteenth century. They had close connections with critics and writers, and were fully acquainted with the complex institutions of modern life. Even if their relations with the Salons, the great exhibitions that proclaimed and shaped official taste and style, were not happy ones, the impressionist painters thoroughly understood their workings. The very fact that they called their own exhibitions *Salon des refusés* shows how closely linked in thought they were with contemporary institutions and their ideology. That they did not produce a literary body of theory cannot be explained by a simplistic sociological description.

For the critical student all this may be self-evident, yet in trying to discuss a theory of impressionism it should be emphasized that the impressionist painters, in striving for a direct, unmediated visual experience and in aiming to represent reality "as we see it," did not naively speak their "pure" mind. They may have wanted to free themselves from what they believed was the mind's control over the process of visual experience, but this very wish was in fact based on a highly sophisticated cultural concept of what vision is. The lack of a theory of painting, then, was the result of a philosophical worldview.

Here the difficulties become manifest. Since the impressionists did not formulate a general theory, they also did not define, in literal or theoretical form, the individual, specific problems with which they were concerned in their work. If we do not limit ourselves to our own analysis of the impressionists' paintings, we must try and reconstruct their views from fragmentary observations scattered in letters and brief notes by the artists and their early critics. I shall begin with one such note.

The impressionists' ideological opposition to the idea of an official art, as presented to the public at the annual Salon, is well known. Yet most of the impressionist painters realized the social significance of the Salon. For

many reasons they wished to enter it, including the purpose of "coming face to face with the big public." As early as 1874, only two years after the first impressionist exhibition, Théodore Duret, probably the most intelligent critic supporting the rebellious young artists, wrote a letter to Pissaro, urging him and his friends to try to get into the Salon. In this letter he briefly listed some of the issues on which the impressionists diverged from the art of the Salon. This list may serve us as a starting point in reconstructing the chapters of a theory of impressionistic art. "I urge you," Duret wrote, "to select pictures that have a subject, something resembling a composition; pictures that are not too freshly painted, and have some finish to them."[1] These, then, were the main topics, as Duret listed them: the lack of subject matter, the lack of composition, pictures "too freshly painted," and the lack of finish. These were the main themes of their theory of art. We shall follow Duret's sequence in our discussion.

Subject Matter

The dramatic change in artists' and audiences' attitude to the subject matter of pictures is one of the better known processes in modern culture; there is no need to retell this story. It was essentially in the last third of the nineteenth century that the shift occurred from high admiration for the subject matter or "theme" of a painting to almost complete disregard of it. At the beginning of the nineteenth century Philip Otto Runge took it for granted that even for the purpose of expressing personal emotion the artist should look for appropriate subject matter. "We seek an event that corresponds in character to the feeling we want to express, and when we have found it, we have chosen the subject of art."[2] In the mid-nineteenth century, to adduce another testimony, Pierre-Joseph Proudhon wrote a whole book, *Du principe de l'art et de sa destination sociale*, published posthumously in 1863, to refute the theory of "art for art's sake" that could do without significant subject matter. Such an art, Proudhon said, pursues only the aim of pleasure and of sheer egotistical delight.[3] Even those critics who turned away from what an earlier generation considered "noble subject matter," such as mythological and historical themes, preached the gospel of modernity and praised "the heroes of modern life," as did Baudelaire,[4] still believed in the necessity of important subject matter.

In the decade in which Proudhon's book was published, we begin to hear the voice of a younger generation. They expressed the very opposite of ad-

miration for the noble subject matter of the past, such as mythology or history painting, as well as for "the heroes of our time." The young artists, and first of all the impressionists, did not explicitly discuss the status of subject matter in art as a theoretical problem. They were largely indifferent to the philosophical question of how important or unimportant a picture's theme was. But their views on what constitute the value of a work of art implied a direction of thought with regard to subject matter.

Let us return to the brief quotation in the Introduction to this part. In May 1867 none other than Edouard Manet wrote in concise, if somewhat vague, form the ultimate aim of the new art. "The artist does not say today, 'Come and see faultless works,' but 'Come and see sincere works.'"[5] One understands the tone of this statement by a young and revolutionary artist who believed that he was proclaiming the principles of a new era in painting, but what precisely is the "sincerity" that for Manet was the hallmark of the new type of work of art? Sincerity is a heavily charged term, particularly when used to characterize the artist's attitude to his work. It will be useful to cast a brief glance at the history of this concept in modern aesthetics.

Several great movements in modern art and literature have invoked sincerity as the foundation and touchstone of their work. Romanticism conceived of sincerity as a cardinal value of art. Romantic critics (sometimes they were the poets themselves) made sincerity a primary criterion of excellence in poetry. Wordsworth wanted "to establish a criterion of sincerity by which a writer may be judged. . . . Nothing can please us, however well executed in its kind, if we are persuaded that the primary virtues of sincerity, earnestness and a moral interest in the main object are wanting."[6] The sincerity Wordsworth had in mind, it should be remembered, was the sincerity of the artist; it was the sincerity of the poet's emotions. In a discussion of this concept in Romantic criticism, H. M. Abrams reminds the reader that the term "sincerity" emerged in the Reformation, and originally meant that a believer protesting a religious or moral sentiment actually experienced this emotion.[7] In its Romantic interpretation (as emotion) the concept became so influential that its impact can still be felt quite clearly at the end of the century. Thus Tolstoy, writing about Maupassant in 1894, said that in order to produce a true work of art the artist needed three qualities: a moral attitude, a clear expression, "and, thirdly, sincerity—unfeigned love or unfeigned hatred for what he depicts."[8] The sincerity of the artist was the extent to which he himself was moved by what he was relating.[9]

In Romanticism, to answer our specific question, speaking of sincerity meant to speak of the painting's or statue's subject matter, and of the artist's

attitude to that subject matter. The fundamental significance of subject matter for a work of art was taken for granted.

About the middle of the nineteenth century, possibly only one or two decades before the first appearance of the impressionists, the concept of sincerity acquired a somewhat different connotation. Essentially it meant that the sincere artist did not idealize the reality he was representing in his work. The ideological formulation was that the artist should search for truth, and be truthful in his representation of it. It was the Realists who stated this demand. Now, the theoretical formulation does not say very much: the very same demand, sometimes formulated in the same words, is also found in Renaissance treatises on painting. The intention is different, however. While in the Renaissance "truthful" essentially meant "correct," in nineteenth-century Realism it meant "not embellished," unadorned. In other words, to describe a work as sincere in the nineteenth century meant that it did not idealize what it represented, and thus did not change what the artist saw by interposing inherited cultural patterns or models between himself and the piece of reality he was portraying.

Typical of the realistic attitude was the notion of *naiveté* that was now employed. To some extent it foreshadowed the attitude of the impressionists, but it also announced the desire to understand and appreciate the "primitive." The notion of *naiveté* formed part of the intellectual movement that gave rise to modern anthropology, to the longing for the primitive that was so powerfully expressed in Gauguin's work. These aspects will be discussed in some detail in part 3 of this volume. Here we should only mention that the critic and novelist Jules Castagnary, the "codifier of the principles of the realists," conceived of "*naiveté* of vision" as being "free from the prejudice of education," that is, free from those cultural traditions that impressed upon the artist the value of idealizing something.[10] Childlike naiveté, it was believed, would make "true" representation feasible. To achieve such innocence of perception and representation, rebellious young artists sometimes made wild suggestions: the academies of art, the institutions in which the "prejudices of education" were taught, should be closed. In a particularly wild moment the suggestion was even made that the Louvre be burned down. In painting, discussion of *naiveté* took for granted the primary significance of subject matter for the work of art. What was discussed was only the way in which subject matter should be represented in the picture or statue.

As we shall see, something of the realistic attitude to subject matter and much more of the wording that this movement made fashionable at the

time, survived in the impressionists' conception. In essence, however, the attitude changed. When Manet spoke of sincerity he meant something other than the mere freedom from inherited prejudice. He meant that the sensual impression should be reproduced on canvas without the artist's ideology and education interfering with what he perceived. Manet implicitly referred to the Realists when he said that "The effect of sincerity is to give to works a character that makes them resemble a protest. . . ." But Manet stayed aloof from the Realists' social impact. He "has never wished to protest." The impressionist's "only concern . . . has been to render his impressions."[11] We might add: to render them sincerely.

The unavoidable effect of this sincerity, and of the impressionists' attitude in general, was to minimize the importance of subject matter, or altogether negate it. A sincere artist, it followed, was not one who rendered reality unadorned, but one for whom the fleeting sensual impression was the reality. It is worthwhile to recall here a statement made a few years after Manet's declaration. In 1873, a year after the first impressionistic exhibition, the progressive art dealer Durand-Ruel published a catalog of the artists he represented, and had the critic Armand Sylvestre write an introduction in which he justified the inclusion of "contemporary" artists. Discussing the impressionists, Sylvestre wrote:

> It is M. Monet, who by choice of the subjects themselves, betrays his preoccupation most clearly. He loves to juxtapose on the lightly ruffled surface of the water the multicolored reflections of the setting sun, or brightly colored boats, of changing clouds. Metallic tones, given off by the smoothness of the waves which splash over small, even surfaces, are recorded in his works, and the image of the shore is mutable—the houses are broken up as they are in a jigsaw puzzle. This effect, which is absolutely true to experience, . . . strongly attracts the young painters, who surrender to it absolutely.[12]

Here it becomes obvious that subject matter is nothing but sense impressions. This is no longer subject matter in the traditional sense, whether Romantic or Realistic. Théodore Duret knew what he was saying when he asked the impressionists to make pictures "that have a subject."

That the impressionist painter averted his attention from subject matter was not an isolated device, it was not a single principle detached from the main tendency of the movement; rather it followed from the fundamental philosophy of impressionism. If only what could be experienced directly and immediately should be represented, there was no room for what had traditionally been called subject matter.

Composition

The impressionists' abandonment of subject matter implied, and was necessarily accompanied by, some distinct formal features, some basic shapes of style within the works of art themselves. Perhaps the most obvious of these features was that they dropped what is called composition. In impressionist ideology, though not necessarily in the actual art, the rejection of composition is a well-known feature. Théodore Duret, whose letter we are following in the sequence of our comments, was well aware of this in urging the impressionists to offer to the jury of the Salon pictures that had "something resembling a composition." He knew what his painter friends tried to avoid in their works.

Once again, it should be emphasized, the impressionists' rejection of composition, a traditional element in the concepts and practice of art, followed naturally and directly from the very essence of the thought and attitude of the movement. Various ages and schools have offered slightly different formulations of this concept. All, however, agreed that composition is the combination of the elements of a picture or some other work of art into a satisfactory visual whole. All ages and schools also agreed—some openly, some only implicitly that composition originates with the artist. It is the artist's intervention in the process of observation, study, and representation. In the sense used here, we do not find composition in nature, it is imposed by the artist on what he sees.

The novelist Henry James saw this clearly at the very beginning of impressionism. In an article published in 1876, he wrote that the impressionist painters were "absolute foes of arrangement, embellishment, selection."[13] But since James clung to the hallowed concepts of art, he declared later in the same article that the impressionistic doctrine was "incompatible, in an artist's mind, with the existence of first-rate talent."

As a theoretical concept, "composition," especially the composition of a painting, was a creation of the Renaissance, more specifically of the sixteenth century. What the Renaissance designated by this term was the organization and arrangement of the forms of a work of art, and their combination into a unified whole. Giovanni Battista Armenini, the sixteenth-century writer on art who was perhaps closer to the artist's workshop than any other author of the period, said that "composition is that fusion . . . by means of which one gives final perfection to paintings, so that the whole body is fully adjusted and filled with highest unity."[14] Composition, then, is not necessarily found in what we see in nature; rather it results from the

artist's intentional planning. As it aims to unify the individual features represented in the work of art, it may well involve shifting the figures and objects depicted, departing from what we see in the outside world, and possibly even in plain contrast to what is given to the eye.

In nineteenth-century academic practice and doctrine, the term "composition" acquired yet another meaning, one that emphasized both the fact that composition originates in the artist's mind and that it is an initial stage in the process of shaping a work of art. The term came to denote what we now call a "sketch." In other words, it is the laying out of the main organization of a planned work of art which precedes the painter's study of the individual figures and objects that will make up the composition. Note, however, that even though the individual figures are still vague (and may be changed in the course of work), the arrangement of the whole, such as the organization of space and the placement of groups, is fully outlined. Such an outline or composition is clearly the imposition of a design from the artist's mind upon the visual experience of the single figures and objects. To speak in traditional terms, it is the imposition of an *idea* on what is seen in nature.

In the academic tradition, the term "composition" also came to denote a stage in the process of producing a work of art. It was the initial stage, in which the general outline of the work was established. Already Jacques-Louis David, in the first years of the nineteenth century, ran a monthly sketching competition to stimulate his pupils, in his words, "to practice composition."[15] Once again it should be noted that at this stage the observation and study of nature had not yet begun; the artist was still detached from the exterior and drew from the "depth of his own mind" the general layout of the work to be.

To the impressionists, and the whole orientation of their ideas, "composition" was altogether unacceptable. This does not mean, of course, that impressionist paintings lack any form of composition. Like many students, I believe impressionist paintings do indeed have a great deal of balanced arrangement not copied from the natural scene portrayed; but this kind of composition is usually hidden behind the seemingly chance conditions of the painters looking at what they were representing. To critics, as to those who defended the impressionistic movement, the paintings of the "school" seemed to lack preconceived composition. These critics emphasized the random appearance of objects and segments in impressionist paintings. Thus the American critic Theodore Child wrote in *Harper's New Monthly Magazine* in January 1887: "Another marked peculiarity of the impression-

ists is the truncated composition, the placing in the foreground of the pic-
tures of fragments of figures and objects, half a ballet-girl, for instance, or
the hind-quarters of a dog sliced off from the rest of his body...."[16]

To the impressionist mind, and to the principles of impressionistic the-
ory (insofar as such a theory existed), composition as an abstract concept
was anathema. It embodied the very principle and general attitude against
which impressionism, both as philosophical attitude and pictorial move-
ment, was in revolt. As we have seen, the concept of composition implies
that a pattern originating in the mind, not in visual experience, determines
the scope and basic arrangement of what we perceive in nature, and of what
we represent, and how, in our painting. Once composition is accepted as an
overall principle of pictorial creation, visual experience, no matter how
highly we regard the faithful representation of what we see in nature, is sub-
ordinated to the artist's design. A painter wishing to represent what he sees,
as he sees it, cannot have any use for composition.

The impressionists did not speak explicitly about composition. The con-
cept may have seemed to them too remote both from our actual experience
and from the painter's work to concern them in the practice of their craft.
But they occasionally expressed, in words, their rejection of line. By line, we
should remember, they understood both the contour of individual figures
and objects, and the general layout of the picture, that is, its composition.
"No lines, only spots of light and dark, of light and shadow"—so Max
Liebermann summarized in 1899 the style and work of Degas.[17]

In discussing what composition may mean in painting, a new and inter-
esting approach to time in the visual arts was suggested. I shall quote a state-
ment by Edmond Duranty, the editor of the short-lived periodical *Le réal-
isme*, whom I have already mentioned in an earlier volume of the present
work.[18] Duranty, who was profoundly concerned with modern life and cul-
ture, was a kind of speaker for impressionism, mainly for Edgar Degas. In
writing about the impressionists' exhibition ("A group of artists who exhibit
at the Gallery Durand-Ruel," as he called them), he tried to explain the aims
of impressionism, using a variety of metaphors: "They [the impressionists]
have tried to render the walk, the movement, the tremor, the intermingling
of passersby, just as they have tried to render the trembling of leaves, the shiv-
ering of water, and the vibration of air inundated with light...."[19]

We know, of course, what the role the concept of time played in great-
narrative or "history" painting. Whether it was the linear succession of de-
pictions from left to right that we see in so many medieval illuminated
manuscripts, or in the carefully selected "fruitful moment" of history paint-

ing, time was always considered a continuous progression from past to future. It was essential that the past as well as the future be somehow suggested. Impressionism presented a new view of time in painting. What it wished to show was a tiny fragment of time, an instant disconnected from any other, the isolated moment rather than the progression of time.

Impressionist painters and critics did not formulate this view theoretically, but they suggested it clearly enough. As early as 1860 Charles Baudelaire, the most important critic of the second half of the nineteenth century, believed that "Modernity is the transitory, the fleeting, the contingent. . . ."[20] The French poet and critic Jules Laforgue developed this view further, and found it most fully expressed in the landscapes of the impressionists. He praised the impressionist whose painting was "done in front of its subject, however impractical, and in the shortest possible time, considering how quickly the light changes."[21] He continued: "even if one remains only fifteen minutes before a landscape, one's work will never be the real equivalent of the fugitive reality . . ." (p. 18).

The attempt to capture the ever changing conditions of light, the fugitive reality, revealed a dimension of time hitherto far unknown or insufficiently appreciated.

Color

While the impressionists' attitude to composition, to the outline of a painting conceived in the mind and preceding any visual experience, remained implicit and must be reconstructed from what was, or was not, acceptable to their line of thought, their views on color were explicit, and have often been formulated in words. Again this formulation is only fragmentary. The impressionists' concept of color is one of the best known aspects of their ideology and pictorial doctrine, which reveals their general attitude more clearly perhaps than any other element of their theory. One cannot speak, of course, of a well-developed and systematic theory of color, but their overall understanding of the subject emerges in fairly discernible outline.

Several strands of thought, and the experience of several schools of painting, flowed into the impressionist doctrine of color to form a synthesis. It may, however, be useful to distinguish the main aspects of their color theory for the purpose of the present analysis. I shall attempt to group the many fragmentary statements pertaining to color that were made by im-

pressionist painters and critics in three clusters: scientific, aesthetic, and expressive. This grouping follows what was emphasized in a given statement. This does not mean, of course, that the literary fragments can be neatly separated from each other. Often the same fragment will be adduced for more than one aspect.

The Scientific Aspect

In the first years of impressionism the concept of "prismatic color" emerged. The French poet Jules Laforgue, who at an early stage understood and highly appreciated impressionistic painting, wrote in 1883 that the "Impressionist sees light as bathing everything not with a dead whiteness but rather with a thousand vibrant struggling colors of rich prismatic decomposition."[22] The English critic George Moore, an early promoter of the impressionists, also used the term. "Surely," he wrote in 1893 in an important article to which we shall shortly revert, "broken brushwork and violet shadows lead to only one possible goal . . . the prismatic colors."[23] The phrase "prismatic colors" did not catch on among impressionist painters and critics, it did not become a rallying cry for the new school of painting. Nevertheless it is a useful starting point because it indicates that a trend of thought that was widespread at the time had reached the intellectual world of the new movement in painting, and this may suggest a possible source for the impressionists' views.

The term "prismatic color" clearly has a scientific ring. As we have seen, in the intensive study of visual experience that began around the middle of the nineteenth century, the decomposition of color was one of the factors considered.[24] We do not know exactly how the term reached impressionist painters and critics, yet some more or less direct contact with developments in science seems likely. Jules Laforgue, who seems to have been the first to apply the concept of prismatic color to impressionistic painting, had a highly versatile mind, with some scientific interests. Moreover, he began his article "Impressionism" with a brief section that bore the title "Physiological Origin of Impressionism" (p. 15). He even explicitly referred to the theory of color vision developed by Young and Helmholtz (p. 16) and mentioned Fechner's law of vision (p. 19).[25] All this indicates a familiarity with what was going on in the scientific study of vision. A direct derivation of the term from contemporary science thus seems likely.

Whatever the origin of the term, what specifically did the impressionistic critics and painters using it have in mind? What they called "prismatic

color" was not exactly the same thing that the scientists described thus, nor was it identical with what the Neoimpressionists meant by it a decade later. Both scientists and Neoimpressionists were thinking of an actual decomposition of tones and shades into their primary color components. Seurat and Signac, as we know, believed that they could apply tiny patches of pure primary color, leaving it to the beholder's eye to combine them in the visual experience. The impressionist critics and painters writing and speaking in the seventies and eighties had was something different in mind. They were thinking mainly of the recording of colored reflections as they are (supposedly) perceived by the eye, and thus also of the replacement of dark shadows by colored ones. The French journalist and art critic Théodore Duret wrote as early as 1878, only a few years after the first exhibition of the Impressionists, "When the winter comes, the Impressionist paints snow. He sees that the shadows on the snow are blue in the sunlight; unhesitatingly he paints blue shadows. . . . Under the summer sun, with reflections of green foliage, skin and clothing take on a violet tint. The Impressionist paints people in violet woods."[26]

The very perception of colored shadows was seen as an achievement. Laforgue suggested an interesting pattern for a history of perception. Primitive man, whose eye knows "only white light with its indecomposable shadows . . . availed himself of tactile experiment" (p. 16). As a result he perceived bodies, material things. The impressionist's eye, on the other hand, acting only "in its faculty of prismatic sensibility," perceived the decomposed colors, and could "forget the tactile illusions." In other words, what Laforgue called the "polyphony of color" made it possible for the artist to detach himself from the world of material objects and bodies, a world perceived in both optical and tactile experience. This world of bodies was the world of primitive man. In the impressionist's vision, Laforgue implied, pure seeing achieved ultimate realization. "The Impressionist eye is, in short, the most advanced eye in human evolution, the one which until now has grasped and rendered the most complicated combination of nuances known" (p. 17). This eye, we should keep in mind, replaced objects, bodies, or things with nonmaterial phenomena. The painter's choice of colors thus assumed metaphysical dimensions, even if only tacitly.

Jules Laforgue sang the praises of the "unusual sensibility of the [impressionist's] eye." This sensibility was reflected in the pictorial craft, on the painter's palette. From a discussion of lofty philosophical questions such as the juxtaposition of a world of nonmaterial phenomena and a world of solid objects, we therefore move to a brief analysis of the painter's craft.

What was it that the impressionists wanted to suppress? What was their polyphony of color meant to replace? I think there were two assumptions that the impressionist painter wanted to reject. These were, first, the color technique resulting from adherence to a world of solid objects, and, second, the age-old tradition, especially common in workshops, of what was called "local color."

We have already touched on the first issue. What Laforgue called "white light" was light fully separated from color. Such light makes objects stand out in unmitigated material solidity. It will produce dark (or "black"), opaque shadows; together they will create powerful *chiaroscuro* effects. This kind of painting (pertaining to the world of solid objects) was rejected by the impressionist. In his work, dominated by what the poet Stephane Mallarmé called "diaphanous shadows,"[27] there was "[n]o line, light, relief, perspective or chiaroscuro, none of these childish classifications" (p. 17). The impressionist converted all these "into the vibration of color and [they] must be obtained on canvas solely by the vibration of color" (p. 17).

The impressionists' rejection of "white light" was perceived as a crucial and revolutionary feature. As early as 1876 Edmond Duranty proclaimed: "As far as method of coloring is concerned, they [the impressionists] have made a real discovery, whose origin cannot be found elsewhere. . . . Their discovery actually consists in having recognized that full light *de-colors* tones . . ." (p. 4).

The impressionists, both painters and critics, were well aware that their concepts of light and color had a historical dimension; they were openly contradicting the inherited cultural tradition. Although they claimed that their way of looking at the outside world was the "natural" one and that it had a physiological basis, they were well aware that the viewer had to educate the eye to be able to see as they did. Jules Laforgue devoted a section of his early presentation of the impressionists' message to what he called the "False Training of the Eye" (p. 17). Here the impressionists' awareness of their revolutionary role in the history of painting was clearly expressed.

The Disappearance of "Local" Color

The other aspect, closer to the painter's craft, is more easily stated. This was the impressionists' rejection of what was called "local color." For centuries the concept of local color dominated the doctrine of painting. Every object, the painter was taught, has a color of its own: the leaves are green, the cardinal's robe is of a particular red, and so forth. When the object is il-

luminated, the color becomes brighter; when it does not receive sufficient light, it becomes darker. However, the basic chromatic character of the object will not change; the leaves will remain green, the cardinal's robe will stay red. An old workshop precept, going back to the fourteenth century, advised the painter to prepare six shades of the same color, from the brightest to the darkest, and to model with them the object or figure to be represented.[28] Using the conceptual terms employed by the impressionists we can say that local color was part of the world of objects.

For centuries, painters and theoreticians of painting knew, of course, that under certain conditions the local color of an object or a figure may be influenced by colored reflections. In the fifteenth century Leone Battista Alberti wrote that a man walking on a green lawn may have green reflections on his face.[29] The depiction of colored reflections was a permanent and important feature of pictorial practice. However, colored reflections were never perceived as casting any doubt on the primacy of local color. Even though colored reflections may have been much appreciated, they remained a mere adornment of painting that was essentially based on the concept of local color.

It was this particular assumption that was violently shaken by impressionism. The assumption underlying the impressionists' thinking was that what we see, and therefore what the painter should depict, is an intricate network of colored reflections that, in fact, altogether obscure the object's or figure's local color. Once again Stephane Mallarmé's formulation is helpful. Writing about Renoir's work, he said: "The shifting shimmer of gleam and shadow which the changing reflected lights, themselves influenced by every neighboring thing, cast upon each advancing or departing figure, and the fleeting combinations in which these dissimilar reflections form one harmony or many, such are the favorite effects of Renoir. . . ."[30] As the solid, material object dissolved into a cluster of appearances. so local color dissolves into a net of reflections.

Sometimes some kind of philosophical reflection creeps into the impressionists' description of color appearances, emphasizing that what we see is, in fact, quite far removed from what we believe is the local color of an object. Once again I shall have to make do with a single quotation, adduced only as an example. In Laforgue's statement on impressionism, after he has stressed at length the ever changing appearances of nature, we find the following statement: "Subject and object are then irretrievably in motion, inapprehensible and inapprehending. In the flashes of identity between subject and object lies the nature of genius. And any attempt to cod-

ify such flashes is but an academic pastime" (p. 18). The concepts of "subject" and "object," terms heavily charged in philosophical discourse, should not be taken as seriously as we might take them in a purely theoretical treatise. Nevertheless they show that the impressionists were aware that they were depicting something that was *between* subject and object without fully corresponding to either.

Aesthetics of Color

Impressionists often protested their lack of concern for, and interest in, aesthetics. In fact the painters and critics of this movement made almost no elaborate statement about aesthetics. Not only was aesthetics a domain beyond the impressionist painter's direct concern, but he also vaguely perceived it as a cultural power that had dominated reflection on art, and thus pictorial practice itself. It assumed the character of a cultural antipode to what the impressionists were aiming at. Aesthetics suggested an absolute norm. The aestheticians, Laforgue said, "have foolishly insisted" on two criteria: Absolute Beauty and Absolute Taste" (p. 15). Such absolutes embodied the very opposite of the ever changing, subjective (or perceptual) world of the impressionists. Not surprisingly, therefore, the impressionists did not have much use for aesthetics.

In their notes, however, they disclosed, probably without intending to do so, the impact of the aesthetic thought of centuries. Moreover, they implicitly acknowledged that they accepted a specific aesthetic idea, one that was often brought into contact with "Absolute Beauty," as a pictorial value and thus a guideline to their own work. This was the notion of Harmony. The attentive reader cannot help noting with some surprise how often the words "harmony" and "harmonious" were used by impressionists, and in what significant contexts this happens.

We should note, first, that impressionists spoke of harmony only in the context of color. But since color played such an overwhelming part in their reflections, what they said about the harmony of color assumes a general significance. Harmony is well balanced proportionality, and as such it dominates the relationship between the aspect of nature represented and the picture representing it. To quote again from Laforgue: "What one might call an innate harmonic agreement operates automatically between the visual effect of the landscape and the paint on the palette" (p. 17). The harmonic agreement between visual experience and the paint on the palette is thus the basic principle of all painting.

While such general harmony may be metaphoric, the impressionists also spoke of harmony in more specific and concrete pictorial conditions. As early as 1873 Durand-Ruel published a *Recueilles d'estampes*, to which Armand Silvestre wrote the Introduction. "What immediately strikes us when looking at a painting of this [i.e., impressionist] kind is the immediate caress which the eye receives. . . ."[31] The eye was caressed because of the tonal relationship. The secret of this caressing quality, he wrote in the Introduction, was "based on a very fine and exact observation of the relation of one tone to the other."

Harmony can be imagined in very different forms in different schools and traditions of cultural taste, even if these traditions belong to the same general culture. An amusing illustration of this truism is that in the same year in which Silvestre suggested that harmony was a supreme value for the impressionists, an unsigned review of a London exhibition of French painting that appeared in the *Times* said the very opposite about them. The works of the old Corot, the writer remarked, "have no more distinctive qualities than tenderness and delicacy." In the new French painting, however, "we find a harshness in the juxtaposition of tints, a crudeness of local coloring, a heaviness of hands. . . ."[32] As an illustration the anonymous reviewer specifically mentioned the works of Claude Monet, among other painters. Two years later, another unsigned review of an exhibition of French painting continued in the same vein. Here Manet's painting was adduced as an example of the school of French painting "we should prefer to call coarse and ostentatiously defiant of both rule and culture. . . ."[33]

Yet, though the conservative taste of critics found impressionist painting "harsh" or even "ugly," the impressionists themselves adhered to harmony as an ideal, even if they did not focus their attention on it.

While harmony may have been understood to some extent as an abstract notion, impressionistic writings also refer to more simple and direct experiences that can be considered "aesthetic." Such experiences may have had far-reaching implications for the impressionists' views on painting. An important example is their reception of Japanese prints. The impressionists turned to, or "discovered" for themselves, Japanese painting for different reasons. One of these was their simple enjoyment of unusual but beautiful color combinations. In the latter part of the nineteenth century, such enjoyment of unusual color combinations may have been linked with the cultural climate that was beginning to consider the child's naive view of unfamiliar things as a source or component of art. Théodore Duret, who in the pamphlet we have already often quoted explained the liberating effect of

Japanese prints on the impressionists, also said that many people looked at Japanese prints "for a mere gaudy mixture of colors."[34] It was only after enjoying the gaudiness of the colors that the impressionists discovered that such color combinations could also be observed in nature. "When you stroll along the banks of the Seine," said Duret, "you can take in with a single glance the red roof and the dazzlingly white wall of a cottage, the tender green of a poplar, the yellow of the road, the blue of the river." Painters did not use such strong colors because of the inhibitions imposed on them by an inherited aesthetics. Now, under the impact of another aesthetics, they felt free to represent in painting what they actually saw.

Expressive Coloring

Whatever their distance from aesthetics, the impressionists were even farther removed from any idea of color symbolism and of the intuitively expressive effects of shades. Although in their time these notions were very much in the air, the impressionists do not seem to have been touched by them. Nevertheless they did perceive something of the expressive dimension. Thus Armand Silvestre wrote in 1873:

> What could help ensure the eventual success of these young painters is the fact that their pictures are done in a singularly bright tonal range. A blond light pervades them, and everything is gaiety, clarity, spring festivals, golden evenings, or apple trees in blossom—once again an inspiration from Japan. Their canvases, uncluttered, in medium size, are open in the surface they decorate; they are windows opening on the joyous countryside, on rivers full of pleasure boats stretching into the distance, on a sky that shines with light mists, on the outdoor life, panoramic and charming."[35]

Not only was the color scale of the impressionists infused with gaiety; occasionally the idea of an expressive distinction of colors appeared in their notes as well. In an article published in 1893 (a shorter version had appeared a year earlier) George Moore, the British author and promoter of impressionism, made some interesting observations on color in impressionist paintings that expressed moods. Monet's early painting, Moore said, were "all composed in pensive greys and violets, and exhaled the weary sadness of tilth and grange and scant orchard trees."[36] Especially "the violet spaces between the houses are the very saddest."

In impressionist writings references to the expressive effects of colors or color combinations were rare. Nonetheless this domain was not altogether absent from their thought.

Brushwork and Finish

In the letter that Théodore Duret wrote in 1874 to Pissaro in order to urge him and the other impressionists to make an effort to have their works shown in the Salon, he mentioned, as we have already seen, those characteristics of the impressionists' paintings that were considered obstacles to acceptance. He advised them to choose pictures that had a subject, some semblance of a composition, and "that are not too freshly painted, and have some finish to them."[37] This sentence alone suggests two obvious conclusions: First, the impressionist painters must have been aware that their works were "freshly painted" and lacked "finish." Second, they knew that these characteristics were a stumbling block to their works' acceptance by the Salon, a recognition they sought. If they nonetheless persisted in painting this way, we have to conclude that they did so for some purpose.

In order to understand what the new style of painting may have meant to the impressionists themselves, and possibly also to their original audience, we must, at this point, answer the two questions. First, to what extent were the impressionist painters themselves aware of the lack of finish in their pictures? If it turns out that they were fully aware of their disregard for finish, why did they reject or ignore an important and traditionally hallowed part of the craft of painting, namely, finish?

The term "finish" in painting, frequently used in criticism, would seem to be self-evident. Duret employed it on the assumption that Pissaro and the other impressionists he was addressing would be in no doubt as to his meaning. While most likely this was indeed the case, the concept of finish in painting is rather complex, and its aims and meanings are not as clear as may seem. Without taking up the subject as a whole (a subject that would well deserve more attention than it has received so far), I shall briefly discuss what "finish" may have meant in late-nineteenth-century art and art theory.

What critics in the nineteenth and twentieth centuries described as "academic" technique and artistic procedures consisted mainly "of the rigid and dogmatic application of the *fini*."[38] This seems to have been well known in the impressionists' time, when the value and precise limits of the *fini* were a matter of debate. Théophile Thore, a liberal critic open to "modernist" thought (who also contributed to establishing art history in France), questioned the validity of the *fini*. "Is a picture in fact ever finished?" he rather rhetorically asked. "For my part, I do not find Gerard Dou's painstaking efforts 'finished': they are over-finished. Perhaps they were more complete,

that is to say more expressive of what the painter was trying to convey, at an earlier stage of preparation, thanks to delicate brushwork."[39]

When looking at works of art we instantly distinguish, without having to ask complicated questions and to apply sophisticated criteria, between pictures that have a high degree of finish and those that do not. Yet it is important to ask in what the finish of a painting actually consists, and what is achieved by it. In the context of our present theme, two aspects of finish need to be stressed. First, the various technical procedures that are combined under the label of "finish" give the painting a smooth, seemingly polished surface, and in many schools also a luminous quality. Second, at the finish stage all traces of the process of production, of shaping the painting, and all the work invested in it, are blotted out, fully eliminated. To be sure, in the course of the centuries there were many ways of finishing a painting; diverse patterns and techniques of finish crystallized in different periods as well as in different schools. In all of them, however, these two characteristics—a smooth surface and the obliteration of all traces of former work—seem to be present.

Already in early Netherlandish painting we learn about the specific surface quality of the "finished" picture. The shining, unbroken surface of the paintings we encounter here reminds us of the precious materials in which relics, or sacred objects in general, were often encased. Perhaps the luminosity and the smooth polished surface of these "finished" paintings were meant to evoke the sensation of the gold and enamel of sacred objects.[40] Be that as it may, it is significant that the texture of the objects represented (often with such convincing naturalism) was in no way reflected in the surface of the picture. The part of the surface on which a rough wall or a piece of hairy fur were rendered feels exactly as smooth as the piece on which a highly polished glass or a silken robe were painted. The smooth, even surface of the finished picture was a quality of the picture as a specific kind of object.

This kind of surface survived in later periods, even when the intense luminosity of the painting was no longer preserved. Originally part of the artist's, and the artisan's, pride, the polished surface became part of the public's taste. Théodore Duret, as we have seen, thought that impressionists' disregard for finish was a major reason for their being rejected by the central organization of prevailing taste, the Salon. The Salon juries that rejected the impressionists may well have felt, though they did not put it in so many words, that the lack of a finished surface indicated the picture's break with a long tradition, with the origins of easel painting in artisanship, and with the inherent wish to produce precious objects.

More complex was the other part of Duret's advice to the young impressionists: in submitting paintings to the Salon, he told them, they should choose pictures that were not "too freshly painted." What he meant by "freshly painted" seems fairly obvious. He had in mind the free and highly visible brush strokes that are such a prominent hallmark of impressionist painting. In his pamphlet *The Impressionist Painters* he spoke of three major achievements of the new painting: he described it as "light colored painting, finally freed from litharge, from bitumen, from chocolate, from tobacco juice," by which he obviously meant the yellowish and dark brownish tones that dominated traditional painting; the out-of-doors painting, that was so revolutionary; and what he called "that impulsive brushwork proceeding by means of large strokes and masses, which alone defies time" (p. 6).[41] While all this seems obvious, we must again ask why it was believed that a painting should not openly show brush strokes, and why, on the other hand, the impressionists insisted on parading them.

Our modern age, fascinated with the idea of the artist's individuality, sometimes appreciates the openly visible brushwork as an immediate record of the painter's touch. Perhaps due to the influence of modern graphology which uses a person's handwriting as a means of identification, the brushwork in a picture is occasionally characterized as the painter's "handwriting." Was this how visible traces of the brush in a painting were understood in fifteenth-century workshops? The artists, investing much effort to remove traces of the brush in the paintings, probably did not care so much about wiping out the traces of an individual who, in any case, was not well known. They were probably guided by the artisan's ideal of producing a perfect work. In artisanal thought perfection and completion were closely interrelated. An incomplete work was a flawed work. A painting showing traces of the working procedure and of the tools employed in the process of shaping it seemed incomplete, and hence flawed.

What, then, were the impressionists' specific reasons for so consistently leaving the traces of the painter's brush in their paintings, and making them so ostentatiously visible? As far as we can tell, the desire to identify an individual artist through his work was not the central motive for their technique. I was not able to find a single sentence to this effect. Nor did I find any reference to the difference between the brush stroke in the pictures of, say, Monet and Seurat. A contemporary student may well discover such differences,[42] but the impressionists themselves do not seem to have noticed such distinguishing marks, nor assigned great significance to them. While an *argumentum ex silentio* is notoriously weak, there are some indications

to the effect that brushwork was not seen as an individual mark. On the contrary, the openly displayed brushwork was seen as characteristic of *all* impressionist painters. When Duret suggested that the young painters submit to the Salon pictures that were "not too freshly painted, and have some finish to them," he was not addressing an individual painter; rather, he had the group as a whole in mind. He obviously considered the open brushwork a technique common to all the impressionists. This view continued to be held. Thus, in 1893 George Moore wrote that the "authority for Monet's broken brushwork is to be found in Manet's last pictures."[43] Clearly, the display of a painter's individuality was not the reason for letting the brushwork remain visible in the paintings.

Why, then, did the impressionists insist on employing this technique? Since free and visible brushwork was so obviously a stumbling block to their acceptance by wide audiences, their adherence to this technique suggests that it must have been a matter of principle. Although neither impressionist painters nor critics have provided posterity with explicit answers, yet fragmentary utterances indicate that they perceived the pictorial surface made up of little brush strokes as a particularly vibrant surface which corresponded to the vibrant nature of the visual experience.

Once again we turn to Jules Laforgue, who understood the spirit of impressionism better perhaps than any other critic. Writing about the exhibition of the impressionists he said that "the formula is visible especially in the works of Monet and Pissaro . . . where everything is obtained by a thousand little dancing strokes in every direction like straws of color—all in vital competition for the whole impression. . . . Such is the principle of the *plein-air* Impressionist school" (p. 17). A little earlier, speaking about the "polyphony of color" characteristic of the "impressionist eye," he juxtaposed the white light of academic painting to the "thousand vibrant struggling colors" of the new movement. "The Impressionist sees and renders nature as it is—that is, wholly in the vibration of color" (pp. 16–17). Form was "obtained not by line but solely by vibration and contrast of color" (p. 15). "Essentially the eye should know only luminous vibrations" (p. 18). Note, vibration was the keyword.

In groping for the proper term and an explanatory reason for the open brushwork technique, speed is often suggested. Speed is mandatory in the painter's efforts to catch the transience he observes in nature, prompting him to allow the brush strokes to stay undisguised on the canvas. But citing the painter's speed was a critical, even derogatory, observation. In 1888, in an address given at the opening of an exhibition, the former pre-Raphaelite

artist Holman Hunt subtly expressed his scorn for the impressionists who "evidently are in a hurry" to capture the appearances of nature.[44] Speed may explain the open brushwork, the academic critics thought, but it was no justification. In a review of an exhibition of impressionist paintings in 1874 (a review composed in the form of a dialogue) we read;

> . . . "The shadow in the foreground is really peculiar."
> "It's the vibration of tone which astonishes you."
> "Call it sloppiness of tone and I'd understand you better. . . ."[45]

The impressionists' originality in this bold technique is evident from the fact that the accepted critical vocabulary of art criticism did not have a term for such openly displayed brushwork. Critics knew, of course, the occasional use of undisguised brush strokes in the paintings of Franz Hals or Velasquez. But in no work by these venerated painters was the whole surface of the picture covered with clearly distinguishable brush strokes. An anonymous British reviewer writing in the *Times* in 1876 of the "protest-provoking pictures" of the impressionists, said that the paintings were "coarse and ostentatiously defiant of rule and culture." To explain their technique, he said further: "The handling is an exaggeration of the coarsest methods of the scene painters. . . ."[46] He was referring to the paintings' extreme sketchiness. The "scene painter," forced to quickly produce backdrops that would be discarded after use, left the strokes of his coarse brush undisguised; the object he was painting would be seen from a distance, and as long as it achieved its main purpose, illusion, no further effort on it was necessary.

NOTES

1. Bernard Devir, ed., *The Impressionists at First Hand* (London, 1991), p. 85.

2. Elizabeth Gilmore Holt, ed., *From the Classicists to the Impressionists: A Documentary History of Art and Architecture in the Nineteenth Century*, 2 vols. (Garden City, N.Y., 1966), p. 76.

3. Albert Cassagne, *La Théorie de l'art pour l'art en France* (Geneva, 1979; original edition: Paris, 1906), p. 92.

4. Linda Nochlin, *Realism* (Harmondsworth, 1971), p. 179.

5. Holt, *A Documentary History*, p. 369.

6. H. M. Abrams, *The Mirror and the Lamp* (Oxford, 1953), p. 318.

7. Abrams, *The Mirror and the Lamp*, pp. 317–20.

8. Quoted from George J. Becker, ed., *Documents of Modern Literary Criticism*

(Princeton, 1963), p. 414. See also Monroe C. Beardsley, *Aesthetics from Classical Greece to the Present: A Short History* (New York, 1966), p. 297.

9. Tolstoy in Becker, *Documents of Modern Literary Criticism*, p. 275.

10. Nochlin, *Realism*, p. 36.

11. All quotations in this paragraph are from Holt, *A Documentary History* p. 369.

12. Devir, *The Impressionists at First Hand*, p. 79.

13. Devir, *The Impressionists at First Hand*, p. 102.

14. See Giovanni Battista Armenini, *De veri precetti della pittura* (Ravenna, 1587), p. 44 (I, chapter 5). For Armenini, see Barasch, *Theories of Art*, pp. 236–41. For a survey of Renaissance views on composition in painting, see Karl Birch-Hirschfeld, *Die Lehre von der Malerei im Cinquecento* (Rome, 1912), pp. 75–89.

15. Albert Boime, *The Academy and French Painting in the Nineteenth Century* (New York, 1971), pp. 43–47.

16. Quoted in Kate Flint, ed., *The Impressionists in England: The Critical Reception* (London, 1984), p. 78.

17. Richard Hamann and Jost Hermand, *Impressionismus* (Epochen deutscher Kultur von 1870 bis zur Gegenwart, 3) (Frankfurt am Main, 1977), p. 218.

18. Barasch, *Modern Theories of Art*, 1, p. 330.

19. Linda Nochlin, *Impressionism and Post-Impressionism 1874–1904: Sources und Documents in the History of Art* (Englewood Cliffs, N.J., 1978), p. 7. For the original formulation, see Edmond Duranty, *La Nouvelle Peinture: A propos du groupe d'artistes qui expose dans les Galeries Durand Ruel* (1876), edited by Marcel Guerin (Paris, 1946), p. 46.

20. Charles Baudelaire, *The Painters of Modern Life* translated by Jonathan Mayne (New York, 1986), p. 13.

21. Nochlin. *Impressionism and Post-Impressionism*, p. 15.

22. Nochlin, *Impressionism and Post-Impressionism*, p. 16.

23. Devir, *The Impressionists at First Hand*, p. 52. The article appeared in *Modern Painting*, 1993, pp. 84–96, and is reprinted in Flint, *The Impressionists in England*, pp. 122–29. I quote from the reprint.

24. See above, chapter 3.

25. For Fechner, see below, part 2, chapter 8.

26. Quoted from Nochlin, *Impressionism and Post-Impressionism*, p. 9. Originally the text appeared as a pamphlet. See Théodore Duret, *Les Peintres impressionistes* (Paris, 1878).

27. Devir, *The Impressionists at First Hand*, p. 56.

28. For Renaissance color conception, mainly of local color, see Moshe Barasch, *Light and Color in the Italian Renaissance Theory of Art* (New York, 1978).

29. Leone Battista Alberti said that reflected light carries the color of the reflecting object. "You may have noticed that anyone who walks through a meadow in the sun appears greenish in the face." Alberti, *On Painting*, p. 51.

30. Devir, *The Impressionists at First Hand*, p. 61.

31. Devir, *The Impressionists at First Hand*, p. 79.

32. Flint, *The Impressionists in England*, p. 35. The review appeared on April 27, 1874.

33. Flint, *The Impressionists in England*, p. 36. The review appeared in the *Times* of April 25, 1876.

34. Nochlin, *Impressionism and Post-Impressionism*, p. 9.

35. Devir, *The Impressionists at First Hand*, p. 79.

36. Flint, *The Impressionists in England*, pp. 122–29, esp. p. 123.

37. Devir, *The Impressionists at First Hand*, p. 85, And see above, the introduction to the present chapter.

38. Boime, *The Academy and French Painting*, p. 20.

39. Théophile Thore, *Salons de W. Burger*, I (Paris, 1870), p. 49; here quoted from Boime, p. 99.

40. As far as I am aware, the motivation of early Flemish painters in producing these precious surfaces has not been sufficiently investigated in modern research, though the literature on this art is rather large. For some comments, see Erwin Panofsky, *Early Netherlandish Painting: Its Origins and Character* (Cambridge, Mass., 1953), pp. 150 ff.

41. In Duret's text the order was inverted; he began with the brush strokes. Litharge is lead monoxide, of a very light yellow color. Bitumen is a dark brown paint, one of its components being asphalt; it is a color that dominated a great deal of traditional academic painting. "Chocolate" and "tobacco juice" are critical descriptions of this dark brown tone in traditional painting.

42. I should like to mention the studies by Fritz Novotny, *Die grossen französischen Impressionisten, ihre Vorläufer und ihre Nachfolge* (Vienna, 1952), and his *Painting and Sculpture in Europe, 1780–1880* (Baltimore, 1960).

43. See Flint, *The Impressionists in England*, p. 124.

44. Flint, *The Impressionists in England*, p. 88.

45. The review, "L'Exposition des impressionistes," was written by Louis Leroy and published on April 25, 1874, in the satirical journal *Charivari*. See John Rewald, *The History of Impressionism*, rev. ed. (New York, 1973), pp. 318–24. The English translation is reprinted in Nochlin, *Impressionism and Post-Impressionism*, pp. 10–14.

46. Reprinted in Flint, *The Impressionists in England*, pp. 36–37.

6

The Fragment as Art Form

Painting was clearly the main medium in which impressionism scored its most important and most characteristic achievements, and on which it left its major mark. But the influence of the various art movements linked with impressionism was not limited to painting alone. We shall conclude this part with the discussion of a phenomenon principally realized in sculpture rather than painting. It represents the emergence of a new art form. Though this form did not achieve the prominent position held by, say, impressionist color scale or brush work, it shows clearly in which direction the basic developments of the new art movement were heading. What I have in mind are pieces of sculpture representing a small part of the whole figure—a head, a hand, or a torso. These pieces, fragmentary though they may seem, were conceived as complete, self-enclosed works of art, and were meant to be shown in this seemingly fragmentary state. They may appropriately be described as "autonomous fragments."

It has been said that the autonomous fragment is the most important legacy of nineteenth-century sculpture to modern art.[1] To appreciate how revolutionary a departure it was from artistic traditions that had endured for millennia, let us briefly recall the history of attitudes to the fragment in art, and mainly of sculpture. To be sure, the partial figure was not a nineteenth-century invention. If we take the term literally, we shall find that works of art representing only one part of a figure go back to the earliest stages of history. The so-called "reserve heads" found in some ancient Egyptian tombs could, in purely visual terms, qualify as independent fragments of the body. However, these heads were not meant to be seen as autonomous self-enclosed pieces. Rather they were conceived as "spare parts," so to speak, to be placed on the statue in case the original head, the most important part of the body and the seat of life, should be damaged. Not only, then, can these heads not claim independent aesthetic completeness, but they were explicitly conceived as parts of the whole figure.

The bust, mainly in Greek and Roman art, is a special case with firmly established conventions of its own; it should be seen as an "abbreviated figure" rather than as a fragment. Another type of fragment, common in the ancient world, is the votive gift deposited at the temple, frequently representing single limbs, such as feet, hands, female breasts, and genitals. These were not meant to be shown. They were made for a magical purpose, to indicate which part of the believer's body required cure and the help of the god.

Classical art could not conceive of an "autonomous fragment." The idea of a Greek sculptor purposely making a human body without head or limbs is simply unthinkable. This was true not only for classical Antiquity, but for all the periods and styles preceding the middle of the nineteenth century.

The Middle Ages had their own category of partial figures, mainly in the form of relic boxes. The relics within them could be a piece of the cross, a thistle of the crown of thorns, and so on. A significant proportion of the relics, however, consisted of parts of bodies, like the head of a saint, his arm, his hand, and so forth. These remains were kept in precious and elaborate containers, or reliquaries, that sometimes assumed the shape of the body part they enclosed. Some of the reliquaries were life-size representations of parts of a human body. The ideas behind these precious reliquary boxes did not promote the fragment as an art form. The individual piece of the saint's body did not "represent" a figure. It was not meant to be understood as a part; rather it recalled the martyrdom and sacrifice of the saint as a whole person of whom by chance the single hand or finger had survived. The idea of a fragment being independent was beyond the horizon of the medieval mind.

The Renaissance took several steps toward creating the independent fragment in art. The new attitude toward the fragment of classical art was one of them. In the Renaissance the torso, the broken off head, and so on, of ancient art were thought to embody timeless values.

The other step the Renaissance took, the increasing appreciation of drawings, bozzetti, or unfinished works by great masters, grew out of the veneration of genius, an attitude that played a crucial part in the culture of the period. In Antiquity and the Middle Ages such drawings and bozzetti, records of the efforts made while shaping finished works of art, were simply thrown away; in the Renaissance they were collected and studied as "tokens of genius." They showed genius's individual, characteristic way of handling and shaping a work of art.

Still, no Renaissance artist is known to have produced a fragmentary work on purpose, whether a marble or a painting, or even to have considered the possibility of the fragment as an art form. This happened in the latter part of the nineteenth century. As far as we know from art historical research, it was the French sculptor François Rude who in 1855, shortly before his death, carved a life-size marble representing a truncated Christ on the Cross.[2] Not only is the body cut off at a point just above the navel, but Christ's arms are truncated along with those of the cross. In 1857 this piece, altogether unusual for its time, was admitted to the Salon, the jury probably not daring to reject the last work of a revered master. But the idea of the independent fragment was evidently "in the air," judging by how rapidly it caught on. In the next two or three decades many important and very characteristic pieces of sculpture assumed the form of fragments. This trend culminated in the famous works of Auguste Rodin, to whose reflections on art we shall shortly return. Rodin, as is well known, revealed the variety of artistic possibilities in the fragmentary, the truncated, and the incomplete. In his work, the fragment became an established art form.

We have cast a brief glance, a bird's-eye view, over the long history of sculpture in order to show how novel and revolutionary the fragment was as an art form and how totally opposed to accepted norms it was to make one. Nevertheless, in the last third of the nineteenth century the fragment became widespread, being produced by many artists and accepted by broad audiences. Two observations are in order here. First, the fragment could not have become an established and accepted art form without intense and sustained theoretical reflection on the basic principles of the art of sculpture. To make it acceptable, the artists, and at least some of the audience, must have been made aware of the conceptual foundations of art. Second, this radical change in sculptural norms took place during the same years, and in the very same city, in which impressionism took root in painting. Impressionist painting raised problems comparable to those of fragmentary sculpture. These developments in painting and sculpture cannot be understood in complete isolation. What were the ideas that brought about, or justified, the transformation of the fragment into a basic pattern of artistic creation?

It is very difficult even to attempt to answer these questions. While it is obvious that the autonomous fragment could not have come into being without theoretical reflection on the part of the artists, and at least some conceptual awareness among the audience, there are no literary documents that directly bear on this subject. Not only is there no record of a system-

atic treatment of the fragment, but even such scattered and incomplete utterances as those of the impressionists on color and brushwork are not found on the sculptural fragment. Where, then, do we find an echo of the mental process in which the fragmentary figure was created in sculpture? We shall have to turn to developments that, at first glance, may seem rather far removed from the theme of this chapter.

The fragmentary, the incomplete, or the ruined have always fascinated the human mind. Since Romanticism, and throughout the nineteenth century, it was a topic of frequent reflection. In the course of this century, the fragmentary was felt to be characteristic of the modern world. Already at the end of the eighteenth century, the German poet Friedrich Schiller, describing the wound that "culture itself inflicted upon modern humanity," said that "[we] see not merely individual persons but whole classes of human beings developing only part of their capacities, while the rest of them, like a stunted plant, show only a feeble vestige of their nature."[3] These words were written in 1795. But shortly thereafter, in 1806, the philosopher Georg Wilhelm Friedrich Hegel emphasized the positive impact of fragmentation. "The Life of the mind," he wrote in the *Phänomenologie des Geistes*, "only wins to its truth when it finds it utterly torn asunder."[4] Almost half a century later Chateaubriand claimed that "Tous les hommes ont un secret attrait pour les ruines. Ce sentiment tient à la fragilité de notre nature, à une conformité secrète entre ces monuments détruits et la rapidité de notre existence."[5] And still one generation later, Friedrich Nietzsche hailed the "charm of imperfection" (*Reiz der Unvollkommenheit*).

In spite of this tradition, the artists of the late nineteenth century either did not talk about the autonomous fragment, or else their reflections were not recorded in writing. Thus, although they created these intentional fragments in sculpture and painting, they left almost no theoretical testimony on the subject. Yet some discussions about the fragmentary in art, contemporary with the pieces of sculpture and painting we have referred to, indicate the intellectual and emotional attitudes that determined some of the works in stone, bronze, and color. I shall briefly comment on two areas in which attempts were made to understand the autonomous fragment.

The first area is the reflection of poets, mainly of the French poet Paul Valéry, on the Unfinished, the Incomplete in works of the visual arts. To be sure, Paul Valéry died as late as 1945, but most of his ideas, at least those that concern us here, go back to the 1890s. At that time, Paul Valéry was close to the impressionists, and the problem of the incomplete in sculpture and painting stands out clearly in his thinking. It is in the con-

text of paintings and statues that he took up the aesthetic problems of the fragment.

Valéry saw the fragment, the incomplete work, in a metaphysical context, as the reflection of a basic human condition. The work of art, he believed, was created in the area between "the will and the power, the idea and the act." The tension between these poles fascinated him. He even proclaimed that "the process of manufacture is more interesting than the work itself."[6] Even a slight discrepancy between the two may result in a fragmentary state of the product. "The moderns" (and Paul Valéry though this was a failure) made these fragments, these rough drafts (*ebauches*), these sketches, objects of a cult. Such unfinished attempts, he noted, were believed to express the sublime genius, the personality of the artist.

Once again the problem of what "finish" is, and what it means in practical terms to complete a work of art arises with full force. Valéry gave an old definition of completing a work of art: to him it meant to make everything that may remind us of its growth and production disappear altogether, erasing the stages of its emergence and final casting into shape. Valéry's definition was a time-honored one, though he transformed it in an original way. The "art to hide art," to make a depiction that was produced in long struggle against obstacles appear as if it flew from the artist's mind and hand easily and "in a natural way" was an old concept, one we have encountered earlier in the history of art theory.[7]

For centuries it was assumed, Valéry suggested, that the artist should "show himself only in his style," that is, after he had deleted everything that might serve as a clue to the process of shaping the work he was showing. In modern times the interest in the work of art shifted from what Valéry called its "style," that is, its finished final form and appearance, to what he termed "the person and the moment," that is, the artist and the inception and growth of the work. For such an interest, the finished and completed form of a work of art "seemed not only useless and disturbing, it was even incompatible with the truth, with emotion, nay, even with the revelation of genius. . . . The sketch and the painting became of equal value."[8]

Paul Valéry accepted this evaluation. In his "Letter about Mallarmé," published only in 1927 but going back to much earlier thoughts, he wrote: "It is not the finished work or the impression it makes on the world that can develop and complete us, but only the manner in which the work was performed." And therefore, "in this respect I withdrew some degree of importance from the *work* and transferred it to the will and purposes of the *agent*. It does not follow that I was willing to see the work neglected, but

rather the contrary."[9] All this, of course, necessarily led to a reevaluation of the sketch and the unfinished work. And a little later, in his notes entitled "I Would Sometimes Say to Stephane Mallarmé," he wrote: "Everything that is most admirable in a work of art is owed to the instantaneous mood of its author. . . ."[10]

How do we see this "instantaneous mood"? Obviously, by not deleting the clues to its original appearance. The fragment, then, and this is what follows from Paul Valéry's comments, not only had a specific character, but it also had a value of its own, a value that could only be found in the unfinished.

Another approach to accepting the fragment as akin to an art form, or at least to asking whether it is an art form, was made in an altogether different area, namely, in the professional study of art and its history. In the late nineteenth century it was mainly historians of art, that is, representatives of an academic discipline established a generation or two earlier, who in their studies came across great works of art (works by great and influential artists) that had remained unfinished. These works, and particularly the spell they cast on the spectator in spite of their fragmentary state, posed a challenge to common wisdom, to concepts and norms handed down in a long tradition of aesthetic teaching and judgment. For art historians in the last decades of the nineteenth century it was primarily the many fragmentary unfinished works of Michelangelo that forcefully urged a rethinking of the fragment as an artistic category.

Two kinds of questions, closely related to each other yet not identical, arose from these unfinished works of art. The first and obvious question was: why did they remain unfinished? The other question, perhaps less obvious but unavoidable, concerned the expressive power of these fragmentary works. What was it that made these incomplete works so fascinating to the beholder?

The first question seemed, at least in principle, easy to answer. Michelangelo could not complete the *St. Matthew* because of his many other commitments, his call to Rome, and so on. For some of his other great projects (the Tomb of Pope Julius II, and the Tombs of the Medici) there were external reasons that were known. In still other cases there may well have been material reasons: the reason why Michelangelo abandoned the *Pieta* now in Duomo in Florence (this was the sculpture the artist intended for his own tomb) before it was completed appears to have been a flaw in the marble slab from which he carved it. The professional art historians, conscientious scholars that they were, carefully recorded these reasons and analyzed their

possible impact on his works. And yet the nagging question remained: why was it that the conditions of incompletion, so diverse in themselves, confronted the same artist with such unusual intensity? Whatever the reason for the incompletion of each individual work, was the existence of so many different incomplete works by a single genius not a reflection of that artist's character?

I shall here briefly adduce one or two examples of what some of the more profound and more imaginative scholars around 1900 said about Michelangelo's noncompleted statues. Thus Karl Borinski, an inspired student of the classical tradition, said that it was Michelangelo himself who used the Neoplatonic image (known to the Middle Ages and the Renaissance) of carving a statue as a process of liberating a figure encapsulated (and held captive) in a slab of stone.[11] Scholars imagined this "process of liberation" as the struggle of a live and distinct idea against inert and shapeless matter. Carl Justi, a scholarly and imaginative art historian, described the movement of Michelangelo's *St. Matthew* as the heavy effort a miner makes when moving with difficulty in a narrow tunnel.[12]

These scholars, usually well read in the classics, also reminded their readers that already Plotinus had interpreted the sculptural process moralistically as a means of self-liberation and self-purification (*Ennead.* 1,6,9). Scholars such as Ludwig von Scheffler and Henry Thode especially did not fail to stress that Neoplatonic philosophy played an important part in Renaissance thought, and, in fact, formed Michelangelo's intellectual world.[13]

The spiritual world of Neoplatonism also suggested that, in the struggle against matter, the idea can never attain complete victory if the form is to be cast in stone or in any other tangible material. Seen in such a context, the incomplete may acquire a new significance. The artist who in the course of shaping a work of art becomes aware of his limitations, who sees that he will not be able to embody the idea in his mind in the hard matter with which he shapes his statue, abandons his work, leaves it incomplete. These considerations suggest that the fragmentary state of so many of Michelangelo's works was not due to external or material reasons alone. It was indeed a reflection of the artist's personality, and of the basic problem of art, as Michelangelo saw it.

The other kind of question is less historical. What is it that makes Michelangelo's incomplete statues, sometimes really resembling fragments, such powerful images? The scholars who studied these unfinished works of Michelangelo often pointed out that in the Renaissance—a period, that is, when a fragment was produced by intention—the beauty of

these incomplete statues was recognized. Thus Vasari said about the Madonna in the Medici Chapel, "Although unfinished, the perfection of the work is apparent."[14] And Ascanio Condivi, Michelangelo's contemporary who recorded the master's thoughts, wrote that the incomplete condition of an artistic image "does not prevent the perfection and beauty of the work."[15]

European students at the turn of the century were very receptive to such suggestions. Whether or not they explicitly said so, they suggested that the unfinished, the incomplete, and the fragmentary have a perfection of their own. Professional art historians did not formulate an aesthetic theory of the autonomous fragment. There can be little doubt, however, that underlying their careful historical and stylistic studies was the assumption, perhaps sometimes unknown to themselves and blurred in outline yet distinct in direction, that the fragment was an art form in itself, with its own specific needs and norms.

Still another issue that attracted attention in the late nineteenth century, one that had a profound impact on how our cities look, brought the subject of the fragment into relief. It was the question of whether monuments of the past, partly damaged in the course of time, should be restored to the point of original completion, or whether the signs of time should be left for the spectator to see. Needless to say, this problem is still very much with us, and it agitates people's minds in the present day. In the nineteenth century, with large-scale restoration of monuments (that sometimes almost amounted to rebuilding), this question became urgent and revealed its wide-ranging dimensions (a subject that deserves separate treatment of its own, but that is far beyond the scope of this volume). One of the aspects of this issue, implied rather than explicitly stated, was the question of whether the fragment has, or has not, a value and right of existence of its own.

As a rule, artists did not take an active part in this debate, though some isolated remarks they made may further illustrate their attitude to the fragment. The question of whether one should restore Gothic cathedrals to what one believed was their original shape and condition was, of course, particularly topical in France. Auguste Rodin, the most important sculptor in this period, was naturally concerned with the sculptures in Gothic cathedrals. Rodin's witty remark against extensive restoration is revealing, and is worth quoting at the conclusion of this discussion: "More beautiful than a beautiful thing is the ruin of a beautiful thing." The fragment or ruin, then, obviously had a beauty, an aesthetic value, of its own.

Acknowledging the inherent value of the fragment, and hence its aesthetic and expressive possibilities, was one of the achievements of impressionism as an intellectual and artistic movement.

NOTES

1. H. W. Janson, in his unpublished Mellon Lectures delivered at the National Gallery in Washington, 1979.

2. H. W. Janson, *Nineteenth-Century Sculpture* (New York, 1985), pp. 131–32,

3. Friedrich Schiller, *On the Aesthetic Education of Man*, translated by Elizabeth M. Wilkinson and L. A. Willoughby (Oxford, 1986), p. 33. About Romantic thought on fragments, mainly in English literature, I learned from Thomas McFarland, *Wordsworth, Coleridge, and the Modalities of Fragmentation* (Princeton, 1981). For a Marxist interpretation of Schiller's views, see Georg Lukacs, *Goethe und seine Zeit* (Bern, 1947), pp. 78–109.

4. Quoted from McFarland, *Wordsworth, Coleridge, and the Modalities of Fragmentation*, p. 12.

5. See McFarland, *Wordsworth, Coleridge, and the Modalities of Fragmentation*, p. 15.

6. I quote the English translation. See Paul Valéry, *Aesthetics*, translated by Ralph Manheim in *The Collected Works of Paul Valéry*, vol. 13 (New York, 1964), p. 137. This point, he said, was "very close to my heart."

7. See Samuel Monk, "A Grace beyond the Reach of Art," *Journal of the History of Ideas* V (1944), pp. 144 ff.

8. See Paul Valéry, *Pièces sur l'art* (Paris, 1934), p. 205 ff. See also Maurice Bemol, "L'Inachevé et l'achevé dans l'esthétique de Paul Valéry," *Das Unvollednete als künstlerische Form*, edited by J. A. Schmoll gen. Eisenwerth (Bern and Munich, 1959), pp. 155–60.

9. Paul Valéry, *Leonardo Poe Mallarmé*, translated by Malcolm Cowley and James R. Lawler in *The Collected Works of Paul Valéry*, vol. 8 (New York, 1972), p. 249.

10. Valéry, *Leonardo Poe Mallarmé*, p. 285.

11. Karl Borinski, *Die Rätsel Michelangelos: Michelangelo und Dante* (Munich, 1908), pp. 93 ff.

12. Carl Justi, *Michelangelo: Neue Beiträge* (Berlin, 1909), p. 204.

13. Ludwig von Scheffler, *Michelangelo: Eine Renaissancestudie* (Altenburg, 1892); Henry Thode, *Michelangelo*, II (Berlin, 1902), pp. 191 ff. See also Karl Borinski, *Die Antike in Poetik und Kunsttheorie*, I (Leipzig, 1914), pp. 169–70. In the scholarly literature on Michelangelo, particularly around 1900, the Neoplatonic impact is frequently discussed. For an important later discussion, also critically reviews the literature mentioned here, see Erwin Panofsky, *Studies in Iconology: Humanistic Themes in the Art of the Renaissance* (New York, 1939), pp. 171 ff.

14. I quote from the English translation by A. B. Hinds. See Giogio Vasari, *The Lives of the Painters, Sculptors and Architects*, III (New York, 1980), p. 134.

15. Ascanio Condivi, *The Life of Michelangelo*, translated by A. S. Wohl (Baton Rouge, Louisiana), p. 67; see also pp. 28, 30.

Empathy

7

Introduction

An Empathy Tradition
in the Theory of Art

In these crucial four decades from the end of the nineteenth century to the beginning of the twentieth, a further trend emerged in the theoretical reflection on art that became increasingly dominant in early-twentieth-century thought. Strange as it may seem, this trend is difficult to define precisely in a single word or short phrase; no simple label fits it exactly, it does not go under any "ism." The cluster of ideas and conceptual endeavors of which it is constituted is far more diverse than those making up other contemporary trends in art criticism. These difficulties of labeling are confusing. One surely cannot speak of a "doctrine" here. One cannot even envisage the pertinent statements as parts of a common tradition. It is often not clear whether the same trend of thought is being referred to in the different attempts to understand the emotional life and art that are to be considered here.

Yet no serious student following the stages of the movement we shall present, would doubt its intrinsic unity and coherence. What the different attempts, seemingly worlds apart, have in common is, first of all, a dominant theme, and even some specific ramifications following from the overall subject. Closer investigation may further reveal some common attitudes. In the following discussion we shall call this theme "empathy," and will speak of an empathy tradition in the theory of art. The term "empathy" should not be understood as an indication of a tightly closed conceptual framework defining the theme of our discussion. Rather, it should be understood as the designation of the main core, of the mere center, of these variegated attempts to solve the riddle of art.

The history of what we here call the empathy trend is complex and intricate. Before we begin our story, it may therefore be useful to indicate

briefly what is currently meant by empathy. It has two main meanings—closely related to each other, yet not fully identical—that are significant in our context. It means, first, the projection of one's own personality onto the personality of another in order to understand him or her better; the intellectual and emotional identification of oneself with another. One's own personality may also be projected onto an inanimate object, and one's emotions, feelings, and responses may thus be attributed to such an object. Second, and this is of particular importance in the experience and study of art, empathy may describe the artist's attitude to what he represents, and particularly the attitude of the spectator, who revives in his or her own mind the emotions conveyed by the artist's representation.

The latter element of our brief description, the spectator's intuitive grasp of the mood expressed in the work of art he is looking at, must have been taken for granted in most periods of history. Ever since there was a theory of art, it seemed self-evident (whether or not explicitly stated) that the spectator relives, and thus understands, what is represented in the work of art. In the very first text that can be considered a "theory of art," Leone Battista Alberti's book *On Painting*, written in 1435, this view is clearly stated. "The *istoria* will move the soul of the beholder when each man painted there clearly shows the movement of his own soul. It happens in nature that nothing more than herself is found capable of things like herself; we weep with the weeping, laugh with the laughing, grieve with the grieving."[1]

Leonardo da Vinci expressed a similar attitude. To illustrate the power of the image, for example, he wrote: "A painter once made a picture which made everybody who saw it yawn and yawn repeatedly as long as they kept their eyes on this picture, which represented a man who was also yawning."[2] The power of the image is manifested in its ability to elicit the empathy of the beholder. This conceptual tradition continued vigorously continued into the following centuries.

Without delving into the complex story of empathy any further (that would require a volume of its own), we can say that, though the tradition of various empathy concepts that emerged between the fifteenth to the eighteenth and nineteenth centuries was not forgotten, in the second half of the nineteenth and the early years of the twentieth centuries there arose a radically new approach to empathy. Both the scope of empathy and the ways in which the concept were used were new. In turning to these modern developments we shall first take a brief look at what the sciences

taught about this subject, and then concentrate on what was said about art.

NOTES

1. Alberti, *On Painting*, p. 77.
2. da Vinci, *Treatise on Painting*, # 22.

8

Gustav Fechner

To indicate the particular moment at which the movement we shall attempt to trace in this part first appeared, and also to suggest something of the intellectual situation that formed its original background, it seems appropriate to begin with a discussion of Fechner. Fechner was a student and thinker of unusual richness of interest and complexity of thought; his work shows an exceptional versatility. It should therefore be stressed at the outset that we do not intend to draw a portrait of Fechner the scholar, but only to emphasize some assumptions that, if only indirectly, had a formative influence on the orientation of the empathy trend in art theory, and to a large extent indicated the problems that remained at its center.

Gustav Theodor Fechner (1843–87) was primarily a student of chemistry and physiology; he is remembered as the founder of what is called psychophysics, and promoter of the measurement of the phenomena under study. After a nervous breakdown, he turned to the study of philosophy, with particular emphasis on metaphysics (including what he had learned of Indian thought), and even some theology. To all these he tried to apply the experimental methods of the natural sciences, the study of which he pursued throughout his life.[1]

Fechner is also known as the founder of experimental aesthetics. It was mainly in the later stage of his life that he included aesthetics in the wide range of his studies. His major work in this field, *Vorschule der Aesthetik* (1876),[2] was one of his last. But as Rudolf Arnheim has rightly noted, Fechner's concern for aesthetics derived directly from the core of his basic conceptions.[3] The *Vorschule* shows how Fechner's studies in various disciplines merged, but it also indicates how greatly the reflection on beauty and art was, at least in one intellectual current, permeated by scientific thought. Though a collection of essays rather than a systematically planned treatise, it gives a distinct idea of Fechner's approach to the visual arts. This approach, incidentally, had already been briefly outlined by him in an article ("On Experimental Aesthetics") published in 1871.[4]

In his explicit discussion of aesthetics, it has convincingly been shown that Fechner was more hesitant about speaking out with regard to his general ideas than he was in his other works.[5] Why in the *Vorschule* he should have failed to spell out his guiding principles is a matter of conjecture; the very fact that he dealt with beauty (no matter how one interprets this concept) as the subject matter of aesthetics has been taken as an indication of his compromise with accepted views, hallowed by a venerable tradition. But it has also been maintained that his whole work has an important aesthetic dimension or bearing on the matter of aesthetics.

Fechner began the *Vorschule* with a revealing juxtaposition: aesthetics, he said, can be studied "from above" and "from below." In this short opening essay (I, pp. 1–7) he provided both an indication of his own doctrine, and a polemical clarification of his position versus the philosophical tradition of reflection on the arts. Aesthetics "from above" begins with the "ideas and concepts of beauty, art, and style, and their position within the system of the most general concepts, especially their relation to the true and the good." The difficulty with this approach is that it does not give us a clear orientation, and it does not explain why we find things the way they are. He called this approach "philosophical," making it clear that he had the philosophy of German idealism in mind, that is, the philosophies of Schelling and Hegel (I, pp. 2, 6).

Aesthetics "from below" is not philosophical; it is, as he said, "empirical" (I, p. 2). The true themes of empirical aesthetics are not the ideas of beauty and art, but our actual experiences and their careful analysis. It is not our thought but our experience that matters. Aesthetics "from below," it should be kept in mind, is not only a change of direction (whatever this may mean precisely); it is in an important sense a change of subject matter; it simply deals with something other than aesthetics "from above." Empirical aesthetics is concerned with experiences and perceptions, not with ideas. If Hegelian reflection on the arts was ultimately a contemplation of ideas, Fechner's reflections became a kind of applied psychology.

By turning from an analysis of pure ideas to the observation and investigation of aesthetic experiences as they take place in the real world, Fechner hoped to achieve his main aim, namely, to make aesthetics an experimental science. Setting himself this goal implied tacitly accepting several assumptions. To some of these assumptions I shall shortly return. I shall begin, however, with what Fechner openly declared as his purpose in his discussion of aesthetics.

Fechner believed that experimental aesthetics, based on careful observation and the comparison of many actual aesthetic experiences, makes possible the discovery and formulation of "aesthetic laws." To formulate such laws should be the major aim of aesthetics. "The essential task of a general aesthetics are . . . the classification of the concepts and the stipulation of the laws . . . and their most important application in the theory of art" (I, p. 5).

Now, Fechner was well aware of the complexities of the subject; hence he knew that finding general, compelling rules, or "laws," is a particularly difficult and intricate matter in the field of aesthetics and the arts. You cannot discover laws in aesthetics as you can—or so some people believe—in, say, physics. If there is here a general law, Fechner said, a law that determines the spectator's individual aesthetic reactions and experiences, "it is for us still covered by darkness" (I, p. 42). Nor did he believe, it seems almost unnecessary to say, that such a law, were we ever able to discover it, would make it possible to "program" an artist (to use a modern term) to create aesthetically satisfactory works of art. But awareness of all these shortcomings of human nature did not excuse the student from the task of searching for aesthetic laws.

Aesthetics and the study of art, Fechner believed, seek to discover the laws of beauty. But what is termed "laws of beauty" is an intricate, deceptive matter. The concept does not simply describe a common emotional response to a given form, or complex of forms, it attempts to be more than the observation of a rule of human behavior. Fechner supposed (without saying so explicitly) that a law of beauty also has some kind of metaphysical nature and status. A law of beauty, embodied in a visually perceived object or form, demands an experience on two levels, as it were; we should add that it has a certain degree of ambiguity.

Aesthetic reflection in Antiquity was acquainted with the problem. We know of several Greek and Roman artists, architects, and philosophers who distinguished between beauty in itself and its pleasing appearance.[6] The latter is well known under the Greek term *eurhythmia*. Already in the fourth century B.C. Philo Mechanicus said that those shapes are eurhythmic which "are suited to the vision and have the appearance of being well shaped." And we recall the distinction made by Vitruvius, the first-century architect, between *symmetria* and *eurhythmia*, the latter being "a pleasing appearance and a suitable aspect."[7] In other words, ancient thinkers had a special category for the pleasing quality of forms as they appear in our subjective experience. Fechner did not quote the ancient sources, but he clearly adopted and further developed, their conceptual framework. He spoke of *Wohlge-*

fälligkeit, which may be translated as "pleasant" or "agreeable," though it may carry a stronger connotation than the English.

Given Fechner's frame of mind it seems natural that he would try to find some specific laws of beauty. To be sure, he did not even suggest that these laws could be models offered for imitation, but such ideas had been suggested in vague and confused form by others. By searching for such laws, Fechner placed himself within a venerable tradition, partly philosophical and partly workshop-oriented; it was a tradition that had many intrinsic affinities with the practical theory of art. Fechner was well aware of this ancestry. He himself referred to the solutions offered by Winckelmann, Hogarth, and others (I, pp. 184 ff.). But before we look at what he said about these writers and artists, it is worth noting that essentially he conceived of beauty—the beauty perceived by the eye and represented in the visual arts—as a kind of relationship, a system of proportions reducible to mathematical terms. At least in this respect, he was within the great conceptual tradition that goes back to Plato. Perfect beauty for him was a relationship between different magnitudes, expressible in numerical terms.

Now, Fechner knew that in the course of history several concrete models had been suggested as embodiments of beauty (I, p. 183). These were models of "direct pleasantness" (*directe Wohlgefälligkeit*). He was particularly attracted by the Golden Section. In the second half of the nineteenth century it was believed that in the thought and calculations of ancient Greek artists a specific model of proportions was considered the full embodiment of perfect beauty. In this model the smaller part of an object, like its larger parts, related to the whole object; numerically, it was believed, this could be expressed by the formula 3 is to 5 as 5 is to 8. Here we do not have to investigate how consistent the Golden Section actually was, or whether it was, in fact, articulated in ancient Greek thought. In both respects we cannot overcome some serious doubts. In our present context we need simply to remember that belief in the Golden Section was rather common in the nineteenth century and that this belief also influenced Fechner's thinking.

Many of Fechner's ideas—such as the search for laws in aesthetics, and even the preference for specific models—were, of course, "in the air" at the time. It is important to recognize these ideas in order to better understand the new attitude to art and the analysis of works of art that was emerging in the second half of the nineteenth century. What was decisive in Fechner's system, however, was the role he assigned to experiment. For him the experiment was the final foundation of all matters of art. Only by experiment—so Fechner and many of his readers believed—could you show pos-

itively that there are laws of beauty and of *Wohlgefälligkeit*, and could you even discriminate between them and other models. Moreover, it was by using experiment that aesthetics became a "science," and that its findings were endowed with that high degree of certainty one is accustomed to associating with the findings of science.

An interesting illustration of the application of an experimental—perhaps we should say of the statistical—method to matters of art is found in Fechner's discussion of the proper formats of paintings. The very fact that the formats of paintings were the subject of investigation (II, pp. 179–92) will immediately arouse the modern student's attention; Fechner here clearly anticipated a trend of thought that came into its own only a century later. He also tried to establish the proper proportions for different types of paintings. To this end he measured thousands of paintings in the various museums of Europe, presented his findings in graphic plans, and suggested mathematical formulae for their consideration (II, pp. 273–313).

So far I have tried to lay out, as briefly as possible, Fechner's ideas about the problems we are concerned with in the present essay. Before we continue with this presentation, we should ask ourselves about the implicit assumptions of his doctrine of an experimental aesthetics. It may well be that Fechner himself was not always aware of his assumptions. With the advantage of hindsight, however, we may be able to distinguish what the author himself perhaps could not see. To do this is of particular importance, since here we can observe, in an early stage, the assumptions underlying a "scientific" reflection on matters of art. Let me say in advance that in the following comments I do not intend to criticize Fechner, but only to point out certain basic characteristics of his system.

There is one assumption, or an implicit thesis, in particular that bears on our subject. This is the belief that every work of art, or object, shape, or view in general, is open, is in fact equally available, to aesthetic experience. The laws of aesthetics—like the laws of nature—are really universal, that is, they apply in principle to every object and to every spectator. Fechner did not mention, and one feels certain he did not conceive, that for reasons of, say, differences of culture, some art objects, though physically present before us, might not be fully "available" to our aesthetic experience. To take an example topical in Fechner's time: how do we explain the fact that many European spectators, for reasons of cultural diversity, had difficulty in experiencing the beauty of, say, Japanese prints?

To deal with such problems which are central for any kind of applied aesthetics, Fechner employed the category of "taste" (*Geschmack*). The con-

cept of taste, he said, like the other notions employed in aesthetics, cannot be firmly circumscribed; but after all the deviations and questionable cases are allowed for, "there remains, as a rule, a common core" (I, p. 232). What, then, is this core?

"Taste," as Fechner defined it, "is a subjective supplement to the objective conditions of pleasing and displeasing" (I, p. 238). Now, it is true that you cannot debate taste,[8] but neither can you doubt the very existence of different tastes, nor question the impact this variety has on our lives. Among the many examples Fechner adduced to illustrate this point there is a lengthy quotation from a speech by William Hogarth in which the English painter sang the praise of the wig that was so popular in the early eighteenth century. Now imagine, continued Fechner, a man wearing a wig, and the dress that in Hogarth's time went with it, suddenly appearing in classical Athens or on the marketplace in ancient Rome. We can imagine the reaction—from consternation to outright laughter. The difference of dress is a difference in taste, and we cannot but conclude that the difference in taste, and its impact on our lives, are very real.

Fechner also accepted, as a given reality, that in the visual arts one can discern a history. He talked of how the "antique taste" was lost in the Middle Ages, to be renewed in the Renaissance. (Here he was following the myth dominating Renaissance historiography, mainly in Vasari.) Later, he said, echoing Winckelmann, Bernini was more highly regarded than the ancients, and at an even later stage "Canova's softness and pretentiousness" were also considered superior to classical Greek art. The *Apollo* that Winckelmann saw as a divine figure must now accept a "second rate position" (I, p. 239).

But while Fechner accepted the plurality of tastes and the history of preferring one taste over another, he did not see all this as an ultimate reality. Had he done so, it would have meant that he was embracing a relativism or subjectivism which by necessity would have undermined the "scientific" approach to art as he and his time understood it. It was therefore inevitable that he should have asked not only how various tastes emerged and were possible, but mainly, what the "principles of the good and correct taste" were (I, pp. 256 ff.).

So far I have tried to present Fechner's aesthetic doctrine to show what, in the view of nineteenth-century students, advanced science, physical experiments, and statistical methods could do to explain the secret of art. But this presentation gives only half the story. The other half is filled with mysticism. The same student who measured thousands of paintings in many

museums in order to determine the perfect proportions for various kinds of paintings was also a mystic visionary. Moreover, he implanted his mysticism within his scientific experiments.

At the core of Fechner's mysticism was his belief in a close parallelism between body and mind, or of matter and soul. Arnheim believes that this parallelism was "directly derived" from Spinoza.[9] Though I am not sure that the derivation is as direct as Arnheim assumes, there is little doubt that seventeenth-century thought on the body-mind problem played a large part in the formulation of Fechner's doctrines. It is important to note that Fechner did not conceive of the duality or parallelism of matter and soul in terms of strife and unceasing struggle. That oriental religions had such a conception of dualism, understood as a cosmic drama and often leading to world catastrophes, was known in Greek philosophy and in Patristic polemics against dualistic faiths. In Fechner's thought, however, the parallelism was a companionship, a harmony.

That parallelism overcomes the hiatus, which the sciences accepted, between "reality" as it is, and our perception of that reality. It is a "night view," Fechner said, to claim that what we know as light and color are, in themselves and beyond our perception, nothing but some movement of particles (or however else you explain it), and that our sensory apparatus alone transforms these movements into the sensation, or appearance, of light and color. In an interesting though strange book, *Die Tagesansicht gegenüber der Nachtansicht* (The Day-View versus the Night-View), Fechner made an eloquent case for belief in the real, independent existence of the sensory agents, especially of light and color.

Fechner found manifestations of the overall, omnipresent animation of the world in many aspects of the world surrounding us. Of particular interest is what he said about plants. Here he offered perhaps his most eloquent, almost poetic, description of how the soul-life moves bodies. One of his early works, *Nanna oder über das Seelenleben der Pflanzen* (Nanna or on the Soul-Life of Plants), which appeared in 1848, is devoted to this subject. It appealed to a wide public and went through many editions. Noting that plants "follow the sun" and move their position so as to get the most of it, he interpreted their movement as sensation, and even as a kind of psychic life.

Fechner looked for earlier expressions of his panpsychism, especially with regard to plants. He quoted Schelling to the effect that, "had the plant consciousness, it would adore light as its god." But he went on to say that even if the plant did not have a developed consciousness, one that resem-

bled ours, "in the ray of the sun it could still gain a feeling that it is elevated above its former sphere as we are by receiving the divine in our soul."[10] Earlier in *Nanna*, Fechner wrote:

> One hot summer day, I stood next to a pond and contemplated a water-lily that spread her leaves flatly over the water, and, with open blossom, exposed herself to the light. How very happy this flower would be, I thought, bathed from above in sun, and diving below into the water, could it only sense something of the sun and the water. And why, so I asked myself, should it not [be able to experience these sensations]? (chapter 3)

Fechner's fantastic physiology, to quote Arnheim once again, was not likely to find favor with representatives of the exact sciences. Yet one is not surprised to learn that it had a great appeal for students of the artistic imagination. Here we are not concerned with Fechner as a scientist, or with his position as the founder of modern panpsychism as a scientific-philosophical school of thought. What we have tried to do is to see what made him so important in the reflection on art.

Summarizing the comments I have made, in several respects Fechner's doctrines indicate a watershed in the development of art theory, and mark the emergence of a modern conceptual attitude in this field. His "experimental aesthetics," the attempt to discover "laws of art" that can be discovered and empirically verified, mark the final divorce of modern aesthetic thought from the great philosophical systems in which art was assigned a specific, yet limited, role. Hegel and his followers are the best example of this system of thought in aesthetics.[11] "Aesthetics from below" was meant to be a final farewell to this great tradition of speculative thought.

The empirical, experimental approach also implicitly implied an abandonment of belief in the significance of history in both the creation and the experience of art. The first two generations of the nineteenth century were firm in their conviction of the importance of history and accumulated culture. By preaching an experimental attitude, and by drawing conclusions from one's own experience of works of art, it was implied that art (in principle, all art, the art of all times, countries, and cultures) was "available" to everybody's immediate experience. The historical and cultural identity of a work of art, whether it belonged, say, to the Middle Ages, or was created in Japan, was not a barrier making direct access impossible; what was artistically essential in a painting or a sculpture was accessible to direct experience.

Even more than the other characteristics of his thought, Fechner's panpsychism pointed to the future. By assuming that everything around us

is animated, that matter always also has mind, and thus in principle experiences emotions, Fechner laid the ground for what came to be known as "empathy." Empathy became the conceptual slogan of an important school of art interpretation, and became the ancestor to a major trend in twentieth-century art.

NOTES

1. For a brief but useful survey of Fechner's doctrine, mainly of his psychophysics, see Edwin G. Boring, *Sensation and Perception in the History of Experimental Psychology* (New York and London, 1942), pp. 34–45.

2. Gustav Theodor Fechner, *Vorschule der Aesthetik* (Leipzig, 1876). The work appeared in two volumes. Throughout this discussion I shall refer to the *Vorschule* in the text, giving volume and page number in parentheses.

3. See Arnheim's article, "The Other Gustav Theodor Fechner," reprinted in Rudolf Arnheim, *New Essays on the Psychology of Art* (Berkeley, Los Angeles, and London, 1986), pp. 39 ff., esp. p. 40.

4. See Gustav Theodor Fechner, "Zur experimentellen Aesthetik," *Abhandlungen der Sächsischen Gesellschaft der Wissenschaften*, Mathematisch-physikalische Klasse (Leipzig, 1871), pp. 556 ff. It is remarkable that this study of the principles of aesthetics appeared in the scientific division, rather than in the "philosophical."

5. On this particular point, see also, in addition to Arnheim, Wilhelm Wundt's interesting lecture, *Gustav Theodor Fechner* (Leipzig, 1901), especially pp. 74 ff.

6. See the sources collected and translated under the term *eurhythmia*, in J. J. Pollitt, *The Ancient View of Greek Art: Criticism, History, and Terminology* (New Haven and London, 1974), pp. 169–81.

7. For Vitruvius, see Barasch, *Theories of Art*, p. 40.

8. In parentheses Fechner (I, p. 244) explained what this phrase actually means: when we say that tastes cannot be debated we mean that the debate cannot be (rationally) decided.

9. Arnheim, *New Essays on the Psychology of Art*, p. 41.

10. Gustav Theodor Fechner, *Nanna oder über das Seelenleben der Pflanzen*, 5th ed. (Leipzig, 1921), p. 53. Fechner did not give the precise reference, but he probably had in mind *Nanna*, pp. 38 ff. With these sentences Fechner opened the fourth chapter of his book.

11. See Barasch, *Modern Theories of Art, 1*, pp. 171 ff., esp pp 178 ff.

9

Charles Darwin
The Science of Expression

In the last third of the nineteenth century an old interest and concern attained a significance rarely matched in its age-long history; these decades saw attempts to transform the study of what we call "expression" into a science, and thus to place it on solid rational foundations. To a large extent these attempts facilitated the success of Fechner's psychophysics, particularly in the aesthetic domain, and enabled the concept of empathy to become a central issue in the theory and explanation of art.

How we express our emotions and how we grasp and understand the emotions that our fellowmen express—these problems have occupied man's mind since the dawn of history, and written records of this fascination with expression, and attempts to explain it, persist at least since the days of Aristotle.[1] In reflection on art it comes up time and again.[2] For our present purpose it may be useful to briefly indicate some of the scientific treatments of the problem earlier in the nineteenth century.

In 1872 Charles Darwin published *The Expression of the Emotions in Man and Animals*,[3] only one year after the appearance of *The Descent of Man*. Darwin wrote his work on the *Expression of Emotions* in a very short time (less than a year), but the studies it is based on go back to much earlier periods in his life. What he had to say on expression was not accepted without debate and criticism, but it marked a stage in the development of ideas about the subject. The student of the theory of art cannot disregard at least some aspects of Darwin's thought on this problem, a central one for almost any artist.

For our purposes Darwin's work is of particular significance because of the classifications of expression he suggested, and because of distinctions he made in this field of experience and study. Two issues concern us here. One is the question: which aspects (or parts) of human expression did Darwin include in his study, and which did he disregard? The other is: what in his view can art contribute to the study of the whole subject? Though these

issues cannot be said to belong directly to the problem of empathy, they may help us to outline the notion more clearly, and will also highlight the ideas underlying its emergence.

"Many works have been written on Expression, but a greater number on Physiognomy," so reads the opening sentence of *The Expression of the Emotions in Man and Animals* (p. 1). On the very first page of his work Darwin emphasized that he would be concerned with the expression of emotions, not with physiognomy. In making this clear distinction he announced, as it were, that his study formed part of a great tradition, and that he assumed a modern position in this history.

The doctrine that we express our "souls" in the movements, and other features and appearances, of our bodies is among the oldest beliefs of mankind; in articulate form it goes back to Greece, and to even earlier stages of human culture. Without attempting to trace the history of this fascinating subject,[4] we can say that, in a general way, this doctrine often did not distinguish with sufficient clarity between the permanent components of what was called our "soul" and the temporary feelings that hold us in their grip for a moment or an hour. For want of better terms we can use the traditional nomenclature, and speak of "character" and "emotions." Of course, the theories of expression throughout the ages treated both components, but in the earlier stages of history the main emphasis was placed on the expression of the permanent structural features of our personality, that is, on character. Physiognomics, once considered a serious science, dealt exclusively with these permanent features. To be sure, the emotions were by no means disregarded. Seneca wrote a whole treatise *On Anger*. And yet it was character, and what was later called "temperament"—also describing the permanent, stable "nature" of one's soul—that held pride of place in this science before the modern age.

In modern times, that is, since the Renaissance, the emphasis seems to have shifted in favor of the temporary, the emotions.[5] Already in the sixteenth century a whole book could be written *On Laughing*,[6] and in later developments of psychology the temporary emotion was emphasized even more. Suffice it to mention the famous *Traité des passions* by Descartes, published in Amsterdam in 1649, a work of great influence on modern thought. In 1672, to give another example of historical importance, Charles Le Brun, head of the newly founded French Academy of Art, published a model book, consisting mainly of drawings, which he called *Méthode pour apprendre à dessiner les passions* (a work that incidentally earned Darwin's somewhat reserved praise [p. 1]). Le Brun's examples were copied and im-

itated for more than two centuries. All this is not to say that the interest in permanent features disappeared, only to indicate the stronger interest in emotions that seems characteristic of modern times.

By emphasizing the distinction between character and emotion, and by concentrating exclusively on the latter, Darwin clearly proclaimed his "modern" leanings on this subject. This tendency also became the central concern in aesthetic reflection. The influence of Darwin's theory on the theory of art, even if not direct and immediate, should not be disregarded. In the following brief comments we will concentrate on some points that for Darwin himself were marginal at best. For the understanding of late-nineteenth-century theories of art, and of the climate in which they developed, however, these points are important.

My first comment concerns the question of whether certain expressive features are really universal. Are the essential expressive formulae universal, and can everybody instinctively and immediately grasp them? This was a question that occupied the minds of artists and critics especially in the nineteenth century. Artists in their reflections and critics in their doctrines or comments have often not kept the story and the way it is expressed sufficiently apart, or, to use more professional terms, the iconography and the formal patterns of expression. Everybody understood the raised hands and bent head of the Virgin holding the dead Christ on her lap as gestures of sadness and lamentation. But would a spectator who knew nothing of the Gospel story also understand the Virgin's gestures in the same way? The question was asked with increasing frequency. In a culture such as that of Europe in the late nineteenth century, into which very different arts—such as Far Eastern and later also primitive—had penetrated, the question necessarily acquired urgency, and demanded an answer. If the spectator who does not know the Gospel story will not understand the meaning of the Virgin's gestures, one must conclude that such expressions are part of only one specific culture, that they are learned or "conventional," to use the term now preferred, and that they lack true universality.

In light of these questions and considerations Darwin's view acquired special significance for the theory of art. Darwin emphasized what in colloquial parlance we call "human nature," that is, in our case the universal and unchanging structure and direction of our emotional reactions to what we perceive. To be sure, Darwin did not use the term in the sense an artist would employ it. But what a student of art would derive from reading *The Expression of the Emotions in Man and Animals* is that every human being, whatever his race and the specific conditions of his life and experience, will

make the same expressive gestures, and hence will understand them when he sees them performed. If that is true, at least the core of expressive human behavior and understanding is universal. "Whenever the same movements of the features or body express the same emotions in several distinct races of man, we may infer with much probability, that such expressions are true ones,—that is, are innate or instinctive" (p. 15).

It is well known, of course, that Darwin did not assume that human nature was miraculously created. On the contrary, it was the result of an unimaginably long development. "It seemed probable," he said in the introduction, "that the habit of expressing our feelings by certain movements, though now rendered innate, had been in some manner gradually acquired" (p. 19). Now, however, these movements were "innate," and their validity was universal—this was the truth many artists and art theorists were looking for.

We now come to our next question. What was Darwin's attitude to art, what did he look for, and what did he find when he was contemplating a painting or a statue? Reading his work on the expression of the emotions one cannot help feeling that his attitude was ambiguous. In the context of his study on expression, he approached art as a domain of "sources," as a field that would provide him with careful and precisely recorded observations of nature. He was disappointed. In the introduction to *The Expression of the Emotions in Man and Animals* he briefly described and evaluated his various sources of information, such as the behavior of infants, of the insane, experiments with galvanized muscles, and so on. In works of the visual arts he hoped to find important materials for his study, and thus originally made it a field of sources. This was not to be.

> Fourthly, I had hoped to derive much aid from the great masters of painting and sculpture, who are such close observers. Accordingly, I have looked at photographs and engravings of many well known works; but, with a few exceptions, have not thus profited. The reason no doubt is that in the works of art, beauty is the chief object; and strongly contracted facial muscles destroy beauty. The story of the composition is generally told with wonderful force and truth by skillfully given accessories.[7]

This passage is an interesting testimony to the modern attitude to art, and it is well worth careful scrutiny. It was part of Darwin's upbringing, and of the intellectual inheritance still alive in the middle of the nineteenth century immediately preceding our "four crucial decades," to assume as a matter of course that artists were "close observers" of nature and that their

works carefully recorded their subtle observations. This was an old belief, and what we find here is, in fact, still the Renaissance figure of the artist embodied in the exemplary legend of Leonardo da Vinci; this artist is the faithful mirror of the world. In Renaissance fashion, the work of art was considered a scientifically correct, "true" statement about the world.

Darwin knew that this image of art and the artist was not true. For his scientific purpose he had "not profited" from looking at paintings and statues, as he said. It is remarkable that in his whole book on the *Expression of Emotions*, in the hundreds of examples he described and analyzed, not a single example was taken from a museum of art, and/or was based on a work of art. He had a chapter on Suffering and Weeping (chapter VI, pp. 146–75), but he did not as much as mention the *Laocoön*. I do not think this can be explained only by the claim that art is not precise; Darwin's observation of crying infants was not much more precise than the famous sculpture. It should also be mentioned that Darwin frequently used imprecise sources, which he then critically evaluated. His systematic exclusion of works of art had a different reason.

Darwin's statement, however, contained not only the expression of his disappointment that the high expectations in works of art as sources of information for the natural scientist had not materialized; he also told his readers what he believed were the reasons for the "failure" of art. What emerges from the short passage quoted above is that the function of art is not the close mirroring of the reality that surrounds us, the faithful representation of nature, as the old saying went. Darwin, like many of his contemporaries, still had the Renaissance view of the artist's task in mind, or what many nineteenth-century intellectuals thought was the Renaissance view. But, said Darwin, the true task of the artist is not to be a mirror of the world, but rather to reveal beauty, to embody and manifest it in his work. To faithfully portray the world would indeed make the artist a figure closely related to the scientist. But art is informed by another specific value and task—beauty. Whatever Darwin understood by "beauty," and whatever we may think is the artist's true mission, it is obvious that the great nineteenth-century scientist assigned to art a value of its own.

Moreover, Darwin foresaw a direct conflict between scientific truth and the specific value of art, which he called "beauty." The scientist finds that, under the impact of certain emotions, both human beings and animals forcefully contract their facial muscles, and, as a scientist, he faithfully records these contractions. The artist, on the other hand, being true to the unique value of art that informs him in his work and thus determines what

he produces, will refrain from faithfully recording these strong contractions.

Two points implied in Darwin's brief statement explaining the exclusion of works of art from his sources in the study of expression, are of interest for our present study. First, he acknowledged that artists are close observers; the "great masters of painting and sculpture" *are* "close observers." Second, what eventually determines the shape of their work is not the ability to observe, but the aesthetic character, that is, the unique and incomparable value of the work of art. This was one of the early instances in modern time where, in principle, the possibility of a conflict between science and art was in some way envisaged.

NOTES

1. It would be foolhardy to attempt a bibliography. I should only like to mention the important work by the Vienna psychologist Karl Bühler, *Ausdruckstheorie: Das System an der Geschichte aufgezeigt* (Jena, 1933).

2. See Barasch, *Theories of Art,* pp. 15 ff., 333 ff.; and Barasch *Modern Theories of Art, 1*, pp. 117, 130.

3. I use a current paperback edition. See Charles Darwin, *The Expression of the Emotions in Man and Animals* (Chicago, 1974). Page references, given in parentheses in the text, will refer to this edition.

4. I hope in the future to be able to discuss at least some parts of this history.

5. It should be emphasized that, since the whole subject still awaits careful study, the opinion roughly outlined here is impressionistic rather than a carefully weighed comparison of analyzed evidence.

6. Laurent Joubert, *Traité du ris* (Paris, 1579). There is an English translation. See Laurent Joubert, *Treatise on Laughter*, translated by George D. de Roches (Alabama, 1980). Cf. Moshe Barasch, *The Language of Art: Studies in Interpretation* (New York and London, 1997), pp. 172 ff.

7. Darwin, *The Expression of the Emotions*, p. 14.

10

Robert Vischer

In the last third of the nineteenth century the issue that artists and critics know as the "problem of expression" came to occupy a central place both in some of the sciences and in the domain of aesthetics. Fechner and Darwin, and the great scientific traditions they represented or initiated, were signs of this profound concern with what to many seemed a newly discovered dimension of existence, the expression of modes of psychic reality. How are emotions manifested, and how is it that these manifestations seem to be instantly understood by spectators? Moreover, how should we account for the strange fact that emotional characters are perceived in parts of nature that, we were taught to believe, are devoid of feeling? How should we account, for example, for our speaking of a serene or a melancholy landscape? Questions like these attracted much interest in the decades beginning about 1870.

Fechner's answer, as we have seen, was ultimately reminiscent in some way of the old beliefs in a World Soul. To a reader grossly overstating the case it may have seemed that Fechner was thinking of a mysterious Soul that infused everything with an intrinsic Life, thus creating a bridge between the different realms and layers of being. Darwin intended to leave little room for metaphysical assumptions, but he, too, wondered how an infant so naturally grasps the meaning of expressions of specific emotions. In summarizing the wealth of distinct observations and penetrating analyses he made in his *The Expression of Emotions in Man and Animals*, Darwin reminded the reader of a fact well known from everyday experience: "... when a child cries or laughs, he knows in a general way what he is doing and what he feels. ..." How does the infant know it, how does he or she acquire this knowledge? Darwin continued: "But the question is, do our children acquire their knowledge of expression solely by experience through the power of association and reason?" And in conclusion: "As most of the movement of expression must have been gradually acquired, afterwards becoming instinctive, there seems to be some degree of a priori probability that their recognition would likewise have become instinctive."[1]

Ideas and observations such as Darwin's developed mainly in the sciences. As we know, in making these observations and formulating these problems, scientists had little contact with the arts. Painting and sculpture, Darwin explicitly stated in the introduction to his work on expression, had different aims to those of science, and hence the scientist could not rely on artists' observations and their record of human expression. Because these scientific ideas were famous in their time, the artists and art critics probably learned of them quite quickly, though in many cases we do not know precisely when and under what specific conditions they did so. But however they learned of them, they must have felt in these ideas a kindred spirit. It must have appeared to them that these ideas held the promise of a "natural history" of art, a scientific foundation for the process of creating and understanding a work of art.

It was in this general atmosphere that aesthetic thought shaped (or perhaps revived) a concept that was to become one of the focal notions of modern theories of art, the concept of "empathy." To the emergence, history, and meanings of this concept the present part is devoted. But before we take up the discussion, it might be useful to outline briefly the intellectual conditions under which the concept emerged.

Several factors, mainly new directions taken by leading trends of intellectual development, came together to create these conditions. First one should remember the central position that the natural sciences came to hold in the world of study and reflection during the last third of the nineteenth century. The shift of the center of attention from systematic and speculative philosophy to experimental science was a process that shaped the intellectual world of Europe, and this shift was clearly perceived at the time. Alois Riehl, a well-known philosopher in those years, said that "living philosophy" was now to be found in the works and laboratories of Helmholtz and Robert Mayer.

Among the sciences, psychology became a kind of model for the study of the world of man and particularly for the study of the arts. Here was a branch of knowledge that seemed to have all the important virtues of natural science: it was based on careful observation, its procedures and results could be corroborated by experiment; many believed that its findings could even be expressed in mathematical terms. On the other hand, the subject matter of this science was man himself, and this seems to include what he does, makes, and shapes. Did not such a science hold the key to the secrets of culture, religion, and the arts? Given the ideas current in the last decades of the nineteenth century, one can understand how students in various

fields could believe that psychology was some kind of "general science," the *scientia universalis* that so many generations had been looking for.

It goes without saying that what late-nineteenth-century students of culture, of religion, and of the arts meant by "psychology" was probably quite far removed from what present-day psychologists have in mind when they use this generic term. To the intellectual audience after, say, 1870 psychology denoted mainly an approach, a method. The world produced by man, the world of culture and art, can be understood if we understand how it emerged. Psychology, so it was thought, could provide guidelines that no other interpretation was capable of suggesting.

In the early 1870s a new school of interpreting the riddle of art emerged. Its founder, it now seems, was Robert Vischer. In 1873 young Robert Vischer published his somewhat unusual dissertation *Über das optische Formgefühl* (On the Optical Sense of Form).[2] It is no exaggeration to say that we start the history of modern doctrines of empathy in the interpretation of art with this slim volume.

Robert Vischer was the son of the philosopher and theoretician of art Friedrich Theodor Vischer, who, around the middle of the nineteenth century, published a monumental work, *Aesthetik oder die Wissenschaft des Schonen*.[3] The son was stimulated by his own reflections, as he wrote in the introduction to *Über das optische Formgefühl* (p. iii), by problems raised by his father. In a review of his own thought, Friedrich Theodor Vischer wondered about the expressive qualities of pure forms. "The different dimensions of line and surface, the distinctions between their movements become emblematic; the vertical [line] lifts up, the horizontal one widens, the swinging [line] moves more vividly than the straight. . . ."[4] The son, Robert Vischer, quoted this passage in the introduction to his dissertation (p. iv), and made this question the starting point for his own investigation and theory.

Vischer the son opened his discussion with a brief presentation of a suggested typology of seeing. Seeing, of course, is a subject that was considered to belong both to psychology and to the study of art, and it thus epitomizes what at the time were regarded as the critic's central problems. What the young author said here in a few pages (pp. 1–4) echoes the great questions encountered in attempts to understand works of the visual arts, and the ways of their creation. It also surprisingly anticipated doctrines of painting and sculpture that emerged in the next generation.

There are two ways of seeing, Robert Vischer said. One is seeing "without effort," mere looking. Right at the outset the author emphasized that by

this type of looking he did not mean the concentration of the eye on a certain point. Such a concentrated look would mean that we disregard everything surrounding the one thing we are looking at. What he meant was, on the contrary, a simple perception, the reception of everything that filled the field of vision without focusing on some special spot or object. It was, he said, "a quiet imprint" on our eye of what was seen. He called this kind of vision "*Sehen*," looking or seeing.

With the advantage of hindsight we can see that here Robert Vischer was formulating the impressionists' type of detached vision. To be sure, he knew neither the impressionists nor their work, yet the affinity of his first type of vision and that underlying impressionist works is striking. Were we to look for "symbolic" indications we could find them in the dates. The year 1871–72, in which Robert Vischer's first study was written, was the *annus mirabilis* of impressionistic painting.

Robert Vischer called the other type of seeing "*Schauen*," gazing. Gazing is more active, it has more movement than the type he called looking; by gazing we analyze the dimensions of the objects seen, we make our glance move up and down, to the right and to the left, in order to "grasp" the objects seen. In other words, gazing is a cognitive activity, we employ it when we make the world our own. Not surprisingly, therefore, we gaze with a high degree of awareness. It is only gazing, our author added, that makes artistic representation possible.

Within gazing Vischer found two attitudes, which the modern historian notes were analogous to the two basic types of style in art. One type is concerned with tracing lines, mainly the contours of objects seen. The other type consists in the "laying out of masses" (*Anlegen von Massen*). These brief comments remind one of the polarity of styles Heinrich Woelfflin suggested, the "linear" and the "painterly."[5] Woelfflin, we know, read Robert Vischer and was influenced by him.[6] It is, therefore, not too bold to assume that we have here a source of the most popular doctrine of style in the twentieth century.

The eye, Vischer said, has a close associate, the sensitive, moving hand. There is a close link between eye and hand. Touching is a coarse kind of seeing, seeing a fine kind of touching (p. 3). That there might be some hidden affinity between seeing and touching is one of the oldest insights of the doctrine of vision; it was taught in ancient Greece.[7] It was modern science that impressed upon wide audiences the abysmal gap between the experience of the two senses. Rediscovering the affinity between them initiated an interesting and important trend in the understanding of art. Alois Riegl, to

whom we shall return in a later chapter in this part, made the distinction and interdependence of visual and tactile experience a keystone of his doctrine of art.

It is no surprise, however, that Vischer concentrated on visual experience. Visual sensations, he said, are divided into two groups, "stressed" and "not-stressed" (*betont* and *nicht betont*). The image that is not stressed is one to which we are indifferent. "Not stressed, vague, and indifferent is a sight (*Anblick*) when it is perceived unconsciously . . ." (p. 5). In fact, we are concerned only with images that are "stressed." It is these that affect us, that please or displease us. But what causes something to be "stressed" or "emphasized" is not obvious at first glance, and Robert Vischer does not tell us what it is. From the whole discussion it emerges, however, that what he had in mind was the spectator's attitude, the way he perceived what he saw.

After such an introduction a contemporary student would expect some kind of relativistic doctrine, emphasizing the fact that matters of taste depend on the spectator's "cultural background," as we have learned from so many anthropological studies. But Vischer and his contemporaries had an altogether different cast of mind. Our accumulated historical experience and our various cultures are not as much as mentioned in *Das optische Formgefühl*. His generation saw their ideal in the natural sciences. As these sciences looked for universal and unchanging "laws," so should investigations in the foundations of taste. When he spoke of the spectator, he was therefore referring to man as a natural (not cultural) creature, to his body.

Why do certain visual sensations, certain shapes and figures please us, while others displease us? This was the question that loomed behind Robert Vischer's discussion. It was, of course, an old problem that had occupied the minds of critics and teachers of art in all ages. But with Vischer and the intellectual tradition to which he belonged it acquired new urgency. He wanted to find something comparable to a natural law, a general criterion that would hold the key to answering this central question of all criticism. This criterion was the similarity of what we perceive to ourselves, more specifically to our own bodies. When the object seen has a structure similar to that of our body, the sight strikes us as pleasant; when the thing seen differs in structure from that of our body, it impresses us as unpleasant.

The way from this general "law" to specific art forms seems to have been rather simple for Vischer; he made the transition without difficulty. Regular shapes, perhaps particularly symmetrical forms, are pleasant, while irregular and nonsymmetrical ones are unpleasant. This, he believed, was easily deduced from the structure of our bodies. Regularity and symmetry

prevail in body structure: we have two eyes, two arms, and so on. This symmetry is the "law of the human body." Symmetrical objects and shapes are easily assimilated to the symmetry of our bodies, hence they please us. Moreover, in visual experience we expect symmetry; if we find irregular and nonsymmetrical shapes, they displease us because they are, in Wilhelm Wundt's formulation, "disturbed expectations."

From these observations Vischer drew a larger, more comprehensive conclusion. We have the marvelous ability, he said, "to impute our own shape to an objective shape," and to make ourselves part of the object we see (p. 20). Vischer was aware that such an imputation necessarily implied a wholesale animation of the inanimate world. "I think the inanimate form is capable [of experiencing] my individual life, as I rightly believe that another human being (a non-I) is capable of [experiencing] it." This imputation of one's personal life to an inanimate object Vischer called "*Einfühlung*" (p. 21). The American psychologist E. B. Titchener translated the term *Einfühlung* (feeling-in) as "empathy."

In tracing the course of thinking that led to Vischer's ideas about empathy we shall have to disregard a great many opinions and reflections derived from the Enlightenment way of thinking; such opinions and ideas were commonplace in the thought of the late nineteenth century. We shall concentrate on what was original and significant in his thought, and here we come to the question Vischer asked: what is it that brings about this fusion of subject and object, of the person seeing and the object seen? In spite of his often rationalistic vocabulary, here Vischer was presenting us with what, in fact, is a metaphysical assumption: in our emotional life there is a "pantheistic urge" toward union with the world surrounding us. This urge, he assumed, is not limited to seeking a union with other human beings; consciously or unconsciously we apply this urge to the whole world. To the world, animate and inanimate, we attribute intentions like those of human beings. The peasant who watches a storm destroying his crops, an avalanche demolishing his house and killing his family, will easily think that a power with intentions similar to those of human beings is behind the disaster. Hence he will turn to this power with supplication and prayer. Primitive man did not admit any mechanical causes, the causes we now term "real"; he thought only in terms of powers intentionally causing the effects he could observe. Even today, said Vischer, the man burning charcoal will curse the fire if it does not light up properly (p. 30).

It has been claimed,[8] with some justification, I think, that Vischer's theory goes beyond the limits of psychology proper. Psychology, it is now gen-

erally agreed, is an empirical science whose methods can be tested and verified, as with any other science. Vischer exploded this framework of scientific psychology. Instead of concerning himself with the observation and testable analysis of limited segments of reality, he offered a sweeping explanation of a bewildering complex of phenomena. His conceptual language was metaphorical. Where he spoke of "the eye," Vischer did not necessarily mean the eye as such; rather, he was referring to the symbolic and conceptual unity of the specific part of the body that perceives what appears in the field of vision and the soul's ability to create, or conjure up, images. Behind his study of psychology or psychophysics, was the desire to understand the artist's imagination.

Vischer attempted to trace in principle (though not in detailed description or analysis) the psychophysical acts the artist performs in producing the image; he wished to reconstruct the emergence of the work of art itself from the mind and nature of its creator. The work of art, as we see it, is permeated by human sensations. Subjective elements are present not only in our attitude to the work of art we are looking at, but also within the work itself. There was, he said, "a will within the picture" (p. 36). We speak of forms relating to each other in a friendly or an unfriendly way within the work itself. In this respect the work of art is the epitome of our general experience of the world. If looking at external objects amounts in fact to the attempt to assimilate them to human nature, this leaning is perfectly realized in the work of art.

The artist's gift, his ability to cast matter into the shape of an image, is based on the "inner totality," the perfect fusion of body and soul. Therefore we can speak of an "eye full of soul," or of an "eye-like soul" (p. 39). What art does is to raise the power of sensuality to a higher degree; it is, at it were, "a higher physics of nature" (p. 40). At the same time, however, every work of art is an object in which man reaches the full emotional experience of himself, it is "humanity that has become an object" (p. 41).

It was one of the characteristic motifs of Robert Vischer's thought that he tried to see how the projection of human feelings upon inanimate matter acts in the inception and shaping of a work of art. In other words, based on the concept of empathy, he attempted to outline a doctrine of artistic creation, and to describe the essential stages in the emergence of a work of art.

The first stage in the creation of a work of art is that the artist conceives in his inner being a "collective plan." What Vischer meant by this term was something like a general, comprehensive vision of the work to be produced

("collective" here having the meaning of "total"). Perhaps the artist also had something like a rough sketch in mind. In that "collective plan," Vischer emphasized, the general conditions of light and the rough grouping of figures were indicated.

Art, however, urges us to bring out the essentials, and here the second stage in the process of shaping, the working out of the work, begins. We reshape nature in light of the initial collective plan. This is the process of actually producing and shaping the work of art. Looking at the completed work we still discern the rhythm and movement of the artist's hand. We sense the nature (verve, vibration, or quiet rhythm) of the movements of the hand that held the brush or the chisel. Vischer called this the "symbolism of delivery" or of execution (*Symbolik des Vortrags*). The nature of delivery is the specific artistic concern. There are significant temperamental differences in delivery; Rubens, for instance, had a tempestuous delivery, or presentation (p. 43). In old age Vischer came back to Rubens, and appended a very interesting lengthy note on the master's execution.[9] The reason Rubens's delivery was so significant, he said, was that we can clearly follow the physical movements by which he shaped the objects of his world.

Let us pause for a moment here in this presentation of Vischer's views, and compare what he said to the teachings of his time, inherited from a distant past, and to the contemporary doctrine of impressionism. He differed from both. As for the inherited theory of classical and Renaissance culture, he did not even mention imitation and the creation of an optical illusion, those centerpieces of the classical theory of art. It is obvious that he considered neither as an autonomous value, and did not assign any important function in art to them.

But he also differed profoundly from impressionism. That he did not mention impressionism explicitly is not surprising. In 1872, when Vischer was writing *Über das optische Formgefühl*, the doctrine of impressionism had not yet been articulated, and the movement had not yet spread and achieved fame. But the intellectual foundations of Vischer's views invite comparison with impressionism and its concepts. The impressionists, as we have seen,[10] considered mere sensation, the initial, original state of visual perception, as worthy of preservation in the completed painting. For Vischer, such a first impression of nature, consisting of nothing but optical perception, was only the starting point for the artist's work. The artist, he said, works "from outside inside" (p. 43).

The case of the Vischers, father and son, affords us a rare opportunity to study the mutual interaction between generations. Early in this chapter we

mentioned that Robert Vischer began his study of empathy where his father had left off. At the end of the century, more than a decade after *Über das optische Formgefühl* appeared in print, the aged Friedrich Theodor Vischer took up the problem his son Robert had raised. In 1887 he contributed a paper, "Das Symbol," to a volume in honor of the historian of Greek philosophy, Eduard Zeller.[11] This article, stimulating and abounding in ideas, was to have a significant influence on Aby Warburg, and thus on the twentieth-century interpretation of art.[12]

The symbol, said the elder Vischer, was the connection of an image with a meaning. That connection, however, lay along a wide scale. One pole consisted of "the mere external link" between image and meaning. This purely conventional connection was so well known that the author did not discuss it in any detail. The other pole was characterized by a connection he called "darkly confused" or "interchanging" (*dunkel verwechselnd*). Symbols of the second type were found primarily in religions, mainly primitive ones. While the first type of symbol posed a problem that must be solved by logic, the second type called for a psychological interpretation. But were these religious symbols still symbols? It was characteristic of this type that image and meaning were mixed up. The image was taken for what it was meant to signify. This type of symbolism was also found in highly developed religions. It was, Vischer said, the "sacramental" view. To the believer, the bread and wine that were the sacrament *were* the body and blood of Christ (pp. 316 ff.).

There was, however, a median type of symbolism that consisted in "introducing a human soul into what is non-personal" (p. 326). This was the type of empathy. Here Friedrich Theodor Vischer discussed the work of his son Robert. It was a particular form of symbolism in which something spiritual actually became physical. It was found in physiognomics; inspired by a mood, by something that appeared in our imagination, we actually modified the muscles of our face, and thus created a facial expression (pp. 337 ff.). The symbolism based on empathy was particularly suited to the visual arts, and therefore was essential to the understanding and interpretation of painting and sculpture.

NOTES

1. Darwin, *The Expression of the Emotions*, p. 357.
2. Robert Vischer, *Über das optische Formgefühl: Ein Beitrag zur Aesthetik* (Leipzig, 1873). References to this work are given, in parentheses, in the text.

3. See Barasch, *Modern Theories of Art, 1,* pp. 262–65.

4. Friedrich Theodor Vischer, *Kritische Gänge,* 5. Heft, p. 145.

5. Heinrich Woelfflin, *Kunstgeschichtliche Grundbegriffe* (Basel. 1915).

6. Meinhold Lurz, *Heinrich Woelfflin: Biographie einer Kunsttheorie* (Worms, 1981), pp. 68 ff.

7. See John I. Beare, *Greek Theories of Elementary Cognition from Alcmeon to Aristotle* (Oxford, 1906), pp. 9–91.

8. See Hermann Glockner, "Robert Vischer und die Krisis der Geisteswissenschaften im letzten Drittel des neunzehnten Jahrhunderts," *Logos* XIV (1925), pp. 297–343, and XV (1926), pp. 47–102. See especially XV, pp. 66 ff.

9. Vischer's late work on Rubens appeared in 1904. When I wrote the present chapter, it was available to me only in an Italian translation. See Roberto Vischer, *Raffaello e Rubens: Due saggi di critica d'arte,* translated into Italian by E. C. Croce (Bari, 1945). For the note I am referring to, see pp. 124–39, especially pp. 129 ff.

10. See above, chapters 3 and 4.

11. I use the reprint in Friedrich Theodor Vischer, *Ausgewählte Werke,* vol. VIII (Leipzig, n.d.), pp. 312–47. Page references are given in the text, in parentheses.

12. For the impact of Vischer's article on Warburg and his school, cf. E. H. Gombrich, *Aby Warburg: An Intellectual Biography* (London, 1970), pp. 72 ff. See also Edgar Wind, "Warburgs Begriff der Kulturwissenschaft und seine Bedeutung für die Asthetik," *Zeitschrift für Ästhetik und Allgemeine Kunstwissenschaft* XXV (1931), pp. 161–79.

11

Empathy
Toward a Definition

Robert Vischer, as we have just seen, suggested a theory of empathy, though only in very broad and vague outline. He also coined the term *Einfühlung*, that was soon to become a household notion in the conceptual vocabulary of certain trends in psychology and in the theory of art. In the decades following the publication of Vischer's dissertation (1873), the theory of empathy underwent extensive development in several fields of study. This dissemination was particularly manifest in several sciences as well as in popular criticism, mainly of literature. It also affected some disciplines that had a bearing, direct or indirect, on the investigation of art and of the creative process. Before turning to the actual theories of art, it may therefore be useful at this stage to explore the main lines of the theory of empathy as it was developed in psychology and in philosophical aesthetics.

To put the original conception of what we now call "empathy" with extreme and crude brevity, we should say, first of all, that it consists in the projection of human feelings, emotions, and attitudes onto inanimate objects. As such it had already been presented by Aristotle. In his discussion of metaphors, especially as they were used by Homer (*Rhetorics* III, 11; 1411 b 33 ff.), he explored "the practice of giving metaphorical life to lifeless things," and quoted such Homeric expressions as the arrow flew "eagerly" or "the spear in its fury drew full through his [the foe's] breastbone." But although such projection of human feelings and emotions onto lifeless objects was known for millennia as a stylistic means, it was not until the late nineteenth century that it became the cornerstone of an aesthetic and psychological theory. It was also then that the term *Einfühlung* was coined, and was translated into English by Edward Titchener as "empathy."

When considered as a way of experiencing works of art, empathy may be said to raise two major problems. One is the fact that human emotions have to be projected onto, or "read" from, such lifeless objects as a picture or a statue; the other is that the proper emotions—or, as we say, the "correct"

feelings—have to be evoked and projected. These two functions were endowed with varying degrees of significance in different fields of study.

Psychologists are familiar with the phenomenon of projecting emotions onto visual forms. Some of them have ascribed crucial significance to such projection in defining a person's character. The best-known application of this view is the famous Rorschach Test. Hermann Rorschach, the son of an art teacher (or teacher of drawing), devised a famous inkblot test, consisting in our identifying, or "reading," symmetrically arranged inkblots.[1] In this process we project our thoughts and emotions onto the inkblots. It is perhaps worth noting that Rorschach began working on these tests in 1911, that is, only a few years after the doctrines of *Einfühlung* were first presented at a time when they were very much alive in the culture. Even if Rorschach did not refer to these theories explicitly, the idea of the projection of emotions was therefore at the forefront of people's minds.

In his investigation of the imagination's projection, Rorschach did not consider the artist's creative process, nor the specific question of understanding the work of art. We know, however, that very similar techniques—projecting one's fantasies onto stains or clouds—were known to artists as sources of inspiration. I shall quote only Leonardo da Vinci's famous note:

> Look at walls splashed with a number of stains or stones of various mixed colors. If you have to invent some scene, you can see there resemblances to a number of landscapes, adorned in various ways with mountains, rivers, rocks, trees, great plains, valleys and hills. Moreover, you can see various battles, and rapid actions of figures, strange expressions of faces, costumes, and an infinite number of things, which you can reduce to good, integrated form. This happens thus on walls and varicolored stones, as in the sound of bells, in whose pealing you can find every name and word you can imagine.[2]

Such observations, however, remained isolated. The school of thought that made the projection of emotions an important concept in psychology and aesthetics became theoretically significant only at the turn of the nineteenth and beginning of the twentieth centuries. It was a broad phenomenon in European thought and letters, represented in Germany mainly by Theodor Lipps and Johannes Volkelt, in France by Victor Basch, and in England by Vernon Lee.

Here, however, the approach of the psychologist and of the student of art begin to differ. For the psychologist and in psychiatric diagnosis it is the very process of projection that is crucial. To a certain extent the artist projecting the images in his mind onto the vague shapes suggested by clouds

or crumbling walls may find them imaginatively stimulating. For the student of art, however, from whatever point he may approach his subject, projection in itself, essential as it is, cannot be considered sufficient; it is only the initial part of *Einfühlung*.

When empathy is approached as an explanation of art, two additional issues acquire central significance. One is that the empathetic emotion I perceive while looking at a painting or a statue has to be "correct." In other words, in order to make empathy a valuable tool in understanding works of art, it is mandatory that the spectator's empathy reenact what the figure depicted is intended to "feel." A projection that is free-floating, as it were, is neither sufficient nor useful for empathy as a way of understanding art. Only when the spectator's emotional experience is properly channeled is empathy a way of understanding art. The second issue, though implied in the first, is the question of whether what is valid for our empathy with another living person's experience also applies to our experiencing a work of art, a painting, or a statue. Only these specific questions, not projection in general, will be considered in the following brief comments.

Theodor Lipps was one of the main thinkers who provided the theoretical foundation for the doctrine of empathy as a theory of art. He began his presentation of the doctrine with a discussion of expressive movements in reality, in nature, with no necessary relation to art. In his major theoretical work, *Grundlegung der Aesthetik*,[3] Lipps defined "expressive movements" (*Ausdrucksbewegungen*) as movements of the body that manifest "inner conditions" (p. 107). He was not so concerned with how expressive movements come into being. What was at the forefront of his mind was the question, how do we understand what these body movements mean when we see them performed in reality? In other words, it was not the shaping, or even the essence, of the expression that he wanted to explore and explain, but rather how we correctly understand this expression. This way of posing the question has far-reaching, perhaps even crucial, consequences for the theory of art, to which we shall shortly return. For the time being let us stay with Lipps.

Now, how do we recognize an emotion, or a psychological condition, when we see its manifestations in body movements? Lipps's answer, to put it in crude and oversimplified form, was: we understand what we see because we know it from our own experience. I see an eye expressing pride. What I actually perceive are minor movements in and around the eye. I don't see the pride itself, I only understand that the minor movements express pride. Lipps described this act of understanding expressive move-

ments as a "participation" (*Mitmachen*) in what was perceived (p. 111). I understand by participating, that is, by making what I perceive part of my own personal experience.

The "participation," of course, is not necessarily a physical bodily activity. When I see an eye expressing pride I don't have to actually repeat the muscle contraction that produces the expression of pride in order to grasp what it means. Empathy, Lipps believed, is in fact a kind of repetition of what we see, but this repetition is performed in our minds only, it is not actually executed by the body. It is, Lipps said, an "inner" action. The "experience" (*Erlebnis*) that allows us to grasp the expression in a fellow human being's behavior is an "intrinsic action of the will" (p. 122).

It is the same inner mechanism—namely, that we understand because we know something from our own experience—that ensures (so we must assume) that empathy will evoke the correct emotions, that is, the emotions that the figure we see experienced. In the writings of the modern philosophers who formulated the theory of empathy not much attention was devoted to this question. It seems largely to have been taken for granted that we reexperience the proper emotion. The problem has been raised in the past history of art theory and we come back for a moment to these earlier sources. Again, a single quotation will suffice. Leone Battista Alberti, the first Renaissance author to write a theoretical treatise on painting, said in discussing the expression of emotions: "The *istoria* will move the soul of the beholder when each man painted there clearly shows the movement of his own soul. It happens in nature that nothing more than herself is found capable of things like herself, we weep with the weeping, laugh with the laughing, and grieve with the grieving."[4] A similar attitude prevails in modern theories of empathy.

As a rule, modern philosophical discussions of empathy did not make a sharp distinction, or often did not make a distinction at all, between our understanding the emotions of live people and those represented in works of art. Once again it seems to have been taken for granted that what holds true for the one is also true for the other. This may well have been part of the tradition that art is in essence an imitation of nature. In fact, however, the theory of empathy was mainly concerned with our direct empathy with our fellow human beings. A branch, of psychology thus became, at least for certain thinkers and audiences, a major theory of art. But does the work of art not pose particular problems for the theory of empathy? Does it not have requirements that are not identical with what live experience requires?

In experiencing a work of art with empathy, Volkelt believed, we have to distinguish between two types. One is what he called "proper empathy" (*eigentliche Einfühlung*); the other is "empathy of mood" (*Stimmungsein-fühlung*) (I, pp. 213 ff.). "Proper" empathy, also termed "object empathy" (*dingliche Einfuhlung*) (I, p. 114 ff.)[5] is our understanding of the traditional subject matter and expressive meaning of the work of art. When I see the classical group of *Niobe* with her daughter who, seeking protection, clings to her mother's body, I understand the event by "proper," that is simple, natural empathy (I, p. 215). This type of empathy does not differ essentially from what I would experience were I to watch the event in nature, rather than in a representation in cold marble. But the matter is different when it comes to the "empathy of mood." Empathy of mood is the imputation of emotion onto something, without necessarily reading that emotion out of what is represented in the work of art. The examples Volkelt here adduced were landscapes, and the whole range of objects we would call still life, and even abstract configurations. The simple sensual components and relations in nature and its arbitrary combinations (connections of tone, of color, and of form) are subjects to which we impute human moods (I, p. 213 ff.).

In view of the problems we shall have to discuss later in this part, and mainly in the final one, it is worth stressing that full empathy, in the sense of a complete and unhampered projection of our emotions, is found mainly where the spectator looks at what we would now call "abstract" views or creations. Volkelt's work appeared several years before Wassily Kandinsky made his first abstract paintings. Without attempting to suggest a direct connection between the academic philosopher Volkelt and the great nonacademic painter Kandinsky, the former's unusual observation throws yet more light on the deep roots of abstract art in the intellectual world of the time.

We may be of different minds concerning the actual significance of academic philosophy, even if its subject matter is aesthetics, for a live and dynamic theory of art, and even for the intellectual atmosphere in which such creative reflection develops. However, the doctrines of empathy we have traced in bare outline here bear important testimony to spiritual developments in thought on art in the first decade of the twentieth century. Two points particularly should be stressed here. We shall return frequently to these issues in this and the following sections.

The first point is that making empathy the central approach to experiencing and understanding works of art necessarily implies that what is es-

sential in these works—and hence in art in general—is something that can be reached and grasped by empathy. Now, what can we have empathy with? *Einfühlung* derives from *Fühlen* (feel) or *Gefühl* (emotion), the meaning of the Greek *empatheia*, from which the English "empathy," as a sentiment or emotion, is derived. The term itself, then, says that empathy is an emotional condition. "Aesthetic sentiments," said Victor Basch, the French philosopher who made a substantial contribution to the doctrine of empathy, "are above all sentiments of fellowship" (*sentiments sympathiques*).[6] When I look at a work of art I participate to a degree in the emotional character infused in it. In looking at a work of art, the *sentiments sympathiques* are a "weakened revival of an affective condition mediated by [an artistic] presentation." To explain what he meant by this condition, Basch spoke of a "contagion of feeling," using a term coined by the nineteenth-century British psychologist James Sully.[7] We can summarize, then, by saying that what can be grasped by empathy is an emotional condition. What we call Expression is thus the core, or central component, of art.

Seeing expression as the core of art, however, is not the only far-reaching conclusion that can be drawn from the concept of empathy as an attempt to understand art. Another shift of emphasis concerning the problems of art is also implied in the doctrine of *Einfühlung*. Though not discussed in the writings of the theorists mentioned, it is of great consequence for the historian of doctrines of the visual arts. To put it simply: in the doctrine of empathy as a central explanation of art, our way of experiencing and perceiving is turned into the main pivot of all explanation of painting, sculpture, and the related arts. If empathy is totally based on our intuitive ability to read a person's mind, or to read whatever aspect of mind and soul has been projected onto the image of a lifeless object, then it is obviously the "reader's" experience and activity that are fundamental to the whole theory.

Now, making the spectator's experience (or the experience of the artist as a spectator of nature) the central issue is a dramatic change in the history of art theory. Though not altogether sudden (it was to some degree adumbrated by impressionism), this trend appears clearly only in the theory of empathy. The theory of art, we should remember, was originally a theory by and for the creating artist. Even if already in the Renaissance the artist was naturally advised to take into account his public's taste, the central theoretical category of art theory was, and remained for centuries, that of "making" the painting or the statue. In the aesthetic theory of empathy, making was, at least to some extent, replaced by experiencing.

I should like to conclude with an example that frequently appears in the discussion of empathy: for centuries the column, as a major form of classical architecture, has been discussed in writings on art. People spoke about its forms, its proportions, and its placement in relation to other parts of the building. Theorists of empathy, however, saw it as the artist's task to bring out the effort made, as it were, by the column to support the roof, or the architrave, that weighs on it so heavily.

Speaking in old and traditional terms: while the doctrine of empathy had the propensity to animate everything, it was also inclined to make man as such, not specifically the artist, the agent infusing a soul into every object.

NOTES

1. Hermann Rorschach, *Psychodiagnostics*, translated by Paul Lemkau and Bernard Kronenberg (New York, 1949). The original German edition was entitled *Psychodiagnostik* (Berne and Berlin, 1921).

2. da Vinci, *Treatise on Painting*, p. 90 (# 76).

3. Theodor Lipps, *Grundlegung der Aesthetik*, I (Hamburg and Leipzig, 1903). The second volume was not published. Page references to this work are given, in parentheses, in the text.

4. Alberti, *On Painting*, p. 77. We have here an implicit reference to Cicero, *De amicitia*, XIV, p. 50.

5. Johannes Volkelt, *System der Aesthetik, I, Grundlegung* (Munich, 1905), p. 114.

6. Victor Basch, *Essai critique sur l'Esthétique de Kant* (Paris, 1927). The original edition appeared in 1896.

7. James Sully himself was a psychologist, with little concern for the problems of theoretical aesthetics. His best-known work was *The Human Mind: A Textbook of Psychology* (London, 1892).

12

Wilhelm Dilthey

Modern art theory's dependence on psychology, the "science of the soul," brought about one of the major trends in art criticism of the modern age. As we have seen, in earlier periods, when people tried to understand artistic creation and to judge works of art, they turned for enlightenment to the great cultural traditions and invoked the inherited models rather than concentrate on the description and analysis of what goes on in the artist's soul and mind. The orientation toward the psychological aspects of art also resulted in a certain shift in the subject matter of art theory. The increasing concern of twentieth-century criticism with the artist's personality, and with the spontaneity of the creative process, was one of the consequences of building art theory on psychological foundations.

A dominant representative of this trend was Wilhelm Dilthey (1833–1911). He was not primarily concerned with art theory, and the visual arts played only a marginal part in his rich intellectual world. Dilthey, one of the great humanistic scholars of the late nineteenth century, was remarkable for the scope of his profound learning even in his age, and for his analytical power. Best known for his studies of *Weltanschauung* (worldview), or *Historisches Bewusstsein* (historical consciousness), he was also concerned with literature and historical aesthetics. His contributions to "Poetics" had a formative effect on a great deal of art theory and criticism. In our comments we will concentrate on this aspect of his thoughts.

Erlebnis and *Leben*, "emotional experience" and "life," were key concepts in Dilthey's general philosophy, especially in his aesthetics. It has been said, not without some justification, that in this doctrine he became the speaker of the irrational trend in later nineteenth-century thought,[1] the movement in modern Europe that turned against the Enlightenment and its legacy. In a sophisticated way he also turned against Hegelian philosophy, although he was the biographer and interpreter of the young Hegel.[2] Hegel, we recall, made *Geist* (Spirit or Reason) the ruler of the universe and the content of

history. Dilthey assumed that science can grasp only a limited aspect of historical and cultural reality. There is a gap between what science can observe and analyze and what he called *Lebensgestaltung* (life formation), a kind of totality of human life and culture. The sciences can grasp only the causal connection between things and events. What Dilthey termed the "significance of life" remained beyond the reach of the sciences.[3] In the modern world, in which religion has lost its hold, many contemporary people find in art and in poetry, not in science, an "authentic interpretation of life itself."

Dilthey's philosophy of art centered on the artist's creative faculty. The artist's creative power is his imagination (*Phantasie*). The artist's imagination always puzzled spectators and critics; in aesthetics it is a subject as old as any reflection on art. Time and again people asked, what is the mysterious power that enables the artist to produce something that did not exist before he made it?[4] Yet in theories of the visual arts, the imagination was never the single, or even the central, subject of systematic contemplation. This was what Dilthey did. "The imagination of the poet . . . is the central point of all history of literature" (*ED*, p. 136).[5] And "The imagination in its position towards the world of experiences forms the necessary point of departure" (*ED*, p. 145).

Dilthey knew, of course, that the work of art is shaped by factors beyond the domain of personal experience. As a historian of ideas and of religious beliefs, he did not have to be reminded of their impact on the thought and imagery of a period or an individual. He nevertheless chose to concentrate on the individual artist's power because he saw in the artist's imagination the specific, unique character of poetry and art.

Imagination, the artist's creative power, is a primary, fundamental faculty of human nature; in some individuals it is stronger and more intense than in others. Something of the artist's creative faculty may thus be found in all of us. Though the imagination may seem altogether spontaneous, taking what it creates from its own hidden depths, it does in fact draw on accumulated impressions from the outside world. It was in this context (*ED*, pp. 145 ff.) that Dilthey spoke of "memory images" (*Erinnerungsbilder*).

The images accumulated in our memory, however, are not raw perceptions, untouched building blocks from which our imagination deliberately chooses what it wants. A continuous interaction goes on in our minds between memory and the creative imagination. Even what we seem to remember with perfect clarity and distinctness is not exactly the original im-

pression we received in the past. "As little as a new spring can make visible to us the old leaves on the trees, so little are the impressions of yesterday revived today. . . ." Our minds continuously build an inner world in which only such outside impressions are received as we need (*ED*, pp. 148–149).

The imagination, then, builds a "second world." This is a universal world and, to some degree, it is given to everyone. Thus the world the imagination creates reveals itself involuntarily in the dream, "the oldest of all poets" (*ED*, p. 153).[6] The role fantasy plays in hallucinations and in some forms and conditions of madness also shows that imagination is not limited to the artist. Dilthey was among the first modern thinkers who drew seriously upon psychiatry to show the relation between poetry and madness (especially in a lecture, given in 1886, on "Poetic Imagination and Madness," reprinted in *GS*, VI, pp. 90–102). The possible relevance of psychiatry to the study of art is the assumption that the creative imagination, seemingly only the artist's prerogative, is in fact a universal trait.

The view that the creative imagination is given, if in varying degrees, to all human beings, raises with particular clarity two questions that are crucial to any theory of art. First, how is the mental image transferred to the material object and thus crystallized in the work of art—the poem, the picture, the piece of music? How is it transformed from a fleeting appearance in the mind to a definitely shaped "thing" in the external world? This, of course, is a difficult question in the theory of any art, but it seems particularly pertinent to the student of the visual arts, the arts consisting of actual material objects. The other question is: how do we—reader, spectator, listener—experience the work of art, understand it, and make it our own? How do we grasp the record of the experience of another individual, that of the artist?

Dilthey's answer to the first question—how is the passage from mind to work accomplished?—poses more problems than it solves. Art, he believed, is essentially expression. And expression is by its very nature altogether spontaneous. "Expression springs from the soul immediately, without reflection" (*GS*, 7, pp. 328 f.). Dilthey often returned to the self-acting, spontaneous nature of expression. Not only does expression take place without preconceived meditation or reflection, but it reaches into layers of our minds and beings into which consciousness never penetrates. Sometimes his formulations adumbrate something that seems close to the modern concept of the subconscious. "Expression may contain more of psychic connection than any introspection will yield. It draws from depths that consciousness does not illumine" (*GS*, 7, p. 206).

Spontaneity of expression, Dilthey believed, need not, and perhaps cannot, be derived from any other cause. In his view, the spontaneous nature of expression is a primary datum, and therefore cannot rest on any foundation outside itself. The spontaneous nature of artistic expression is a matter for descriptive psychology.

Even if we accept that expression is a primary reality not to be derived from anything else, the question still arises what does it express? Dilthey's main answer to this question has a common label, *Erlebnis*, experience. Yet the concept of *Erlebnis*, crucial as it is in Dilthey's aesthetics, is not defined with sufficient clarity; it scintillates in many lights. Though an *Erlebnis* is usually the experience of a particular event or individual, it is not necessarily limited to such specific condition. An *Erlebnis* can also be determined "by moods that arise from within, independently of the outside world, or by a cluster of ideas, be it historical or philosophical." Such an "emotional process (*Gefühlsverlauf*) is always the starting point of the poem and the contents expressed in it" (*ED*, p. 377).

The work of art blends the internal and the external. "*Erlebnis* that forms the nuclear meaning of all poetry, always contains a condition of mood as an inner core and an image or image-context, a place, a situation, or a person as an internal core; in the undissolved unity of the two there is the living force of poetry" (*GS*, 6, p. 128).

So far we have briefly considered the meaning of *Erlebnis* as the artist's experience and its role in the creation of a work of art. But as we have said above, *Erlebnis* is also the core notion of Dilthey's doctrine of how we perceive works of art. It suggests, if only vaguely, the break with attitudes prevailing in nineteenth-century aesthetics, a break of far-reaching consequences for our own time.

In the course of the nineteenth century it was the attitude that originated with Kant that dominated aesthetic thought. The key concept in Kantian reflection on aesthetic experience was distance, or, as he himself called it, "disinterestedness." Aesthetic experience exists only when there is "disinterested pleasure."[7] If I am interested in any way in the use, value, or application, of the object or contents of the artistic representation, my experience cannot be "aesthetic." The same is true for the observation of art. Experiencing a work of art while being detached from it, from what it says and what is often called its "message," was thus crucial for the Kantian philosophy of aesthetics.

It was precisely this basic principle of complete detachment that Dilthey's aesthetic doctrine sought to undermine (with or without explicit

intention). *Erlebnis* as the core component of the aesthetic experience of a work of art meant, first of all, emotional involvement, participation in feeling, reliving what was represented. It thus necessarily canceled the spectator's distance from what he saw in the work of art. Though Dilthey was deeply concerned with the response of the audience, the reader, and the spectator, to the work of art, as far as I know he nowhere presented an explicit discussion of the Kantian requirement of "disinterestedness."[8] His main doctrine, however, implicitly (and occasionally even explicitly) questioned disinterestedness as an essential feature of aesthetic experience. So what happens when we read a poem or look at a painting?

Here we should emphasize two points. The first is that Dilthey's theory of the *Erlebnis* as a model of understanding the work of art reveals that his whole conception was, in fact, opposed to the doctrine of detachment as the core of aesthetic experience. Finding oneself in the work one is looking at means that the distance between the two, the spectator and the work being seen, is practically annulled. It replaces the spectator's emotional restraint in looking at something that is not depicted. To repeat: Dilthey did not intend to negate the Kantian theory of aesthetics, but the actual effect of his thought led in this direction.

The second point, more closely related to our specific concerns, is more problematic, but it is of great significance. Dilthey's theory of art marked a profound shift in thought on art. He replaced the old thesis that art is an imitation of nature,[9] a thesis that had dominated aesthetic reflection for centuries, by a new definition. Notwithstanding his traditional erudition Dilthey presented, at least in the discussion of how poems and works of art in general, emerge, ideas and concepts that had little to do with the depiction of outside reality. The problem of perception, so important in the impressionist trend of the same time, is not even mentioned in his writings. The striving toward "pure seeing," common to a great deal of aesthetic reflection in the late nineteenth century, had no room whatsoever in Dilthey's philosophy. Pure seeing is directed toward something outside ourselves as human beings formed by culture. Dilthey did not even try to get out from what may perhaps be called the inner human world into the surrounding physical reality. Summarizing the direction of his thought rather freely, we should emphasize that in his philosophy art was a thoroughly human affair. The only basis for art was the world of the imagination that was built up in our minds or souls.

A final point should be made here. For a long time it was common wisdom that art aims at illusion. Whatever the changes of style that occurred in

the course of centuries in actual art, it was a matter of faith to assume that art conjures up an imaginary, illusionary world. Dilthey, however, believed that "what is experienced [in our psychic life] enters completely into the expression [of art]" (ED, p. 179 ff.). In a culture that encourages one to suppress one's emotions, the work of art, far from being an illusion, is the embodiment of full truth. "In human society filled with lies [the artist's work] is always true" (GS, 5, p. 320). In a formulation that has a modern ring to it he said that in art "we enter a realm in which deception ends" (GS, 7, p. 207).

NOTES

1. Georg Lukacs, *Die Zerstörung der Vernunft* (Berlin, 1953), writing from a Marxist point of view.

2. Wilhelm Dilthey, *Die Jugendgeschichte Hegels und andere Abhandlungen zur Geschichte des deutschen Idealismus*, in *Gesammelte Schriften*, IV (Leipzig and Berlin, 1926). Gombrich believes that Dilthey remained, at least in the way he posed some problems, under Hegel's spell. See E. H. Gombrich, "In Search of Cultural History," reprinted in his *Ideals and Idols: Essays on Values in History and in Art* (Oxford, 1979), pp. 43–44. Whether or not Dilthey remained faithful to Hegel in the posing of certain problems, he definitely did not see Reason (in any form) as the main content of history.

3. *Gesammelte Schriften*, V, pp. xix–xxi (the Introduction by Georg Misch). For this aspect, see the chapter on Dilthey in Rene Wellek, *A History of Modern Criticism, 1750–1950*, vol. 4, *The Later Nineteenth Century* (Cambridge, 1965), pp. 320–35.

4. Among modern investigations of the answers given to this question, see particularly Erwin Panofsky, *Idea: A Concept in Art Theory* (New York, 1968; original German edition: Leipzig, 1924).

5. Page references will be given in parentheses in the text. *Gesammelte Schriften* are quoted as *GS*. Wilhelm Dilthey, *Das Erlebnis und die Dichtung: Lessing, Goethe, Novalis, Hölderlin* (Leipzig, 1906) is referred to as *ED*, followed by page number.

6. Dilthey came back to the designation of the dream as a kind of artist. See *GS*, 6, p. 179, where it reads: "Der Traum, dieser verborgene Poet in uns."

7. The literature is enormous. For a brief summary of the problem, as I understand it, see Barasch, *Modern Theories of Art, 1*, pp. 24 ff.

8. Nor was he always consistent in this respect. In his old age he seems to have had second thoughts concerning the matter of disinterestedness. See Wellek, *A History of Modern Criticism*, especially pp. 322 ff.

9. In addition to Karol Sauerland, *Diltheys Erlebnisbegriff: Entstehung, Glanzzeit und Verkümmerung eines literar-historischen Begriffs* (Berlin, 1972), pp. 117 ff., see also Kurt Müller-Vollmer, *Towards a Phenomenological Theory of Literature: A Study of Wilhelm Dilthey's Poetik* (The Hague, 1963).

13 | Conrad Fiedler

In the last decades of the nineteenth century the idea of pure visibility was much in the air, and found powerful resonance among artists and students of art. Scientists were thought to have discovered the intellectual significance of seeing, as well as the complexity and inherent order of this seemingly simple sensual experience. How is the artist's domain of vision structured? Though the idea of "pure visibility" may have meant different things to different people and to the scientific disciplines, the common orientation of reflections on this notion seems clear. Interestingly, the abstract character of the concept had almost the character of a revelation.

Among the critics concerned with "pure vision," Conrad Fiedler (1841–95) was perhaps the most influential. A wealthy young man, patron and intimate friend of artists (especially of the painter Hans von Marees), an independent scholar who never sought any link to established institutions of learning, Fiedler belongs to a type that has now almost completely disappeared. Scholars of his kind were not constrained by the requirements and limitations imposed by the traditions of institutionalized learning. They were given to crossing disciplinary borders, and to a freewheeling working of the mind, often setting themselves intellectual goals that would not have found a favorable reception in a university. Fiedler's work reflects these conditions.

Conrad Fiedler's literary *oeuvre* is not very large, being contained, with some additions, in two volumes.[1] Despite its somewhat heavy and abstruse style, it exerted a striking influence. The only explanation for this is that the power of the idea, if not always expressed with full clarity, impressed readers, and made it possible for the text to exercise a strong formative impact on them. Fiedler's thought was dominated by a single problem, best expressed in his longish study "Concerning the Origin of Artistic activity," written in 1887.[2]

Fiedler's basic argument is clearly stated. To understand art, he said, many students begin by investigating the works of art, that is, the final re-

sult of the artist's endeavors; from the effects of art they try to infer the essence of artistic activity. "This point of departure is clearly wrong," Fiedler said (p. 187). Our aim is not to interpret works of art, but to understand the artist's creative activity, and the way it works.

Artistic activity, he believed, is spontaneous and creative; it does not depend on the outside world that it portrays. To make his case, Fiedler began with a brief discussion of language, to which art is often compared. By studying language he hoped to get a more profound insight into art. Now, Fiedler was no linguist, and thus he patterned his notion of language to fit his concept of art. Common wisdom has it that the task of language is to denote the reality to which it refers; to put it crudely, it coins a word for every object we perceive. Philosophers and scholars are therefore used to juxtaposing language to reality. But language, Fiedler emphasized, is not simply a final system of notation that denotes outside objects; rather it is an "expressive movement," an *Ausdrucksbewegung.* Language is not, he said, a "universal means" of coining "signs" for a variety of contents that exist independently of the process of expressing them. Rather it is "a level in the development of a psychophysical process." What is achieved in the expressive movement, the final result of the process, cannot be compared to an object or condition that supposedly exists in the outside world but has not yet entered our consciousness. Language cannot be juxtaposed to reality.

When we cast "a glance into the inner workshop" (p. 198) of language, and of human consciousness in general, we may be surprised by what we find there. The "inner workshop" of the human mind is not filled with the "solid property of completed figures," with ready-made formulae; rather, it is a process of infinite change and constant transformation.[3] Fiedler described this process of infinite change vividly, saying in conclusion that it is "a muddy stream that hardly touches the threshold of consciousness...." The only element in this "muddy stream" (which obviously includes all attempts to coin names for objects and conditions) that is constant and that can be grasped, as it were, is what linguistic energy itself has created, namely, the word. Since the word is rooted in the mind alone, it cannot be compared with the objects, conditions, and so on, outside the range of language, that is, with what we may call reality itself. The word denoting a color (Fiedler's example) has nothing to do with the sensation we perceive. To be sure, terms get fixed in our minds, and reconstitute, if necessary, certain cognitions. But this function, important as it is, does not indicate any intrinsic link between the term and the thing it names. Cognition, Fiedler emphasized, is always the product of the mind itself (p. 202). Therefore he

concluded his brief discussion of language by saying that the mind, wishing to reach what is called a cognition of the world, not only has "to construct the building," but it also has to produce the "building materials" (p. 203). The marvel of language, Fiedler's finally concluded, is not that it "means a being, but that it *is* a being" (p. 205; italics added). Language, like all great domains of the mind, including art, remains altogether autonomous.

These reflections were not adduced in order to defend a purely theoretical type of knowledge. Time and again, Fiedler stressed the cognitive significance of sensual intuition and experience. Cognition by means of sensual experience is natural, here nature itself teaches us. Yet when in our thought we rely on theoretical, say linguistic, means only, we are in need of instruction (p. 212). The world of sensual appearances has an obvious priority over a world based on merely "intellectual," theoretical operations. But passive, receptive, sensual experience can never replace theoretical reflection. "The spiritual development of man begins only there where he stops [behaving] only as sensually perceiving, where he begins to consider the sensually perceived reality as a given material, and to treat it, use it, and transform it according to the requirements of his mind" (p. 216).

Fiedler never mentioned Leonardo da Vinci, yet in many respects he followed, and in some sense revived, the philosophical attitude of the Renaissance master. It may well be that the doctrine of "precise sensual cognition," of which Leonardo da Vinci was a kind of founder in the sixteenth century,[4] has never been so powerfully stated as in the trend represented by Conrad Fiedler in modern times.

Like Leonardo, Fiedler was aware of the limitations and shortcomings of sensual experience as a means of cognition. What we perceive directly with our senses is always elusive; it is made up of fragmented, detached pieces of reality that disintegrate or transform themselves as soon as we believe we have grasped them. To understand the nature of sensual experience and its concealed dimensions, it was best, Fiedler believed, to concentrate on one aspect or one domain. He chose the domain of visibility (*Sichtbarkeit*).

Within the scope of visibility there is a great range of intensities. In everyday life, the attention paid to the appearance of things, that is, to the images perceived by the eye, usually remains superficial. Yet in some visual activities, mainly those of the scientist and the artist, we reach completeness and the highest precision that cognition by the eye can offer. In the scientist's and artist's work such perfection is reached not only in the experience

of material objects that are actually and tangibly present, but also in looking at mental images.

Fiedler wanted to isolate vision and visibility from all other kinds of sensual experience. As we know, common wisdom has it that we can verify what we perceive by sight, by what we learn about the same object through the other senses, such as touching, tasting, and smelling. What we can see, but are not able to corroborate by the other senses, we often consider a mere "optical illusion," as we say, a *fata morgana*. According to Fiedler, however convincing and natural this assumption may appear at first, it is erroneous. What is visible, he stressed time and again, is in fact not commensurable with what can be touched, tasted, or smelled. In comparing sight with touch, taste, or smell, we assume some reality beyond our experience. But this assumption, it follows from Fiedler's fundamental thesis (influenced by Kant) is "grasping into emptiness" (p. 245). Such "grasping into emptiness" means, in Fiedler's parlance, going beyond what is visible.

But what about seeing correctly? This question is crucial for representation, if only by implication. Fiedler must have been familiar with the artistic tradition of "correct representation," a tradition that, beginning with the Renaissance, dominated the theory of art up to the late nineteenth century. In the Renaissance, as is well known, some theories considered a painting a kind of scientific statement about what it portrayed. The belief in the scientific nature of painting was based on the idea that you can prove the correctness of representation by comparing what we see with what we can learn from the other senses. But if we isolate visibility from the other kinds of sense impression, how can we discriminate between correct and false seeing and representation?

Fiedler took a radical attitude. He rejected the question altogether. When we ask whether we see correctly, we are in fact asking about the correspondence of our visual perception, and the representation based on it, with the reality outside us that we are supposedly portraying. But that "outside reality" as such is not available to us, and it is not the artist's concern. The scientist, whose concern it is to study that outside reality precisely, may try to corroborate what he sees by measuring or weighing the object seen. But for the artist, who is altogether devoted to what he sees, such attempts are simply meaningless. "What use is it to the form that arises only from the eye and for the eye if we find a different form that is invisible and cannot appear in our perceiving and imagining consciousness" (p. 248).

Visual experience has distinct qualities that are not found in any other type of sensual experience. Such qualities are color, the difference between

brighter and darker areas or tones, and "highlights" or "luster"(*Glanz*). These qualities cannot be found in, and cannot be compared to, anything that is not perceived by the eye; they cannot be reduced to anything outside visual experience itself. All we can do is to compare one visual experience to another, and one impression to another. It is only when we limit ourselves completely to visual impressions, Fiedler concluded, that the objects of the real world will become to us true appearances (p. 254).

The restriction to sheer visibility, a crucial issue in Fiedler's doctrine, leads to consideration of its consequences. It is taken for granted that the primary, perhaps the sole, purpose of seeing is to gain information about the world of objects. But Fiedler believed that proper, or full, seeing is achieved only when all connections between the images in our eyes and the world of "objective" reality have been cut off. Full "seeing is for its own sake" (p. 255).

In Fiedler's time and culture the idea of concentrating on the phenomena perceived while altogether disregarding the physical reality of the objects reflected in these images was "in the air." Only a few years after Fiedler wrote his essay, the new philosophical school of phenomenology began systematically preaching a complete detachment of the image in our minds from the object in the outside world. Edmund Husserl, the leading philosopher of the school, spoke of "putting the world in parentheses" while focusing on the phenomena in our minds.[5] Fiedler would certainly have embraced the idea of "putting the world in parentheses."

Seeing, however, may acquire different connotations in a philosophical system and in reflection on the artist's work. Fiedler was less interested in visual perception in general than in the specific question of the artist's way to his work. Though still speaking of seeing in general, in fact he concentrated on the artist's experience. In vision the mere perception of existent objects was not at issue, "but the development and formation of images (*Vorstellungen*) in which reality presents itself to the degree that it is a reality that can be perceived visually" (p. 255). In other words, Fiedler was less concerned with the general process of seeing than with the formation of mental images.

Fiedler's doctrine concerning the senses other than vision is interesting in our context. He altogether disregarded the sense of hearing, and thus also the art of music. He did not indicate the reasons for his neglect of sound and music. Was it because sounds are further removed from the rendering of actual reality than the sensations produced by the other senses, or because he was less attracted to music than to painting and sculpture? We

do not know. Yet while he disregarded the domain of sounds, he frequently discussed the sense of touch. He compared and frequently juxtaposed sight to touch. The sense of touch, especially in juxtaposition to the sense of vision, played a significant part in the concepts and terms that arose in the study of art in the next decade, in the nineties of the nineteenth century.[6]

Not only does the sense of touch give information about texture; Fiedler believed that it also provides some notion of form. Some shapes in our mind *do* indeed originate in the experience of touch. Touching is a form-shaping activity. The two senses are, therefore, compared with, as well as distinguished from, each other in terms of the character of the experience, mainly of their specific place in the hierarchy of the senses.[7] Fiedler set out to prove that seeing is superior to touching. To do so he undertook an analysis of the arts.

To show the superiority of sight Fiedler did not dwell on what the eye can achieve as compared to the other senses, mainly touch (as Leonardo did) but on the visual arts. In drawing, painting, and carving, he believed, we produce something that, from its very inception, is intended to be experienced by the sense of vision only. In the domain of no other sense (including that of touch) do we find anything comparable. How is this strange and significant fact to be explained? Implicitly referring to naturalistic explanations and theories that found a strong response at the time, Fiedler mentioned the then popular notions of a "drive of imitation" or a "play drive."[8] Critics using these concepts completely disregarded the question we are concerned with here: how are we to understand that man could develop "out of himself such an activity" only in the domain of one particular sense that of vision? The marvel, Fiedler concluded, is that only "in a specific area of his sensual nature does man achieve the ability to reach expression in a sensual material" (p. 268).

Fiedler did not offer an explanation. He only stated the fact, and emphasized its significance. But this "fact" has wide implications. Thus it tacitly assumes that the purpose of the visual arts is that they appeal to the spectator's eye. This is true not only in the sense that the artist's product cannot be perceived by any means other than sight, but it also implies that anything in a painting or sculpture that does not speak to the eye does not form part of the proper purpose of the visual arts.

At the back of Fiedler's mind there was also another question: why art at all? Though not explicitly raised, it surfaces time and again in the course of his thought. Some of the arguments against mimetic art, against the representation in painting and the related arts of what is called "nature," argu-

ments that were to attain great popularity in the ideological art criticism of the coming decades, were initially raised by Fiedler. "Nature," the reality surrounding us that is supposedly portrayed in painting and the other visual arts, can always be seen. The artist's rendering of what he sees is always incomplete. Just compare an imperfect figuration, such as a gesture or the clumsy beginning of pictorial representation, with the visible appearance of the object in nature itself, as it presents itself to our eye. Of what use is the poor pictorial representation of a reality that in any case is so easily available to the eye in perfect form?

Here Fiedler's real purpose in writing his treatise becomes manifest: his true aim was to write an *apologia* for the visual arts. In the course of the centuries this had been attempted many times. Fiedler's essay differs from all the others in that he did not focus on the nature and function of the articulately shaped work of art. In fact, he did not pay much attention to the product of artistic activity; he had little to say about the picture or the statue. Instead, he concentrated fully on the creative *process*. It was in creative activity, not in its finished product, that he found the value of art.

Here we have to reconsider our notions of representation. We understand a pictorial representation as the relationship between a model and an image reflecting that model. In Fiedler's rather unusual German, he described it as the relationship between a *Vorbild* and a *Nachbild* (p. 274). Fiedler believed that linguistic theories particularly juxtapose the objects of representation and the images those objects portray. Both spheres, then, are separated, even independent, from each other. But the linguistic pattern does not apply to the visual arts. In the creative activity of the painter or sculptor—this was his *credo*—we do not juxtapose the model and its image. The "model" itself, like anything that is part of nature and the external world, is not directly available to us. It is out there, in a domain that, as we have seen, is beyond our reach. What we really have in mind is the artist's visual perception of the model, and his representation of that perception. The same process is continued, though on a different level, in the transition from seeing something to representing it. The artist's hand does not simply record what his eye has seen; rather it continues the process where the eye has left off.

By looking at the creative process which begins with the artist's seeing and leads to his shaping of a representative form, we learn, on the one hand, how art grows out of human experience (and hence, how we can all understand art), and, on the other, the uniqueness of the artist, or "the marvel of art."

Every human being is endowed with the sense of sight. In the initial stage of the creative process, the stage of seeing, we are therefore all on the same level, we are all artists, as it were. Only in the more advanced stages of the process, when it comes to representing what is seen, is the artist distinguished from those who are not creative. While most people do not go beyond mere perception, the artist articulates what he perceives, and casts it into increasingly specific expressive patterns that can be grasped by his audience (p. 271).

The creative process does not move a partial aspect or special ability, it affects the whole person. Fiedler believed that the distinction between bodily and spiritual acts cannot be made in the artist's creative act. Artistic activity, he emphasized time and again, begins with something that happens in our bodily condition, with a "clumsy gesture" that attempts to represent, or to articulate, something of what we see (p. 290). However, this bodily gesture is not a mere "symbol" of a spiritual content or idea; rather, it is part and parcel of the articulation that comes after seeing a form. When the creative process has fully unfolded, including its physical, material activities, the artist attains a particular "brightness of consciousness" (p. 297). Though his work is executed with chisel or brush in hand, in the course of it the artist experiences an "elevated consciousness."

Grasping the unity of body and mind led Fiedler back to the oldest problem in all aesthetic theories, namely, the relationship between art and nature. Fiedler considered it a given that art imitates nature. It was precisely in comparing art to nature that he was confronted with the "unbridgeable" gap between the two, and thus discovered the true foundations for the autonomy of art. Visible nature, in the regular sense of the term, is "the enormous and motley jumble of perceptions and intuitions" that passes before our eyes in a constant flow. No particular effort is called for from the spectator in order to experience nature. The "infinite row of objects that, in infinite combinations," presents itself to our eyes, is "a gift we get without doing anything." In art it is altogether different. Here visibility is not taken for granted. Art is the act of shaping visibility (*Sichtbarkeitsgestaltung*) (p. 312). Art, so Fiedler believed, is essentially a constriction: any articulation necessarily requires reduction. In art, then, nature is transformed. The crude character of the natural object disappears, the material is forced to deny and disavow its very nature.

Here we reach one of the most interesting parts of Fiedler's discussion, though it is only vaguely outlined rather than spelled out in detail. It is devoted to the notion of form. It goes without saying that nature has "visible

form." If nature did not possess such form, we would not be able to perceive it. But nature's form is "confused." Artistic form does not begin from nothing. In this respect Fiedler's thinking was directly opposed to the medieval concept of *creatio ex nihilo*. Artistic form begins with the form offered in abundance by nature. To put it simply: creative activity does not consist in inventing, but rather in refining. The shaping of artistic form is a spiritual process, it is "a progress from confusion to clarity, from the indefiniteness of the interior procedure to the exactitude of the external expression" (p. 323). Natural form and art form are not juxtaposed to each other. A single process of creation leads from the form in nature to the form in art.

At this point Fiedler drew the conclusion—unusual in the various reflections on art—that the task of the artist, or, as he put it, the labor (*Arbeit*) of art, will forever remain incomplete and fragmentary. The overall task or labor of art consists in our ever renewed attempts to push forward into the territory of visible reality, and to bring this reality to human consciousness in the articulate, well-patterned form of art. There will always be a residue—so Fiedler said—of artistically unshaped reality, and hence the task of artistic shaping can never come to an end. The impact of contemporary philosophical trends, mainly of the Neo-Kantian school, is obvious here.[9] But Fiedler presented these ideas not as part of a remote, purely theoretical formulation, but as the "natural" conclusion of his reflections on seeing and the artistic process.

Only here, at the end of his long essay, did Fiedler have something to say about creating the work of art, the artist's actual activity and his working in concrete materials. However one formulates the purpose of the artist's activity, said Fiedler, the latter will always strive to achieve a union or a fusion of the visible and the invisible (*Anschauliches* and *Nichtanschauliches*) (p. 342). Fiedler did not tell his readers what that "invisible" was. He himself was probably not always clear as to what he meant by this notion. But whatever the invisible may have meant specifically in a given work of art, to him it always denoted something that, in a simple sense of the word, was not there; something that was suggested, conjured up, expressed, though it could not be measured and contained in a part of the canvas that could be delineated. Fiedler took it for granted that the work of art has both a material and a spiritual existence.

The expressionist trend in the interpretation of art played a significant role in the eighties of the nineteenth century, perhaps particularly in popular literature and criticism. Fiedler objected to this trend, and this argument, though brief, is significant for the understanding of his overall con-

ceptual attitude. Neither pure vision nor the artist's work aimed to portray expression. "The artist's interest does not aim at expression, in which different interests of emotions and thought combine into one unity . . ." (pp. 342–44). For the history of expressionist theory it is of interest that Fiedler located the expression of a work of art with the spectator. A close reading of Fiedler's text reveals that what we call expression is the spectator's emotional reaction to a work of art. But we should keep in mind that emotional stimulation as such is not unique to art, as Fiedler emphasized. "From a piece of nature (a *Naturprodukt*) we can also receive emotional stimulations. . . ." Even if we find expressive value in a work of art, we should remember that the stimulation of emotion and reflection by a work of art are a "by-value" (*Nebenwert*) of true artistic activity (p. 346).

Fiedler, then, did not deny that the work of art may have a significant impact on audiences and spectators; he even found strong words to describe the effect art has on us. As a particularly illuminating example he briefly analyzed the impact of religious images on devout spectators (pp. 358 ff.). But from all that he said it follows that we have to free ourselves from the "prejudice" that the value of the artistic activity should be sought in the effect the work may have on us. The artist does not reach his highest purpose by subordinating his faculties to any of the sensory powers, but by standing up to them and triumphing over them (p. 364). Perhaps with the advantage of hindsight we can clearly sense how close Fiedler was to concepts of abstract art, and how much these ideas were in the air.

NOTES

1. See Hermann Konnerth, ed., *Konrad Fiedlers Schriften über Kunst* (Munich, 1913). The editor also published a little book on Fiedler's thought, which is not very helpful. See Hermann Konnerth, *Die Kunsttheorie Conrad Fiedlers* (Munich and Leipzig, 1909). Translations from Fiedler are mine.

2. Conrad Fiedler, "Über den Ursprung der künstlerischen Tatigkeit," *Schriften*, pp. 183–367.

3. For the study of language and linguistic theory it may be of some interest that language is here conceived as an activity, sometimes even as an energy. It is also interesting to note that Fiedler distinguishes between the process of language and the completed words.

4. The concept of a "precise sensual cognition," patterned after Goethe's "exact sensible fantasy," is employed by Ernst Cassirer, *The Individual and the Cosmos in Renaissance Philosophy* (New York and Evanston, 1963; the original German edi-

tion appeared in Leipzig and Berlin, 1927), pp. 153 ff. For a survey of Leonardo's reflections on the subject, see Barasch, *Theories of Art*, pp. 134 f.

5. For the school of phenomenology, see especially the works of Edmund Husserl.

6. I should particularly refer to Alois Riegl, for whom see below, chapter 15.

7. It is worth recalling that the hierarchy of the senses is an old theme of human reflection. While in most periods it was considered a scientific problem, it was sometimes also seen in the context of art. See Harry A. Wolfson, "The Internal Senses in Latin, Arabic, and Hebrew Philosophic Texts," *Harvard Theological Review* XXVIII (1956), pp. 69–132.

8. For a later philosophy of the "play drive," also giving some of the concept's history, see Johan Huizinga, *Homo Ludens: A Study in the Play Element in Culture* (London, 1948). This work has been frequently published in many translations.

9. Neo-Kantian philosophy taught that progress in science is an infinite process; there will always be parts of nature that cognition has not reached. This theory, however, was also applied to the arts. See especially Ernst Cassirer, *The Logic of the Humanities*, translated by Clarence Smith Howe (New Haven and London, 1960).

14

Adolf Hildebrand

The significance of vision in general, and of reflection on what was called "pure vision" in particular, is amply manifested in Fiedler's thought. Fiedler, as we have seen, was also aware of the wide inner range of seeing; he knew very well that there are different stages in the visual process, between, say, perceiving an everyday object and what he called "pure seeing." Do we indeed perceive with the same kind of vision an object that is present in front of us and the not clearly defined image of "pure seeing"? He did not suggest an answer. Hildebrand took over where Fiedler left off.

In the late nineteenth century Adolf Hildebrand (1847–1927) was already well known as one of Germany's esteemed sculptors. The son of a liberal professor of economics at Marburg (who took an active part in the revolution of 1848, and consequently had to flee to Switzerland), Adolf Hildebrand grew up in a highly intellectual milieu, but without any contact with practicing artists. His decision to turn to sculpture was, therefore, not taken lightly. After studying at the Academy of Munich, he went to Rome, and it was there that he met the painter Hans von Marees and his friend, the critic Conrad Fiedler. After spending two decades in Italy, mostly in Florence, he returned to Germany in the last years of the nineteenth century, and became part of the art movement.

During his Italian period Hildebrand was profoundly concerned with problems of art theory. He lived and worked in close connection with Marees and Fiedler, and it was mainly the latter's influence and stimulus that shaped his intellectual personality.

During this time, and in constant interaction with his friends, mainly Fiedler, Hildebrand composed his theoretical treatise, *Das Problem der Form in den bildenden Künsten* (The Problem of Form in the Visual Arts).[1] When this short book appeared in 1893, it almost immediately found a surprisingly wide and lively response. By 1914, a mere twenty-one years later, it had already gone through nine editions. This is surprising since the style and presentation are often rather dry, and the text makes for heavy reading.

Nevertheless, in the literature on art we know of very few books whose success can be compared with Hildebrand's. Though not all readers and critics, ranging from artists and historians to philosophers and psychologists, embraced the ideas Hildebrand preached, they were all influenced, in one way or another, by his doctrine.

Das Problem der Form grew slowly.[2] We have the drafts that Hildebrand submitted to his friends, and thus we can watch the gradual emergence of the text, and of the views expressed therein. We should keep in mind, however, that in spite of the way it was composed, *Das Problem der Form* is not a scientific or scholarly book. Hildebrand had little use for theories, past or present, suggested by other students, nor did he attempt to find the foundation for his ideas in the materials of the history of art. His little book contains an artist's confessions and personal reflections. That such a personal book evoked so widespread a response suggests that the author was articulating ideas and emotions that were shared by a large audience.

The starting point of Hildebrand's reflections, like those of Conrad Fiedler's, was not the completed work of art, but the creative process. Fiedler was aware that this involved a radical departure from earlier theories of art. "Since antiquity two great principles, that of imitation and that of the transformation of nature, have squabbled for the right of being the true expression of the essence of art; the conciliation of this quarrel seems possible only by replacing these two principles by a third one, the principle of producing reality. Art is nothing but one of the means by which originally man gains reality."[3] Hildebrand seems to have taken over this thesis implicitly. Understanding art was, to him, to understand the creative process. But the attempt to understand the creative process led him back to trying to figure out what sensual perception is, and how it works for the artist.

Already at an early stage of his development Hildebrand was interested in the problems posed by sensual perception. No doubt, scientific discussions at the time and artists' and critics' reflections had an impact in raising this concern in his mind. In 1873, at the age of barely twenty-six, he wrote to Fiedler that perception is only the receiving of something by means of the eye; it is human reason (*Verstand*) that, with the help of the sensations of touch, combines individual perceptions into a spatial whole.[4] The combination of visual and tactile sensations was to become a major theme in *Das Problem der Form*, and it was a core issue in Hildebrand's influence on thought on art in the next generation.

The concept of a conceptual link between visual and tactile perceptions (even if it appears as a juxtaposition) is not as new or surprising as it may

at first seem. It is a motif of long standing in the history of philosophical psychology, particularly in the early modern age. We are best acquainted with the assumption of such a link from the work of the English philosopher George Berkeley, who wrote mainly in the first decade of the eighteenth century. In Berkeley's *An Essay toward a New Theory of Vision* (1709) the concepts of the relationship between seeing and touching reached classical formulation. The "ideas" in our mind that result from visual experience inform us as to the tactile sensations we are to expect. To some extent, visual space is reduced to space as we know it from tactile experience.[5]

While Berkeley and his followers made important contributions to our specific problem, it goes without saying that they did not consider the problem of vision in connection with art. The originality of Hildebrand's thought lay in his application of the notion of visual and tactile experiences to painting and sculpture.

Hildebrand began his *Problem der Form* with a piece of layman psychology. It was a discussion of what he called "two kinds of pure visual activity." These two kinds, he said, have to be "strictly distinguished" from each other. Let us assume that we are looking at a nearby object set against a distant background. In this rather common situation we actually employ two ways of seeing. For seeing the distant background the spectator does not have to move his gaze, his eyes remain at rest. The objects making up the distant background appear as a flat, two-dimensional extension; the sensation of material depth is altogether lost in these bodies. For these reasons the spectator takes in the background at a single glance.

The nearby object, on the other hand, cannot be grasped in a single glance. The image we have of it has to be composed, as it were, from many individual views. To see that object's various views and dimensions, the viewer's eye has to move from one viewpoint to another, always looking at only one view of the object. To properly see the nearby object and bring it into focus, the eye has to move continuously. This permanent movement of the glance is akin to examining the object by touching it.[6]

Hildebrand coined several terms for these two kinds of seeing, and for the object perceived in them. Thus he spoke of *Nahbild* (image close by) and *Fernbild* (distant image, or image of distance), seeing that is like touching (*Abtasten*) the object, and seeing that is only visual (*Gesichtsvorstellung* or *Fernbild*) (p. 205). He also assigned the two major ways of seeing to the two major visual arts, sculpture and painting, respectively.

For the sculptor the appropriate way of seeing is that employed in perceiving an object close by. His spiritual materials are the images of move-

ment. The painter's materials, on the other hand, pertain to the *Fernbild*. He presents what he sees (in nature or in his mind) on a surface, as if it were a distant image (pp. 209–10). The comparison of the various arts, and particularly of painting and sculpture, is a topic too well known in art literature to be retold here. As a rule, the comparison was presented, particularly in the so-called *Paragone* literature, as a confrontation of their respective values, as a competition between the arts.[7] For Hildebrand the comparison of the arts was not, of course, a matter of ranking them, but of defining what made their natures different.

Hildebrand's views of how the kinds of seeing determine the nature of the arts are most clearly put forward in his discussion of the relief as an art form. The concept of the relief, though invented in ancient Greece, has a timeless validity. It "provides the viewer with a sure relationship to [what he sees in] nature" or to whatever else he looks at (p. 236). But what is the relief? The analysis of this art form was a core piece of Hildebrand's theory.

In the relief, the clash between surface and depth is solved in a way that makes the work of art possible. Hildebrand believed that figures and objects occupying different points in space will be most easily perceived when they are placed on a few clearly separate planes, more or less parallel to the surface of the relief. Such a concept of the relief seems to have occupied him throughout his life. In 1876, when he was less than thirty years old, Hildebrand wrote to Fiedler that he wanted to "define clearly what is frontal to the eye. One separates objects in clear stages which lie one behind another, and everything that appears and lies at one stage, I easily recognize with some sense of distance."[8]

All this leads to one of the decisive premises of Hildebrand's theory. The jungle of different spatial directions is confusing to the spectator. To bring some order into this three-dimensional world in which surface values struggle with those of depth, the artist has to organize the extension into depth in a few imaginary layers of limited thickness. While in itself the figure (or any other material object) is three-dimensional, when it is represented in art it tends to occupy a flat layer. "The figure lives, as it were, in a planar layer (*Flachenschicht*)," wrote Hildebrand; every form strives to expand in surface (p. 235). The patterning in planar layers is the only way the artist can overcome the danger of deep space.

The aesthetic and perceptual foundation of the relief is the distant image (p. 237). In other words, Hildebrand's point of departure was the unifying effect of the surface, into which surface the suggestion of depth is inserted.

The more distinct the two-dimensional character, the more unified and pleasing the work will be. Both the surface image and the distant view are endowed with a particular aesthetic value.

So crucial a part did surface and relief play in Hildebrand's thought that he also conceived of them as the origin of sculpture, particularly of carving in stone, the principal kind of sculpture. Sculpture, he says, "has without doubt emerged from drawing" (p. 256). This he believed to be literally true in the actual process of carving a statue. Hildebrand imagined the piece of stone into which the artist carved his figure as a slab with more or less flat surfaces. The sculptor prefers a slab with flat surfaces in order to begin at the beginning, so to speak, and not to follow something already shaped. On the surface of the slab he then draws the figure in outline. The carving into depth of the stone that then follows is the imbuing of volume to what was originally a drawing on a flat surface. The carving, Hildebrand said, is a "bringing to life of the surface" (p. 256).

Even in the course of the carving process, the surface is in a sense preserved. After the artist has outlined his figure on the surface, he removes layer after layer of the stone from the frontal plane. The model Hildebrand has in mind is the famous method of Michelangelo who likened the carving of a figure in stone to emptying a water basin in which the figure is placed. In such a process "parts lying in the same plane have to be finished before going on to the next layer. In order to maintain a unified vision, the back of the block should remain standing as long as possible and, in any case, any procedure departing from the deliberate freeing of the figure, layer after layer, would lead to confusion."[9]

The great artistic model Hildebrand saw in his mind was not Michelangelo (who in many respects would be ill-suited as a model for such a classic approach), but the cubic figures of Egyptian art. The ancient Egyptians, our author believed, carved squatting, crouching figures from simple cubic stones. In the process the flat surfaces remained perfectly intact. In the spectator's mind, the stone cube may lose its object character: we see a figure rather than a cube. Implicitly, however, the cube continues to exist. The spectator's eye perceives the cubic spatial unit as it originally existed before the carver drew the outlines of the figure.

Let us pause in this discussion of Hildebrand's views to emphasize two points that are inherent to his thought, and in a sense form the very foundation of his doctrine. Hildebrand himself did not spell them out, and may indeed have been unaware of them every time he actually made them. The modern reader, however, cannot fail to note them.

The first point is obvious, being related to the values to which he adhered. Clarity was the supreme ruling value in Hildebrand's doctrine of art. The artist strives for a well-ordered cosmos, it being his aim to present such a cosmos (or some aspect of it) in his work. The reason the suction into deep space is so disquieting, one presumes, is that it forces the spectator into a chaotic unknown. The relief, or the planar composition, are pleasing because they tend to show a well-balanced arrangement. Planar layers are "obstacles" (p. 225) to the pull into depth.

The other point, closely related to the first but not identical with it, is the endowing of certain forms, or comprehensive formal patterns, with emotional qualities. The planar composition is a major case in point, but additional examples may be found in Hildebrand's writings. It should be stressed that our artist-author did not aim at emotional expression in the sense developed in the Renaissance and Baroque periods. In the art of these periods certain individual forms served to express particular emotions (such as anger, sadness, joy, etc.). Hildebrand did not look for a language of physiognomic signs, as it were. He looked for some few basic conditions of form and of broad emotional character alike. What he wanted to find were basic types of form from which general emotional conditions naturally emerge. In this sense he spoke of "building a scaffolding" (p. 221), or of "the tormenting of the cubic" (*das Quälende des Kubischen*) that had not been transformed into a relief (p. 242).

So far we have considered the spatial connotations of figures and other representations. We have seen that aspects of reality, by being represented in art, become "readable" phenomena; from a figure, or a composition, we can read a whole spatial pattern. But this readability of the work of art is not confined to figuring out mere spatial relationships; in a phenomenon, an image in the artist's mind, or an actual work of art, we can also read what Hildebrand called "a motif, an action, an occurrence" (p. 245). The reading of a motif amounts to an explanation of posture or gesture, or of any change or movement in form, by assuming a cause that motivates the change. In so doing, said Hildebrand, we actually impute to the appearance a past, a future, or a permanent effect.

It is not very clear whom Hildebrand had in mind when he spoke of imputing a story (a "past and future") that explains what we see. Was he referring to the artist who reads into a natural configuration of objects a "story" that would explain them, and thus transforms them into the work of art he is about to shape? Or was he referring to the spectator who is confronted with a completed work of art, and makes it intelligible to himself

by inventing the "cause" of the movement represented? As I have just said, Hildebrand's text does not give a clear-cut answer to this question. He may also well have seen in the "imputing" of a past and future a quality common to the perception of both artist and spectator.

While we do not know precisely who does the imputing, we are left in no doubt as to how it is done. We read the phenomena, the artistic images, by enacting with our own bodies what they show. It is in this way that the motifs become intelligible to us. As the child learns to read the facial expressions of laughing and crying by performing the appropriate muscular configurations himself, and thus perceiving the pleasure or displeasure of others from the movements of his own muscles, so we understand images by enacting what we see in them. As Hildebrand put it, we understand images and works of art by directly enlivening them by means of our own bodily sensations (p. 245).

This theory is one of the most widely known and most influential doctrines in art understanding in the modern world. Underlying Hildebrand's approach was the idea of projecting onto the work of art, or onto any object or image, our own emotions. At the turn of the century, this idea was widespread among students in various disciplines and had a profound influence on many fields of study, particularly those prone to psychological interpretations. In the 1890s, in the same decade in which Hildebrand published *Das Problem der Form* but independently of it, Sigmund Freud described projection as "a process of ascribing one's own drives, feelings, and sentiments to other people or to the outside world," and interpreted it as a "defensive process" on the part of the person performing it.[10] A few years later, in his systematic work on aesthetics from a psychological point of view, Theodor Lipps laid down the theoretical foundation of the doctrine of projection.[11] The vigor and influence of the idea of projection can be inferred from one of the most famous creations of this doctrine, which we now know as the Rorschach Test. Published only in 1921, the test went back to experiments initiated a decade earlier.[12]

These ideas, then, were in the air and influenced the thought of Hildebrand's generation. He applied them to art, and particularly to the concept of form. As we have seen before, to understand form our author conceived of the figure in motion. But to read the action by projecting our own sensations onto the statue or painting, the figure represented need not be in actual motion. We can also understand the potential of movement and action. A sinewy hand with long fingers, though seen at perfect rest, will show us the ability to grasp. "It bears as it were the mark of an activity in a latent

condition" (p. 246). Onto such a hand we will project our sensation of grasping. Strongly developed jaw bones impress us as signs of force and energy, because when we forcefully express our wills we tend to clench our jaws.

There is reason to ask what precisely Hildebrand was aiming at in applying the projection theory to art. It is well known that in different fields of investigation, particularly in clinical psychology, projection theory marked a subjectivistic trend of thought. The best-known example of this trend is the Rorschach Test, where projection is used to identify a person's individual leanings. Hildebrand, however, was looking for something altogether different. Though he did not spell out his purpose in detail, he suggested it clearly enough. What he had in mind was the discovery of some basic types of function and expression. These types, he seems to have believed, exist objectively. They are preformed, but firm, patterns of action and projection. "By means of projection the artist arrives at the establishing and shaping of certain formal types that have a definite expression and evoke in the spectator definite bodily and mental sensations" (p. 246).

To the modern reader Hildebrand's doctrine of expressive types has an obvious affinity to the theory of "archetypes" that in psychology as well as in other domains of culture had such a profound influence on the spiritual life of our age.[13] It is important to note that in Hildebrand's views the "types" are not necessarily part of an external, material nature. "Whether we find such a type, that strikes us as unified, ready made in nature, or whether the artist creates it, this is without significance; in both cases it has for us the same degree of reality" (p. 247). What is decisive is that the "types" are not a matter of individual, subjective projection, but have a firm existence and structure of their own.

At the end of *Problem der Form*, the two great themes of Hildebrand's doctrine, space and movement, were shown to be reflected in the materials of sculpture and in the techniques of working in them. In our author's view, only two sculptural materials exist, and hence only two techniques are known. One material is clay, the other stone. He juxtaposed the materials to each other, and the techniques of working in them. The juxtaposition of modeling and carving as the two basic procedures of sculpture, appropriate to the two basic materials, is an old theme in art literature,[14] which has even been interpreted allegorically.[15]

Though the subject, then, is traditional, Hildebrand's treatment of it shows an original mind, and clearly bears the mark of the sculptor. Concentrating our attention on the characteristic and original aspects of Hilde-

brand's treatment of a traditional theme, we note that he assigns to each of the two basic techniques of sculpture to one of the two basic forms of seeing. Carving in stone, he said, "follows only the needs of the eye" (p. 258). The process of carving, that is, the removal of stone layer by layer, is a continuous declaration that carving is done for the eye. When layer after layer is removed in carving, we have a series of reliefs. And the relief, as we have shown, is dominated by the eye.

Hildebrand emphasized that the overall space of the statue carved in stone is given in advance, both in extension (including extension in depth) and as in general shape (and hence also the movements represented), by the size and shape of the stone slab. The process of modeling in clay (and hence the subsequent casting of the clay model in bronze as well) begins from altogether different conditions. Here there is no preestablished overall shape or size—all this is produced by the artist. Hence there is a compulsion to arrive at a "closed, regular comprehensive shape" (p. 257). The artist's point of departure here, Hildebrand concluded, is solely his imagination. But since one's imagination develops with the working of one's hand, it is movement, including the movement of hand and eye, that dominates modeling.

This comprehensive duality, reaching from ways of seeing to materials and procedures of carving, was to become a leading theme in theories of art at the turn of the century.

NOTES

1. I use the critical text in Adolf von Hildebrand, *Gesammelte Schriften zur Kunst*, edited by Henning Bock (Cologne and Opladen, 1969), pp. 199–265. I shall quote from this edition, giving page references in parentheses.

2. Henning Bock gives a detailed survey in his introduction to the *Gesammelte Schriften*. See pp. 17–40.

3. See Fiedler's essay "Vom Wesen der Kunst" (Of the Essence of Art) included in the second volume of his *Schriften zur Kunst*.

4. In a letter of June 17. See Bernhard Sattler, *Adolf von Hildebrand und seine Welt: Briefe und Erinnerungen* (Munich, 1962), p. 229. And cf. Bock's introduction to Hildebrand's writings (see note 1), p. 24.

5. Indications of such views appear frequently in George Berkeley's *Theory of Vision*. As an example, see the end of section 136; see also Berkeley's *A Treatise concerning the Principles of Human Knowledge* (Dublin 1710), section 44.

6. The theory of the two kinds of seeing is set out mainly in the first chapter of *Problem der Form*, pp. 204–11 of Bock's edition.

7. For a brief survey of this literature from the point of view of art theory, see Barasch, *Theories of Art*, pp. 164–74.

8. See G. Jachmann, ed., *Hildebrands Briefwechsel mit Konrad Fiedler* (Dresden, 1927), pp. 160 ff., esp. p. 161. And cf. Michael Podro, *The Manifold in Perception: Theories of Art from Kant to Hildebrand* (Oxford, 1972), pp. 82–91.

9. Rudolf Wittkower, *Sculpture: Process and Principles* (Harmondsworth, 1979), p. 248.

10. L. A. Abt and L. Bellak, eds., *Projective Psychology* (New York, 1959), p. 8. Cf. also several essays by Rudolf Arnheim, particularly "Wilhelm Worringer on Abstraction and Empathy," reprinted in Arnheim, *New Essays on the Psychology of Art*, pp. 50–62.

11. Theodor Lipps, *Aesthetik: Psychologie des Schönen in der Kunst*, part II (Hamburg, 1906).

12. The modern student of art will still look at and read the original publication of this doctrine with great interest. See Hermann Rorschach, *Psychodiagnostik* (Berne and Berlin, 1921). The psychological literature on the Rorschach Test is large, and entirely beyond my competence. For the significance of this test for the study of art (to my mind not altogether clear), see again two studies by Arnheim, reprinted in his volume *Toward a Psychology of Art* (Berkeley and Los Angeles, 1972), pp. 74–89 ("Perceptual and Aesthetic Aspects of the Movement Response"), and pp. 90–101 ("Perceptual Analysis of a Rorschach Card").

13. For a discussion of what "archetypes" may mean for the study of art, I should like to mention the article by Jan Bialostocki, "Die 'Rahmenthemen' und die archetypischen Bilder," reprinted in the author's *Stil und Ikonographie: Studen zur Kunstwissenschaft* (Dresden, n.d. [1965]), pp. 111–25.

14. Barasch, *Theories of Art*, pp. 31 f., 168 ff., 245 ff.

15. Panofsky, *Idea*, pp. 32, 288 ff. See also Karl Borinski, *Die Antike in Poetik und Kunsttheorie*, I (Dresden, 1914), pp. 169 ff.

15

Alois Riegl

Background

The trend in the theory of art that we have been following in the present section reached its fullest expression in work done, and in writings published, around 1900 in Vienna. With Alois Riegl, a historian who was also a theoretician of art, it became one of the formative and permanent influences in twentieth-century reflection on the visual arts. The questions Riegl raised remained a powerful challenge to critical thinking throughout the twentieth century. It hardly needs stressing that ideas originating in the intellectual life of the West as a whole colored Riegl's work, but the conditions in which his doctrine was formulated, those prevailing in central Europe, and mainly in Vienna, at the turn of the century, left their specific mark on it. We therefore begin our discussion by looking at the culture of Vienna around 1900, at least insofar as it relates to our subject.

What we now perceive as Viennese culture at the turn of the nineteenth century was mainly an elitist affair, produced for and appreciated by a small group, although it also found expression in public monuments and performances. Yet what dominated this culture—from our historical perspective—was the undermining of traditional forms and values. The intention to undermine was often not recognized, perhaps not even by the authors and artists who articulated the culture, but the historical effect of breaking up the very foundations of established traditional cultural models and procedures, became clear throughout the century that followed.

I shall not discuss the best-known intellectual creation of those Vienna years which has become a household article in the western world of the twentieth century, namely, psychoanalysis. I should only note that the drive to go behind appearances, to search for clues to a hidden or repressed reality is at the very heart of psychoanalysis. Even in size alone the literature on psychoanalysis has become forbidding, as has its historical impact. Whatever views may prevail at different times, it seems safe to say that in our century few factors have been so successful in undermining belief in reality as

seen by the uninformed eye as has psychoanalysis. Putting it rather loosely, I would say that the attitude promoted by psychoanalysis is the very opposite to that typical of impressionism. The impressionist surrendered to appearances, wishing to detach himself from what the reality behind them might be. The attitude fostered by psychoanalysis, on the other hand, is distrustful of appearances and continuously searching for the "truth" behind them, a truth that is basically different from what originally appeared to the eye or the mind.

In terms of the art world, however, round about 1900 psychoanalysis was in the distant background, perhaps indicating something of a general cultural climate, or at least a significant trend in this culture; but it did not constitute the immediate environment in which the new art theory emerged. Closer to our subject and to Riegl's work were some concrete conditions and disputes that should be briefly recalled.

Art occupied a position of increasing centrality in the culture of late-nineteenth-century Vienna.[1] This culture, heir to long traditions of learning and aristocratic ways of life, was an aesthetic culture. But while it clung to the great and firmly established traditions, its views concerning the scope of art underwent significant transformation. Most of this transformation, perhaps even all of it, necessarily contributed toward undermining the inherited aesthetic norms, and particularly the views of what a work of art is. Two changes are most important for our concerns. Though they partially overlap, one has to consider them separately. I have in mind, on the one hand, a recently awakened interest in the culture and art of different ethnic minorities (that occupied such an important place in the Austro-Hungarian Empire) and of other groups not usually included in the traditional view of what constitutes the art world. On the other hand, there was a new concern with, and new views of, the "lower" arts, that is, the crafts of different periods and cultures that, in the aristocratic tradition, were usually excluded from the art world. Both these transformations were expressed in Riegl's work, and both became permanent elements in the art theories of the twentieth century.

The products of ethnic cultures entered discussions of art under the heading of "folk art." As far as I know, we do not yet have an articulate and comprehensive theory of folk art, one that would distinguish it with sufficient clarity from so-called "tribal art," and would analyze its main structural features and characteristics.[2] Yet whatever the structure of folk art, and whatever the problems it raises, some features will always remain characteristic of it. The first and most obvious is that the work of folk art is anony-

mous. This anonymity does not result from the artist's name having been forgotten or lost, but from the fact that the work has arisen in a way different from what we are used to in "high art." Applying the formulation that Vladimir Propp coined in his discussion of the folktale, we could say that the work of folk art never has an author, an individual artist who created it. Purging the notion of romantic errors, Propp likens the folktale not to literature, but to language.[3] Just as language does not have an author or authors, so the folktale does not have them. The same, we should add, applies to works of folk art in the visual media. Not surprisingly, therefore, nineteenth-century scholars and critics, raised on the traditional model of every work of art having an individual author, found it difficult to include folk art in the subject matter they studied.

The other distinctive feature of folk art also runs counter to the accepted notions of aesthetics derived from the study of high art. This is the simple fact that all, or at least the overwhelming proportion, of works of folk art are objects of some practical use. To be sure, the decoration of these objects may go much further than any practical purpose may require or suggest. But no matter how abundant the decoration, the weaver still makes a tablecloth or a curtain; the embroiderer a shirt or a dress; and the carver some other useful object. The very idea of producing an object—a work of art—the only purpose of which is to be experienced aesthetically is outside the scope and mental reach of folk art.

In addition to folk art, another topic that was a distinctive feature informing Riegl's thought related to the problems arising in the scholarly analysis of the crafts and their products. In the course of the nineteenth century craft products attracted gradually increasing attention. In 1862 the Museum of Arts and Crafts (now the Victoria and Albert Museum) opened in London. It was the first of its kind. One year later, in 1863, the Vienna Museum für Kunstgewerbe (Museum for Arts and Crafts) opened its doors to the public (the architect of the building was Gottfried Semper, who played an important part in the theory of art, as we shall see in chapter 18). True, in the intellectual life of the period, "crafts" remained separate from "art." It was typical, of course, that there were two separate museums for the products of the two kinds of creation. Nevertheless, the concern with craft, however separate from art it remained, widened the range of visual forms and motifs to receive serious scholarly attention.

The intellectual openness to considering craft problems had far-reaching implications for the scope of the study of art with regard both to the historical periods and the cultural areas investigated. Riegl's studies of an-

cient Egyptian textiles and oriental carpets show this clearly. It is obvious, in any case, that the concern with contemporary crafts, with the products of simple peasants and modest artisans, broadened the view of the past.

In addition to extending the range of materials to be considered by research, however, the new appreciation of crafts indicated important shifts in intellectual orientation. Two such orientations are of particular significance for our purpose. First, slowly the "great" painting, the fresco cycle, and the great sculptural monument became less exclusively the subject matter of art historical study. Another aspect is scholarly appreciation of the value of skill that the study of craft products fostered. This was not the skill that leads to a certain effect (such as that invested in producing a deceptive illusion of reality), but rather the display of skill in itself. Scholars came closer to discovering the value, or at least to investigating the complexity, of an intricate interlacing, of the virtuosity demonstrated in tiny pieces of ivory inserted in book covers, or the fascination of handling precious stones as parts of sacred objects.

In the brief comments made so far I have emphasized aspects outside high art that contributed to modifying intellectual perspectives in the study of art. But even in the position and understanding of the traditional domains of art ("high art") there were some processes at work that contributed to the undermining of established norms. One of the wider contexts that should be mentioned is the impact of impressionism, which had begun to be felt outside France. It affected not only painting, but also the way paintings, including those of the past, were seen.

One facet of this impact is directly related to our subject. Franz Wickhoff (1853–1904), a senior scholar at the University of Vienna (only five years older than Riegl), took an important step in appropriating impressionism through his analysis of Roman wall painting. In the introduction to his work on the *Vienna Genesis*, a famous Christian illuminated manuscript from the fifth century A.D., he traced the development of Roman art from Augustus to Constantine, with particular emphasis on painting. Wickhoff's intention was to stop this development being considered an art of "decline," a label commonly assigned to it in the earlier nineteenth century. The wall paintings of the first centuries of our era, especially those of Pompeii, particularly needed defense and explanation. The sketchiness of the Pompeii paintings was interpreted as a sign of the general decline of art in late Antiquity. The "perfunctoriness" of late antique painting, Wickhoff argued, was not a sign of the loss of representative power, as the advocates of the "decline" theory would have it, but the necessary consequence of a new

ideal, namely, of "illusionism." Pompeian painters and their followers did not strive for the representation of objects as we know them to be; instead, they wanted to convey in their pictures the illusion of their being present at the sites and scenes they depicted. The affinity of such illusionism to the impressionism of the late nineteenth century is obvious. Indeed, it was recognized at the time.

The interpretation of Pompeian painting, a core treasure of the classical heritage, as close in style to impressionism shows the implicit, and sometimes even the explicit, impact of modern art on academic thought; occasionally it also foreshadowed scholarly involvement with contemporary painting. A *cause célèbre* in Vienna around 1900 was what has become known (and was famous at the time) as the "Klimt Affair." In the mid-1890s the University of Vienna commissioned Gustav Klimt, a young but already well-known painter, to make three large ceiling paintings for the ceremonial hall of the new university building. In the tradition of the Enlightenment, the subject for these paintings was defined as the "Triumph of Light over Darkness." But while the subject matter seemed traditional, Klimt's execution of the paintings was not, or so at least some of the faculty thought. Protesting professors, led by the philosopher Friedrich Jodl, rejected Klimt's paintings. What Klimt had done, they said, was to show "blurred ideas through blurred forms" (*Verschwommene Gedanken durch verschwommene Formen*). When the debate became heated, the main argument against Klimt's paintings was presented in aesthetic terms. The paintings, Jodl said, were "ugly."

At this stage Franz Wickhoff, followed by some professors, among them Riegl, rose to Klimt's defense. Picking up Jodl's argument and developing it into a theoretical discussion, Wickhoff asked, "What is Ugly"? This was the title of a lecture he gave in 1900 at the Philosophical Society of Vienna. The question was not new in philosophical thought. In 1853 Carl Rosenkrantz, a student of Hegel's, had published a great work *Die Aesthetik des Hässlichen* (The Aesthetics of the Ugly). But while Rosenkrantz's discussion was both comprehensive and abstract (not concentrating on specific trends and even less on specific images), Wickhoff had a definite pictorial direction in mind; it was the direction represented by Klimt's paintings. Wickhoff pointed to the historical, and therefore changing, nature of judgments of beauty or ugliness. What one period considered ugly, another may see as beautiful. More important in our context, however, was another point in this debate. What Jodl defined as "ugly," so Wickhoff suggested, was a specific trend in painting, and thus it followed that the

"ugly" had well-defined characteristics. The blurred, the indistinct, the lack of firm outlines, Wickhoff concluded, were considered ugly. Now, it is clear that the blurred, indistinct shape, and the lack of clear outlines have a close affinity to central features of the impressionistic style as it was perceived at this time.

Wickhoff's discussion shows that a sense of crisis had penetrated the interpretation of the visual arts. The breaking up of established categories and norms necessarily affected the intellectual domains of high art reflection. It was in this context that Riegl formulated his theory. In some respects it expressed the sense of crisis and showed more clearly than other theories of the time the crumbling of accepted norms and notions. In other respects, however, it attempted to provide an answer to some of the principal questions posed by the crisis of tradition.

Riegl: The Works

Alois Riegl (1858–1905) was not primarily a theoretician or critic of art in the traditional sense. He was a historian, a professional student of the history of art, a field recently established as an accepted academic discipline. Being a historian, of course, his attitude was oriented toward the diachronic story of events and a concern with concrete objects. A considerable part of Riegl's professional life was spent in museums, largely in the Museum für Kunstgewerbe that had recently been established in Vienna. He was thus necessarily concerned with questions of connoisseurship. But his work in museums also made him attentive to the structure of different media, a structure that does not necessarily change in the course of time.

Many of his writings, among them pioneering studies that opened up new fields of investigation, were closely linked with his work in the museum. His early studies of Egyptian textiles (Die Ägyptischen Textilfunde im Oesterreichischen Museum, Wien [Waldheim, 1889]) as well as of contemporary craft ("Die Textilindustrie im nordöstlichen Boehmen," that appeared in 1886 in the Mitteilungen des Oesterreichischen Museums) show this clearly. His first major book dealt with oriental carpets (Altorientalische Teppiche [Leipzig, 1891]), examining their structure rather than their history over time. Even his best known, most influential work, the monumental study of "Late Roman Arts and Crafts" (Spätrömische Kunstindustrie) dealt primarily with objects in the rich collections of the Vienna Museum; it was even commissioned by the Museum. It is certainly Riegl's most

challenging book, one of the central documents of reflection on the visual arts composed in modern times.

His main study of a historical development was *Stilfragen: Grundlegung zu einer Geschichte der Ornamentik* (Problems of Style: Foundations of a History of Ornament) (Berlin, 1893). Here he brilliantly traced the continuous history of an ornamental motif from the early Egyptian lotus to the late "Sarrazean" (i.e. Islamic) arabesque. Other works, though devoted to historical subjects, were more concerned with permanent structure than with the flow of events. Among them was *Das Holländische Gruppenportrait* (The Group Portrait in Dutch Art), originally a two hundred-page article that appeared in 1902 in *Jahrbuch des Allerhöchsten Kaiserhauses*, later reprinted as an independent volume. Though this work dealt with a specific historical phenomenon, the group portrait in seventeenth-century Holland, in it Riegl was searching mainly for the "essence" of this art form. Even his lectures on *Die Entstehung der Barockkunst in Rome* (The Emergence of Baroque Art in Rome), published posthumously by his former students A. Burda and Max Dvorak (Vienna, 1908), was a study of the essential character of Baroque art rather than of the stages of its emergence.

In all his works, then, Riegl combined historical and structural aspects. It should be noted, however, that nowhere did he deal with abstract problems of theory. His discussion always centered on a group of tangible objects pertaining to a certain time in history, or the flow of a motif through the ages. Riegl was thus not a student of theory. Nevertheless, philosophical, psychological, and aesthetic theory played a crucial part in his thought, although usually not explicitly presented. After almost a century, his theoretical legacy is still a living power.

In this chapter I shall not discuss Riegl's contributions to the history of art, but shall concentrate on his theoretical assumptions, even if they are obscured by a historical study. For this reason I shall consider his writings selectively, concentrating on certain problems of art theory that emerge from them.

The Theory

Modes of Sensual Experience

Among the leading ideas of Riegl's theory of art is the antithesis between what he called the "tactile" or "haptic" and the "optic" forms. He himself

considered this contradistinction as basic to his whole theory, as we can see from the fact that he began his major work, *Die Spätrömische Kunstindustrie*, with a presentation of these notions.[4] Though concise (pp. 24–26; 32–33) the discussion was in fact complete, and adduced all the major ideas Riegl dealt with in the context. Before we turn to a discussion of what "haptic" and "optic," and their polarity, imply, we should first see why Riegl introduced these concepts, and, second, how they arose.

Dealing in this work with the art of late Antiquity, Riegl naturally had to come to terms with the way it was viewed in his time. Late antique art, it was reiterated indefatigably, was an art of decline which showed the inability of the artists and artisans of the early Christian centuries to live up to the great models of classical beauty. Late Roman buildings and images showed the marks of "barbarization." Riegl's defense of late antique art and his attempt to present its specific forms and values were of course no simple apology. Not only did he differ from most students at the time in his evaluation of the achievements of late antique works, but he also demanded different criteria of judgment. This caused several difficulties, and had far-reaching consequences both for the philosophy and history of art.

One of the most important conceptual developments at the turn of the century was the broadening of the scope of what art means. We have already considered some aspects of the impact of so-called "primitive" products on the notion of art.[5] Perhaps following the example of "primitive art," a new concept was coined, "children's art." Scholars tried to outline the scope of "children's art" and to bring to the fore the specific approaches that prevailed in it, thus educating the public to appreciate the products of children's imaginations. A late, but (as far as possible) complete, presentation of these ideas was made by the American educator Victor Löwenfeld (originally from Vienna).[6] According to Löwenfeld, children's drawings should be judged by standards other than those applied to high art. "It is extremely important," he stressed, "not to use naturalistic modes of expression as the criterion of value, but to free oneself of such conceptions."[7]

But how was one to describe, and explain the emergence of, the mode in which a child represents the world surrounding it? The optical refinements of high art, especially of the painting that followed the classical model, if only freely, was obviously not to be found in children's drawings, as they cannot be found in genuinely primitive art. The empty space, the foreshortened figure or object, the overlapping of one figure by another—all these were clearly and consistently missing from these drawings. Could this not be explained by the fact, psychologists asked, that a child's mode of rep-

resentation was based on a dimension of experience and perception other than that assumed by adults? It was in this context as this that the theory of tactile experience as a source of pictorial imagery arose.

Haptic and optic experience, that is, experience by touch or by sight, naturally diverge in scope. The ideas accepted in our culture make sight not only our major, but practically our only, source of cognition of the outside world. There is, nevertheless, a venerable tradition which favors considering cognitions of the world derived from the other senses, mainly touch. Thus the particular refinement of touch that the blind seem to possess attracted the attention of philosophers and critics. Already at the end of the seventeenth century the English philosopher John Locke noted the tactile abilities of the blind.[8] About the middle of the eighteenth century, Denis Diderot, one of the central figures of the French Enlightenment, devoted an important study, the *Lettre sur les aveugles* (appeared 1759), to the cognitive abilities of the blind.

Only a decade after Diderot's *Lettre sur les aveugles*, the German philosopher and man of letters Johann Gottfried Herder wrote his little known but important essay on sculpture (*Plastik*).[9] It was the first systematic attempt to link sculpture to tactile experience. We shall shortly come back to this particular subject. At the moment, however, we shall briefly consider Herder's views on visual and tactile experience as such, regardless of its meaning for art.

Though he was aware of the complexities involved, Herder tried to reduce the two modes of sensual experience to a simple formula. "Vision shows us figures (*Gestalten*), touch shows us bodies (*Korper*)" (p. 243). Everything that has (or is) shape is grasped by the sensation of touch; by vision we grasp only surfaces, visible surfaces, but not bodies. The qualities of "impenetrability, hardness, softness, smoothness, form, shape, roundness cannot be grasped by the eye." We believe that we see them because in fact we are assisted by the experience of the touching hand (p. 245). Touching, then, is a basic human experience. Come to the child's nursery, Herder said, and see how that "little person of experience" grasps everything with his hands, "weighs, touches, measures with hands and feet." Bodies and material objects are treated by touching.

Vision, on the other hand, cannot provide this fullness of material solidity. In vision we perceive only surfaces. "To provide to the eye massive objects as such is as impossible as it is to depict a singing lover behind a thick wall, or the peasant within the windmill" (p. 243). To the eye the object shows just as much of itself as my mirror image shows of myself. No

wonder, then, that Herder summarized his views in the epigrammatic sentence: "In vision there is dream [illusion], in [tactile] sensation, truth" (p. 247). But in spite of his passionate apology for the world of touch, Herder was well aware of the unique ability of the sense of vision to grasp some dimensions of our sensual experience that cannot be reached by any of the other senses. Most important, vision can grasp the space between one solid object and another, and the overall space in which they are placed. It is for this reason that vision can create a continuity that is not limited to extended tangible objects, and that includes the "full" and the "void," as it were. For this reason, Herder believed, vision is the most spiritual of the senses.

We need not add further references to the development of a comparative study of touch and vision. In the nineteenth century, investigations of sensual perception became part of empirical science, and branched out in a variety of specific subjects well beyond the horizon of the student of art. We conclude this discussion by noting that when students primarily concerned with the arts compared the two modes of experience, the tactile and the visual, they tended to emphasize the contrast, even conflict, between them. Following the line of thought presented by Herder one may find it difficult, perhaps even impossible, to understand how the transition could be made from one mode of experience to the other. What, then, was the specific meaning of haptic and visual in a discussion of art? Here we come back to Riegl.

For Riegl, haptic and optic were two modes of sensual experience and two types of style. But they were also two extremities in a historical process. Riegl was the son of his time in many respects, among them in seeing history as unfolding in cycles. In the nineteenth century, it seems, the cycle theory was particularly prominent in what we would today call cultural studies. Riegl saw a huge cycle in the history of ancient art, beginning with early Egypt and ending with the last works of late Antiquity produced in the early Christian era. This lengthy process passed through three main stages; the specific nature of these stages showed the transition from the haptic to the optic.

The three-phase cycle was a favored model in nineteenth-century thought. We remember Hegel's model of the "unfolding of the spirit" in three historical stages, as presented in his *Aesthetics*.[10] Riegl cannot have been unaware of Hegel's philosophy,[11] though at the turn of the century an anti-Hegelian mood was clearly prevalent. His own theory of the cyclical

phases, which differed from those Hegel proposed, attempts to answer our question, namely, how does the haptic pass into the optic.

The first stage of the cycle is dominated by a purely sensual perception of the world. At this stage man does not step back to survey the objects around him: rather he sticks close to them. This closeness to the objects "suggests," as Riegl put it, tactile experience. If we want to speak in terms of seeing, we would say that it is the visual experience of the very near-sighted, a person who, in order to see, comes up very close to the thing he is looking at. Now, what do we perceive when we are so close to the object of our perception? We perceive, first, the plain material solidity of the object, its "impenetrability." Second, we perceive the quality of the object's substance, what in another context may be described as its texture. What we do not perceive is space itself, the extension into depth. In other words, we do not perceive whatever is not the object itself.

In imagery this stage is best represented by the art of ancient Egypt, though it is also manifested in some works of archaic Greece. Egyptian art consistently avoided foreshortenings and shadows because both "betray" the existence of deep space, and thus go beyond the mere object. "Foreshortenings and shadows (as betrayers of deep space) are as carefully avoided as the manifestation of emotions (as betrayers of the subjective life of the soul)" (p. 32). In this first stage the limits of the material object are emphasized.

Even at the risk of stating the self-evident, it has to be recalled that Riegl used the terms "haptic" and "optic" metaphorically, in order to describe or suggest certain qualities of style in all the visual arts. That the art of the first stage is haptic does not mean that it actually originated from touching rather than from seeing. The image that Riegl evoked of a man touching the shape of the object (the artist?) or of the carved relief (the spectator?) Was only meant to indicate the nature of the style.

The second stage holds the middle between the short-sighted and the far-sighted; it is the stage of the normal sighted, of balance between the haptic and the optic. At this stage man draws back, as it were, from the object, and the eye becomes the major means of reporting to one the shapes of the world. However, the distance between man and object does not widen so far as to make one lose sight of the continuous material solidity of the object. At this stage, shadows are noted and represented, but they are only "half-shadows" that make plain the material continuity of the figure or object represented. The art of classical Greece fully represents this stage.

The process from haptic to optic reaches its end and completion in the third stage. Metaphorically we could say that man has now moved back from close proximity to the objects that fill his world, and now looks at the reality surrounding him from a distance. What are the new and specific features of the art of the last stage of the cycle? First, it is only at this stage that we perceive objects and figures as extending into three-dimensional depth. Riegl's presentation implies that what we call three-dimensionality is typical of visual experience. Only when I move away from the material object and look at it from a distance (without actually touching it) do I perceive it as having the dimension of depth. A second feature is that objects "emerge" from the surface of the picture; they become detached from their background. In an Egyptian relief the carved figures never really interrupt the surface. In Egyptian painting, the figures are sharply outlined, but within the outlines they are not modeled (p. 96). In late antique relief and painting the three-dimensionality of material figures and objects interrupt and invalidate the continuity of the surface. The surface itself is interrupted, mainly in painting, by deep shadows. A third feature, finally, is the fact that things seen in the far distance sometimes have blurred outlines, so that they seem to merge with the space surrounding them. The close affinity of these features to impressionistic style is obvious. In fact, in the early twentieth century scholars often spoke of "ancient impressionism."[12] In a note in *Die Spätrömische Kunstindustrie* (p. 35) Riegl found it necessary to set off the "optic" style of late antique painting from modern impressionism, but he also admitted their close affinity. It seems clear that developments in modern art, the art of Riegl's own time, inspired and partially shaped his views on ancient art.

Let us stop here for a moment in order to try and assess, if only in bare outline, the place of Riegl's theory in the history of reflections on art in the modern world. Here old and new, inherited traditions and recent upheavals against them, interact. On the one hand, the impact on Riegl of the philosophical tradition that was prevalent throughout the nineteenth century is striking. In considering the concise outline of the historical cycle that underlies his whole work, one is reminded of Hegel's gigantic construction of the unfolding of the arts in the course of history. Hegel, too, began with a culture (Egypt) in which the material character is overwhelming and determines all types of artistic creation. He ended with a "spiritual" stage, of which painting and poetry were characteristic. There are, of course, many obvious differences between Hegel's final, spiritual stage in the unfolding of the arts and Riegl's concept of late antique and early Christian art as "optical," yet one

cannot but note their similarity. Riegl's "optical" art was in many respects a true parallel to Hegel's spiritual stage in the history of the arts. It is also worth noting that for both Hegel and Riegl, however much they may have differed from one another in other respects, the art of classical Greece constituted a harmonious balance between two extreme poles: between the material and the spiritual for Hegel, between the haptic and the optic for Riegl. For both, classical art remained the embodiment of harmony.

The differences between Hegel and Riegl, however, are no less striking. While Hegel's basic assumption, which served as the foundation for the whole historical structure in his *Aesthetics*, was that the Spirit moves from dependence on, and embodiment in, sheer matter to free itself to spirituality, Riegl's basic assumption was the existence of different modes of sensual experience. For him, the different structures of sensual experience ultimately explained the different types of artistic creation. In thus totally basing himself on the empirical level of measurable experience, Riegl was part and parcel of late-nineteenth-century culture. It was a culture that transformed empirical, experimental psychology into a kind of general science. Many believed that psychology would be able to solve most problems in the arts, and serve as a solid foundation for the study of the life of the mind in general.

Harmony

Haptic and optic are two polarized types of style; as we have seen, they are also the opposite ends of a great historical process. But what is their meaning in art beyond the obvious, namely, that they are modes of perception leading to distinct styles? And what moves that historical process that leads art from the haptic to the optic style? Riegl nowhere discussed these questions directly, he hardly even referred to them as subjects for further investigation. But carefully reading his work one cannot doubt that questions of this kind occupied his mind, though they did not surface in a systematic text. By reconstructing some of these half-submerged thoughts, we will better understand the views he put forward explicitly. It may also shed some light on the reasons for the profound impact of Riegl's thought on the reflection on art in the century that has passed since his work was published. We shall begin with the second question: what makes the style of art move from one type to another?

In 1899 Riegl published an interesting, though unfortunately little known, article entitled, "Die Stimmung als Inhalt der modernen Kunst"

(Mood as the Subject Matter of Modern Art).[13] That same year he gave a course of lectures at the University of Vienna under the title, "Historische Grammatik der bildenden Künste" (Historical Grammar of the Visual Arts), which remained unpublished for over sixty years.[14] In these studies, so different in form, Riegl provided in bare outline a kind of conceptual framework for the explanation of the historical process. This framework may be described as a general historical doctrine of man, something resembling a philosophical anthropology. I shall try to lay out this doctrine without asking if any part of it is tenable and can be accepted in our own day.

Riegl's basic assumption was that man continuously longs for redemption. Redemption appeared to Riegl as perfect harmony. The drive for harmony is characteristic of man; animals, he believed, have no emotional need for harmony (*HG*, p. 256). Looking at a beautiful and peaceful landscape in nature one sometimes experiences the "redeeming mood" of harmony (*A*, p. 30), but what one usually encounters in nature is only "permanent unrest" (*HG*, p. 216). Man desires to be freed from the condition of unceasing restlessness, of continuous strife. This is where art comes in.

Since we cannot find the redeeming harmony we seek in nature, we want art to conjure it up for us. Right from the beginning, Riegl stated rather boldly, art has had no purpose other than to provide man with the "consoling assurance" that the order and harmony he cannot find in nature do indeed exist (*A*, p. 31). Artistic creation competes with nature in the expression of a world harmony (*HG*, p. 217), and the history of art is a movement oriented toward a redemptory final goal. In some respects Riegl's construction of history was again surprisingly similar to Hegel's, who conceived of history as an unfolding toward the Spirit knowing itself. Riegl's view of the history of art as an unfolding of the desire for a redemptive harmony, and of mankind's gradual attainment of that goal, also derived from the Christian worldview of mankind's way to final redemption. Although these sources of his thought are not explicitly stated, it was within these cultural traditions that his views developed and were articulated.

On its way to attaining this goal, art passed through several stages. The first stage, the beginning of the story, was the state of general warfare; everybody fought everybody else. This stage, Riegl said, caused a feeling of unease (*Unbehagen*). In this condition man created a material embodiment of the hostile forces, and worshiped it in the belief that such behavior would bring about harmony. This embodiment was itself a fetish. "The fetish marks the beginning of religion and of all higher art" (*A*, p. 31).

The years in which Riegl articulated this doctrine were a time of dra-
matic development in the study of religion, and particularly of primitive
and tribal religions. It was also a time when the artistic character of the
products of primitive societies, to be discussed later in this volume, was dis-
covered.[15] By stating that the fetish was the beginning of both religion and
art, Riegl reflected issues that dominated some of the major intellectual
trends of his time.

The next stage of development, Riegl believed, was the time when the
stronger attained complete victory and thus imposed harmony by force.
This period spanned the whole of Antiquity, and found its natural climax
and end in the Roman emperor (*A*, pp. 31–32). "Hence, ancient art cele-
brates physical force, the victorious. . . ." In Antiquity the gods were always
strong and beautiful. A "naive trust in god" prevailed in this period. But the
harmony, even if only imposed by force, was disturbed by awareness of the
tension between body and soul, between sheer matter and the spirit. In Hel-
lenism awareness of the gap between the material and the spiritual began
to emerge, creating once again a feeling of "unease" (*A*. p. 32; *HG*, pp.
231–232).

The *Unbehagen* just mentioned initiated the third stage in development.
This was the stage of Christianity which extended from the end of the
pagan world of Antiquity to modern times. It was a stage of spiritual reli-
gion, and the art of this time expressed this nature. Christian art continu-
ously emphasized the spiritual character of God and the saints. The spiri-
tual—this was Riegl's underlying assumption—brings or assures harmony.
But here too an intrinsic contradiction remained. For Christian medieval
art, as for the art of pagan Antiquity, the human body was the central sub-
ject matter. But since Christian art was concerned with spiritual perfection
rather than with the body's beauty, it concentrated on that part of the fig-
ure in which the movements of the soul were more clearly reflected than in
others, namely, the face (*A*, p. 33). This focus on the spiritual derived from
the desire to attain harmony. Artists tried to show the spiritual God
through the mirror of spirituality, the face.

For a proper understanding of what Riegl meant by "mood," the end to-
ward which this whole construction of history should lead, it is significant
that he included the Renaissance in the encompassing frame of Christian
art. Riegl was, of course, aware of the many features in Renaissance culture
that contradicted medieval beliefs and artistic practices, yet he believed that
in the period of "Revival" the crucial step toward a modern worldview had
not yet been taken (*HG*, pp. 241–42).

Here we reach the fourth stage, "perhaps best described as that of a scientific worldview" (*A*, p. 34). This was the stage of the modern world. Riegl had some difficulty discerning where and when it began (*HG*, p. 243). Note, it was not the transition from religious belief to secular views and culture that was crucial to him, but rather the transition to a period in which knowledge was the central feature. Hence he elevated the awareness of the principle of causality (which seemed to him to be a complete embodiment of knowledge) to the level of an almost religious truth. The sermon of scientific knowledge was here preached with a conviction and fervor that is known to us only from the domain of religious enthusiasm. What was it in the awareness of causality, and in scientific knowledge in general, that endowed it with this almost messianic nature?

Riegl's answer was that scientific knowledge becomes insight into the prevailing harmony, and this insight is redeeming. Scientific knowledge

> creates for us the redeeming harmony by letting us see, beyond the narrowness of conflicting phenomena, a whole range of such phenomena from a distance. The more phenomena we comprise in one glance, the more certain, liberating, and elevating is the conviction that there is an order that settles everything harmoniously for the best. It is essentially on this harmony, both provoked and presented by knowledge, that modern art, the art of the mood, is based. (*A*, p. 34)

Riegl's historical construction has obvious flaws, most of which we have not even mentioned.[16] If nevertheless we have traced the outlines of this construction, it is mainly to show how, in his mind, the "art of mood" was the final, and he believed, the necessary, outcome of a development encompassing the whole of human history. But what did he mean by "mood" (or whatever the translation of *Stimmung*) and how is it related to Riegl's theory of the visual arts?

The German word *Stimmung* is a very complex one, only partially translated an "mood." The philologist Leo Spitzer has devoted a whole volume to tracing the many sources and connotations of this word, and in so doing has opened up fascinating perspectives in the history of ideas.[17] In *fin-de-siècle* Vienna, it was popular and fashionable to speak of *Stimmung*.[18] It is thus not surprising that this word is so versatile in meaning that it can serve a variety of purposes. All this need not mislead us, however, in understanding what Riegl intended by *Stimmung*. Two main characteristics should be emphasized in his application of this word to art.

First, in Riegl's usage of the word, *Stimmung* was not just an emotional condition, fitting different moods. It had something of the redeeming quality of resolving dissonances, a condition to which we all strive. "*Stimmung* as the aim of painting," Riegl wrote, "is thus in the last place nothing else than the soothing conviction of the immovable rule of the law of causality" (*A*, p. 35). Note that in this context Riegl did not speak of a *Stimmung* of, say, despair, or of rage, or even of hope. What he means by this term was thus not simply "mood." He had in mind that harmony that is the final hope of mankind.

The second characteristic of *Stimmung*, as Riegl applied this concept to art, was its abstract nature. We recall that in the first stage of history people made a fetish, a thing, or an object, to embody evil forces. In the second stage, it was the figure of the god or the emperor that was central. In the third stage, the Christian period, the figure of the spiritual God was still a tangible body, even if artists concentrated their attention on His face. But *Stimmung* was not a thing, it could not be turned into an object or body. It necessarily remained less material, less bodylike than anything representing earlier periods.

How was this theory of *Stimmung* as the subject of modern art related to the whole of Riegl's art theory? It appears that the *Stimmung* doctrine of modern art was intimately linked with other aspects of Riegl's theory. I shall concentrate on a few areas.

The most obvious issue leads us back to modes of perception. As *Stimmung* is not tangible, it is not an object or a figure, and no tactile, haptic perception of it is conceivable. *Stimmung* necessarily requires optic perception or distant vision (*Fernsicht*). Thus one understands, wrote Riegl, "that the modern need for *Stimmung* can be satisfied only by a distant-vision painting based on purely optical perception" (*A*, pp. 35–36). Such an attitude implies that space is significant as a subject matter, or perhaps *the* subject matter, of painting. But space, we recall, is a subject that by its very nature can never be turned into a thing, a tangible object. The significance of space implies, in turn, that painting is superior to all the other visual arts, mainly to sculpture. Just listen to what Riegl had to say about sculpture in the modern age: "But that other kind of 'higher' art that dominated classical Antiquity—sculpture that provokes the sense of touch and hence necessarily is [an art] of close vision—essentially owes its continuous care [or attention] nowadays only to the tendency to inertia of cultural tradition and to the need for ornamentation" (*A*, p. 35). The time for sculpture was over, the new message came from painting.

The contemporary reader will note that the "harmonious" painting Riegl envisioned actually came quite close to some mild form of impressionism. Riegl himself seemed to have been aware of this. In a discussion of semi-impressionistic works of Dutch painting he said that in the pictures of certain modern artists, when viewed

> in extreme close-up, this kind of really broadly painted image is frequently unviewable. We perceive a chaos of strokes and spots. In modern exhibitions, one can assure oneself of this at every step. Only when observed from somewhat of a distance do the spots of color unite properly into unified and soft planes. What do we gain thereby? While the finely fused painted object of the old masters seemed, when viewed from a distance, stiff, lifeless, woodenly flat, and . . . hard, things treated in the newer manner seem to acquire soft outlines, physical roundness, in short: life. . . . Sometimes one imagines one sees the air between it [the figure or object] and its environment. Thus the painter paints even the incorporeal.[19]

It is, I believe, because of his philosophical construction of history that Riegl thus became the prophet of impressionism. Personally he seems to have had little use for the impressionistic painting of his own day. I have not been able to find any reference to the French impressionists in his published work. In the 1899 article we have so often quoted he said, "In the most immediate form the essence of Stimmung reveals itself in works of masters like Max Liebermann or Storm van s'Gravesande, who represent a segment of their environment with all its optically perceptible accidents, in contour and movement, light and color" (*A*, p. 36). As far as I can see, Riegl did not come back to the works of Liebermann and s'Gravesande. It is obvious, I think, that it was not their individual creation that made them so prominent in his eyes, but their being exemplars or representatives of a stage of art history. In his construction of history their impressionistic painting achieved the realization of that harmony to which all art aspired.

Organic and Crystalline Beauty

Riegl explored the two opposed types, haptic and optic, not only as modes of perception and as the extremities of a great historical cycle, but also because he considered them to be articulate entities existing in themselves, beyond sensual perception or historical development. He projected them as "objective" beings of some kind. If you wish, one could say that he gave them something of a metaphysical existence. Two main questions nat-

urally arise here. First, what is the status of this self-enclosed, objective entity that he envisioned? And second, what is the specific nature of each of these types qua objective entity? We shall examine the concepts occasionally called "organic and crystalline beauty."

It should be stressed at the beginning that Riegl nowhere presented his views on this subject in any coherent and systematic fashion. He made only a few fragmentary allusions to it. The main source for his comments is the lecture notes of 1899 (*HG*, pp. 257 ff.), in addition to some references in *Die Spätrömische Kunstindustrie* (p. 247). But though Riegl's comments were fragmentary and scattered, they were significant in the overall structure of his thought, and there can be no doubt that they made a profound impact on twentieth-century reflection on art. Notwithstanding the fragmentary character of these comments, Riegl's ideas on the two entities can be reconstructed in their main lines.

In the course of a long history of classical and classicist aesthetics it has been tacitly assumed that there is only a single type of beauty or perfect form. From time to time, to be sure, different views have been voiced. Dürer's suggestion that the peasant has a beauty that differs from the beauty of a knight comes to mind.[20] But such views did not influence the profound belief that there is a single norm of beauty and perfection. "In beauty there is no variety"—in these words Winckelmann summarized the great tradition of classicist aesthetics.[21] It was Kant who showed that two basic and different types of beauty were possible, in his discussion of "free beauty" and "adherent beauty."[22] To be sure, Kant's types of beauty differed in nature from those assumed and studied by later thinkers. But the very idea that different types of beauty were in principle possible was an important legacy of Kantian philosophy to the aesthetic thought of the nineteenth century. In the field of the visual arts, however, Riegl seems to have been the first to distinguish between two types of beauty or intrinsic formal perfection.

Riegl linked the types of beauty to different stages in the historical development of art. One type was characteristic of an earlier stage, the other of a later. This should not mislead us, however, into assigning different degrees of value to the two types. Though different in nature, the two types were never considered unequal in intrinsic consistency and formal perfection.

What was it that distinguished one type from the other? "All things in the world" that can be subject to artistic representation, Riegl said, are divided into two groups: one consists of "the inanimate, dead, inorganic motifs";

the other of "the live, organic motifs." The criterion that separates one group from the other, he emphasized, "is life, and life manifests itself in movement" (*HG*, p. 247). Note, it was not movement as such that divided the groups, but life. Objects pertaining to both groups were, in principle, in continuous motion. But in the motifs pertaining to the first group, the organic one, movement was inherent; in those forming the other, movement resulted from the impact of external forces. This division was not only a matter of grouping living bodies on the one hand and inanimate objects on the other. Riegl was also thinking of two comprehensive principles of form, the organic and the crystalline (as he called the inanimate forms). These principles had an existence of their own. Hence he spoke of "Crystallinism" (*Kristallinismus*).

Riegl was obviously fascinated by the crystalline forms and motifs, devoting less space and attention to the organic ones. The reason for this unequal consideration may well be that organic forms were the inherited, traditional norm of high art. Giving the impression of life was for centuries the highest aim of art; it was also the accepted norm for appreciating works of painting and sculpture. The perfection and value of the crystalline forms and motifs had to be shown to be equal to those of the organic, and this was what Riegl tried to do. In his 1899 lecture notes he gave a description of the crystal as a geometric form, which reads almost like a description of the work of art.

> The crystall in its purest form, as an orderly polyeder, . . . is an absolutely symmetrically shaped body, that by every cut through its center is divided into two fully identical halves: right and left, top and bottom are always the same. It is further limited by equally symmetrical surfaces that meet in sharp angles. Such a crystal is absolutely clear in its appearance: it is an individual (*Individuum*), necessarily enclosed in itself by the symmetry of the whole; but it is also clear in its parts that are limited by edges. (*HG*, p. 247)

The formal characteristics of the crystalline mode were thus (1) absolute symmetry, and (2) sharp distinction.

These were precisely the features that Riegl discovered to be characteristic of certain styles and of the artistic production of certain periods. He found the perfect model of "crystalline" art and beauty in the artistic legacy of ancient Egypt. In their works of art "the ancient Egyptians [showed] the rigid material crystallization" (*KI*, p. 247; tr., p. 137). Basing himself on late-nineteenth-century discussions,[23] Riegl analyzed specific "laws" indicative of this attitude in Egypt. The major specific rule ("law") was that in all fig-

ures, mainly in sculpture in the round, the head and torso of the figure held precisely the same axis. A straight line led from the top of the skull to the figure's sexual organs; if one were to split the figure down this line, one would obtain two identical halves. This meant that in head and torso there was no real movement. Movement was restricted to the extremities (*KI*, p. 247; tr., pp. 137 ff.).

A second characteristic was the lack of any emotional expression. "Among the ancient Egyptians the rigid material crystallization expressed in this scheme [of frontality] was by no means reduced through any sign of spiritual life . . ." (*KI*, p. 247; tr., p. 137). In Byzantine art rigid frontality returned, and there was a renewed flowering of crystallinism. But in Byzantine art "the intention was obviously to evoke with the sharp turn of the eyes the impression of spiritual animation opposite to the rigidity of the bodily position" (KI, pp. 237–38; tr., pp. 137–38).

We need not discuss in detail the specific ways in which crystalline forms were articulated in Egyptian and Byzantine art. This is the domain of the historian of art. The student of art theory has a different question: were the crystalline styles an altogether formal matter, totally divorced from the general culture of the period and society which produced them? Or were they, on the contrary, part—to the modern spectator, perhaps the most visible and striking part—of a comprehensive culture?

In modern research Riegl is frequently cited as the representative of a purely formal approach to art, and we shall shortly come back in some detail to this question. Here I shall only briefly discuss what he said in this context about crystalline style. Riegl was aware that some scholars linked the appearance and articulation of crystalline forms in art with a culture he himself called "ceremonial." An attempt had been made, he said, to explain the appearance of crystalline forms as emerging "from a spirit of ceremoniality' (*aus zeremoniösem Geist*). The Egyptians, some late-nineteenth-century students thought, believed that superior human dignity goes together with a restriction in lively movement. Riegl added that some scholars held "as man behaves socially, . . . this he will also see in art" (*HG*, p. 259).

Riegl's attitude to this parallelism was inconclusive. He did not reject the observation itself, but he doubted its significance. There was something to all these explanations, he said, but they did not touch the very core. Ceremoniality was a phenomenon parallel to frontality. Crystalline frontality could be reduced to something that necessarily led to both crystallinism and to ceremoniality (*HG*, p. 259). This reduction leads us to the intricate problem that occupies the mind of all Riegl students, the so-called *Kunstwollen*.

Kunstwollen

Few concepts in the study and interpretation of art have been discussed as often and as fervently in the twentieth century as Riegl's *Kunstwollen*. Literally translated the term would mean something like the "will of art" or "artistic volition." It is obvious, however, that such simple translations do not adequately convey Riegl's thought.[24] In the course of twentieth-century discussions many ambiguities, obscurities, and perhaps even outright contradictions, of the concept have been uncovered; at the same time, however, the crucial importance of this notion, especially for our century's approach to art, has also become evident. Nowhere in his writings did Riegl himself clearly state what he meant by *Kunstwollen*. He referred to it as to something obvious that was in no need of definition. Yet in fact this is far from being the case.

Let us begin by juxtaposing a few quotations. Rejecting the technical (or "mechanistic") explanation of how the work of art comes into being, an approach then generally linked to Gottfried Semper,[25] Riegl wrote in the introduction to his *Spätrömische Kunstindustrie*: "As opposed to this [Semper's] mechanistic perception of the nature of the work of art I presented for the first time in my *Stilfragen*, a teleological approach [proceeds] which recognizes the art work as the result of a definite and purposeful *Kunstwollen* which makes its way forward in the struggle with function, raw material and technique" (*KI*, p. 9; tr., p. 9). At the end of the same work we read: "The late Roman *Kunstwollen* has in common with the *Kunstwollen* of all previous antiquity that it was still oriented toward the pure perception of the individual shape with its immediately evident material appearance, while modern art is less concerned with the sharp separation of the individual . . ." (*KI*, p. 389; tr., p. 223). While in the first quotation, *Kunstwollen* would clearly seem to be what, perhaps in our ignorance of the methodological intricacies involved, we might call the artist's intention, something that is not tangible (like material) and not as easily measurable as technique, but that assumes a crucial part in shaping an individual work. In the latter quotation, *Kunstwollen* means something like an orientation of period style, something like a factor in history, that suggests historical continuities.

The two quotations, taken from the same book, give at least an intimation of the difficulties encountered with this notion. In the following comments I do not undertake to resolve the difficulties or to offer a unified version of the different strands of thought inherent in this concept. However,

I shall try to show how profoundly the concept of *Kunstwollen* touches on the core problems confronting any attempt to understand art. I shall proceed by discussing a series of questions that impose themselves upon anyone attempting to fully understand Riegl's central concept, questions that have been debated in the twentieth-century literature on the visual arts.

The first question that comes to mind, as already indicated, is whether "art volition" is meant to be an individual's intention, as "will" in an everyday sense, or whether it should be understood as the orientation of a culture, or of another collective entity. Clearly, an individual's subjective intention and the objective orientation of a society at a given period are very different in nature. The term "volition" (*Wollen*) is taken from the vocabulary of psychology. But since psychology was considered some kind of universal science in the latter half of the nineteenth century, the origin of the term does not point conclusively to its meaning. A careful reading of Riegl convinces us, I think, that as a rule he always had supraindividual attitudes, orientations, or even drives in mind when he spoke of *Kunstwollen*.

But whatever the specific subject, *Kunstwollen* always refers to something that is behind the immediately visible or tangible work. Riegl distinguished between *Kunstwollen* and the purpose of the work of art, just as he distinguished between the purpose of the work and its style. "Every work of the visual arts is created for a certain purpose. In every work of art the purpose should be distinguished from its *habitus*" (*HG*, p. 61).[26] Style is the overall configuration of a work of art, of the art of a school, or a period. Style cannot be explained by any other concept, it must be experienced directly. But there is something else that makes a period or a culture develop a particular style, and that makes the style change from one kind to another. This something that is behind the work and its style, is *Kunstwollen*.

Another question was raised most clearly by Panofsky.[27] Whether the *Kunstwollen* is the intention of an individual (and thus deliberate to some extent) or the powerful orientation of a collective entity, the conclusions we draw from it will always be in doubt. We simply do not have direct access to the *Kunstwollen*, regardless of whether it is an individual's intention or a collective entity's drive or orientation. What we, following Riegl, call "artistic volition" is actually derived from our own interpretation of the work of this artist or period. We have, then, a circular argument. We are attempting to explain what we see, said Panofsky, by assuming something that is derived from our "hypostatizing of an impression we receive" from the works we see. This circularity is not avoided by our referring to the artist's or period's statements, since these, too, are in need of interpretation.

Panofsky did not want to completely reject the concept of *Kunstwollen*. He said that *Kunstwollen* cannot be a psychological reality, and that therefore it cannot be discussed in psychological terms. He did not deny that behind what we see there is still another layer, but that layer is not a psychological one, it has a particular kind of objective meaning. "The Kunstwollen cannot be anything but that which objectively (not just for us) 'lies' in the artistic phenomenon as the ultimate meaning, if this expression is to signify neither a psychological reality nor an abstract term of classification" (Panofsky, p. 38).

The third issue in Riegl's theory, much debated and criticized, was the fact that he considered the *Kunstwollen* a cause for the creation of art, and believed it has an impact on style. Riegl himself suggested that "artistic volition" is the force that brings about and determines style. Style reflects an underlying *Kunstwollen*. Speaking of the Probus diptych, an ivory of the first years of the fifth century A.D., he said that "Already the first sight shows that the figures possess 'style', which means that it expresses an articulate specific *Kunstwollen* which seems to be presented with greatest security, even though this *Kunstwollen* may be very different from our own one" (KI, p. 216; tr., p. 121).[28]

The history of art, that is, the consecutive changes of style, are also explained by the dynamic nature of the *Kunstwollen*. Even if some styles in the past, or the artistic production of some periods, do not seem satisfactory to us, they are of crucial significance for the history of art; they represent, to use Hegelian terms, the stages the *Kunstwollen* undergoes on its way to final completion. Modern taste, said Riegl, may consider certain features in Roman art after the time of Marcus Aurelius

> to be crude and inanimated . . . [they are] the naturally necessary expression of the great unavoidable fate of Greek art from its very beginning, but which also was of interest for all future development in art as Christianity was in the general development of humanity. The criticized non-beauty and inanimation indeed immediately becomes an element of progress and rising development as soon as one considers that these two were the ones which broke through the ancient barrier of negating space thus ending the circle and freeing the route for the solution of a new task: the representation of the individual shape in infinite space. (*KI*, p. 130; tr., p. 78)

The final question that should be mentioned here concerns the specific scope of "artistic volition." To put it simply: is the *Kunstwollen*, whatever may have flowed into it, limited to art only and valid for art alone, or does

it affect and is it affected by other realms of the life of the mind and of social experience? Once again the contemporary reader has to concede that Riegl's formulations were vague and ambiguous.

Modern scholars consider Riegl a "formalist," that is, a student who tended to emphasize the autonomy of art, and largely also that of the artist. In *Stilfragen*, his first major work, the concept of *Kunstwollen* denotes above all the (relative) creative freedom of the artist, and sets this "subjective" factor off against the dependence on material, purpose, and technique that were emphasized by many students in the second half of the nineteenth century. This freedom was specific to art only, and therefore free "artistic volition" testified to the autonomy of art. Even in the *Spätrömische Kunstindustrie*, as has recently been noted, Riegl employed terms of subjective volition in connection with *Kunstwollen*. Thus, the Egyptian artists "strove to" (*erstrebten*) a certain art (*KI*, p. 98); modern art "desires" (*begehrt*) not to separate, but to connect the forms in space (*KI*, p. 92); mankind "wanted" (*wollte*) to see "the visual appearances according to outline and color on the plane or in space at different times in a different manner . . ." (*KI*, p. 392; tr., 225). All this, and many other statements that could be added, would seem to point to art as a matter of form only. Clearly Riegl had mainly, or only, formal and visual elements in mind here.

On the other hand, however, Riegl sometimes clearly indicated that the *Kunstwollen* was intimately linked with, or formed part of, a general cultural, spiritual attitude. We need not seek many quotations; a single reference will suffice. At the end of *Spätrömische Kunstindustrie* he stressed that in the late Roman period it was the same *Kunstwollen* that informed all the four visual arts (architecture, sculpture, painting, and the decorative arts), and continued: "The character of this *Wollen* (volition) is always determined by what may be termed the conception of the world (Weltanschauung) at a given time (again in the widest sense of the term), not only in religion, philosophy, science, but also in government and law, where one or the other form of expression mentioned above usually dominates" (*KI*, pp. 400–401; tr., p. 231).

In sum, then, the precise scope of the *Kunstwollen*—restricted to art or part of a *Weltanschauung*—is no less ambiguous than the other aspects of this notion.

None of these ambiguities, however, have invalidated, perhaps not even restricted, the profound and revolutionary impact of the concept of *Kunstwollen*, and of Riegl's doctrine in general, on reflection on art. It may well be that the power of this concept lies in the fact that the ambiguities it

brought to light reflect the inherent problems and the multileveled and multisided nature of the subject it deals with, the visual arts.

NOTES

1. Carl Schorske, *Fin-de-Siècle Vienna: Politics and Culture* (New York, 1981), pp. 297 ff.

2. There are, of course, well-known studies of the folktale concerned with this aspect. See, for instance, the classic work by Vladimir Propp, *Theory and History of Folklore*, translated from the Russian by A. and R. Martin (Minneapolis, Minn., 1984), a work that deals mainly with the folktale. On the other hand, there are also some classic works on "primitive" art, discussed in the following part.

3. See Propp, *Folklore*, p. 7.

4. I use the fourth edition. See Alois Riegl, *Die Spätrömische Kunstindustrie* (Darmstadt, 1973). There is now an English translation by Rolf Winkes. See Alois Riegl, *Late Roman Art Industry* (Rome, 1985). Page references, given in parentheses in the text, refer to these editions. The first figure refers to the German edition; the second, after a semicolon, to the English translation.

5. See below, part 3.

6. Victor Löwenfeld, *The Nature of Creative Activity* (New York, 1939), and all his other writings. And cf. Arnheim's interesting article, "Victor Löwenfeld and Tactility," reprinted in Arnheim, *New Essays on the Psychology of Art*, pp. 240–51.

7. Löwenfeld, *The Nature of Creative Activity*, p. 12.

8. John Locke, *Essay Concerning Human Understanding*, Book II, chapter 9 (1690).

9. This short book, *Plastik: Einige Wahrnehmungen über Form und Gestalt*, was written in the years 1766–70, but not published until 1778. I quote from Johann Gottfried von Herder, *Antiquarische Briefe* (Tübingen, 1809), pp. 241–363. Translations from *Plastik* are mine. Herder's essay on sculpture has not been sufficiently studied. But see Bernhard Schweitzer, "Herders 'Plastik' und die Entstehung der neuern Kunstwissenschaft," reprinted in Bernhard Schweitzer, *Zur Kunst der Antike: Ausgewahlte Schriften* (Tübingen, 1963), pp. 198–257.

10. See Barasch, *Modern Theories of Art, 1*, pp. 178–99.

11. For Riegl as a Hegelian, mainly in the explanation of art and its history, see Gombrich, *Ideals and Idols*, pp. 43–44 (in the essay "In Search of Cultural History"). Gombrich does not refer, however, to the question of whether Riegl did, or did not, know Hegel, but stresses the similarity or affinity of their approaches.

12. Werner Weisbach, *Impressionismus: Ein Problem der Malerei in der Antike und Neuzeit* (Berlin, 1910) speaks of ancient impressionism (I, pp. 9–53) without feeling the need to justify the concept. See also E. H. Gombrich, *The Sense of Order: A Study in the Psychology of Decorative Art* (Oxford, 1979), pp. 196–97 and 203–4.

13. See Alois Riegl, *Gesammelte Aufsätze* (Augsburg and Vienna, 1929), pp. 28–39. Page references will be given in the text, in parentheses, as *A* and the respective page number. "Inhalt" in the title of Riegl's article, may be meant both as subject matter (as the word would be used in iconography), and content or meaning—significance in a broader sense.

14. Alois Riegl, *Historische Grammatik der bildenden Künste*, Aus dem Nachlass herausgegeben von Karl M. Swoboda and Otto Pacht (Graz-Cologne, 1966), pp. 206–314. Page references will be given (in parentheses) in the text; *HG* stands for *Historische Grammatik*.

15. See below, part 3.

16. Among them we should mention particularly the association of certain traits of style, or more generally of culture, with races. Thus, for example, the Egyptian or (ancient) Jewish attitudes (*HG*, pp. 222–26). It should be kept in mind, however, that such views were common at the time in many fields of study.

17. Leo Spitzer, *Classical and Christian Ideas of World Harmony: Prolegomena to an Interpretation of the Word "Stimmung"* (Baltimore, 1963).

18. Margaret Olin, *Forms of Representation in Alois Riegl's Theory of Art* (University Park, Penn., 1992), pp. 122–27.

19. I quote the translation by Olin, *Forms of Representation*, pp. 96–97, citing from unpublished lecture notes for a course on Dutch painting. The precise reference is on p. 212, note 19.

20. For a concise survey of Dürer's views on the subject, see Erwin Panofsky, *Albrecht Dürer* (Princeton, 1943; 3d ed., 1948), pp. 266–70.

21. See especially chapter IV of Winckelmann's *History of Ancient Art*. I use the Phaidon edition: J. Winckelmann, *Geschichte der Kunst des Altertums* (Vienna, 1934), pp. 128 ff.

22. I. Kant, *Kritik der Urteilskraft*, par. 16. I use the Cassirer edition: *Immanuel Kants Werke*, V (Berlin, 1914), pp. 299 ff.

23. Riegl specifically referred to J. Lange's "law of frontality."

24. This is the reason, I assume, why many scholars, no matter what language they write in, use the concept in its original German formulation. Rudolf Winkes, in his translation of Riegl's *Die Spätrömische Kunstindustrie* (see *Late Roman Art Industry*) also gives the original German term.

25. For Gottfried Semper, see below, part 3, chapter 18.

26. The term *habitus* is perhaps best translated as "bearing" or even "appearance" in this context.

27. Panofsky's article, "Der Begriff des Kunstwollens," originally appeared in *Zeitschrift fur Asthetik und Allgemeine Kunstwissenschaft*, 14 (1920), and is reprinted in Erwin Panofsky, *Aufsätze zu Grundfragen der Kunstwissenschaft*, edited by Hariolf Oberer and Egon Verheyen (Berlin, 1964), pp. 33–47. An English translation, "The Concept of Artistic Volition," appeared in *Critical Inquiry* 8 (1981), pp. 17–33. For a recent discussion of this article, see Margaret Iversen,

Alois Riegl: Art History and Theory (Cambridge, Mass., and London, 1993), pp.152–58.

28. An error has slipped into the translation. Instead of "articulate specific *Kunstwollen*" the published translation has "vague specific *Kunstwollen*." The original German version reads "ein ganz bestimmtes Kunstwollen."

16

Wilhelm Worringer
Abstraction and Empathy

A year after Riegl's death (1905), a young doctoral student, Wilhelm Worringer, wrote a dissertation that, two years later, in 1908, was published as a slim volume (as was customary with many German dissertations at the time) under the title *Abstraktion und Einfühlung: Ein Beitrag zur Stilpsychologie* (Abstraction and Empathy: A Contribution to the Psychology of Style).[1] At that time, doctoral dissertations were compositions usually overflowing with learned notes and bibliography to display the author's erudition. Worringer's book is not a characteristic example of the type. It is a study consisting of highly speculative, wide ranging ideas, unusual in fate no less than in character. Many doctoral dissertations of the early twentieth century (though by no means all of them) made some solid scholarly contribution to a well-defined, and often rather narrowly limited, topic, and were read by the few scholars concerned with that specific subject. Worringer's *Abstraktion und Einfühlung* became an astonishing commercial success almost overnight. Edition followed edition in quick succession, and it was translated into all major western languages. In 1948, as the book was again reissued (forty years after its original publication) Worringer was justified in writing that it "has proved its continually effective vitality by the incessant need for new editions." He continued: "Looking back objectively, I am fully aware that the unusually wide influence exercised by this first work is to be explained by the conjunction, quite unsuspected by myself, of my personal disposition for certain problems with the fact that a whole period was disposed for a radical reorientation of its standards of aesthetic value" (vii).

When we turn to Worringer's book now, some ninety years after the original publication of this influential treatise, both the aim and the limits of our discussion should be made clear at the outset. First, we shall not be considering Worringer's whole work as a student of art here; we shall

disregard his other books, written in later years, mentioning them (if at all) only insofar as they add to, or clarify, the ideas expressed in *Abstraktion und Einfühlung*. Our present subject is only this early book and the echo it evoked in the spiritual life of Europe in the early twentieth century. Second, we will not be asking whether or not the ideas and attitudes Worringer expressed in this book are true, whether they can be accepted or modified, or should be rejected altogether. What interests us at this stage is what he said (and meant), and what it was that made *Abstraktion und Einfühlung* so influential, assured its ideas such wide distribution, and, as we shall try to show in later chapters, had such a profound impact on thought about art.

Theory of Empathy: The Background

Worringer began his argument by discussing a thesis (though he did not develop it) that, as we have seen above,[2] had some significance in his immediate cultural environment. He strictly separated the experience of a work of art from the experience of a view in nature. It was part of the Kantian heritage (not to speak of earlier sources) to assume that our sense of beauty is the same, whatever we experience as beautiful, and that therefore the experience of nature and the experience of art have much in common, even if they are not altogether identical. Worringer rejected this tradition. "The work of art," he says, "as an autonomous organism, stands beside nature on equal terms and, in the deepest and innermost essence, devoid of any connection with it . . ." (p. 1; 3). Hence there were "laws" of art that have nothing to do with the laws of nature.

The confusion of art and nature in modern reflection on beauty, the author seemed to suggest, became possible because nineteenth-century aesthetics replaced the artist's work with the spectator's experience of both nature and art as the foundation of the theory. Had the artist's job remained at the center, the confusion of art and nature in aesthetics would have been avoided. "Modern aesthetics," he rightly remarked, "which has taken the decisive step from aesthetic objectivism to aesthetic subjectivism, i.e. which no longer takes the aesthetic as the starting-point of its investigations, but proceeds from the behavior of the contemplating subject, culminates in a doctrine that may be characterized by the broad general name of the theory of empathy" (p. 2; 4).

Two Types

For a good deal of western art, however, empathy cannot be the guideline for explaining styles and works. We have to look for another principle. The "Archimedian point [of such art] is situated at *one* pole of human artistic feeling alone. It will only assume the shape of a comprehensive aesthetic system when it has united with the lines that lead from the opposite pole" (p. 3; 4). That opposite pole Worringer called "abstraction." The whole history of art, it appeared to him, could be described as a pendulum swinging between these two poles, a series of movements (perhaps cyclic) from one end of this scale to the other, and back again.

Worringer sometimes used the terms "empathy" and "abstraction" as if they were self-evident. In fact, they were not, and we shall have to discuss them at some length. But before we attempt to define the essence of the two types, as Worringer saw them, we must ask what it is that brings about the two attitudes in the mind of the spectator looking at a work of art. To put it as concisely as possible: Two basic assumptions were made in the discussion of empathy as an aesthetic doctrine, and particularly in the explanation of how the spectator experiences and understands a work of art. First, as we have seen, empathy was considered a natural intuitive ability, even a propensity, given to us to participate (though to a smaller degree) in the emotions and passions of our fellowmen (and, by implication, in an artistic representation), if and when we observe them. This ability, it was believed, is innate, it is part of our "nature." In other words, empathy was assumed to be a primary, original drive of human nature. Now, by seeing it as primary and original we admit that it cannot, and does not have to, be derived from other sources. In this sense one could speak of a "contagion" of emotions. Second, it was assumed that empathy is a universal category, encompassing both what pleases and displeases us. What causes us pleasure, said Lipps, attests to "positive empathy," while what causes us displeasure is the result of "negative empathy." In other words, empathy is an all-encompassing explanation of art. What we experience or even recognize in the work of art is our own feelings. The work of art turns our experiences into an object. Worringer used a somewhat simplistic formula to express this thought: "Aesthetic enjoyment is objectified self-enjoyment" (p. 30; 23).[3]

In accepting the comprehensive scope of empathy, Worringer problematized dualism in general, and the category of abstraction in particular. If empathy is indeed universal, where does abstraction come from? Here Worringer, possibly without being fully aware of it, suggested a history of

styles. He explained their emergence in terms of a kind of psychology of periods. His theory sought to explain the dualism of styles. Moreover, if one believes empathy to be innate and universal, Worringer made the same assumptions for "abstraction," the other pole of the style-scale. There is in our nature, he believed, a drive or "urge" (*Drang*) to abstraction, as there is a drive or urge, to empathy. "Just as the urge to empathy as a pre-assumption of aesthetic experience finds its gratification in the beauty of the organic, so the urge to abstraction (*Abstraktionsdrang*) finds its beauty in the life-denying inorganic, in the crystalline or, in general terms, in all abstract law and necessity" (p. 4; 4). In the intellectual conditions of Worringer's time and world, a world in which empathy was taken for granted, he naturally concentrated on abstraction.

Making abstraction as innate and primary as empathy was, of course, a radical departure from the original theory of empathy as presented in nineteenth-century aesthetics. While the philosophical tradition from Vischer to Lipps, Volkelt, and Victor Basch conceived of empathy as a universal human trait, altogether independent of historical periods and particular styles, in Worringer's view empathy became but *one* type of style and feeling, which was juxtaposed with abstraction, the other type. Here *Einfühlung* was valid only for an art of a *certain* expressive nature.

Worringer's scope was truly comprehensive. Style in art is shaped by, and reflects, man's feelings toward the world in which he lives. A history of art styles, therefore, would "be a history of the feeling about the world and, as such, would stand alongside the history of religion as its equal" (p. 15; 13). This approach naturally raises two questions: First, what are the types of feeling towards the world that are expressed in art? Secondly, by what specific means and forms do we express these feelings? As the title of Worringer's book says, he assumes two kinds of feelings, empathy and abstraction.

What are the "psychic presuppositions" of these feelings, Worringer asked. The question reflected the hierarchic scale of scientific disciplines that was broadly accepted in the culture of the time. To a large extent, psychology (whatever that may have meant in any given case) was conceived as a kind of "universal science," a new *mathesis universalis*, holding the answers to questions that arose in many disciplines. In *Abstraktion und Einfühlung* Worringer answered his own question clearly:

> Whereas the precondition for the urge to empathy is a happy pantheistic relationship of confidence between man and the phenomena of the external

world, the urge to abstraction is the outcome of a great inner unrest inspired in man by the phenomena of the outside world; in a religious respect it corresponds to a strongly transcendental tinge to all notions. We might describe this state as an immense spiritual dread. . . ." (p. 19; 15)

Much of the debate that *Abstraktion und Einfühlung* evoked was tinged with ideological attitudes that had little to do with the theory of art. We shall make some brief comments on only one contribution to this debate, made by a famous figure outside the field of art, the psychologist Carl Gustav Jung. The very fact that Jung, then at the height of his renown, found it necessary to discuss the publication of a young, and hitherto hardly known, art historian shows how strong a nerve Worringer had struck in the culture of the early twentieth century.

Jung's article, "The Problem of Typical Attitudes in Aesthetics,"[4] deals with aesthetics, but what he really had in mind was art and how to explain it. Aesthetics, Jung said, is in essence "applied psychology." The study of aesthetics deals not so much with a specific subject matter, that is, with the aesthetic essence of things, as with the question of different aesthetic attitudes, and this is a psychological matter (p. 407).

A basic pattern of psychological typology is the juxtaposition of introvert and extrovert characters. This typology, Jung believed, is also found in art. It formed the foundation of Worringer's juxtaposition of "abstract" and "empathic" types. As introversion and extroversion are fundamental in the psychic typology of human beings, so abstraction and empathy are fundamental in the typology of attitudes to art. Jung's interpretation of the two psychological types is thus of great interest for the student of art.

Empathy, as we have seen in many contexts, is a projection of the subject's feelings onto the object that he or she sees. The object looked at seems animated because the spectator has his or her own feelings projected onto it. Such projection, Jung says, is what Freud calls *Übertragung* (transfer). (p. 409) Empathy, being a projection of the subject's emotional life onto an inanimate object, is what psychologists would call extroversion. The extrovert artist presumes (whether or not he is aware of it) that the world surrounding him is devoid of emotions; it is "empty," as Jung calls it. Therefore it is in need of man's, the artist's, subjective emotions in order to have life and a soul. The extrovert artist, or man in general, "confidently lends [the world surrounding him] animation" (p. 412). No wonder, then, that the world he sees, and that the artist portrays, is *his* world, a world in which he finds himself wherever he turns.

The very opposite obtains at the other pole, in abstraction. The artist belonging to this type does not radiate his own life, his own emotions, and experiences onto the world surrounding him. To him, the objects in the world in which he lives are not "empty," and therefore no *Übertragung* of the artist's own personal life need, or even can, take place. In contrast to the extrovert type, the introvert perceives the objects and creatures of the world around him as filled with a distinct life of their own, as harboring within themselves their own specific forces. Man, Jung believed, feels threatened by what surrounds him. He cannot look at the objects and creatures surrounding him with confidence because they have "frightening qualities." He has to protect himself against them (p. 411). This self-protection takes on the shape of introversion. Man, or the artist, concentrates upon himself. He totally separates himself from the alien or even hostile world surrounding him.

Jung's interpretation of Worringer's polar types is, of course, a psychologist's reading of what a student of art found in the investigation of styles. It sheds light, however, on the wide implications of *Abstraktion und Einfühlung*.

The Origin of the Types

Illuminating as Jung's observations may have been, they were made from the perspective of individual psychology; they originated from age-old attempts to build theories to diagnose, describe, and explain the character of individuals. But Worringer was not a psychologist. His themes were not individuals, not even individual artists. In his entire book one does not find more than a single sentence about any individual artist. His true subjects were great historical periods or types of culture, the ways in which they express their nature in the visual arts, and the repertory and character of the forms employed in this process.

We shall shortly come back to the specific forms and images Worringer had in mind when he spoke of the "Empathic or Organic," on the one hand, and of the "Crystalline or Abstract," on the other. First we shall ask another question. Simply put: why was one period or culture inclined toward abstract forms, while another tended to empathy and organic forms? What is it that causes mankind to change from one type to the other? Of course, this is not a question to which there are easy answers; restated in a recent formulation, it amounts to asking why art has a history at all. Worringer, how-

ever, paid little attention to historical change. The gradual process of a style's transformation was not even touched upon in his study. He followed the framework of great periods, megaperiods as it were (like Egyptian or Greek art), and within them he looked for explicit, fully articulated types, making no attempt to observe and describe gradual changes or variations of style.

As we have seen, when a "happy pantheistic relationship" prevails and man looks at his world with "confidence," an art emerges to which empathy is the proper approach. This was by no means a new idea, though Worringer gave it a different formulation. Already Winckelmann had explained the beauty, harmony, and softness of classical Greek art by the Greeks' attitude to the well-balanced nature surrounding them, the institutions of their society, and even the climate and the countryside.[5] In many forms, and with various qualifications, this idea was repeated from the eighteenth century onward. What Worringer had to say, or suggest, about the origins of the other type of art, the art described as "crystalline" or "abstract," was less traditional. He himself saw his major contribution in the analysis of "abstract" art and its origins. In *Abstraktion und Einfühlung* he stressed that his "primary concern in this essay is to analyse this urge [the urge to abstraction] and to substantiate the importance it assumes within the evolution of art" (pp. 18–19; 14).

In Worringer's view, human history, and therefore also art, begins with a profound sense of insecurity, of fear and dread. The "extended, disconnected, bewildering world of phenomena" was frightening. As long as man could depend "upon the assurances of his sense of touch" the world seemed more stable, and therefore less frightening. But when he stopped acquainting himself with the world by touch and had to rely more on vision (Worringer believed this happened at an early stage of history when man was becoming a biped), his dread increased. It was an original anxiety, an anxiety which "may also be assumed as the root of artistic creation" (p. 20; 15).

Where did dread start? To Worringer it did so with the experience of open space. Space is that limitless extension that is not a "thing"; in sheer space you have nothing to hold on to, nothing that will assure you of a stable position. The urge to master open space (or to suppress it) is characteristic of archaic man. This we learn from early art. It is reflected not only in archaic painting, but also in the other, more "material" arts. The idea that man desires to enclose, even to eliminate, open space was also not new in the study of art. Worringer referred (tr., p. 137, note 8) with approval to

Riegl's analysis of space in early Egyptian buildings. In the architecture of early Egypt, for instance in the Temple at Karnak, Riegl wrote,

> the wide planes of the four walls, ceiling, and pavement [are] perceived at a distance and thus having an optical effect, would have created a most uncomfortable impression of space for the Egyptians. . . . The halls are consequently filled with columns supporting the ceiling at such short intervals that all those planes that could have had a spatial effect were now cut up. Spatial impression was thus suppressed to the point of elimination.[6]

Though the idea that open space causes a sense of dread was thus not new, Worringer made it a cornerstone of his theory.

The fear of open space, the torment caused "by the entangled inter-relationship and flux of the phenomena of the outer world," Worringer believed, is a basic human reaction to the experience of reality, and therefore it is not restricted to a specific period. However, it was particularly manifest in archaic cultures. At this early stage of development, people "were dominated by an immense need for tranquility" (p. 21; 16). Archaic cultures craved to attain tranquility, and thus to overcome their dread. Now, what in the domain of visual experience can help attain tranquility? Regularity is the configuration that has this almost magic effect. Regularity that wrests objects from their arbitrariness, from their ever changing shape and place in "the unending flux of being." Regularity, then, is the form and principle best able to give man the sense of security he so needs and longs for. Therefore, "The style most perfect in its regularity, the style of the highest abstraction, most strict in its exclusion of life, is peculiar to the people at their most primitive cultural level" (pp. 22–23; 17).

What man does not have, what he lacks and is deprived of is what he projects in his art, and embodies in the shapes he creates. The regularity that gives us the sense of security that cannot be found in nature, is created in art. Art, then, is not an imitation of nature, as was believed for centuries. We do not produce art because we enjoy re-creating the objects, images, and order that we have around us. On the contrary, art is the imaginary realization of what we do not have and cannot achieve in the real world.

Worringer did not explicitly draw this far-reaching conclusion, but it follows from his thought. During the early years of the twentieth century, both in philosophical aesthetics and in other forms of the theoretical study of art, the thesis that the work of art is essentially a representation of what exists in nature, was still unchallenged. What nature is, and hence what a

representation of nature should look like, could be a matter of dispute. But almost all philosophers, scholars, and critics accepted, in one form or another, that art imitates nature.

In other fields of study, however, attempts were being made to explain images and beliefs as an imaginary materialization of what does not exist. This approach was particularly significant in the interpretation of religion. An important example of this was a work by Ludwig Feuerbach, *The Essence of Christianity*, originally published in 1841. It soon became a classic, and has remained popular to this very day. Feuerbach's thesis was that the image that people form of their God is endowed with all the characteristics that they themselves do not have, and that they long for. Thus, Feuerbach said, the God of the weak is strong, the God of those who do not find compassion and suffer from cruelty in their actual lives, is a God of compassion and mercy.[7]

At the turn of the century the idea of creating, in one medium or another, some kind of surrogate reality supplying what one cannot attain in actual life was popularized in various domains and forms, with a great many shades of precision or vagueness. Suffice it to recall the concept of "wish fulfillment," now common not only among psychologists, but a household word in ordinary speech.

In Worringer's dissertation there was no reference, neither explicit nor oblique, to the aforementioned doctrines in the study of religion or of psychology. It is unlikely that Worringer had read either Feuerbach or Freud at this stage of his development. Yet the similarity between his approach and that of these great scholars leaves little doubt, I think, that he belonged to the same broad trend as they did.

Abstraction

"Abstraction and Empathy" was a catchy title. In its conciseness and in its presentation of a clear, sharp contrast it immediately stirred the imagination of many readers. But is this title accurate? Does it say precisely what the author meant? As we have already said, Worringer treated the concept of empathy as self-evident. He took it for granted that everybody understood what empathy was (though this was certainly not always the case). His main concern was with the other pole of the title, with "abstraction." Here, he felt, explanation was needed. Therefore, he devoted his main intellectual effort to the analysis of "abstraction," giving it far more attention than to empa-

thy. In our brief discussion we shall, therefore, also concentrate on Worringer's concept of abstraction.

Let us begin with the term. In a strictly literal sense, Worringer's use of the term abstraction is certainly wrong. It was not abstraction as such that he had in mind when he tried to characterize a certain style. Literally *abstraho, abstrahere* means to "drag away" (as any dictionary will tell us); in a more metaphorical sense it means to exclude, estrange. An abstract outline or statement has fewer details, specific forms, or information than the full statement. But Worringer did not use the term "abstraction" in a literal sense. He was not saying that in an "abstract" work of art there were fewer individual forms or specific motifs than in one that, in his view, called for empathy. The figure of the high classical *Niobe* (representative of the style of "empathy") for example, is not richer in detail and specific motifs than, say, that of an Egyptian priest or a saint in the portal of Chartres (representatives of "abstract" styles). Worringer wanted to emphasize that the character of forms and motifs in works of art pertaining to the "abstract" type was profoundly different from those of works belonging to the other type. The difference between them was not a matter of more or fewer shapes (as would be the case were we to take the term "abstract" in a literal sense); it is rather a matter of their overall character and expression, or, as one used to say at the time, of their "spirit."

What Worringer called "abstract" was what Riegl had called "crystalline." In other words, it was not a system in which a multitude of forms and views was reduced to essential patterns (which would roughly correspond to what we usually mean by abstract), but a system of forms of a nonorganic nature, forms from which life and movement had been excluded. Worringer was aware that he was following Riegl's concept of the crystalline. He spoke of the possibility of "deliver[ing] the object from its relativity and eternalis[ing] it by approximation to abstract crystalline forms" (p. 49; 37). He emphasized that "abstract" forms were geometric shapes, devoid of organic life. "In the face of the bewildering and disquieting mutations of the phenomena in the outer world," artistic creation is motivated by the urge "to create resting points, opportunities for repose, necessities in the contemplation of which the spirit exhausted by the caprice of perception could halt awhile. This urge was bound to find its first satisfaction in pure geometric abstraction . . ." (pp. 45–46; 34–35). Abstraction, to repeat, was not a "dragging away." It was a system of geometric forms and of images cast in a "geometric" spirit.

To create "geometric" form in art required, first of all, the exclusion of space. This followed from Worringer's analysis of the way the urge to abstraction was expressed in the representation of nature. The artist was faced with two possibilities. "The first possibility was . . . by the exclusion of the representation of space and by the exclusion of all subjective adulteration. The second possibility was to deliver the object [represented] from its relativity and externalise it by approximation to abstract crystalline forms" (p. 49; 37).

In linking space with the human agent Worringer was following a broadly accepted concept. Throughout the nineteenth century, particularly in the German philosophical tradition, the Kantian idea that space was a "form of intuition" had a powerful impact on different branches of science and reflection, including aesthetics. As a form of intuition it was believed to be based in the observer rather than in the reality he observed. Space was not "real" in itself, in the sense that an object is real, that is, tangible, weighable, and so on. Space was what we perceive. It was an "adulteration" of objective reality like any other feature of illusion rooted in visual experience.

Seen with the painter's eye, the embodiment of space had two main features, in which the subjective quality of our spatial experience was fully manifest. The first was the "roundness" of the figures and objects depicted, that is, the illusion of their volume; the other was what we call "foreshortening." Both roundness and foreshortening appear mainly in Renaissance painting, and ever since they have been celebrated among the painter's major achievements. Both, of course, are optical illusions. The canvas or board on which a "round" figure is depicted is not really round. The roundness is an illusion, conjured up in the spectator's eye by the painter's technique. The same holds true for foreshortening. In reality the foreshortened finger pointing at the spectator, a popular motif in attempts to create a direct appeal to the audience (think of the famous poster "Uncle Sam Wants You") is of course not really shorter than the other ones. The powerful effect of foreshortening is a mere illusion, part of the use the painter makes of our subjective visual experience.

There is yet another aspect of space that, used by the painter, is apt to undermine the solid material unity of the individual object. This aspect may be less tangible, but it is no less important: it is what we call, perhaps not with sufficient precision, space as atmosphere. Listen to Worringer: "It is precisely space which, filled with atmospheric air, linking things together and destroying their individual closedness, gives things their temporal

value and draws them into the cosmic interplay of phenomena; most important of all in this connection is the fact that space as such is not susceptible of individualisation" (p. 51; 38). It is characteristic that in this context, in the very same paragraph, Worringer spoke of "a purely impressionistic representation." Now, in fact the impressionists, as we have seen in an earlier section,[8] did not separate the object from its environment or "background" either in their way of seeing or in their style of depiction. They did not make a basic distinction between the material figure or object and the nonmaterial space surrounding it. It was this attitude, we recall, that made impressionism the most "subjective" trend in painting, a trend that aimed to depict our impressions of reality rather than reality itself.

It was to avoid the fear of the solid object dissolving into impressions, to counteract the anxiety of the stable world becoming a chaotic, irregular sequence of subjective images, that the art of several great periods aimed at crystalline regularity and disregarded space altogether. The depiction of space, to sum up, is a core element of an artist's subjective attitude, an attitude to be approached by what Worringer called empathy. The artist seeking crystalline regularity rejects illusionary roundness and foreshortening as well as atmosphere, qualities conveying the infinite change and movement that ultimately produce a sense of frightening instability.

Regularity, as Worringer himself said, is an important characteristic of geometric form. But regularity itself, in the simple form in which it is presented, is not the central feature that geometric form provides. One could well imagine organic shapes and living bodies arranged with almost perfect regularity. Would live, organic bodies, in an orderly arrangement manifesting regularity, provide the same sense of security that man, lost in the universe, was believed to be seeking? It was crucial to Worringer's concept that "geometric" form be inanimate, opposed in its very essence to the movement inherent in living beings. Worringer was aiming at something more than mere regularity. In making "abstract form" a universal principle, he had in mind not merely inanimate regularity itself, but the imposition of shapes of a nonorganic spirit and character upon the organic, moving, and changing nature of living beings. It was not just the abstract ornament, but the human figure conceived as an angular, geometric form (as if it were an arrangement of lifeless crystals) that fascinated him most.

In this context Worringer used a word that reverberated with many connotations at the turn of the century and achieved an intensity and appearance of depth and urgency rarely encountered. This was the word "alienation" or "self-alienation." In his view, "In the urge to abstraction," that is,

at the very root of the crystalline form, "the intensity of the self-alienative impulse is incomparably greater and more consistent" than the urge to empathy (p. 31; 23). The concept of "alienation," at least in its modern version, originated in the philosophy of Hegel, where it was termed *Entfremdung*. We need not delve into the rich history of this concept here.[9] I shall only remark that in central Europe the term came to express the feeling of alienation between man and his world that was so common at the turn of the century. In establishing a "self-alienative impulse" that created abstract art, Worringer made this widespread feeling, and the anxiety accompanying it, the foundation for a theory of art.

Some Conclusions

In the preceding comments I have attempted to present the main ideas of *Abstraktion und Einfühlung*, at least insofar as they form part of a theory of art. I have tried not to pass judgment or to openly criticize the work. In concluding this chapter, however, it is difficult not to make some brief comments on what Worringer's theories look like ninety years after they first appeared in print, and on what they may tell us about some of the momentous developments, both in the theory of art and in art itself, that took place in the decades after the thesis was published. I shall limit myself to short and necessarily summary observations on three themes that invite the reader's attention.

First of all, one cannot help feeling (this may seem harsh) that what Worringer presents in *Abstraktion und Einfühlung* is a kind of mythology of art. In German academic analyses of art, particularly at the turn of the century, it was common to employ pairs of contrasting concepts. Earlier in the present part we discussed Riegl's juxtaposition of "haptic" and "optic," but other contemporary examples of such opposing notions can easily be mentioned. One thinks, of course, of Woelfflin's pairs, but there are also many others.[10] In most cases, this contrasting of concepts or models was explicitly meant as a device to discover the nature of an art world, a means of bringing to the fore the overall character of a style by juxtaposing it to the opposite model or style. Worringer followed this fashionable and influential example. Yet in his writing a significant change occurred. He transformed a device for discovery into an almost mythical reality. There is in us, he believed, an inborn "urge to abstraction," or a "self-alienative impulse." Such urges or impulses were no longer a means to describe a style; they were in-

dependent realities, and thus the cause for the emergence and character of an art or a style.

From considering man's sense of alienation as a source of art it was only a step further to projecting a kind of mythical anthropology, to imagining a gallery of human types separated from one another by unbridgeable gaps. Worringer took that step. There are different kinds of man, he believed, and their different natures are reflected in different types of art and of style. In an article on "Transcendence and Immanence in Art," added as an appendix to the third edition of *Abstraktion und Einfühlung* (published in 1910) he explicitly spoke of "Gothic man, ancient Oriental man, primeval American man, and so forth" who were essentially different "from our contemporary humanity" (pp. 162–63; 123). The attentive reader cannot miss the affinity between Worringer's unchangeable types of human beings and their expression, and the classification of men that played such a fateful role in twentieth-century thought.

This brings us to another subject in the critical argument with the doctrine of *Abstraktion und Einfühlung*. Seeing the visual representative arts as consisting of two basically different types, Worringer in principle disregarded the complexity of each world of art, and so excluded any attempt to understand the history of art as a gradual process of profound transformation. Let us briefly consider these two points.

Worringer saw the two great orientations in art—that is, abstraction and empathy—as pure types. What he said about Gothic sculpture is an appropriate example, which also reveals the dangers inherent in his approach. Gothic art, he said, is "the last style" of "unnaturalness—the hallmark of all artistic creation determined by the urge of abstraction . . ." (p. 158; 120). Worringer was aware, of course, of the motifs in Gothic sculpture and painting characterized both in the depiction of nature and in the psychological animation of figures by a rare naturalism, a closeness to human experience. He knew the evocative smiling or sad faces of some famous Gothic statues, and was familiar with the surprisingly naturalistic rendering of individual fruits and vegetables on the pedestals of which some Gothic figures are placed. Shortly after the publication of Worringer's dissertation, another famous work, Johan Huizinga's *The Waning of the Middle Ages*, made this very naturalism, sometimes extreme, the hallmark of Gothic culture.[11] How do such natural motifs and feeling for vegetation go together with the abstract character of Gothic sculpture, an art that Worringer believed, resulted from "the urge of abstraction"? These naturalistic features and leanings, he assumed, were perhaps remnants of a former at-

titude, one that belonged to the art of empathy. Several years after he published his dissertation, he opened his interesting book on late medieval book illustrations in Germany with the sentence: "The naive sensuality of the eye is not given to the German."[12] However, we know quite well that Gothic stone carvers and woodcut artists, including those in Germany, did not take over their naturalistic motifs, expressions, and renderings from the past. Such models were simply not available to them. The representation of a living fruit or of the face of a smiling girl were often the original achievements of the Gothic artists themselves, betraying the artist's sheer delight in the observation of nature, a truly "naive sensuality of the eye." Concentrating on the "urge of the abstract" Worringer overlooked other aspects of Gothic art.

It is not in order to criticize Worringer's connoisseurship, or to find errors or "mistakes," that I stress the fact that he overlooked one of the important components in Gothic art. Worringer knew his material quite well. However, within the framework of his metaphysical theory he could not do justice to the complexity of the art of every period. His typology of extreme contrasts and his assumption that "pure" styles exist as a reality, deprived him of the ability to see the variety of trends and the diversity of their interrelationships in the art of any given period. In other words, the construction of two extreme attitudes did not let him see the complexity characteristic of every world of great art.

Worringer's scant concern for history, for the changes occurring within the types he discussed, followed from his strict division between the types. The historical development of art can be understood only in terms of an increase (or decrease) of certain contrasting elements *within* the same type. "Pure types" are timeless, they have no history. History, that is, the shift from one type to the other, thus remained beyond Worringer's horizon. Here we can see the profound difference between Riegl and Worringer. Although in many respects Worringer was profoundly influenced by the conceptual constructions of Alois Riegl (as, for instance, in the concept of the crystalline), he did not share the latter's fascination with periods of transition. In such periods, the variety of trends and components within the same art world becomes particularly evident, and the purity of the type, of any type, becomes questionable. Worringer had little use for transitional periods. He concentrated on styles that, in their consistency and purity, seemed eternal, such as Egyptian and High Gothic art. The difference in "material," in historical subject matter, reveals the divergence of intellectual orientation between him and Riegl.

A final observation is in order regarding *Abstraktion und Einfühlung* as a historical document. A certain affinity in spirit as well as the proximity in time between Worringer's ideology of the abstract in art theory and abstract painting in the artists' studios is obvious. Without necessarily looking for a direct or immediate connection between the academic art historian and the revolutionary painter, it is worth noting that in 1906, the very year that Worringer's dissertation was published, and immediately enthusiastically received, the first cubist pictures were painted, and three or four years later the first "abstract" paintings were created.

NOTES

1. Wilhelm Worringer, *Abstraktion und Einfühlung: Ein Beitrag zur Stilpsychologie* (Munich, 1908). I use the ninth edition (Bonn, 1919). There is an English translation: *Abstraction and Empathy: A Contribution to the Psychology of Style*, translated by Michael Bullock (Cleveland and New York, 1967). Page references will be given in the text; the first figure refers to the German edition, the second (after a semicolon) to the English translation.

2. See above in this part, chapter 11 (on the definition of empathy), and 13 (on Conrad Fiedler).

3. In this respect, as in many others, Worringer was of course following the school of empathy in aesthetics, mainly Lipps's. For this school, see above in this section, chapter 14. Worringer's formulations, however, were often more pointed than those of more cautious philosophers like Lipps or Volkelt.

4. C. D. Jung, *Psychologische Typen* (Zurich, Leipzig, and Stuttgart, 1930), pp. 407–21. The book originally appeared in 1921. Page references, given in parentheses in the text, refer to the 1930 edition.

5. This idea, quite common in the eighteenth century, appeared in most of Winckelmann's writings. See for instance the first section of chapter IV of his *History of Ancient Art*.

6. Riegl, *Die Spätrömische Kunstindustrie*, p. 36; *Late Roman Art Industry*, p. 27.

7. See Ludwig Feuerbach, *Das Wesen des Christentums*. I use the edition in Feuerbach's *Sämmtliche Werke*, vol. VI (Stuttgart, 1903). See especially pp. 32 ff.

8. See above, part 1, especially chapter 4.

9. Less than two decades after Worringer's use of the term, Georg Lukacs, a half-heretic Marxist (at least part of the time), wrote one of the more interesting and highly influential studies of early-twentieth-century thought on the concept of alienation, his *Geschichte und Klassenbewusstsein* (Berlin, 1923), pp. 94–228. Lukacs's book (recanted, reprinted, and translated) is fascinating as a document of his time. Paradoxically, it may help us to understand the intellectual atmosphere that produced Worringer's theory.

10. See Woelfflin, *Kunstgeschichtliche Grundbegriffe.* Other famous examples include the pair of Idealism-Naturalism in Max Dvořàk, *Kunstgeschichte als Geistesgeschichte* (Munich, 1928), and Verworn's Ideoplastic-Physioplastic, discussed below, part 3, chapter 19.

11. See Johan Huizinga, *Herfsttif der Middeleeuwen* (Harlem, 1919), translated into English as *The Waning of the Middle Ages* (Harmondsworth, 1955). The first English translation appeared in 1924. From the point of view of art history Huizinga's work and view have recently been discussed by Francis Haskell, *History and Its Images: Art and the Interpretation of the Past* (New Haven and London, 1993), pp. 431–95.

12. Wilhelm Worringer, *Die altdeutsche Buchillustration* (Munich and Leipzig, 1912), p. 5.

Discovering the Primitive

17

Introduction

Conditions of Modern Primitivism

The student who attempts to investigate primitivism in nineteenth-century reflections on art is faced with a strange dilemma. Primitivism, as we know, is one of the oldest concepts of mankind, but at the same time it is conceived as a characteristic of the modern world and its art. How do we understand this apparent contradiction? And what precisely is primitivism anyhow?

One might expect primitivism to be simple and easy to grasp. In fact, however, few concepts in our vocabulary are more complex and intricate. The notion of "primitivism" calls for explanation at two different levels: at one level, it is an objective statement of fact, testimony to a concern with something that is seen as primitive. On the other, the concept suggests an intellectual or moral attitude to, or appreciation of, what is described as primitive, seeing it as superior to one's own condition and thus worthy of imitation. In fact, the term "primitivism," particularly with this suffix, indicates that some features of the "primitive" have been appropriated or are deserving of imitation.

Primitivism, one should keep in mind, is typical of highly developed cultures (whatever the latter term may mean). In a learned and enlightening work, two American scholars, Arthur Lovejoy and George Boas, systematically distinguished between what they called "chronological" and "cultural" primitivism.[1] "Chronological primitivism" looks for the primitive in the earliest stages of history; "cultural primitivism" looks for the primitive in cultures that differ from our own, regardless of their particular stage of history. Using this distinction we can say that to be a primitivist—whether in the "chronological" or "cultural" sense—one has to be aware that one's own world and culture differ from those considered primitive. It is only in developed societies, in cultures that have produced a rich reflective life of the mind, that we encounter such awareness, and hence also primitivism.

Yet primitivism is not only an academic concern, that is, a description of the fact that some people or groups are concerned with realities they describe as "primitive," whether these realities are remote in time (belonging to a distant past), or removed in space (found in other countries or other continents). In addition to being a purely intellectual concern, primitivism is an attitude that aims to actively reshape one's own society or culture, or some part of it. Primitivism, as we know it from history, intended to make an impact on the real world. Primitivists were reformers; as a rule they attempted to recast their own world and model it on the "primitive" world they esteemed so highly. It has correctly been said that primitivism is often a form of revolt against one's own world.[2] As we shall see, this is also true with regard to primitivism in reflection on art.

From the beginning of historical, in fact of mythical, reflection in classical Antiquity, there were two different views of the primitive condition of man, termed by Lovejoy and Boas the "soft" and the "hard" view of our original state. While the "soft" view pictured primitive conditions in glowing colors, conjuring up an original happy state of man, the "hard" view saw these original conditions as full of hardship and danger, a thoroughly frightening and repulsive situation. It was "progress" that helped us to overcome this original condition. Believers in progress, it need hardly be said, did not preach forms of "primitivism," that is, they did not want to reform society to bring it closer to the original state of man. Whenever primitivism was advocated, it was the "soft" view that prevailed.

It would obviously go beyond the scope of the present essay were we to attempt to recount the history of primitivism in art, even in bare outline. We shall therefore concentrate on the late nineteenth century and the first decade of the twentieth. By way of introduction I shall only briefly mention some of the major conditions that determined the emergence and shape of modern primitivism. Acquaintance with these conditions may help us to understand how primitivism became such an important issue in the intellectual and artistic life of the late nineteenth century, and why it adopted the models it did.

An obvious condition for awakened interest in, and the beginning of study of, "primitive" objects (no matter how modest this study may originally have been) was the simple fact that some of the European states were building up empires with vast colonial possessions at the time, and other countries were aspiring to acquire such possessions. Living in the colonies and being in continuous and versatile contact with the native populations could not fail to make some Europeans attentive to the material cultures

they found in these distant places. This, as we know, ultimately led to the formation of large collections of tribal objects in some of the capital cities of Europe.

European audiences in early modern times (especially since the sixteenth century), originally consisting of the noble and the highly educated, were used to collections of objects other than works of art. *Wunderkammern*, or *cabinets des curiosités* were found in courts and cities, where they exerted a strange fascination on their select audiences.[3] In these collections were a great variety of objects, valued mainly for their strangeness, whether natural (different kinds of monsters), material (e.g., objects of pure gold), or of form. The latter aspect certainly prepared the taste of some European audiences for the encounter with objects of tribal art.

Early in the nineteenth century some people realized that collections of tribal objects, and more generally a better acquaintance with tribal culture, might also be useful in their political and economic enterprises. An ideological pioneer of this aspect of colonial expansion, and a pioneer of anthropological collections in general, was P. F. von Siebold. As early as 1843 he composed a programmatic treatise (in the form of a "letter") suggesting that museums of tribal objects be established in the major cities of Europe. He emphasized not only the educational importance of such museums, but also specifically "the importance of their creation in European states possessing colonies." These museums would help to awaken the interest of the public, and especially of merchants, in the tribal populations. Von Siebold referred to eighteenth-century *cabinets des curiosités* in which "savage utensils" were preserved among other objects. Though he detested "the strangeness and inhumanity" of the primitives' customs, he had some appreciation for their manual skills. In the eighteenth-century *cabinets*, "Some products of the art and the industry of half-civilized peoples were also preserved, but much less in the interests of science than out of regard for the great perfection of the technical arts which had been found among these barbarians."[4]

It was only years later that the museums did, in fact, begin to emerge and take shape. A precise chronology is difficult to establish, both because the categories of the materials collected were rather fluid (where does the difference lie between Far Eastern objects and tribal products?) and because some established museums added, without necessarily displaying, a few anthropological objects to their traditional collections without considering such sporadic acquisitions a decision of principle.[5] To mention a few symbolic events and dates: As early as 1823 the British Museum acquired some Aztec sculptures, possibly the first collection of its kind in Europe. In 1855

the project for an ethnographical museum began to take shape in Paris, the planners being stimulated by the Universal Exposition held that year. The Trocadero Museum in Paris was officially founded in 1878, also under the influence of another Universal Exposition being held in Paris. In 1856 an "ethnographical section" was added to the Museum of Antiquities in Berlin. In 1866 the Peabody Museums of both Harvard and Yale Universities were founded. In 1874 the Ethnographical Museum in Leipzig was opened to the public. A year later, in 1875, the Museo Preistorico ed Etnografico was founded in Rome. In 1877 the Hamburg museum became a *Museum für Völkerkunde*.

Summing up the dates mentioned, it seems fair to say that ethnographical collections came into their own in the third quarter of the nineteenth century. Their growth, proliferation, and appearance as independent institutions, is a good indication of how rapidly interest in the tribal developed.

Another important condition that made it possible for European culture to perceive and adopt the primitive in art was that complex, ill-defined phenomenon known as "exotism." European culture, self-centered though it always was, never completely lost all links with distant civilizations; the attraction of the exotic was felt in all periods and times. But the intensity and impact of this attraction differed from one period to another. In the period immediately preceding the decades discussed in the present essay, exotism, the study of distant cultures and their arts, played a significant role. Some of the typical features of modern life are the product of eighteenth-century exotism. Suffice it to mention the "English Garden" and the impact of Chinese imagery on its shape, the result of the *goût anglo-chinois*.[6] The great flourishing of porcelain in the eighteenth century is also testimony to the pervasive, if somewhat elusive, influence of the Far East on Europe.

Here, too, we cannot attempt to unfold the almost infinite variety of images, forms, and materials that were conceived as "exotic," even if we were to limit ourselves to the late eighteenth and early nineteenth centuries. It has been said that, at least in the first half of the nineteenth century, Islam and Islamic influences provided the bulk of European, primarily French, exoticism. For our purpose it may be more useful to look for a moment at the impact of more distant countries and cultures, mainland China, Japan, and India. The history of the influence these countries, and especially their arts, exerted on European painting in the late nineteenth and early twentieth century has often been studied. Here we shall note only two points related to these studies.

The first of these points is not easily made in a few sentences, but the problem should at least be stated. In the decades discussed here, the distinction between the exotic and the primitive was not obvious; even today they are still sometimes confused. In a significant sense they did, in fact, overlap in the minds of nineteenth-century spectators. Both terms referred to non-European cultures and arts, intrinsically alien to the Greek tradition that was at the base of most western concepts and images of art. Many critics, artists, and educated audiences after, say, the middle of the nineteenth century often found it difficult to conceptually distinguish a Japanese painted screen from an Oceanic woven object. Both were placed in the "Ethnographic Collection," being primarily materials for *Völkerkunde*. But it was not only a matter of where the objects were placed; they were also seen as belonging to the same, or to a related, category. To the European mind in the mid-nineteenth century, a Chinese dragon and a Javanese mask both differed from the category of "art."

In spite of these conceptual problems, however, European artists and critics were well aware of the fact that works of Chinese, Japanese, or Indian art, though "exotic," were not really "primitive." On the contrary, in some exotic art works qualities of preciousness and refined taste and workmanship were found. "In all Chinese art," wrote Apollinaire, "there is a feeling—that is not small minded—for the preciousness of the works of art, an admirable refinement devoid of affectation." And describing objects displayed in an exhibition in Paris, he said: "There are blocks of amber sculpted to perfection, iridescent, tinted in the rarest shades; some of them—and it is these that the Chinese value most highly—have insects or small plants embedded in them."[7] Almost twenty years earlier, Maccoll, a British critic, defending impressionism, had said of Japanese painters that they were "severely logical in their art."[8] The impressionists, said Dewhurst, another English critic, continued some earlier European traditions. "But they added a strange and exotic ingredient. To the art of Corot and Constable they added the art of Japan, an art which had profoundly influenced French design one hundred years before."[9] As these quotations show, European critics knew that the arts labeled "exotic" were far from being primitive; on the contrary, they represented venerable and well-established cultures, even though they differed from the Greek basis of the western tradition.

This then brings us to the second point I should like to make: these strange exotic arts, recognized as manifesting highly refined and venerable cultures, revealed principles of representation that flatly contradicted some

of the essential assumptions of western art. Among those principles were perspective and the illusion of volume, two notions that formed the very center of the pictorial tradition and its ideology since the Renaissance. "From Japanese colour-prints, and the gossamer sketches on silk and rice paper," said Winford Dewhurst in 1904 in the article quoted above, "the Impressionists learnt the manner of painting scenes as observed from an altitude, with the curious perspective that results."[10] The "curious perspective" was the flattening of the scene, that is, the very opposite of the vanishing-point perspective the Renaissance instilled. Théodore Duret, journalist, critic, and collector, had praised the "originality of [Japanese] perspective" and their method of placing figures in space ten years earlier.[11] It was probably this flatness that made Apollinaire think that "Chinese paintings . . . look like infinitely precious advertising posters."[12] In 1897 an anonymous reviewer tried to explain the influence of exotic, especially Japanese, art by declaring that Hokusai's work was a revelation to French painters. "The spontaneous charm and refinement of Japanese artists, their natural instinct for colour and sense of space and air" led the western eye to a rebirth.[13] European critics, one must conclude, were fully aware that Japanese perspective, with all its charm, clearly contradicted Renaissance perspective (as it continued to be taught in academies of art), which claimed to be scientific.

Another point, of no less significance than perspective, was the realization that Far Eastern painting consistently denied the gradual shading that is the main means of creating the illusion of volume. This, too, was a central pillar in the edifice of western, post-Renaissance art theory. Yet it was consistently avoided in Japanese and Chinese art. In D. S. Maccoll's article "The Logic of Painting," to which we have already referred, we read that "The Japanese painters, who are severely logical in their art, actually leave out all shadow and modelling, they present you with the flat patch and the outline."[14] Manet, whom the same critic praised in 1902, under the influence "of Japanese color-prints, designed in outline and colour values only, without cast shadow or shadow modelling."[15] Of Pissaro we learn from yet another critic, the Count de Soissons, that he used "extra light tones, . . . large spots of colour suggested by Japanese art. . . ."[16]

The suppression of shadow and the spreading out of color patches, an important subject we shall have to discuss from many aspects,[17] is mentioned here in a very specific context: it shows, in addition to whatever else it may imply, a consistent negation of the illusionistic principle. This negation was found in fully materialized form in Far Eastern, and particularly

in Japanese, art. In other words, a great traditional art was seen to completely reject the very foundations of European painting.

To sum up this particular argument in a simple sentence: the realization that great cultures, such as those of the Far East, could have principles of art altogether different from those of the European tradition was an important condition of mind that made possible the interest in, and reception of, the primitive, and the development of primitivism in general.

We now ask: where and how did the theoretical discussion of primitive art as a particularly modern concept begin? And what were the major issues and problems of this trend in the intellectual analysis of art? Here we turn to the central themes of the theory of modern primitivism, and to the stages of its development.

NOTES

1. See Arthur O. Lovejoy and George Boas, *Primitivism and Related Ideas in Antiquity* (Baltimore, 1935), especially pp. 1 ff.

2. Lovejoy and Boas, *Primitivism*, p. 8.

3. For a good introduction to the study of the *Wunderkammern*, see the still valuable work by Julius von Schlosser, *Die Kunst- und Wunderkammern der Spät-Renaissance* (Leipzig, 1908).

4. See P. F. de Siebold, *Lettre sur l'utilité des Musées Ethnographiques et sur l'importance de leur création dans les états qui possèdent des Colonies* (Paris, 1843). And cf. the observations by Robert Goldwater, *Primitivism in Modern Art* (Cambridge, Mass., 1986; original edition: 1938), pp. 4 ff.

5. Goldwater, *Primitivism*, pp. 315–19 gives a very useful "Summary Chronology of Ethnographical Museums and Exhibitions." The main difficulty with this list is that it does not separate the tribal from the exotic, say, the African and Oceanian from the Japanese and Chinese. However, this should not be construed as a criticism; the difficulty was inherent in the cultural situation of Europe.

6. The literature is, of course, large. But see M. I. Gothein, *A History of Garden Art* (London and Toronto, n.d.); the German original appeared in Jena, 1926. For the general context, see the still interesting article by Lovejoy, "The Chinese Origin of a Romanticism," reprinted in Arthur O. Lovejoy, *Essays in the History of Ideas* (New York, 1960), pp. 99–135.

7. The quotations are from a review Apollinaire wrote in 1911. See Leroy C. Breuning, ed., *Apollinaire on Art: Essays and Reviews, 1902–1918*, translated by Susan Suleiman (New York, 1972), pp. 164 ff.

8. See D. S. Maccoll, "The Logic of Painting," published in 1892; here quoted from Flint, *The Impressionists in England*, (London, 1984), p. 118.

9. From an article by Winford Dewhurst, published in 1904, and here quoted from Flint, *The Impressionists in England*, p. 192.

10. Flint, *The Impressionists in England*, p. 192.

11. Taken from an article on Degas by Duret. The article is reprinted in Flint, *The Impressionists in England*, pp. 296 ff.; the sentence quoted may be found on p. 297.

12. This characterization of Chinese paintings is found in an article published in 1911. See Breuning, *Apollinaire on Art*, pp. 127 ff., especially p. 128.

13. Flint, *The Impressionists in England*, pp. 143 ff., especially p. 145.

14. Flint, *The Impressionists in England*, p. 118.

15. Flint, *The Impressionists in England*, p. 267.

16. In an article published in 1903, and reprinted in Flint, *The Impressionists in England*, p. 343 ff. For the sentence quoted, see p. 347.

17. See below, chapter 25.

The Beginnings of Scholarly Study
Gottfried Semper

A reader familiar with developments in the nineteenth-century reflection on art may be surprised to find Semper's name in a discussion of ideas concerning the primitive in art. Semper is usually considered a "functionalist," sometimes even a "materialist." These characterizations have attained wide currency as a result of Alois Riegl's critical analysis of his views, mainly in Riegl's *Stilfragen*, a book that marks a watershed in thought on the visual arts. To a considerable extent these characterizations can be supported by what Semper himself had to say. Yet without attempting to reject such interpretations of Semper's work and position I shall try to show that he played an important part in assigning a well-defined place to primitive art in the modern system of thought, and in establishing some of the essential categories employed in its exploration and interpretation.

Gottfried Semper was born in Hamburg in 1803. He became a teacher of architecture in Dresden, but was also actively involved in the revolutionary movement that shook Europe in 1848. As a result he was forced to leave Dresden, and spent many years as a political refugee in England. Semper's English experiences had a formative influence on his intellectual world, and may well have contributed, or at least supported, the direction of his thought. In 1851 he helped organize the Great Exhibition in London. Some of the intellectual vistas that this Exhibition opened up to him are relevant to the consideration of the primitive, and we shall encounter them shortly. In later years he went to Zurich, where he took part in building the Technical University, the Eidgenossische Technische Hochschule. He eventually moved to Vienna, where he died in 1879.

Here we are concerned with Semper's theories of art, particularly with what he had to say about primitive art. But first we must make some general comments on his doctrine. The overall character of Semper's literary work, it has been said,[1] is that of a *Mischform*, composed of art theory, art history, and archaeology. Actually it includes many other elements. Nobody

should be surprised, therefore, that it is so difficult to classify his writings and place them in any accepted category. Semper's influence on the historical study of art was limited, although in his time academic art history was entering one of its most expansive and productive periods. But his impact on the general culture of his time, and of following generations, was considerable. Semper had the rare distinction of having articulated views and attitudes to art that were fully in tune with modern European culture. Even if one disagrees with some of his views, one cannot disregard the historical role played by his doctrine.

It is a truism that the social and intellectual conditions prevailing during an investigation will often be manifested in the problems discussed, or even emphasized, and in its general direction of thought. This is also true for the study of art. In the nineteenth century quite a few studies of art and of its history began in the museum, which reveal the attitude of the curator who cares for his collection. It is easy to distinguish them from writings on art that grew out of art criticism—their character can hardly be mistaken. Still a third group, considerable in weight, of art studies originated in scholars' teachings, in the seminar room, as it were. Semper's scholarly or theoretical work, it has been said,[2] emerged from the workshop. The intimate knowledge of various materials and techniques, so obvious in his writing, is indeed very rare in the art literature of the other kinds of studies. The significance he assigned to these problems also betrays an attitude common in workshops.

If this characterization is correct (and I certainly agree with it), Semper would be an interesting example of a phenomenon that has disappeared in modern times. While in our age theoretical reflections on art are the work of academic and literary people, in the fifteenth and sixteenth centuries many of them came from workshops.[3] The authors of Renaissance treatises on art were often painters or sculptors for whom the question of how to make a work of art, a specifically workshop question, was of central importance. In this respect Semper harks back, probably without being aware of it, to an outlook that was typical of an earlier age.

Were we to leave the description of Semper's thought here, stressing only its affinity to the practical issues of the workshop, we would not portray it accurately. In addition to workshop experience, it should be added, his thought shows a strong leaning toward metaphysical construction. To be sure, this leaning was not openly manifested. If I correctly understand the climate of opinion surrounding Semper, he may even have wished to suppress any connection with metaphysics. The constructions I have in mind

here are, in fact, often those of a layman's metaphysics, lacking the rigor of a philosopher's examination. But however this may be, the nonempirical element forms part and parcel of Semper's thought. This element is of special significance for Semper's contribution to the study of the primitive, and of primitive art, and we shall have to deal with it in some detail.

But before we do that, we should outline some broader aspects of his doctrine. What he wanted to provide, mainly in his great work *Der Stil*, was, in his own words, an "empirical art doctrine."[4] What is an "empirical art doctrine"? In the Middle Ages or in the Renaissance such a term would have denoted a set of rules meant to help the artist "make" a picture, a statue, or some other art object. This was far from Semper's mind. Though he spoke about art, he did not particularly address artists.[5] But nor did he wish to compose an aesthetic doctrine. He was critical of theoretical aesthetics because it "considers form as such"—this was a serious accusation. What he wished to do was "to discover in detail the laws and the order that emerge in the becoming and emerging of artistic phenomena, and to derive general principles, the basic features of an empirical doctrine, from what has been discovered."[6] The language and the spirit of this proclamation were clearly taken from the natural sciences of the nineteenth century, which indicates that our author wanted to articulate a natural science of the arts, or at least of the "technical and tectonic arts." A natural science of the arts was what he meant by the "practical aesthetics" he included in the full title of the work.

Semper's endeavor to establish a natural science of art went together not only with certain methods employed, but it also determined the choice of materials he dealt with, the concrete subject matter of his investigation. In the second half of the nineteenth century, it was believed that a scientific approach requires full distancing from the individual, whether an individual person (for instance, an artist), an object (for instance, a specific work of art), or something else. We must remember that in Semper's time, and within his culture, the division between the historical and natural sciences was the subject of serious philosophical effort. One of the hallmarks of natural science was considered to be its complete detachment from the individual, from the unique character of a specific phenomenon. While History dealt with the unique, Science concentrated on what could be repeated—it had no use for the unique and no means to grasp it. But here a particular difficulty arises for the student of art.

It was considered axiomatic that the work of art is the embodiment of the individual, the unique. This would seem to preclude any scientific ap-

proach to its study. Is a natural science of art conceivable at all, then? Semper thought he had found the answer in the "technical arts," in which it was not the individual and unique that counted, but rather the repeatable. The "technical arts" consisted mainly of architecture (perhaps one should speak instead of the "art of building") and what we would now call ornament and the shaping of form in everyday objects. The "technical arts" roughly overlapped with what, a generation later, Alois Riegl would call by the now famous term *Kunstindustrie*. In this domain, the example and even the motif were replaceable by a similar one. Here, it seemed, the approach of natural science could be applied. Semper could set out to discover "the laws" of the technical arts.

To arrive at these "laws," the shapes of the technical arts or of art objects had to be considered from two points of view, corresponding to the factors that determined them. The first was the purpose for which an object was produced or a shape established. This purpose could be an actual "material service"—that is, a practical purpose, acknowledged as such by Semper and his time—or it could have an imaginary or symbolic purpose (I, p. 7). The second factor was actually a cluster of agents. It consisted of the materials in which a work of art was executed, the tools applied, and the processes carried out to shape it. "Secondly," said Semper, "the work is a result of the *matter* that is used in the production, as well as the *tools* and the *processes* applied in [the production of] it" (I, p. 7). This definition of the shapes and products of the technical arts was interesting in many respects, and we shall discuss it briefly.

Let me first say a word about Semper's grouping of these factors. In modern discussions of his doctrine it has become customary to consider all the factors (purpose, matter, tools, processes) on par with one another, which often gives the impression that Semper distinguished four more or less equivalent factors of similar character and position. But Semper himself presented them differently. He arranged the factors in two groups. Purpose formed a group all by itself, while the three others were lumped together in a second group. This division was not insignificant, as it indicated a difference in the nature of the factors.

The "purpose" was not of a material nature: it was what we envisage as the function the object will fulfill when it is produced. We could perhaps say, with only slight exaggeration, that Semper conceived of the purpose as the object's resemblance to some kind of image dwelling in our minds, a model to which we wish to adjust the object we are producing. The three other factors (matter, tools, procedures) were located at a different level.

They were actually encountered in the process of shaping the artifact; in a simple, realistic sense they were objects of regular experience.

Purpose had still another distinction which set it apart from the other factors. It was, Semper believed, nonhistorical (or beyond history) and did not change, while the other factors were prone to historical change. "The purpose [or designation][7] of each technical product remains the same at all times, as it is based on the general needs of man and on the laws of nature that are valid at all times . . ." while "the kinds of treatment the materials receive change in the course of time, and according to local and various other conditions . . . (I, pp. 7–8). Thus, a band or strip always winds around an object, but whether it is made of linen, wool, or silk, of wood, clay, stone or metal, and where and when it was made—this is a historical question.

It is obvious that Semper believed the nonhistorical to be of central importance, the significance of the historical factors being more marginal. For this reason, he thought, the more general, formal-aesthetic considerations should be linked to the question of purpose, and the historical investigations to that of matter (I, p. 8). The general needs of man, we have just seen, also do not seem to change. In distancing himself from the historical, Semper again showed how close he was to the thinking common in, and the assumptions accepted by, the natural sciences.

For all his empirical intentions, an underlying metaphysical attitude also shines through his treatment of material, although it was never explicitly acknowledged. Material *as such*, he said, need not be a factor that appears in the work of art, but "the form, the idea that has become an appearance [a phenomenon],[8] must not contradict the nature of the material in which it is shaped" (I, p. xvi). To realize the complex implications of Semper's attitude to matter it is worth our while to ask why in effect the form of an art object should not contradict the nature of the material in which it is executed. What were Semper's reasons for this condition? The first answer that occurs to a reader familiar with art ideologies of the twentieth century is that Semper might have considered bringing out the material's nature as an aesthetic value in its own right. In our century similar views are considerably widespread. A careful reading of Semper may occasionally suggest that ideas tending in this direction were not altogether alien to his mind (see I, pp. 90 ff.).

However, an attentive reading of Semper's text makes it equally clear that the main role materials play in his thought is not one of inspiration. In a sweeping generalization, disregarding many important shades of meaning, I may venture to say that materials mainly showed him the limits of our

imagination. Whatever we conceive as purpose and form, the material shows us what can, and what cannot, be materialized, and what purpose can be realized in which material. Semper treated four basic materials, and the media and techniques of producing art objects corresponding to them. They were textile art, ceramics, woodwork, and work in stone. What you could do in one medium and material, you could not do in another. Attaining one's purpose depended on the nature of the material.

The idea that inert matter is a factor limiting the imagination in the creative process, that it ties down the artist's flight of fancy, has a venerable ancestry in European thought. It was Neoplatonism, and mainly Plotinus himself, who lent this idea a weight that was among the formative agents of western aesthetics. Gottfried Semper was far removed from Plotinian philosophy. The subjects he considered, the intellectual and emotional tone of his writings, and the conceptual framework of his thought all seem the very opposite of Neoplatonic reflection. But Semper was too deeply rooted in the artistic and philosophic traditions of Europe not to be sensitive to doctrines borne out by his direct empirical observations.

In the vast field of art objects and their production Semper searched for the "laws" that determined both the shapes articulated and the processes of their articulation. In the course of the nineteenth century, perhaps particularly in the wake of Comte's positivism, the concept of law found favor in many fields of the study of man. In our context it is useful to recall Edward B. Tyler's *Primitive Culture*, published a decade after Semper's *Der Stil*, a work accepted as a landmark in the development of both modern ethnography and the study of religion. To those engaged in "the scientific study of human life" Tyler held up the model of the "physical science [that] pursues, with ever-increasing success, its quest of laws of nature."[9] Semper looked for the primary laws of art, a quest that led him to our specific subject in the present part, primitive art.

Science teaches, so Semper and his contemporaries believed, that Nature, in spite of the inexhaustible abundance of its appearance, is economical in its procedures and motifs. In bringing the various creatures and objects into being and making them grow, Nature employs only a few basic procedures. No matter how variously these creatures and objects adjust to local conditions, their basic forms are few, and they recur countless times. The same is also true for man's creative activities of all kinds, quite particularly for art. A few "basic forms" (*Normalformen*) constitute the foundation for the infinite variety of art products we know from experience. These shapes and types "originate from the oldest traditions" (I, p. viii).

Here Semper made two assumptions of far-reaching consequence for the ideas concerning the primitive in art. First, he assumed that the *Normalformen*, the classic and irreducible shapes, emerged and were clearly articulated in the earliest stages of history. Second, he believed that the study of primitive art as found in our own time is the best way to form an idea of, and understand, the original art, the creation of man's earliest stage. In the combination of these two assumptions he anticipated a great deal of modern reflection on primitive art. It is their interdependence that makes them revolutionary. It will, however, be useful to treat the two assumptions separately.

Semper proclaimed the existence of an art that went back to the beginning of human history. The insistence of these proclamations and their urgent tone suggest that the existence of such an art was not yet fully accepted, that it was far from being taken for granted. Semper often spoke of "antediluvian times" and of "antediluvian art" (e.g., II, pp. 124 ff.). in his time the term "antediluvian" was not unknown in this particular context, even being used in the title of a book on antiquities.[10] But though such concepts and terms were not new, their precise meaning was not fully clear. For Semper the term had two meanings. On the one hand it designated a period of time, the earliest age in human history. On the other, it suggested the world in which the "basic forms" of art had originated. These "oldest root shapes" ultimately explained the wealth of patterns and techniques of historic art. Thus, "the root forms of tectonics are much older than the art of building." They belonged to a "premonumental" world (II, p. 200). Even the judging of an individual work of art was ultimately based on what became manifest in antediluvian art (II, p. 199).

Here one has to ask, how did Semper know of these "root forms"? On what was his knowledge of "antediluvian art" based? The answer is a little surprising. His direct knowledge based on empirical observation, on what he could see for himself, was very limited indeed; as far as art was concerned, it was close to nothing. Sometimes, though very rarely, he did mention archaeological finds that we would now call "prehistoric": in the cave of Miremont in France fragments of pots had been found, mixed with "bones of antediluvian animals." In a South American province remnants of coal had been discovered, with some fragments of ceramics (II, pp. 123 ff.). Note that no forms were mentioned here; it was only suggested that ceramic had been produced. Whence, then, did knowledge of "root forms" arise? How did Semper know that such "root forms" existed, and what they looked like?

Essentially, "antediluvian" art, as Semper saw it, was a conceptual construction, arrived at by a process of thought rather than by empirical observation. To give but one example: the shapes of Celtic, Germanic, Scandinavian, and Slavonic pots are so similar that one can hardly distinguish one from the other. They also have a striking similarity to the oldest products of Greek pottery. They all show, Semper inferred, "undeveloped major shapes." Their formal similarity corresponds to a similarity in use as holy objects in primitive burial customs (II, pp. 124 ff.). to him all this suggested original forms, part of the antediluvian world.

The type of conceptualization we find in Semper's postulation of an antediluvian art—that is, explaining concrete shapes by deriving them from a hypothetical *Urform*—was known in nineteenth-century culture, perhaps particularly in Germany. Everybody remembered the classic example of Goethe who, as a student of nature, projected onto an unreachable past the concept or image of an *Urpflanze*, a primordial plant, that was assumed to explain the coming into being and the development of vegetational forms. Goethe could also serve as a model for seeing art as analogous to nature. There was, then, a venerable intellectual ancestry both to Semper's belief in the existence of an original primordial art from which all later forms were derived, and to the assumption that there was a close analogy between this art and nature.

Antediluvian art, as we have seen, was only postulated. From Semper's construction it followed that such an art must have existed. But nowhere could it be seen directly. Prehistoric paintings and sculptures, we should keep in mind, had not yet been discovered when Semper wrote his great work; the few examples already known at the time (mainly incised bones) were not considered art. There was, then, no immediate way of observing this early art, and of knowing the character of its forms. How was one to conceptualize the nature of antediluvian art? Here we reach Semper's second principle, the belief that there was an affinity between the primitive art of his own day and antediluvian art, and that by looking at the primitive arts of the present age one could get an inkling of what the art of the earliest stages in history was like.

In turning to what Semper said about contemporary primitive art, it is worth noting carefully what was actually known to him, what classes of works he mentioned or failed to mention. He was familiar with those products of primitive art that were available, and known, in mid-nineteenth-century England, his main source being the great World Exhibition held in London in 1851. As we have already noted, when Semper wrote *Der Stil*

very little was known about prehistoric art; not surprisingly, therefore, he hardly refers to it. For the modern reader it is perhaps more surprising that he did not so much as mention African art. The art of black Africa (as distinguished from that of ancient Egypt) had not yet entered European consciousness. The cultural map of the world appeared as seen by the mid-nineteenth-century British Empire. Here primitive art was represented by the art of Polynesia and New Zealand, which was the primitive material in Semper's book.

The context in which Semper discusses Polynesian art is significant. We recall that Semper distinguished four essential media of artistic activity: textile art, ceramics, woodwork, and work in stone. Textile art, he believed, was the "primordial art" (*Urkunst*); all the other arts borrowed their types and symbols is from textile art (I, p. 12). It is, therefore, worth recording that Semper treated Polynesian art as representative of textile art.

The context in which Polynesian art was treated is significant for another reason as well, namely, the historical position it occupied in Semper's views. The section dealing with this art appears in that part of the work that discusses the development of media and techniques. This historical survey begins with Polynesian art, an art produced in Semper's own day, then turns to China (I, pp. 226 ff.), which the author believed had the oldest written history, to India (I, pp. 240 ff.), and only after that to ancient Mesopotamia (I, pp. 250 ff.) and Egypt, and the beginning of European development. The chronological survey thus begins with a contemporary art, and only later turns to that of the oldest cultures. Clearly, Semper assumed that primitive art, no matter when it was actually produced, stood for the art that preceded that of the most ancient cultures. The primitive and the prehistoric merge into one.

Now, what had Semper to say about the art of New Zealand and Polynesia? It is not always easy to isolate his views on this specific art, since he associated primitive art and the art of non-European nations; thus primitive and Chinese art were treated together. In spite of this difficulty, however, two points become clear in his treatment of the primitive.

The first is a certain ambivalence in Semper's attitude to primitive art. He spoke of "the wild and tame nations of non-European culture" (I, p. 223). The arts of non-European culture reached from crude beginnings to refined perfection, as could be seen in the most elementary of the arts, that of weaving.

The other issue is more important. One can perhaps grasp it by asking: what is it that characterized primitive art in the general historical scheme?

Though Semper did not put the question in this form, he answered it. What he found most characteristic of primitive art, as represented by the objects from New Zealand and Polynesia shown in the Exhibition of 1851, was that it is the art of origins and beginnings. All the major arts emerge from nuclei to be found in the simplest objects, such as the products of Polynesian crafts shown in London. Architecture grew out of the wickerwork of fences found in Polynesian villages. "As fortification and enclosure of villages, wickerwork forms among the warlike New Zealanders the basic motif of all architectural forms" (I, p. 224).

But the other arts were also derived from such primitive origins. Sculpture developed from a decoration of the wickerwork fence. These fences were fortified by poles, particularly in the area of the gateways. Painted in lively colors, these poles were decorated with various carvings, mainly of heads (which replaced the actual heads of enemies). It is interesting that Semper saw the origin of sculpture in what we know as architectural sculpture; the independent figurine, which we now consider an important art form of the prehistoric age, is not so much as mentioned in his work.

Painting had a similar origin. Pictures emerged from weaving and from other products of textile art. Basing himself mainly on travelers' reports Semper referred to some kind of *Brustbilder* made by weaving thin, elastic pieces of wood, showing the details of the head as well as the neck (I, p. 225).

NOTES

1. Wilhelm Waetzoldt, *Deutsche Kunsthistoriker*, II, pp. 130 ff., esp. p. 131.

2. Waetzoldt, *Deutsche Kunsthistoriker*, p. 131.

3. See Barasch, *Theories of Art*, pp. 108 ff.

4. The full title reads *Der Stil in den technischen und tektonischen Künsten oder praktische Aesthetik*. I am using the second edition (Munich, 1878). For the sentence quoted, see *Der Stil*, I, p. viii. The translations from Semper are by the present author.

5. At the beginning of *Der Stil* (I, p. viii) Semper stressed that a doctrine such as his "should not be a handbook of the practical execution of art, since it does not show the production of a given art form. . . ."

6. *Der Stil*, I, p. viii. Further references to *Der Stil* will be given, in parentheses, in the text.

7. In the passage quoted here Semper uses the term *Bestimmung*, which should probably be translated as "designation" rather than "purpose." It is, how-

ever, obvious that he uses the terms interchangeably; designation means the same as purpose.

8. This formulation, "the idea that has become an appearance," is of course of well-known Hegelian descent. See Barasch, *Modern Theories of Art, 1*, pp. 182 ff. That Semper here used a Hegelian formula did not necessarily mean that he was a "Hegelian," but it is obvious that, writing less than a generation after Hegel's death, he was familiar with the famous philosopher's views and formulations.

9. Edward B. Tyler, *Primitive Culture* (London, 1871), especially I, pp. 2 ff.

10. Jacques Boucher de Crevecoeur de Perthes, *Antiquités Celtiques et Antediluviennes* (Paris, 1847).

19

Discovering Prehistoric Art
Early Questions and Explanations

Developments in the theory of art have rarely been motivated by what was happening in art theory itself. As we have had ample occasion to see in the preceding volumes, the problems and tasks of art theory were usually posed by events and processes taking place either in the world of the artists or in the society for which their works were made, the world of the spectator. Whatever the exact stimulus to new discussions, it always came from beyond the confines of aesthetic reflection itself. Likewise, conditions and movements in the outside world that determined which way art theory turned in search of solutions. This general truth is particularly evident in the reception and assimilation of primitive art. The discovery of prehistoric art and the attempts to come to terms with it show as in a flash the impact of historical developments and of accepted beliefs and notions about the theory of art.

The stories of how the prehistoric age was discovered, and how prehistoric man's culture and the works of art he left behind were seen and understood by the modern students who were first faced with them—these stories have been told more than once.[1] We need not repeat them here. But it may be useful to make a few comments about those discoveries and the attempts to explain them, that had a direct bearing on reflection on art.

Ever since the Renaissance, vague assumptions were made to the effect that humanity was much older than conventional wisdom had it. Students who could not accept the calculations of biblical chronology or solve other difficulties resulting from the biblical text, often turned to the so-called "Pre-Adamite" theory, a heretical belief found among some learned men in the seventeenth and eighteenth centuries. But these few scholars of independent mind did not waste a thought on early man's ability to create art. So when was prehistoric man's ability to produce works of art recognized, and when did this awareness enter cultural consciousness and become part

of reflection on art? Trying to answer these questions we reach dates very close to the beginning of the twentieth century.

Prehistoric art, and particularly its aesthetic significance, did not appear on the cultural horizon of Europe as a sudden illumination. On the contrary, it was grasped slowly, in an extended, gradual process which is difficult to date precisely. Even after several crucial discoveries were made, students were still far from realizing what the sites and objects they had discovered actually implied.

Some prehistoric engravings on bone fragments had been known for a long time. Suffice it to mention the engraved fragment with a representation of hinds discovered as early as 1834 in the cave of Chaffaud (Vienna). The great age of this object was not immediately recognized. Almost a generation later, excavations on the site of La Madeleine in Paris, begun in 1861, brought to light carved and incised objects whose remote origins could no longer be doubted. In 1864 Dr. Garrigon, an experienced student of prehistoric sites and objects, visited the cave of Niaux, and saw the wall paintings in that cave, including the famous images of animals in the so-called *Salon noir*. These paintings are now generally considered among the masterpieces of prehistoric art. The reaction of our learned visitor was remarkable. After looking at the paintings in the *Salon*, he only made the following entry: "There are some paintings on the wall: what on earth can they be?"[2]

Few stories of archaeological findings are as famous and as illuminating as that of the discovery of the Altamira paintings in northern Spain. The groping attempts to interpret these cave paintings are no less fascinating. The paintings in the cave of Altamira, as is generally known, are among the outstanding achievements of cave art; interpretations of these works have played an important part in our understanding of prehistoric art as a whole. The story is familiar, but it deserves retelling. In 1875, a year of great significance in the history of modern archaeology,[3] a Spanish scholar, Marcelino de Sautuolo, began excavating the cave of Altamira. Four years later, in 1879, his daughter walked into the inner recesses of the dark cave and, lifting her lamp, saw the frightening images of beasts on the ceiling. Running to her father and shouting *Toros! Toros!* she called attention to the paintings that had not yet been noticed. One of the greatest discoveries in prehistoric art had been made.

For our purpose, the next instalment of the Altamira story, the account of how the paintings were received by scholars and educated audiences, is more significant. In 1880 Sautuolo published the Altamira paintings,

claiming they were Paleolithic in age. The publication, which also presented some earlier findings, precipitated a debate that demonstrated the power of accepted beliefs. Some declared that Sautuolo was simply an impostor and a fraud, and that he had hired an artist from Madrid to do the paintings. A French scholar, Edouard Harle, who visited the cave in 1882 and carefully studied the paintings, came to the conclusion that "they were indisputably of very recent date and had probably been executed between Sautuolo's two visits to the cave—that is between 1875, when he never noticed any paintings at all, and 1879, when he discovered them." Some writers even suggested that soldiers with nothing better to do had painted the images when they were taking refuge in the cave.[4] As late as 1902 a German student wishing to visit the cave was warned by a serious French scholar, Massenat, "not to be fooled by such a fake."[5]

Prehistoric cave paintings themselves are not the subject of the present essay, but the reaction to their discovery is. It would be tempting to speculate on the reasons why serious scholars, as well as their educated public, were unable to see the facts that now seem to us so obvious, and what prevented them from acknowledging the existence of prehistoric art. But let us first note the simple fact that it was not religious orthodoxy that prevented scholarly understanding. That the paintings are much older than would seem possible within the framework of biblical chronology—a serious consideration in the thought of earlier centuries—was not a valid argument for students at the turn of the nineteenth and beginning of the twentieth centuries. Both the explorers and their readers were thoroughly familiar with the great age of our world; paleontologists knew of periods lasting millions of years rather than the limited number the Bible allowed. What made it so difficult for them to properly assess prehistoric painting had to do with matters of education and *Weltanschauung*, of philosophical beliefs. These beliefs focused both on what were conceived to be the motives for shaping a work of art, and on what was imagined to be the character of historical progress leading from primitive culture to our own times.

Ever since the discovery of cave paintings, and particularly with the growing realization that they were authentic products of a very early stage in our history, the central question, one that forcefully imposed itself upon scholars and audiences, was: what was the purpose of these images? Why were they made in the first place? The direct impact of the discovery of the prehistoric paintings, particularly those of Altamira, on general reflection on art can best be studied in attempts to answer this question. Did the paintings of Altamira, and of the other caves, have an immediate, well-de-

fined purpose? What prompted prehistoric men to make such great efforts to paint these images? In the intellectual climate of around 1900, the question was of far-reaching consequence. An important, perhaps central, trend in aesthetic reflection in the second half of the nineteenth century claimed that art had no "practical" purpose at all; that it was characteristic of art to be devoid of any purpose, that it did not aim at anything beyond the very contemplation of the work of art. Looking for a purpose was, many thinkers felt, tantamount to disregarding the unique character of art, and to denying its autonomy.

To students holding such views, as did practically all professional scholars at the time, the discovery of the Altamira paintings presented a dilemma. On the one hand, the cave paintings showed art in its earliest formations, and thus, it was believed, in its purest forms. Here one could study—empirically, as it were—what art had been before it became "deformed" and "distorted" by social conventions, alien to its own nature. On the other hand, study of the sites where cave paintings were found made it increasingly difficult to accept the thesis that they were done for pure contemplation. Excavators and interpreters noted that the paintings are located in the deep recesses of the caves, places very difficult to get at, and usually so dark that, without artificial illumination that in prehistoric times was surely hard to come by, they could not be seen at all. These findings obviously underlined the need to explain the paintings by reference to some purpose.

The first serious attempt to deal with the problem was an explicit acceptance of the thesis that the cave paintings were made for a definite purpose. This first proposal set the tone for most of the later explanations, and prevails to this day. In 1903, about two decades after the cave paintings of Altamira became known, Salomon Reinach, a polyhistorian, student of antiquities, of the history of art, and of ancient religions, published an essay in the French journal *L'Anthropologie* under the significant title *L'Art et la magie.*[6]

Earlier in his life Salomon Reinach had been attracted to prehistoric art, and even then it was clear to him that what one said about this earliest age of man would have important implications for the philosophy of art in general. In 1889 he discussed prehistoric stag antlers with incised or engraved decorations, consisting primarily of animal representations. These antlers, he held, were trophies from hunting campaigns.[7] Were these decorated trophies made for "superstitious" purposes? ("Superstition" was the term frequently employed in the late nineteenth century for "magic," the

latter word not yet being fashionable.) Reinach could not decide; at this stage he thought the question could not be answered. In 1903, fifteen years later, the situation had changed: prehistoric art was better known, and the discovery of cave painting had now added new dimensions to thought about that early art. The article on "Art and Magic" was clearly written under the impact of the discovery of cave painting and the great problems it raised.

In his 1903 article Reinach's approach was iconographic, that is, he concentrated on the subject matter of the paintings. Prehistoric art, in painting, engravings, and sculpture in the round, is predominantly an animal art; in modern terms we would say that it is the kingdom of the beasts that provides the essential subject matter for man's earliest art. Studying this subject matter Reinach wrote that he drew up lists of the beasts frequently represented in cave paintings, and of those that appeared only rarely. Such a statistical approach, it should be emphasized, was not known in iconographic studies around 1900; it was a new departure in the study of images.

Reinach divided the beasts represented in cave paintings into two groups: one consisted of beasts desirable to the people for whom they were painted; the other of beasts undesirable to those same people. The desirable beasts were the edible ones, those which provided food. The undesirable were the dangerous ones, mainly carnivorous beasts, such as the great felines (lions, tigers), wolves, but also dangerous snakes. Looking at the cave paintings with this distinction in mind, one is struck by the fact that the only beasts represented are the desirable ones. Neither dangerous ones, nor even harmless creatures such as birds, are depicted. There could be little doubt, Reinach stressed (p. 127), that all these creatures were well known to the societies that produced the cave paintings, and that they occupied people's minds. Why didn't they appear in the paintings? What was the criterion for the selection of the beasts to be painted, of the "subject matter" of the cave paintings?

An iconographer of medieval or Renaissance art, faced with a problem of this kind, would of course look for written testimony; the texts could answer his question, or could at least indicate the direction of thought and research. Since the student of prehistoric art could not look for texts, the only way open to him, as Reinach explicitly emphasized (p. 128), was to study the thought and customs of present-day primitives. He thus accepted the assumption that there was an analogy between the primitive societies of his own day and prehistoric society.

What Reinach learned from the observation of primitive societies was, not surprisingly, that their thought and customs were dominated by magic. What underlay both thought and custom was the age-old belief that everything was attracted to that which was similar to it. This was the principle of sympathetic magic, or of "homaeopathic magic," as Reinach called it. Primitive tribes evoked by imitation whatever they needed or wanted to dominate. Pantomimic imitation is a common and well-known feature in primitive cultures; Reinach spoke of the "animal dance," and specifically mentioned the "kangaroo dance" of the Australian aboriginals. By imitating the beasts one cast a spell on them, and made them do whatever one wished.

Now, what was prehistoric man's purpose in casting a spell on the beasts represented? What was the specific aim of the representation? Reinach simply suggested that men living, or congregating, in the caves wished to attract desirable beasts to the place where the imitations were made. In other words, cave men wished to make the desirable beasts available and plentiful. From contemporary students Reinach learned that in some primitive societies fishermen performed a similar act: they used a sculptural imitation of a fish to attract fish to the place where they spread their nets.[8] Our author inferred that the people who produced the cave paintings had the same idea.

In the same context Reinach adduced still another interesting observation. In a prehistoric bone engraving he found the representation of a horse's head that looks as if it were flayed. Reinach, a student of art and its history, was familiar with the practices of art teaching, and the prehistoric representation of the horse's head reminded him of a device employed in the course of studies in art academies. "Flayed" statuettes, that is, figures showing the muscles beneath the skin (*écorché*), were used to familiarize art students with anatomy. Now, said our author, since one cannot assume that the artists of prehistoric times worked in the same ways and with the same devices, as modern artists, we must ask what these flayed heads meant. His answer was that these heads were trophies which attracted other horses by the magic spell they cast. The trophy of a horse's head "evoked" the living horse. This, then, was the aim of imitation—to evoke something. Turning to matters of principle, he said: the prehistoric artist was "not concerned with pleasing, he was concerned with evoking" (p. 135).

Since the early twentieth century, the thesis explaining images of prehistoric art in the context of magic, as devices employed in magical rituals, has received support from a wealth of new findings and observations; to this day, it is the dominant doctrine explaining the nature of man's earliest im-

ages. Perhaps the most striking observation corroborating the "magical" explanation of these images refers to a detail: in some pictures the animals are shown with arrows in their massive bodies, or with marks of wounds; there are images showing blood streaming from the mouth of the beasts. We even have renderings of an arrow approaching the animal.[9] In the same context we should also mention that clay figures of bears and lions have been found riddled with holes. The prehistoric hunters, modern students agree, must have shot at them, as at real animals. The hunter artists of those days were obviously convinced, just as many primitive hunters are in our own time, that the image gives power over the object represented. Hence, by making an image of the prey struck and pierced by deadly weapons, they thought to ensure a successful hunt for the real animal.

As we have indicated before, speculation concerning the purpose of cave painting could not remain "neutral" within the great debate about the emergence and development of art. On the contrary, the arguments adduced in that comprehensive debate are sometimes reflected in the explanations of the cave paintings themselves. This can be seen in the interpretation of the animal images in prehistoric caves. Let me give two illustrative examples. A few years after the publication of Reinach's article, a representative German psychologist and serious student of prehistoric art, Max Verworn, referred with undisguised scorn to the thesis that cave paintings may have a magical purpose. He mentioned Reinach's suggestion "only as an oddity." This scholar, Verworn said, had proposed "the strange hypothesis that the paleolithic representation of animals had the magic task" to secure success in hunting.[10] Since Reinach's explanation lacked all "psychological probability," Verworn continued, it was not surprising that his thesis had not found any support. Looking at this review from the vantage point of the late twentieth century, one cannot help smiling; Reinach's thesis, as is well known, is not only generally accepted, it seems so firmly established that it is difficult to find anybody who doubts it.

As late as 1915 Karl Woermann, in his general *History of Art*, a work that went through many editions and reflected as well as shaped prevailing opinion, expressed contemporary hesitation between the different interpretations of cave painting, especially the images of beasts. It was difficult to decide, he said, whether all the animal images in prehistoric caves had been painted because of the enjoyment of representing natural appearances, or from religious, symbolic, or "totemistic" motives, "as some well known French and German scholars maintain."[11] Woermann may well have felt that the assumption that the cave paintings had a "purpose," one which

had little to do with art and the aesthetic experience, presented a danger to the autonomy his generation wished to ascribe to art.

Another type of prehistoric work of art also captured the imagination of European audiences, and evoked a vigorous reaction that has a special bearing on the problems we are discussing here. It is the group of small statuettes that represent nude female figures, commonly known as the prehistoric Venuses. The first figure of this kind (or at least the first recorded), carved from a stag's antlers, was found in 1861, the year in which Bachofen published his work on *Mother Right*; the most famous figure is probably the so-called *Venus of Willensdorf*, discovered in 1908. As with cave painting, the interpretation of these female statuettes had a significant bearing on the general reflection on art. As these statuettes were being discovered, the question of the motives for their production intensified.

Many conditions in modern intellectual life contributed to the fascination these statuettes exerted over the European mind. These Venuses, it was soon noticed, formed the only large group of "sculpture in the round" that the prehistoric age had bequeathed to us; they were also the only large group of works of art exclusively representing the human figure. In late-nineteenth-century culture, pervaded as it was by psychological predispositions, the explicit presentation of these nude female bodies with heightened sexual characteristics did not go unnoticed. How, then, did the critical literature between the middle of the nineteenth century and the beginning of the twentieth understand these figures, and what did the authors learn from these statuettes for their interpretation of art in general?

The Venus figurines elicited various interpretations. Some of these readings have an immediate bearing on the problems discussed in the present essay. One of them claimed that the statuettes were meant to be representations of reality. Another reading saw them as the embodiment of an aesthetic ideal. A third interpretation, finally, viewed them as fertility idols, or as goddesses, or as some mythical ancestress. It goes without saying that these interpretations were not mutually exclusive; an image could well be a representation of reality and also be considered an idol. Such partial overlapping, however, should not obscure the question: what was the main motive for producing and using these statuettes, and what was the principal meaning prehistoric man assigned to them?

The first interpretation, people soon realized, had little foundation in the material itself. Prehistoric art did not in any way suggest that it was nothing but, and did not aim at anything other than, the depiction of real-

ity. What supported this explanation was simply the belief, one that late-nineteenth-century intellectuals considered "natural," that man always enjoyed the representation of reality, and that he considered such depiction a worthy aim. In fact this interpretation simply revealed how strong these beliefs were.

Another interpretation, as I have mentioned, claimed that the female figurines represented the embodiment of an "aesthetic ideal." Here two questions arise: first, what does the qualification of the ideal as "aesthetic" mean? Second, what made modern authors think that to represent an ideal was for prehistoric man a central, or even a sufficient, motive for producing of these statuettes? By asking these questions we see immediately that they provide an insight into modern thought.

What an "ideal of beauty" may have meant to prehistoric man remains, of course, obscure. Early interpreters of the Venus figurines, especially those writing after 1900, turned to a more psychological reading of the female images. They replaced "ideal of beauty" with "erotic ideal." Some scholars assumed that, possibly as a result of some changes in the nourishment available, at a certain stage of the prehistoric period men's sexual desires increased in strength, and that this concern with sex was reflected in, and explained the very production of, the female nudes with pronounced sexual characteristics.[12] Whatever the scientific merits of this thesis (and this is a matter for experts in the study of prehistory), it shed further light on the problems and attitudes of modern reflection on art. If we accept the assumption that the Venus statuettes only reflect a concern with sex, we would have to infer that they were not made for a special purpose. That an artist creates an image or shapes a form in order to express his emotions—this is, of course, a common modern belief. It forms part of the more comprehensive view that art is autonomous, that is, that its true purpose is self-referential. To suggest that a prehistoric artist shaped the female figurines to express his concern with sex was, therefore, an extension of the attitude that art is autonomous and without external purpose.

We now turn to an altogether different interpretation of the Venuses, one that is commonly held among students today. It had been noted that many of these statuettes seem to have been employed in something close to a ritual, and that they seem to have been produced for this purpose. It was noted that the feet often taper off to a point, suggesting that they might have been stuck in some special bases. Other female figurines, represented as if sitting, have a polished base, so that they could have been placed in an

upright position. Still other Venuses have perforations in or near their feet, as if for attachment to some other object. All these observations clearly suggest that the figurines were made for some purpose.

Another observation refers to the subject matter of the statuettes, or rather to the character of the figures represented. All the Venuses represent older women, or mother figures. The drastic exaggeration of the breasts and especially of the belly led many investigators to read the figure as that of a pregnant woman. Whether or not scholars concurred with this particular explanation, most of them seemed to accept the thesis that there was a certain link between these figures and religious rituals. Today many students of the prehistoric age take it for granted that the tiny statues are images of mother goddesses or some kind of fertility idol.[13]

Nowadays the interpretation of the Venuses in the context of prehistoric religion is taken for granted. However, when these statuettes first reached the light of day, especially in the first decade of the twentieth century when the earliest serious attempts at interpretation were made, students hesitated; no clear line of thought emerges from the literature. Nevertheless, even then some scholars saw prehistoric art, if I may use this term, as serving religion, or social needs and institutions. The very fact that these statues were called Venuses, Klaatsch said, indicated that people were reminded of a religious ritual comparable to that of Aphrodite in Greece.[14]

What the expert in prehistory has to say about all these problems is not our concern here. In the first decade of the twentieth century it seemed to become increasingly evident that many Paleolithic works of art were produced not merely for pleasure, but with some "practical" aim in mind. The intensive concern with magic in religious studies and the social sciences at the turn of the century emphasized the fact that magic was part of the "real" world, and that it was used when a person wished to achieve some practical result. This had obvious implications for interpreting prehistoric art as magic, and for explaining the part the images played in magical rites or procedures. What Paleolithic man must have wished to achieve by producing images to be used in magical rituals was not aesthetic experience, but some real end in the real world. Art, it followed, was originally produced not for its inherent value, but as a means to an end. This led to a great debate that could almost be described as "ideological." The interpretation of man's earliest artifacts became part of the discussion about the ends of art in general.

The Origins of Art

The reception of both primitive art and the art of the prehistoric age by educated audiences in Europe around the turn of the century, and attempts made by artists and scholars to assimilate what these arts seemed to be saying, were closely linked with concern with several great themes. Whenever these arts were discussed, some of these themes came up one way or another. Two of them stand out in particular. One is the problem of the origins of art, the other the specific stylistic nature of primitive art and the development of style in prehistoric art. Though these themes are distinct from one another, both have an immediate bearing on the subject matter of the present part, and it is therefore useful to discuss them here.

At the end of the nineteenth century, artists, critics, and scholars were becoming increasingly aware of the internal unity and expressive power of prehistoric art. The culture of their own time had prepared them to receive this message and to perceive its significance. Here, they believed, one could empirically study the origins of art. This belief held a particular appeal. A concern with origins, it goes without saying, is found in all periods and cultures, but the second half of the nineteenth century was particularly fascinated by this problem; it was almost obsessed with searching for, and speculating about, origins. Furthermore, the interest in origins was not limited to esoteric scholarly groups. Some of the great issues of the late nineteenth century, issues that stirred the minds of many people and became the subject of public debate, revolved around origins of different kinds.

Late in 1859 Charles Darwin published *The Origin of Species*. As is well known, the first edition quickly sold out, initiating one of the great conceptual debates of the modern age. So vigorous was the discussion that it was echoed in newspapers and political speeches. Whatever the merit of the ideas proposed by the two sides, the debate in itself reflects the significance that late-nineteenth-century Europe assigned to the question of origins.

In 1856, a few years before the Darwin debate began, Max Müller published his *Essays in Comparative Mythology* in Oxford. In this and other works, he proclaimed that the Rig Veda reflects a primordial phase of "Aryan" religion, and hence one of the most archaic stages of religion and mythology in general. To be sure, already in the 1870s Abel Bergaigne, a French Sanskritist of some renown, had showed that the Vedic hymns were not what Max Müller took them to be: they were not spontaneous expressions of an archaic nature religion, but the product of a highly educated, refined class of priests dedicated to firmly established rituals. Max Müller

himself later renounced many of his early positions. However, this did not prevent the Aryan thesis and the belief in a mythical "origin" from becoming a vigorously debated and widely known issue, with the disastrous consequences that the twentieth century experienced.

Another instance in which the problem of origins became a public issue was the impact of Ernst Haeckel's *Natürliche Schöpfungsgeschichte*, the first edition of which was published in 1868. Haeckel was not a great philosopher, yet his historical influence, at least in his time, was noteworthy. Influenced by Darwin, he attempted to understand all nature and society as derived from some origin. The *Natürliche Schöpfungsgeschichte* went into more than twenty editions before the end of the century, and was translated into a dozen languages. What we know as "Social Darwinism" was decisively shaped by Haeckel. Whatever one may think about him, there can be little doubt that Haeckel reflected contemporary concern with the problem of origins, and that he contributed a great deal to ensuring that it remained at the center of attention.

In an intellectual atmosphere such as the above one might also expect questions to have arisen about the origin of art. That such questions should have been raised would seem natural even without the particular stimulation of striking new discoveries. But as we know, it was precisely at this time that primitive as well as prehistoric art were "discovered" and began to penetrate the cultural awareness of the educated European. Both had to do with beginnings and roots, and thus both lent further urgency to the question of how art emerged.

What were the questions asked in, or underlying, the study of prehistoric art? In addition to the concerns usual to any study of this kind (dates, techniques, etc.), there loomed the question of the purpose for which prehistoric paintings and sculptures were made. Whether explicitly stated or only implied, the great debate about the motives and end of art as such—a debate that occupied the minds of critics, philosophers, and artists around 1900—was always present in interpretations of prehistoric images: does art have a purpose outside the aesthetic experience itself?

But first, who were the scholars who occupied themselves with the origins of art? As a rule, they were not professional students of art, but came from other disciplines, mainly ethnology and psychology. They turned to investigating the earliest stages of art in order to solve problems emerging in these other fields. It was inevitable, therefore, that the discussions they initiated often moved in directions other than those typical of the studies of art historians and the reflections of aestheticians.

It was mainly the discovery of figural art in the prehistoric age that astounded students, and challenged their inherited views on art and history alike. Decorative shapes of various kinds could somehow be made to agree with an accepted view of history. But a figural art as evocative and accomplished as that of the cave paintings of Altamira called for a reassessment of established concepts. How did this figural art emerge, and what were its origins? No initial stages were known, and nothing in the monuments discovered seemed to suggest that sketches and preparatory studies ever existed. It seemed like a miracle—an art that suddenly crystallized fully formed. "Altogether surprising is the discovery of figural works of art," declared Max Verworn, a psychologist of considerable merit in the study of prehistoric and primitive art, in 1909.[15]

It was primarily the sudden appearance of these images that was so disturbing. It had been said, Verworn noted, "that figural art begins without preparatory stages, without transitions, a child without a mother."[16] His discussion of what such a sudden appearance meant, and how it could have come about, was one of his most interesting contributions to the debate. As far as technique was concerned, Verworn said, the figural images we see on cave walls did not appear suddenly. We already know of a series of preparatory stages. If you compare cave paintings with the work on bones (sculpture and engraving) that preceded them in time, you will discover that the final images offer nothing new. The full round shapes that so impress us in the paintings were developed during earlier ages when bones were carved and smoothed. (Soft rounded shapes are indeed found in early bone carvings and engravings.) But even the technique of painting was not new at the time Altamira was decorated; for ages people had been dying their skin with bright colors, thus familiarizing themselves with the rudiments of the art of painting.

When we come to the subject matter of prehistoric art the conditions of our investigation change. With regard to its subject matter, Verworn agreed, the figural art of cave man does indeed appear suddenly, without preceding experiments and periods of growth. To explain this sudden emergence our author asked: what can the preparatory stage of a pictorial theme involve? Answering his own question he said, "I cannot think of anything."[17] You either want to draw the image of an animal, or you don't. If you do, and have the ability and skill to perform the job—well, you look at the beast, or recall in your mind how it looks, and draw what you see.

The act of drawing a beast, then, was a kind of mutation, a sudden jump from one domain, the image kept in our memory, to another, the material

paint applied to the palpable wall. That Verworn largely disregarded the possibility of earlier trials and errors as preparatory stages in the domain of representation, and envisaged a mutation-like emergence of the final form indicates perhaps that he here approached the work of art as a natural scientist.

Perhaps even more important for our present purpose is Verworn's notion of *how* these early images were produced, and what the act of drawing or carving an image was like. He sketched an imaginary scene of the prehistoric artist shaping his work. Verworn was too good a scholar to forget that we cannot know the conditions under which the painting or sculpture was actually produced in the cave. The imaginary scene he conjured up, therefore, was meant to be a statement about the true origin of art.

He imagined the prehistoric hunter after a meal at which he had eaten his fill. In his mind images of the beast he had followed, carefully observed, and finally killed were still vivid. Lazily lying around in his lair and playing with the scattered bones of the animal, it was inevitable that all his memories should flow into the shapes he engraved in the bone, or painted on the wall. Here, said Verworn, was the origin of all figural art.

We need not go into the details of this scene. Verworn himself, as I have just said, imagined them only in order to make us understand his conceptual thesis. What was this thesis? It was the old idea that art is the product of leisure. Only after the hunter had eaten his meal and after his more urgent needs were satisfied, did he feel free to turn to art, to the activity of shaping objects and, without any specific intention, expressing his emotions.

As Verworn and most of his contemporaries saw it, leisure is a condition for shaping the work of art, important but external. Without leisure art could not emerge, but in itself leisure is not sufficient to explain the creation of art; one has to look for a positive source. That the primitive hunter would carve the image of the bison only after he had feasted and was idling in his presumably safe cave, and not while he was hungry and exposed to the dangers of the hunt—all this seemed natural to most students of aesthetics in the late nineteenth century. But what made him carve the bison in the first place? Why did he not use his leisure in some way other than to carve or paint an image? At this point speculation about the origins of art went together with certain psychological, or even metaphysical, theories of man. Human nature, many thought, requires that we perform certain activities. A psychological study of art, particularly of its psychological origins, seemed the most important and promising of approaches. Much of

the research and publication that excited attention in the last decade of the nineteenth century bore the title "Psychology of Art." Conspicuous among psychological approaches was the connection of art with play.

A discussion of the theory that considers play a source of art would go far beyond the scope of this essay. I shall only briefly mention some developments in that theory which contributed to thought on the emergence of art among primitive man. We should keep in mind that the theory of play, as formulated by nineteenth-century philosophers and critics, was part of a culture that had very little contact with and awareness of primitive and prehistoric art. When these thinkers spoke of "origins," they did not, as a rule, refer to historical beginnings, the origins of art in time. Nevertheless these theories should be mentioned in the present context; they shaped views concerning the sources of art, and thus by implication played a considerable role in the assessment of primitive and prehistoric images.

Artists and professional students of art, as we have seen, believed in the autonomy of art, including its origins. Art, they assumed, originated in a particular drive, a particular ability of our nature or psyche. They called it the "play drive" (*Spieltrieb*), among other things. Behind all these specific hypotheses was the idea that art has an origin all of its own. What the reality, physical or social, in which we live has to do for art to thrive is simply to recede into the background.

This notion was dominant, but it was not the only one to be held. Views opposed to seeing the origin of art in the "play drive" were proposed by various disciplines, most forcefully by ethnology. For our present purpose not only is the content of the ethnologists' doctrines important, but so also is the intellectual context of their statements, while bearing in mind what they did not see or concern themselves with. They did not ask the question then popular: what is art or aesthetic experience? They were concerned with images, with works of art (or artistic performances) rather than with the general problems of art. And they valued and therefore considered the images themselves mainly for what they could disclose about their functions and the customs related to them, and what they thus revealed about the life of the societies that produced them. Nevertheless, the studies of ethnologists, whatever their original intentions, constitute a powerful statement about the origins of art. In terms of their impact, the ethnologists' views may well have been the most significant of the many statements made at the turn of the century concerning the origins of art.

James George Frazer provides a good starting point for our brief comments. His work sheds light on the ethnologists' role in the debate both

with regard to his positive contribution to the discussion about the origins of art and with regard to what he disregarded. He was not interested in art as art, and had little to say about aesthetic experience. No less important in the present context, he seems to have paid little attention to prehistoric art, although the years in which he wrote and published his major work, *The Golden Bough* (1890–1915), were the same in which scholars and artists were beginning to take note of cave painting and prehistoric sculpture.

Frazer did not ask, what is the origin of art? Art as such was not his subject. But by treating images and other representations in the context of homeopathic, imitative magic, he suggested that the purpose one hoped to achieve by magic was the real origin of art. "Perhaps the most familiar application of the principle that like produces like is the attempt which has been made by many peoples in many ages to injure or destroy an enemy by injuring or destroying an image of him, in the belief that, just as the image suffers, so does the man, and that when it perishes he must die." The examples Frazer adduced were taken from the great cultures of Antiquity—India, Babylon, Egypt, and Greece. But in primitive societies the custom lived on even in the present: ". . . when an Objeway Indian desires to work evil on any one, he makes a little wooden image of his enemy and runs a needle into its head or heart, or shoots an arrow into it, believing that wherever the needle pierces or the arrow strikes the image, his foe will the same instant be seized with a sharp pain in the corresponding part of his body. . . ."[18] Even in modern western societies active vestiges of similar ways of thinking could still be found. "At various places in France it is, or used till lately to be, the practice to dip the image of a saint in water as a means of procuring rain."[19]

His wide knowledge of various cultures provided Frazer with a multitude of patterns in which images served practical ends. Let me only mention the Egyptian custom of giving a stable, noncorruptible body to the ram-god Ammon.[20] In the same vein one should also consider the so-called "reserve heads," to which Frazer did not pay much attention. As is known, the Egyptians placed reserve heads in their tombs, probably to be used when the natural head had deteriorated. However powerfully they may appeal to us aesthetically now, they were made to be hidden in inaccessible tombs, and they originated in a particular combination of religious views that necessitated such precautionary measures.

Of course, Frazer's anthropological observations were not meant as a doctrine on the origin of art. But by showing that certain archaic, primitive uses of images were to be found in many societies, he implied that the wide-

spread application of the image must have had an influence on its origin. It is difficult to accept that images that served to hurt the enemy, to bring about rain, that acted as an idol were nothing but the unintended product of the "play drive." A student of art reading Frazer and his followers must have concluded that the image originated in the desire to fulfill all these practical purposes. The origins of art, he would have concluded, were the urges and needs of actual life in all its complexity.

Many thinkers explicitly concluded that art originated in the necessities of life, and that the main channel by which it emerged was to be found in religion. Emile Durkheim wrote:

> It cannot be doubted that these designs [primitive art] and paintings also have an aesthetic character, here is the first form of art. Since they are also, and even above all, a written language, it follows that the origins of design and those of writing are one. It even becomes clear that man commenced designing, not so much to fix upon wood or stone beautiful forms which charm the senses, as to translate his thought into matter.[21]

Linking the emergence of art with religion did not mean that other sources were excluded. It is interesting to see how contemporary aesthetic doctrines left their mark on Durkheim's thought, and how he tried to combine his own approach with the views held by his society. Stressing once again the "well known fact that games and the principal forms of art seem to have been born of religion," he suggested that the intellectual energies which created the religious symbols left a surplus force available after the original job was done. This surplus "seeks to employ itself in superfluous and supplementary works of luxury, that is to say, in works of art."[22]

Whether or not explicitly stated, the thesis that art emerged from the demands of social life implied denying the full autonomy of art. As we have remarked, the view that art was created in the attempt to achieve (by magic or other methods) some practical end, was mainly proposed by students of subjects other than art, such as ethnology, religion, or psychology. But this thesis also made its way into the philosophy of art, a branch of learning one would expect to have been dominated by pure aesthetic thought. Yrjö Hirn's work *The Origins of Art*,[23] published in 1900, affords an insight into what the aesthetic thought of the late nineteenth century had to say about artistic origins. Yrjö Hirn, a Finnish student of modern literature and aesthetics, was also concerned with the visual arts. In 1912 he published a lengthy discussion of ritual art.[24] In his philosophical reflections he combined the major trends of aesthetic thought in Europe

during the last decades of the nineteenth century with the studies of art as magic.

Hirn's attempt to merge the different lines of thought was undertaken in the shadow of the recent discovery of primitive art, as well as of the newest advances and ideas of the avant-garde art of his own time. News of the discovery of prehistoric paintings and sculptures as distinct works of art does not seem to have been known to him when, shortly before 1900, he was writing his book. Both the discovery of primitive art and artistic developments taking place shortly before the turn of the century signaled alienation and the turning away from beauty and the ideal. For centuries, beauty and ideal perfection were considered the ends of art, and belief in them had been something of a "general law." Now they were being abandoned. "The artistic activities of savage tribes, which have been practically unknown to aesthetic writers until recent years, display many features that cannot be harmonized with the general laws. And in a yet higher degree contemporary art defies generalisations of a uniform theory" (p. 3).

It was mainly from primitive art that we were learning that aesthetic autonomy and self-sufficiency were simply impossible. "Recent ethnological researches have conclusively proved that it is not only difficult, but quite impossible, to apply the criterion of aesthetic independence to the production of savage and barbarous tribes." What we saw as "embellishment," as decoration, "is for the natives . . . full of practical, non-aesthetic significance" (pp. 9–10). This was even true of ornament in primitive cultures. Carvings on weapons, tattooing, various patterns, "all of which the uncritical observer is apt to take for purely artistic compositions," were conceived by the natives as religious symbols (p. 10), and may thus have been meant to serve some purpose. But this also held true for advanced cultures. "We cannot possibly conceal the fact that some of the world's finest love lyrics were originally composed, not in aesthetic freedom, which is independent of all by-purposes, but with the express end of gaining the ear and the favour of a beloved woman" (p. 9).

Hirn was aware, however, that stressing the practical ends for which art had been created—what pure aestheticians might call "foreign purposes"—was not the whole story. There had to be at least some psychological reality of the work of art as an "end in itself," even if only to explain the mere fact that so many theories had been proposed to explain and defend this thesis. Hirn found this reality mainly in the modern spectator's reaction to the work of art. "Whatever we may think about the genesis of particular poems and pictures," he said, "we know that at least they need no

utilitarian, non-aesthetic justification in order to be appreciated by us" (p. 13). It was a "seeming paradox" that mankind had come to devote his energy and zeal to an activity which might be almost entirely devoid of utilitarian purpose or value. Here he saw the problem of the philosophy of art.

The problem of the origin of art is not one we can discuss at any length here. I should only like to emphasize that the question was very strongly and distinctly posed under the impact of the European encounter with primitive art. Seeing the artifacts of primitive societies, as well as those of the prehistoric age, scholars and critics were forced to ask where art came from, and to rethink long-accepted assumptions. An interesting example of this can be seen in the last chapter of Hirn's book, devoted to "Art and Magic."

Sympathetic magic, Hirn said (pp. 278 ff.), "has in recent times become a favorite subject of scientific study." Hirn wished to provide "a psychological interpretation of all the facts" compiled by various students. But there were two classes of sympathetic magic. One was based on the material connection between things. Ethnology taught us how universal were the "folk-beliefs as to the necessity of caution in disposing of clippings of hair or nails. . . . Such objects, it is supposed, would give any enemy into whose hands they might fall the power of injuring through them the person from whom they had proceeded" (p. 279).

Material connection was not a basis for art. But there was a second class of magic, one founded upon a likeness between things. As an example Hirn mentioned pantomimic representation. "Even a single gesture may, according to primitive notions, bring about effects corresponding to its import . . ." (p. 283). Thus primitive man drew rain from heaven by representing in dance and drama the appropriate meteorological phenomena. This was the origin of what Hirn called "picture magic." The examples need not be adduced here; they are well known. In the present context it should be noted that not only did concrete art forms emerge from magic, but so did the very concept of image, the likeness of form. Such likeness, providing another continuity from one thing to the other, from "model" to "image," was not originally conceived in artistic terms. The primitive's fear of being depicted resulted from the belief that the similarity of form was real. The image, then, was real. Hirn did not put it in these words, but for a modern reader this conclusion naturally follows from his presentation. We should stress once more that these concepts were formulated in the context of magic, that is, of primitive efforts to achieve a practical, nonaesthetic end.

Observation of Nature or Mental Image

European scholars and audiences gradually became aware of the wide diffusion of primitive art and of certain distinct characteristics preserved in it; at the same time they were becoming better acquainted with prehistoric cave painting. This new awareness brought new questions to the fore, questions that often seemed to be essential and universally valid. Two subjects particularly became focal. One was the concern with the beginnings of art. Did art begin with the copying of a natural scene that happened to be before the painter's or engraver's eye, or did it start with some more or less abstract pattern dwelling in his mind? This was not only a historical question; it had to be asked for all times and periods. Does the artistic process start in observation of the reality surrounding us, in the reception of visual impressions coming from the outside world, or is it the projection of an "idea," of something originating in our mind?

The other question, equally urgent, was what one might describe as the direction of artistic development as it unfolds in history. Is art more advanced, more "progressive," as one used to call it, when it is closer to nature, and more realistic in style, or does progress, on the contrary, make it less descriptive, less closely akin to material objects in the real world, but more abstract and thus embodying a world of its own? It is obvious that these questions are directly relevant to the aesthetic thought of our age. In this simplified version they originally arose in the context of primitive and prehistoric culture, but they reverberate in the aesthetic reflection on modern art.

These questions were stimulated by many findings, but perhaps no single circumstance was of such consequence as the realization that the oldest paintings on earth, the images found on the walls of the caves, were so strikingly naturalistic. Students were stunned to see the Altamira animal representations, and especially their convincing lifelikeness. This evocative portrayal of nature contradicted what all scholars had believed and thought about the beginnings of art. In fact, when the cave paintings were considered frauds, shortly after being discovered, the main reason for support this assertion was the claim that such convincing realism could not possibly be found in the earliest art in history. How could images produced at the earliest stage of mankind, when artists did not have the privilege of proper training and of the accumulated experience of many ages, attain such a startling degree of realism as that seen in Altamira? This was a rhetorical question, meant not to be answered but only to be acknowledged as an ir-

refutable argument. Yet as time went by and it became evident that the Altamira paintings, and other works of painting and sculpture that belonged to the same period, were indeed authentic works of prehistoric art, the question ceased to be rhetorical; it became real. It disturbed a whole system of views on artistic values and historical development; scholars and critics now found that they had to answer it.

The astounding lifelikeness of humanity's earliest paintings and sculptures called into question two assumptions that had prevailed for centuries, and were taken for granted, in theoretical reflection on the visual arts and their history. One was the old and widely held view that realism, lifelikeness of pictorial representation, was the ultimate achievement of art. Generations were taught and believed that this achievement was only possible after long periods of careful and patient study. Naturalism was the result of accumulated efforts and experience. In most nineteenth-century discourse these views predominated. In universities and academies of art, in scholarly publications and in public lectures, people were told how difficult it was for both the individual artist and for the arts of whole ages to attain a high level of realism. The convincing lifelikeness of classical Athens and of Hellenism had been achieved through a long historical process lasting centuries, in which the "schematic" and "frozen" art of Egypt and the "lifelessness" of archaic Greek art were gradually overcome. The illusionism of Italian Renaissance art, broadly considered a final achievement of art in general, was attained only after medieval modes of thought and traditions of pictorial representation that tended toward lifeless schematism had been superseded in the course of centuries. How then, one could not help wondering, were artists of the prehistoric age, taking the very first steps in representing the world around them, able to begin the history of painting with such extraordinary naturalism? Clearly, the proposition—an aesthetic credo for many generations—that lifelike representation of reality was a final stage of perfection, had to be rethought.

The other assumption that came into question was not concerned with the history of art or with the ranking of artistic values; rather it attempted to describe and explain the process by which a work of art is shaped. This second thesis was not as widely known and held as the first, but it played a significant role in psychological and aesthetic theories attempting to describe how a work of art was "created," and to establish the sequence of the stages in this process. A great intellectual tradition in European culture held that the artist begins painting a picture or carving a statue by introspection, by looking at an idea, a pattern, or ideal model that dwells in his soul or

mind. The work, then, begins with a nonmaterial pattern consisting only of some principal lines. It is only as the work progresses that the artist looks at nature for details, and that the picture or statue becomes more realistic and lifelike. Even the general reader is acquainted with this idea in many formulations. When Ernst Gombrich now says that "making comes before matching," he refers to the same motif: the artist first makes a general outline of his work, and then compares it (or "matches" it) to nature, and makes it more lifelike.[25] Erwin Panofsky's classic study, *Idea*, provides a magnificent map of the history and ramifications of this idea in the European tradition of aesthetics and art theory.[26]

Students around 1900, deeply impressed and perhaps disturbed by the prehistoric art that was being uncovered before their very eyes, could not help feeling that the cave paintings flatly contradicted the belief that the artist begins to paint by looking at a bare model in his mind. This model, as we know, was supposed to be detached from the concrete particularities that so forcefully impress themselves on live experience. Now, it was evident that the prehistoric paintings of beasts and the even older figurines of women were not done in stages, there was not first an idea and a rough outline, and only later a comparison with nature and correction of detail; in other words, there was no "matching" with experience after a first outline was "made" from the artist's mind. The process was obviously instantaneous and complete. The lifelikeness, one could not help concluding, was there in the first outline. How could this finding be explained in view of the prevalent theories of the creative process? One also had to take a further step: when one compared the history of art with the creative process in which a specific work of art was shaped, one expected that the initial stages of art's history would show the same characteristics as the initial stages of the creative process; in the beginning, it followed, both would be characterized by qualities of abstract design. But once again, the paintings one saw in the caves flew in the face of such accepted theories.

Before 1900, little had happened to compel scholars and critics to take up these questions and analyze them on a conceptual level. At the beginning of the twentieth century, however, such a discussion could not be avoided. The inherited hierarchy of styles and the historical model based on this hierarchy could no longer be saved by doubting the age of the cave paintings, or by considering them outright frauds. One had to face the fact that they were indeed among the oldest creations of human art, and yet were of a thoroughly naturalistic lifelike character. This had to be explained. Among the first thinkers to offer a theoretical solution was again

Max Verworn, the noted psychologist who devoted so much effort to solving the mysteries which prehistoric and primitive art had posed to philosophers, historians, and critics. In a series of publications, but mainly in a lecture presented in 1907 (significantly entitled "Towards a Psychology of Primitive Art"), he offered a theory that had a formative influence on the aesthetic thought of the twentieth century.[27]

Verworn's point of departure was more precise than the somewhat vague questions about the general orientation of art history as a whole, or whether something in the artist's mind precedes the actual shaping of a work of art. He noted that within prehistoric art itself a certain development had taken place, and that it involved a distinct shift of conceptual attitude and pictorial style. The art of the initial stage, the Old Stone Age (the Paleolithic), looked altogether different from the art of the last prehistoric period, the New Stone Age (the Neolithic). It is a difference with which even the general public is familiar now. The art of the Old Stone Age, to which such works as the Altamira cave paintings and the *Venus of Willendorf* belonged, was often striking in the convincing lifelikeness of the figures, in the illusion of bulging masses, and in the vivacity of movement. The art of the New Stone Age, perhaps less impressive, and for this reason also less known, though no less important as a historical document, displayed altogether different qualities: the figures were stiff and conventional, a mechanical symmetry was often imposed on the composition, the shapes, as a rule, were geometrical, and quite close to what we now know as "primitive" art. How was it, Verworn asked, that the later art was more conventional and abstract than the earlier one? How were we to understand the fact that prehistoric art in its chronologically most advanced stage was further removed from nature than in the beginning? We must ask, he insisted, what the origins of the two styles were.

Verworn saw the difference between early and late prehistoric art as a problem in the study of mental structures. The different styles of pictorial representation were not the result, not even in part, of different degrees of skill, accomplishment, or the simple ability to represent. He tacitly assumed what some art students explicitly stated:[28] that every period, society, or culture is fully capable of expressing what it wishes to say. The styles, then, were determined only by the nature of the mental life of the groups that produced and used the paintings and sculptures. Visual art, he said, is a depiction of the optical sensations we experience, or of the images we carry in our minds. This is common to all art. The specific character of individual art, its particular or unique style, has to be explained by the way the artists,

and the social groups of which they are a part, approach their task, what they wish to portray in their works, and perhaps also by the overall conditions prevailing in their world.

There are, Verworn said, essentially two types of style, which correspond to two different structures of the mind and to two aims of representation. Verworn called the two styles "physioplastic" and "ideoplastic." Both are fully manifest in prehistoric art. The art of the Old Stone Age is physioplastic, while that of the New Stone Age is ideoplastic. Physioplastic art represents nature, or rather the individual aspect of it that is depicted, as perceived visually. Physioplastic art intuitively tries to follow what the eye sees, and to render it as it is seen. This attitude does not change when the object represented is depicted from memory. In that case, the artist follows the memory image as he would have followed the actual object had it been present in front of him.

Ideoplastic art, on the other hand, is altogether different both in nature and in the way the work is formed. It is not directly based on an individual object or a concrete portrayal of nature, either immediately present before our eyes or distinctly retained in our memory. Rather it follows from a mental image. The mental image itself may ultimately go back to sensual impressions, but these have passed through many filters, having absorbed many associations, and been adjusted and corrected, by many experiences, thoughts, and reflection. The mental image, then, does not resemble any specific sense impression precisely. Ideoplastic art portrays what we *know* of the figure or object we represent. While physioplastic art renders the thing itself, or at least our immediate sensation of it, ideoplastic art represents our thoughts about that same figure or object. It wishes to be a statement rather than the permanent copy of a sense impression.

Verworn almost instantly gained the ear of his generation, possibly because his theory summed up many of the ideas that were in the air around the turn of the century. Before commenting on some of his sources, let us take a brief look at how the theory was applied to the study of prehistoric and primitive art, and what it implied for aesthetic reflection in general. Since style was not primarily determined by specific artistic factors (skill, technique, or the sheer ability of visual articulation), but by overall human condition and nature, Verworn had to ask what kinds of people lived in the Old and New Stone Ages. He thus had to offer, if only in bare outline, a kind of intellectual and emotional portrait of prehistoric humanity. Whether or not the portrait was an accurate one need not detain us here. Modern experts may criticize Verworn's thesis, and may doubt whether the evidence

findings bears out his conclusions. But whether or not his hypothesis is upheld by more recent scientific investigation, the image that he projected exerted a profound influence on aesthetic reflection and on the philosophy of art throughout the twentieth century.

The most characteristic feature of Verworn's intellectual and emotional image of the Paleolithic hunter, the Old Stone Age man who painted the images of the beasts in his caves and carved the Venuses in bone and soft stone, was the dominance of the sensual life, of the immediate impressions his environment made on him. It may sound slightly romantic to hear Verworn say that Paleolithic man lived in profound harmony with the nature around him. A few years after Verworn had presented his lecture on "The Psychology of Primitive Art," Hermann Klaatsch, another student of prehistory, whom we have already mentioned, claimed that this primordial man saw himself as an animal among animals, and that any attempt to discriminate, in a modern sense, between man and beast was alien to him.[29] It was this harmony that enabled him to portray the beasts so convincingly. Such a romanticized image of man living at peace with beasts of prey may belong to the subconscious roots of modern utopias rather than being a sober description of the grim realities of prehistoric man's actual life. Once again, however, we should stress that such beliefs played a significant part in the interpretation of prehistoric art.

This description of Old Stone Age man was, of course, meant to explain his art, both its specific nature and how it came to pass. In a sense, the argument was circular. To explain the naturalistic character of Paleolithic art it was assumed that the artist (if one may use this term in the present context) was under the sway of sensual impressions absorbed from the world around him, and that he lived in harmony with nature. But we have little independent knowledge of man in the Old Stone Age, and our characterizations of him, like the one offered by Verworn, are in fact derived from an analysis of the paintings.

Another assumption, implied but obviously taken for granted, was even more important in our specific context. Since Paleolithic man was so dominated by sensual impressions, Verworn suggested that the forms he shaped, the images of beasts he painted, and the shapes of the women he carved,[30] flowed almost automatically from his mind and memory, and crystallized in the actual and statues without reflection. That the prehistoric artist did not reflect whether or not he should paint the beasts and carve the women, and what they should look like was, of course, an assumption that cannot

be proved independently. Once again it is based on an intuitive imaginative reading of the works of art.

Verworn was a serious scholar, well aware of the many pitfalls in the work he had undertaken. Most important, he knew that seeing, even if understood only as the visual perception of an object or a tiny segment of nature, is a complex process in which many factors interact. Vision does not consist in passively receiving the stimuli ("images") that reach us from the outside world; the "assimilation by thought" (*denkende Verarbeitung*) of these stimuli forms part and parcel of the very process of seeing. But how did all this relate to the concept of physioplastic art? Verworn's answer was that the close affinity to nature that was so characteristic of physioplastic art was feasible only by excluding associations of reflection and thought; if they were allowed to remain, they would interfere with the immediate and naive reception of the images coming from the outside world. Full exclusion of any "disturbing" association or reflection may prove impossible. But to a large extent they could indeed be excluded. The absence of conceptual interference, even if only relative, Verworn claimed in a somewhat later publication,[31] was attained in two ways: either the conceptual associations were absent because they had not yet been formed, or because they had intentionally been excluded (insofar as this was possible). We speak, then, either of a "naive physioplastic" art, or of one that was "intentionally striven for." The art of the Old Stone Age belonged to the first type. The Altamira paintings, to take the best-known example, were done by somebody with a fresh eye, his mind and vision not burdened by reflection nor tied down by conceptual considerations.

The images and shapes portrayed by these earliest artists came from nature. The naiveté of the unburdened eye, ultimately based on the harmony between man and nature, suggested a continuous, almost smooth flow of shapes and images from nature as observed by man, to the work of art as produced by man. The eye, to use a common metaphor, was not burdened, and therefore it did not interfere with what it saw, nor did it transform the shapes and images perceived. Such an understanding of the "eye" was not uncommon in the aesthetic reflection of the time, as Ruskin's notion of the "innocent eye" illustrates.[32]

Ideoplastic art, however, originated from a different source. As we have seen, it represented something other than the art termed physioplastic, rendering mental images rather than sensual impressions. To be sure, the individual motifs and forms originated in man's experience in the real world,

and thus had a link to nature. But since man's mind had so greatly transformed these shapes and motifs, the immediate origin of ideoplastic images was his mental life and the conceptual reflections that played such an important part in it.

Max Verworn expressed an important intellectual concern of his time when he asked how we should explain the direction of historical development, the fact, that is, that abstract ("ideoplastic") shapes replaced natural ("physioplastic") art. Actually there are two questions here. First, what were the reasons for this change? and second, how did it take place, that is, what were the specific transformations in which the historical process was embodied? As a rule, late-nineteenth- and early-twentieth-century authors did not distinguish strictly between the two questions. For our purpose it will be useful, however, to comment on them separately.

The first question—*why* was a naive but highly evocative representation of nature replaced by a stylized, schematic rendering of reality?—did not become a focal theme in the reflections of artists and critics. They may have felt that the quest for underlying reasons is, in fact, a philosophical concern, having to do with a conceptual explanation of whither the historical process in general is leading us. This was where psychologists like Verworn came in.

The reason for the change in artistic style, the psychologists said, is a change in the nature of man and his attitude to the world surrounding him. Paleolithic man, we recall, had a naturalistic, "physioplastic" art because he approached nature naively. In later periods, both in the Neolithic age and in Egyptian and Near Eastern cultures, the style became abstract and "ideoplastic" because reflection increased, and man's attitude to the world surrounding him became more complex and thoughtful.

In the later stages of the prehistoric age, that is, in the period in which ideoplastic art was produced, man's inner life became conceptually more powerful, dominated by "mental imagery" (which is not simply the accumulation of individual memories). Scholars at the turn of the century believed that the idea of the soul, something invisible that hides in the body and moves it, arose in this period.[33] Intellectual life in Europe around 1900 was profoundly stirred by the idea of the soul. The new science of religion, anthropology, and even traditional, established classical studies were all concerned with the emergence of the concept of the soul.[34] Psychoanalysis, being instituted in those very years, also had explicit recourse to the idea of the soul in primordial societies. The different theories proposed in this context need not detain us here; for our purpose suffice it to note that the

issue of the soul was topical. In this new culture and attitude to the world what man himself asked of the arts could no longer be provided by an innocent reception of what is seen in nature. To express these new subjects a different art was needed. It was abstract, conceptual, and "ideoplastic."

In this more advanced stage of human development represented by Neolithic man (as well as by the primitive cultures of our own time and by children in our society), the concept of man and his relation to the world was more obscure than in the initial stages of prehistory, demanding explanations that introduced invisible beings. Art could no longer be a simple representation of what was seen, a visual replica, as it were, of the things and creatures in the environment; rather, it became a statement about man and the world. A statement of this kind may well include ideas or "subject matter" for which there was no corresponding object in the outside world. Take the concept of a soul, for example. For the visual arts it may well have been mandatory to arrive at the depiction of images and shapes that were altogether new creations of the imagination,[35] that is, the arts may have had to go beyond the representation of reality.

The emergence of ideoplastic art was explained, as we have seen, by an increase of reflection, of theoretical consideration in actual life, and by the social and psychological conditions of the groups that developed this art. We now come to our second question and ask, how did the change materialize? What were the main means by which the original, naive representation of what the eye perceived was transformed into the conceptual patterns that constituted the statements man made about nature? This is a question that art historians may ask, but it was raised, and made more significant, by psychologists and theorists of art. The student of art theory will not attempt to trace the actual transformation step by step by analyzing one work after another. But he will ask for the basic possibilities. Verworn discerned two of them.

One of the paths along which the transformation took place was the mixture of artistic genres. Already in the very earliest stage of man's artistic creativity, in the Old Stone Age, we notice two genres of visual art, the ornamental and the figural. Ornamental art, Verworn believed, was the older one. The simple linear engravings we observe in the oldest pieces of the Paleolithic age constitute a "purely ornamental art." These simple linear patterns, Verworn thought, issued from the "play drive" that, in the view of many critics and philosophers, was the ultimate origin of art. Only later did primordial man use lines, colors, and other means to represent figures he knew from experience, such as women or animals.

If one accepts Verworn's views, one would have to assume that the two art forms, the ornamental and the figural, emerged and developed separately and independently from one another. Such a neat division of genres may well be a projection of modern beliefs onto the Old Stone Age. For a long time, the purity of pictorial genres was considered an ideal state of art towards which one should strive.[36] This belief, which was very much alive in the nineteenth century, also determined judgment on the art of different periods. A reason for rejecting Baroque art, for example, was that it confuses the art forms.[37] The division between the genres seemed "natural," and hence it was projected onto the initial stages of art.

The transition from a suggestive naturalism to an abstract presentation of figures took place, according to Verworn, when ornamental patterns arose, in time even dominating figural art. Thus figures or parts of figures, such as heads, were arranged in linear patterns or placed in symmetric compositions. In these pieces the organic forms of the figures were overshadowed by the nonrepresentative, ornamental design of the whole. But the abstract patterns could also transform the organic forms of the figures themselves. Thus the naturalistic outlines of bisons found in the Marsoulas grotto in central France are covered with a regular dotted pattern that has no representative function at all.[38] Verworn knew that this process had many facets and appeared in many periods. He mentioned medieval art as a later example in which a parallel process could be observed. What all these processes had in common, whether they occurred in the Stone Age or in more recent historical periods, was that they created an "ornamental ideoplastic art" or a "schematic ideoplastic art."

Another way in which ideoplastic art came into being and developed, Verworn believed, was in the representation of nature where aspects and features that seemed important were emphasized, while features regarded as devoid of significance were neglected. The very placing of emphasis was an interference with nature which radically changed the configuration of shapes and images. This was a well-known problem that has fascinated psychologists: what happens in a configuration when we pay attention to one of its parts or features, and overlook the others?

To properly understand this explanation we should recall that, according the views I have presented here, physioplastic art neither emphasized certain features nor ignored others. It was an art that innocently reproduced in the painting or statue what was seen in reality, or what was remembered of it. The hunter-painter retained in his mind or memory the appearance of the beast, and so he painted it. Seeing with an innocent eye

obviously does not allow for significant changes in the shapes, proportions, and composition of what is perceived. Therefore there was a kind of naive correspondence between the actual features in nature, the memory image in the mind of early man, and what was eventually painted on the cave wall. A modern spectator, looking carefully, say, at the Altamira paintings, and noticing, for instance, the stupendous bulge of the bull's neck as opposed to the tiny legs, may well doubt that the cave painter did not modify the beast's proportions. Or take the enormous breasts and belly of the Venus figurines as compared to a natural human form. But this was presumably what he remembered, and innocently depicted. Verworn, to reconstruct his theory, assumed that in physioplastic art man did not intentionally interfere with actual or remembered proportions, and that he was convinced that he was depicting them as he had perceived them in nature.

When you pay attention to some part or feature of what you are looking at, a particular kind of image obtains. The audience Verworn was addressing around the turn of the century was familiar with these problems. In the late nineteenth century the problem of attention loomed large in the observations and reflections of psychologists. In 1890 another psychologist and philosopher, William James, published his *Principles of Psychology* in which he gave pride of place to attention. He noted that "although we are besieged at every moment by impressions from our whole sensory surface, we notice so very small a part of them." The part we pay attention to, and which thus enters our conscious experience, runs through the total of physical impressions "like a tiny rill through a broad flowery mead."[39]

What are the implications of attention for pictorial representation? The representation of something that interests us, and that we pay attention to, will obviously differ from what an object would look like were we to see it without our interests interfering with our sense impressions, or if it were not of vital interest to us. By paying attention we create another shape, actually a new one. We exaggerate and intensify (in form, curvature, color, etc.) what we deem of importance, and we neglect or pass over what does not interest us. What obtains is a schema in which one aspect becomes more visible and richer in form; it captures the spectator's gaze at the expense of the others. Verworn adduced as an example a Siberian doll with movable limbs. The function of the schematic head is only to indicate that a human figure is being represented, while the spectator's attention concentrates on the mobile limbs.

Ideoplastic art, when fully developed, eventually led to pictography, to an ideographic symbolism. And it seems intuitively evident that, as picto-

graphic rendering evolved, the similarity between nature, or the live image in the eye or the fresh memory image in the mind, and the painted or carved rendering in the work of art was bound to shrink, and eventually to disappear altogether. Most ideoplastic art did not reach this ultimate stage, but the tendencies are to be found in many periods. In the early twentieth century, Verworn believed, one found it particularly in the art of posters, in caricature, and in what he called "fantastic ideoplastic art," that is, an art in which the object of representation follows from the artist's mind rather than taken from external reality. Clearly, Verworn the psychologist was close, in time as well as in mental attitude, to the origins of abstract art in the first decade of the twentieth century.

The concerns of the psychologist cannot be pursued any further in this study; the significance and character of children's art, crucial for Verworn, is not central to our subject. What I should like to stress here is that ideoplastic art was regarded as the more advanced art. The simple schematic drawing, differing from natural experience by representing what we know, rather than what we see, is an advanced stage of cultural and artistic development.

This appreciation of schematic "ideoplastic" art bore a close affinity to some of the avant-guard trends in the art that was being produced in the very years in which the statements discussed in this chapter were being made. The direction of the developments seems to be the same. Art in the years around 1900, like that in the times preceding written history, was also moving from a faithful, suggestive, and convincing representation of what the eye perceives in nature to images that seemed to be altogether derived from our own minds, images of ideas. The unfolding of prehistoric art seemed like a projection of what was going on at the very same time when these opinions and explanations were being expressed; moreover, the transition from the "physioplastic" to the "ideoplastic" in the most ancient art of man seemed to confirm the truth of modern trends.

NOTES

1. See the fine survey by Glyn Daniel, *The Idea of Prehistory* (Harmondsworth, 1962).

2. Quoted from Annette Laming, *Lascaux* (Harmondsworth, 1959), p. 16.

3. This was the year in which the German mission began systematic excavations in Olympia, Greece. These excavations are considered by many scholars to be the first time modern scientific techniques were systematically applied.

4. See Daniel, *The Idea of Prehistory*, p. 60 (with additional literature).

5. See Hermann Klaatsch, *Die Anfänge von Kunst und Religion in der Urmenschheit* (Leipzig, 1913), p. 19.

6. See *L'Anthropologie* (1903), pp. 257–266. The article is reprinted in Salomon Reinach, *Cultes, mythes et religions*, 1, 3d ed. (Paris, 1922), pp. 125–36. I shall quote from this edition. Page references to this article will be given, in parentheses, in the text.

7. See Salomon Reinach, *Epoque des alluvions et des cavernes* (Paris, 1889), esp. pp. 228 ff.

8. Reinach (p. 129) referred to Yrjö Hirn, *The Origins of Art: A Psychological and Sociological Inquiry* (London, 1900), p. 287. Hirn, to whom we shall revert shortly (see pp. 389–93), also mentioned barren women's custom of wearing images of children.

9. See Johannes Maringer, *The Gods of Prehistoric Man* (London, 1960), esp. pp. 87 ff.

10. Max Verworn, *Zur Psychologie der primitiven Kunst*, 2d ed. (Jena, 1917), pp. 46 ff., note 9. The first edition appeared in 1907.

11. Karl Woermann, *Geschichte der Kunst aller Zeiten und Völker*, 2d ed. (Leipzig and Vienna, 1915), p. 9.

12. See, e.g., Klaatsch, *Die Anfänge*, pp. 62 f.

13. The best survey of modern views is found in Maringer, *Prehistoric Gods*, pp. 108–14.

14. Klaatsch, *Die Anfänge*, p. 11.

15. Max Verworn, *Die Anfänge der Kunst*, 2d ed. (Jena, 1920), p. 39. The first edition appeared in 1909.

16. Max Verworn, *Die Anfänge*, p. 40.

17. Max Verworn, *Die Anfänge*, pp. 52 ff.

18. I use the abridged Macmillan edition of the great work. See James George Frazer, *The Golden Bough: A Study in Magic and Religion* (London, 1957), pp. 16–17.

19. Frazer, *The Golden Bough*, p. 101.

20. Frazer, *The Golden Bough*, pp. 656 ff.

21. Emile Durkheim, *The Elementary Forms of the Religious Life* (New York, 1965), p. 149, note 150. The original French version appeared in 1912.

22. Durkheim, *Elementary Forms*, pp. 425 ff.

23. Hirn, *The Origins of Art*.

24. Yrjö Hirn, *Sacred Shrine: A Study of the Poetry and Art of the Catholic Church* (London, 1912). The Swedish original was published in 1909. There is a new edition of the English translation (Boston, 1957).

25. The idea is found in most of his writings. For a clear formulation, see E. H. Gombrich, *Art and Illusion: A Study in the Psychology of Pictorial Representation* (New York, 1960), pp. 186 ff.

26. The original German edition of Panofsky, *Idea*, appeared in 1924.

27. Verworn, *Zur Psychologie der primitiven Kunst.*

28. See above, section 2, chapter 5.

29. Klaatsch, *Die Anfänge,* pp. 27 ff.

30. Verworn did not mention the Venus statuettes in this context; he restricted his observations to painting. One should perhaps also mention that the *Venus of Willendorf* was discovered in 1906, only a few months before Verworn presented his lecture, though other figurines of the same type had already been known earlier. There is little doubt, however, that the principle of his explanation should also apply to the female figurines.

31. Max Verworn, *Ideoplastische Kunst* (Jena, 1914), especially pp. 40 ff. The same ideas also appear in his other studies.

32. See John Ruskin, *The Elements of Drawing* (London, 1860) note to par. 5.

33. Verworn, *Zur Psychologie der primitiven Kunst,* pp. 31 ff.

34. To give just one prominent example suffice it to mention Erwin Rohde's *Psyche,* a two-volume work of exquisite scholarship that between 1893 and 1921 went through eight editions in the original German, was translated into many languages, and stirred a lively debate that also affected artists.

35. See Verworn, *Ideoplastische Kunst,* p. 5.

36. For the concept of "genre," mainly in literature, see E. D. Hirsch, Jr., *Validity in Interpretation* (New Haven and London, 1967), chapter 3.

37. These views are, of course, well known, and many examples could be adduced. A particularly interesting one is Burckhardt's criticism of Borromini for mixing architecture and woodcarving, or cabinet making, in his thought. See Jacob Burckhardt, *Der Cicerone: Eine Anleitung zum Genuss der Kunstwerke Italiens* (Leipzig, 1869), pp. 369 ff.

38. Verworn, *Ideoplastische Kunst,* p. 14.

39. I am using the abridged edition of the great work. See James, *Psychology,* pp. 227 ff. The thirteenth chapter of the work is devoted to attention.

20

Understanding Distant Cultures
The Case of Egypt

The attempts made in European thought in the course of the late nineteenth century to understand the nature of primitive art and to come to terms with the riddle of prehistoric painting and sculpture were, as we have shown, often, linked with the study of another subject, early or exotic "high civilizations." In our own day we think we are fully aware of the profound difference between a genuinely primitive and a highly developed, if exotic, art. Even today, however, the dividing line between the two is not always easily drawn; in the nineteenth century, as today, people were aware that there is an essential difference between the primitive and the exotic, but the areas of equivocation were larger and more frequently encountered than in the late twentieth. The blurring of distinctions between the primitive and the exotic was abetted by a certain conceptual smoke. As there were no ready-made notions for the study of primitive art, it seemed natural to look for what one could learn from the exotic, and apply this to the analysis of the primitive and the prehistoric.

The range of exotic cultures thus linked with the primitive was not well defined. Anthropology, rapidly expanding in the latter part of the nineteenth century, offered many illustrations that proved difficult to label and to classify as either "primitive" or "exotic." Does a Peruvian idol, to mention an example actually adduced, belong to a high, if distant, civilization, or is it a work of genuinely primitive art? It was compared, on the one hand, with Egyptian figures, and, on the other, with children's drawings.[1]

The art of two areas of very ancient or distant cultures played a particularly important part in the aesthetic reflections of the late nineteenth century. One was the art and civilization of ancient Egypt which, at least at that time, seemed removed not only by millennia, but somehow to belong to a different mythical age. The other was the art of the Far East, mainly China and Japan, but also to some extent India. These arts were not primitive in the sense of the word then accepted. But they were different enough from

the European tradition (or they seemed to be) to make it possible for students to believe that they had something in common with the primitive. In the present chapter I shall discuss only one major area, the reception and interpretation of Egyptian art. This example will show, I hope, the different types of reception, and different lessons that the art criticism of Europe learned from distant and foreign cultures and arts.

European intellectuals, it seems almost superfluous to say, were not unaware of Egypt. From Herodotus to Baudelaire, western students, philosophers, clergymen, travelers, and artists, were in more or less constant touch, in one way or another, with the cultural heritage of Egypt. Wave after wave of Egyptian influence reached Europe, from the Roman Empire to the Italian Renaissance, to the period of the French Revolution and its aftermath. To trace this rich history, even in bare outline, is clearly beyond the scope of the present study. But we can say that this continuous contact ensured that Europeans were aware of Egypt.[2]

This awareness also included, and in fact gave pride of place to Egyptian art. Since so much of Egyptian culture, mainly its script and language, was unknown and could not be deciphered, the image, which seemed to be available to everyone, naturally acquired additional significance. Plato had already referred to Egyptian art with open admiration. In presenting Egyptian art as a model, he offered an articulate interpretation of what he believed to be its nature. Egyptian art had not changed in ten thousand years, said Plato, because it followed the proper rules (*Laws* 656D, E).

The main impact of Egyptian art on western thought, however, was not in the field of style, nor in the admiration of its historical stability. What fascinated European minds more than anything else in Egyptian art was the belief that it contained some important message. This belief gave rise to the atmosphere of mysteriousness with which Europeans surrounded this art. Already in late Antiquity Egyptian figures, and most of all the Egyptian script, the hieroglyphs, were believed to guard a great secret treasure, the key to which was deemed to have been lost. This was also the attitude of Europeans during the Renaissance. Marsilio Ficino, the Neoplatonic philosopher who had a significant influence on European art and intellectual life, maintained that Hermes Trismegistus, an Egyptian sage and a contemporary or even predecessor of Moses, had attained the knowledge of secrets surpassing even those revealed to the Hebrew prophets. Renaissance scholars credited Trismegistus with the invention of hieroglyphic writing. For Ficino, Egyptian wisdom as mysteriously expressed in hieroglyphs, Platonic philosophy, and humanistic studies were united

with Christianity in the purpose of attaining the knowledge of God and of His revelation.

We cannot trace the story of how Egyptian lore was interpreted in Europe in the centuries after the Renaissance, fascinating as the subject is. We should mention, however, that even in the seventeenth and eighteenth centuries, when philology took up these efforts, particularly the decoding of the hieroglyphs, the sense of mystery that had surrounded Egyptian images did not altogether disappear. Athanasius Kircher in the seventeenth, and Montfaucon and the Count de Caylus in the eighteenth centuries, in fact advanced our knowledge of Egypt (though now they are often ridiculed). But they, too, preserved something of the mythical aura that seemed to be part and parcel of the European attitude to Egyptian lore.

By the middle of the nineteenth century this situation was rapidly changing. In the early decades of this century the foundations were laid for scientifically deciphering the hieroglyphs, and the fantastic "solutions" for decoding the mysteries that had been suggested in earlier periods began to die out. In the wake of Napoleon's army, and in the course of the first half of the nineteenth century, archaeologists came to Egypt, excavation missions brought a wealth of objects to light, and many of them were transferred to Europe. In the museums of the great European cities one could now see and carefully study these objects. Detached from their original context, the statues and paintings were no longer seen in the dim light of legendary tombs, but were exhibited in the neutral and temperate light of museum halls. What all this amounted to was not only a rapid increase in modern, better, and more solid knowledge of Egyptian history, language, and art, but also a "demystification," or *Entzauberung*, to use this evocative term, of ancient, sacred Egypt. It is not surprising that such demystification also posed new tasks and raised new questions.

The new conditions of study and the raising of new questions had a particularly dramatic impact on the way the art of ancient Egypt was seen. Students of Egyptian lore in the past had also been acquainted with the statues and other works of art. However, they had studied these works for the "message" that they believed was hidden in them. They did not ask how the works of art were made, but rather what they meant. In the course of the nineteenth century these questions changed.

The encounter of nineteenth-century European scholarship with the heritage of an increasingly "secularized," demystified Egypt, and particularly with its art, was to a considerable extent shaped by two intellectual perceptions or insights. On the one hand, western students looking at

Egyptian statues or reliefs were aware that they were faced with an old, established, and fully crystallized culture, and that this culture had impressed itself in the style and character of every image. On the other hand, the same scholars were intensely conscious of the fact that the culture that spoke to them through the Egyptian statues, reliefs, and paintings differed profoundly from their own. The difference was not one of nuance within a common tradition, nor of different levels of artistic skill. It lay, rather, in the fact that different principles had shaped the formation of the Egyptian works of art. What needed to be asked, then, was: what were the principles that dominated Egyptian art and that underlay the shaping of the individual works that were available to the viewer?

It would be instructive to follow the emergence and articulation of the new questions posed in the study of Egyptian art step by step, but as far as I know no such survey exists. In this essay no attempt of this kind can be made. All I shall do is to briefly outline a few analyses made in the period between the mid-nineteenth and early twentieth centuries, that developed similar, or at least related, ideas, and that suggested, however vaguely, how European awareness of the principles of Egyptian art grew in this period.

Gaston Maspero

A relatively early stage of the new conceptual approach to Egyptian art, based on the recently established scientific study of the subject, is well represented by the work of Gaston Maspero. For at least half a century Gaston Maspero was considered the doyen of Egyptian studies in France, and one of the foremost western students of Egyptian art, culture, and antiquities in general. The major lines of his interpretation were presented, clearly and distinctly, in his *Archéologie Egyptienne* (Paris, 1887). Though it dealt with a very wide range of objects, in fact it concentrated on art, and in the German edition that shortly followed the French original, it was appropriately called *Aegyptische Kunstgeschichte* (Leipzig, 1889).

The basic structure of Maspero's presentation, his division and grouping of the materials discussed, was not chronological, but centered around categories of objects: starting with architecture (private and military buildings first, then temple architecture), tombs followed next, combining architecture and painting. The chapters on the figural arts (sculpture and painting), and on the applied arts that concluded the discussion, were the most important parts of the book. Maspero's grouping of his ample materials was

based on the antiquarian approach, developed mainly in the seventeenth and eighteenth centuries.[3] But in following this approach, Maspero was not only continuing the antiquarian tradition; he was also making a statement about the nature of his subject. In essence, he was saying, Egyptian art was indeed as static as Plato had believed it to be. To be sure, there were some modifications, and Maspero faithfully recorded what he knew of them. But he believed that the nature of Egyptian art had not changed during the millennia of its existence. It was this static character that ultimately justified a presentation based on types and categories of works and tasks rather than on a narrative of developments, such as a "history" would require. Here I shall discuss only what he said about the figural arts.

In *Archéologie Egyptienne*, Maspero dealt with the figural arts of sculpture and painting together. This approach, he explained,[4] was justified by the fact that in both arts color played a crucial role. All Egyptian works of sculpture, if not made of a naturally colored stone like granite or alabaster, were eventually painted; they were not considered complete before the coat of color was applied. Here Maspero differed from some artists and critics among his contemporaries, who believed that in Egyptian art one found "pure sculpture," based on mass only and altogether detached from pictorial effects.[5] But carefully reading Maspero's chapter on the figural arts one easily sees that, in his view, sculpture and painting were linked not so much by color as by line. The use of line, of drawing, was the common element in the painting and sculpture of ancient Egypt. This reminds us of Vasari and his *arti del disegno*.[6] But Vasari's "arts of design" consisted of architecture, sculpture, and painting, while Maspero, as we have just seen, treated architecture separately.

We do not know how the Egyptians learned to draw, Maspero readily admitted. He thought they must have made studies from nature, using as models what they could observe in the world around them. As evidence he cited the resemblance of painted or sculpted faces to individual human beings and the convincing representation of some species of animals, especially in movement (pp. 160, 165 ff.). Though he assumed that such studies were made, Mespero was aware that the main force that had shaped Egyptian drawing was tradition, which he perceived as workshop tradition. Maspero had absorbed, of course, the concepts and attitudes that the Renaissance bequeathed to Europe; hence he considered drawing, at least in part, as a theory to be learned in a theoretical way. In the Egyptian legacy he did not find such a theory. "Their teaching [of drawing] was not theoretical, but purely practical" (p. 160). In the workshop the young artist

copied the models the master made so often that eventually the representation was correct and precise. The Egyptians, he perhaps mistakenly assumed,[7] had no canon of proportions, and thus no way of properly composing the human figure.

However they learned and taught, whatever their workshop traditions and procedures (and in his time Maspero had an unsurpassed knowledge and understanding of ancient Egyptian workshop procedures), Maspero's major goal was to define the unique character of Egyptian art or drawing. He knew quite well that "the characteristics of their drawing differ radically from ours" (p. 165). What, then, was the essential principle of Egyptian drawing? Maspero's view was remarkable for its high degree of conceptual articulation, and for the wide-ranging implications for the theory of art.

"Whether the object drawn was a human being or an animal," Maspero said when he undertook to define Egyptian drawing, "it was always only a silhouette that had to be cut off from the surrounding background" (p. 165). This was the only element he mentioned in defining the work of Egyptian draftsmen. To Maspero, drawing in ancient Egypt basically meant the segregation of figure from ground. Before attempting to discuss the possible consequences of this definition, let us compare it briefly to the definitions of drawing accepted in the late nineteenth century.

Drawing, a central concept in art theory in all ages, has been variously interpreted. Especially since the Renaissance, the meanings attributed to this concept have ranged widely from a metaphysical principle of creation, such as Federico Zuccari's *disegno interno*, to the technical term for a first sketch, the record of the initial stage in the process of creating a work of art.[8] It is not for us to trace this history here, and I shall only mention some versions that, both in time and cultural tradition, were close to Maspero. In the language of nineteenth-century artists and critics, the broadest meaning of drawing was probably the representation of what was seen in a specific medium (usually monochrome). The French *dessin* was also the general term for the first sketch, outlining the composition of a painting or sculpture the artist intended to produce.[9]

The interesting problems that arise here are beyond our present scope, but I should stress that in none of the various definitions offered in the course of the nineteenth was it seen as the sole, or even the primary, function of drawing to separate the figure from the ground. On the contrary, this distinction between figure and ground was gradually obscured. The background was not seen as a passive "filler," as it were, eventually to be dis-

regarded. "Pictorial" trends in the arts and thought of the time increasingly made the "empty" background, that is, the space not filled with objects or figures, an essential part of the painting. Within this mode of thought the separation of the figure from the ground could not be conceived as the main purpose of drawing.

Defining Egyptian drawing as Maspero did, that is, as the segregation of figure from ground, entailed several far-reaching consequences, even if these were limited to the domain of the conceptual only. Some of them Maspero saw and more or less explicitly articulated, others he could not have seen at his time; with the advantage of hindsight, we can perceive them more clearly.

What seems to be implied in Maspero's definition is that Egyptian art was primarily a figural art, or at least that the dominant trend led to concentration on figures alone. Though not spelled out in so many words, it followed from Maspero's presentation that the ground was disregarded after the figure had been detached from it. The Egyptian artist's whole attention was centered on the figure. This seemed to hold true even when landscape features such as a lake, a river, or vegetation were represented. It is they that then became "figures."

Concentration on the figures alone, with total disregard for the "empty" background, was perhaps also supported by its affinity to an essential principle of cave painting. We find a perfect disregard for background in cave painting. The animal painted on the cave wall often partially (but only partially) covered another beast, painted by a former artist. The later artist obviously did not mind that some parts of the former image remained visible. Whatever lay beyond the outlines of the present figure seems simply to have been considered nonexistent. It would, of course, be gravely mistaken to draw a simple parallel between prehistoric cave painting and Egyptian art, or to attempt any suggestion of derivation. Nevertheless, there seems to be a remarkable affinity in the basic attitude.

Another conclusion implied in Maspero's definition of Egyptian drawing is briefly mentioned in his work, although without indication of its origins and significance. I refer to an observation concerning the nature of the line employed in Egyptian art. One characteristic of Egyptian drawing, he said (p. 168), was a "clean line." The lines in Egyptian art were always clean. Maspero devoted much effort to the study of artistic techniques in ancient Egypt; he was both a connoisseur of the materials and techniques, and a scholar who knew that techniques reflect attitudes and ideas. Now, what does a "clean line" mean?

In the second half of the nineteenth century, we should keep in mind, discussions of an artist's line were not rare. On the contrary, the critical literature of the time abounds with observations about the line of a certain painter or draftsman, or with discussions of the way the line in a certain style (say, Baroque) differed from that in another (say, Classicism). In all these discussions, the line itself was considered a constitutive element of artistic creation. The immanent, intrinsic life of the line, an artist's "personal handwriting," as it was then called, formed a central problem in the art theory of the period.

The "clean line" of the Egyptians, it followed from the way Maspero understood it, had an altogether different function, and hence also a different appearance. The function of the clean line was not to be an artistic expressive element, nor to take part in shaping the work of art; its only function was to clearly segregate figure from ground. The figures alone formed the composition. The line has no existence in and of itself; it was nothing but the limit between figure and ground. Its abstract character made it like the line in geometry, devoid of any material being and appearance of its own. Hence it could not be more or less clear, wider or more narrow, darker or lighter.

Maspero revealed the complexity inherent in the encounter of a western spectator who wants to understands what he sees, with Egyptian art, when he said that the figures he was studying are "alien to us, but they were alive" (p. 169). Perhaps "alive" was not the most appropriate term, but the general problem remains. Maspero is aware that in Egyptian art he was faced both with a great culture and with a mastery of the crafts employed, but, on the other hand, he had only the concepts of western aesthetics with which to approach that ancient art. For this reason Maspero not only contributed to the knowledge and understanding of Egyptian lore, but also illustrated some of the characteristics and limitations in western art theory that make it difficult to look at and grasp exotic arts.

These complexities or difficulties are revealed in certain central problems of art theory. Take, for instance, the reading of a multifigural scene. Had the Egyptian artists the ability to compose "groups," that is, multi figure scenes? This question, Maspero noted (pp. 169 ff.), had often been answered in the negative. The very principles of composition employed in most (though not all) Egyptian scenes seemed faulty to western critics. Take the depiction of a funeral meal found in some Thebaic tombs. The oversized deceased are present at the meal given after the burial; different kinds of reality interact here. This plainly contradicts what many believed

was the only way of telling a story in western art: to adhere consistently to one kind of reality, the one that can be perceived in regular visual experience at a given moment. Maspero himself seems to waver in attempting an answer. He did see that Egyptian art employed principles of composition different from those of European narrative art in the post-Renaissance centuries, but his assessment of those principles was not always clear. This was also true for so-called "hierarchic scaling." It was accepted custom, he said, that "the gods were always bigger than men, the kings bigger than their subjects, the deceased bigger than the living" (p. 170). On the other hand, he emphasized the narrative details and fragments, the woman drinking from a cup, the slaves pouring perfume on their masters, and so forth. Maspero summed up the state of his thinking on this problem by saying that "one does not know what to admire more, the tenacity of the Egyptians in circumventing the natural laws of perspective, or their vast dexterity in bringing things into wrong connections with each other" (p. 176).

Heinrich Schäfer

Maspero made a pioneering contribution toward seeing Egyptian art as a distinct and great cultural unit with its own principles of style. He observed, of course, that the art of Egypt differed from that of western Europe, but he was not mainly concerned with this difference. In the next generation of interpretive scholarship and criticism the comparison between the principles of Egyptian art and those embodied in the Greek artistic tradition loomed larger than before. This concern was probably best expressed in Heinrich Schäfer's work. Schäfer's book *Von ägyptischer Kunst* appeared only in 1919,[10] but the studies epitomized in it began in the 1890s. The book thus reflects the concepts and concerns of a whole generation of students trying to understand Egyptian art, and its relationship to both the primitive and western arts.

Like Maspero, Schäfer concentrated on the art of drawing, but his original interests had a somewhat different slant. As he tells us in the introduction (p. v), in the early 1890s he started to study children's drawings, and at the same time tried to grasp the difference between Egyptian and "our" types of drawing. In his mature work, this underlying concern with comparing Egyptian art with the primitive, on the one hand, and with the western European, on the other, remained important. This double interest may well explain the response his work evoked among students of art. To bring

out the distinction between Egyptian and Greek principles of art (the western tradition, he said, follows the latter), Schäfer concentrated on a few issues. Let us begin with perspective.

Perspective, as is well known, has had a profound influence on both painting and the study of its history. Moreover, it possessed an almost symbolic significance for the concepts of the visual arts in general. Ever since certain formulae for the demonstrably correct perspectival representation of what the eye perceives in the outside world were worked out in fifteenth-century Florence, perspective—both in the picture, and in theory—was seen as the apogee of the art of painting. Why should this be so? Perspectival representation is after all not more than a pictorial technique, not of awesome difficulty, and it has been successfully taught to thousands of students generation after generation. Art historians, interested mainly in the emergence of perspective, have rarely concerned themselves with what it meant in later periods, say, in the nineteenth century. Here I shall only comment on the aspects that are important for a comparison of Egyptian and western art.

Two considerations suggest an explanation for the significance that aesthetic thought invested in perspective in the modern age. First, perspective is the most comprehensive law or system for representing in the picture what the eye perceives of the world around us. It is valid only if painting is mimetic, if it represents objects in space, that is, what we see in nature. Within these limitations, however, it is the widest, most encompassing principle; in fact, it provides the framework for every single means of representing the outside world as we see it.

The second consideration is more limited in historical scope, but no less significant for the appreciation of perspectival representation. Ever since the Renaissance, linear perspective was believed to have made the "correctness" of pictorial representation subject to criticism by geometrical construction; it was believed that you could prove that a certain representation was correct, or "true" as was said, while another was false and wrong. Since "true" representation was believed to be the ultimate perfection of pictorial rendering, the "progress" of art became measurable and provable. The idea of progress in art became linked to perspective.

The essential structure of perspectival doctrine, as developed in the Renaissance and further refined in later ages, can be reduced for artists to a few empirical rules, familiar from the actual observation of nature. Most artists, in fact, employ perspective according to these simplified empirical rules of thumb, of which the most important is that the further away an

object is from the eye, the smaller it appears. The examples used in every art school are the image of the road with houses placed at more or less equal distance, or the alley with trees equally tall and equally spaced. The further away the house or the tree, the smaller it looks. The link between distance and diminishing size became, in a sense, the heart of applied perspective.

Now, this simple and elementary observation was conspicuously disregarded—one could say, denied—in Egyptian art. In fact, Schäfer added (p. 46), it was disregarded by all the arts that had no contact, direct or indirect, with Greek art and culture, and were not influenced by them. On the other hand, however, perspectival representation seems natural, reflecting the way we see the reality surrounding us. How do we account for the fact that such a simple, everyday observation—the diminishing of size with the increase of distance from the eye—was so fully and consistently ignored?

There are only two ways of accounting for the contradiction between how we see and how most cultures represent reality. We can either assume that in pre-Greek societies man did not fully realize (did not "consciously experience," as Schäfer put it) the fact that distant objects look smaller than they actually are, or else he disregarded this fact of everyday experience for some other reason, possibly linked with the principles of representation. It is difficult to accept the first hypothesis, namely, that people were not sufficiently aware of the diminution in size with increased distance. People always knew intuitively that distant objects look small, Schäfer protested. After all, even the Stone Age hunter, when he threw a stone or a spear at a distant animal, was not misled by its apparent smallness; he knew quite well that though it looked tiny when so far away it was of normal size. We must look for other ways of explaining the disregard for perspective.

To further prove, if proof were needed, that in pre-Greek civilizations people were fully aware of the basic datum of perspective, namely, that things look smaller the further away they are from the eye, Schäfer adduced (pp. 48 ff.) a beautiful text: the fragment of a mythological Babylonian poem, describing how an eagle lifts up Etana, the hero of the poem, into heaven. At two-hour intervals the eagle lets Etana look back toward earth. What he sees and vividly describes, perfectly articulates the basic law of perspective. Every time the hero looks down the earth appears smaller than before. First the earth surrounded by the sea looks like a flat loaf of bread on a dish, and eventually the seas look like a trough dug by a gardener around a flower bed. Finally Etana is overcome with terror and comes crashing down.

This text shows that it will not do to claim that there were insufficient "conscious experiences" of how things actually look in space, that is, that their size diminishes with the increase of the distance between them and the eye that sees them. In the mythological poem describing Etana's flight to heaven we have a highly articulate, codified expression of natural observation in a great culture. Using modern terminology we might say that the psychology of perception cannot tell us why perspective was not used. Nor can we turn to technique for an explanation of the puzzling fact that pre-Greek civilization disregarded the "natural" way of looking at the world. For a large part of the nineteenth century it was believed that pre-Greek, as well as primitive, cultures were not able to master the difficulties of perspectival representation. "Difficulties" meant mainly technical difficulties. But such objections do not explain the riddle. Schäfer stressed (p. 50) that complications may arise when we want a mathematically correct and provable construction of space. But an intuitive approximation of what we see in nature can cause no particular problem.

Like many students of primitive and prehistoric art, as well as some psychologists, Schäfer noted the affinity of Egyptian representations to children's drawings, and tried to show that in prehistoric times as well as in some parts of the modern world their nonperspectival way of representation seemed natural. From ethnographic literature as well as from personal experience he adduced stories pointing to the fact that, to primitive people, perspectival representations may have appeared misleading. Schäfer's basic thesis, one we have encountered several times, was that there are two ways of depicting reality: how it *looks*, and how it *is* (or how we believe it to be). Perspectival representation, however convincing or deluding, always involves, Schäfer said, a "sacrifice," a renunciation of precision. An Egyptian would have understood perspectival painting as a mere delusion. It was only the Greeks and their followers who made the "sacrifice of the intellect" (p. 53), and followed optical appearance rather than the structure of reality.

The central theme of Egyptian art, as of the art of many other cultures, is of course the human figure. Egyptian representation of the human figure must always have attracted attention; in the nineteenth century it made scholars wonder. At that time it was often noted that in the Egyptian images of the human body two contradictory principles were at work. On the one hand, one could not help marveling at the sharp and precise observations of nature, as well as the well-balanced system of proportions in these figures. On the other hand, however, the composition of the figure as a whole

remained a puzzle, hard to understand and to unravel. From the anatomist's point of view, Gaston Maspero said, the Egyptian rendering of the human figure was a horror.[11] However, this "horror" was obviously a matter of principle, since the method of composing the full-length human figure remained unchanged throughout the history of Egyptian art. But what was this principle? Or, to put it in Schäfer's words, what was the "basic form" (*Grundform*) of the human figure in Egyptian art?

It is remarkable that (at least as far as the written sources attest) for many hundreds of years no European spectator seems to have seriously investigated the strange structure of the human body in Egyptian art. Only after what we have called the secularization of Egyptian art and culture were people struck by the contradictions in the anatomical structure of the human figure. The interpretation now generally accepted developed gradually, over two or three generations. Adolf Erman, the famous Egyptologist, seems to have been among the first, around 1885, to have suggested the view still accepted today. Like Gaston Maspero, Adolf Erman was not an art critic but an eminent Egyptologist. In studying the remains of ancient Egyptian culture he was also struck by the unusual way in which the artists, especially the draftsmen, painters, and makers of reliefs, had represented the human body. In his great work, *Aegypten und aegyptisches Leben im Altertum*,[12] he devoted some passages to this question (pp. 478 ff.). As I have said, his ideas on the subject may have been expressed by others before him, but his formulation seems to have been the one that became classic.

Essentially, two of his observations are of importance for our subject. The first, which he unfortunately sketched in only a few sentences, though it was a weighty one, was that in Egyptian art there were two formal modes—two registers, as it were—for the representation of human figures, and that the principle dominating them was a social one. The simple folk, those belonging to the lower classes of society, were represented in profile only. The king and his officers, that is, the personages belonging to the upper classes, had to be shown with their shoulders in frontal view.

Erman's second observation was that in Egyptian art every part of the body was depicted from an angle which most clearly revealed its characteristic shape. Thus, for example, one always sees the hands from the outside, the fingers always together, showing the nails (the thumb sometimes in the wrong place). The feet are always seen from the inside, so that the toes are obscured,[13] while the legs are depicted in the proper profile view.

What follows from this, although Erman did not put it in these words, was that in Egyptian art the human figure was an ideogram, and the ap-

proach to it was additive. The artist's, and the spectator's, point of departure was the individual limb, or the specific view; from them he built the whole figure. The figure as a whole was a construction.

It was here that Schäfer picked up Erman's trend of thought. By the turn of the century Erman's reading of the Egyptian depiction of the human figure was generally accepted. An underlying question that seems to have occupied the minds of some scholars was whether Egyptian artists were aware of the true nature of their projection, that is, whether they knew that their additive construction of the human body was not a portrayal of nature as seen at a given moment, or whether they employed their constructive method without further reflection, taking it for granted. With this question, clearly, we have come back to the great problem of the primitive mind, and of the art such a mind creates.

Some Egyptologists believed that the ancient artists were fully aware of what they were doing in thus constructing the human figure. Between the principal members portrayed in distinct, typical view (head in profile, shoulders in frontal view, legs and feet in profile) there were parts of the body which were meant to "mediate" between such disjointed aspects, which could never be perceived as a whole in nature. It was particularly the navel, placed by Egyptian artists roughly halfway between the frontal shoulders and the profile legs, whose position was explained as "mediating." Some Egyptologists saw the "invention of a genius" here.

Schäfer rejected any suggestion, explicit or implied, that the Egyptian artists were aware of their particular way of projecting the human figure, or of its shortcomings and internal contradictions. Not only does the wealth of Egyptian art not provide us with anything that might indicate such an awareness, Schäfer said, but he denied such a possibility as a matter of principle. Egyptian art, he said, was an "emerging" art (*werdende Kunst*), an art in its becoming (pp. 171 ff.). And it is in the very nature of such an art that, as soon as the artist becomes aware of an inherent contradiction in his work or methods, he will change his configurations or patterns of procedure so as to attain unity and consistency. Had the Egyptian artist known that his construction of the human figure was contradictory and lacking in consistency, he would have changed that construction and given it the unity we feel is missing. But, said Schäfer, whoever thinks that the Egyptian artist felt the need to reconcile the conflicting aspects of his human figure (and therefore placed the navel midway between frontal shoulders and profile feet) has not freed himself from the modern, western attitude to portraying the human figure.

As a rule, Schäfer did not refer to primitive art in his discussion of Egypt. Egyptian art, in his view, was of high cultural attainment. It is interesting, however, that at this point, when he analyzed and tried to explain the Egyptian projection of the human figure, he adduced (p. 172) a Mexican drawing, obviously "primitive," to make his point. In physiognomic type as well as in proportions, the Mexican drawing is far removed from Egyptian images, but the way the body is constructed is similar: the head is seen in full profile, the shoulders and two female breasts are portrayed from an unimpaired frontal view, the legs and feet are again seen in pure profile. Here the navel is rendered as if the figure were shown in pure profile, but the clasp of the girdle, meant to be precisely beneath the navel, is seen from the front, and placed exactly in the middle of the figure. The affinity of approach, though not of technique and actual models, to Egyptian art is us.

Emanuel Löwy

The problem of how to understand the representation of the human figure in Egyptian art has brought us back to the ideas and notions that emerged in the study of prehistoric and primitive art, and particularly to the concept of the "memory image."[14] Students in several fields contributed to discussions of this concept. In applying it to the study of art few scholars were as important as Emanuel Löwy, who concentrated on Greek art and culture. The historian of art theory will always consider Löwy's studies of Greek art (published in 1900), especially the way the early Greeks represented nature,[15] a milestone in the development of modern aesthetic reflection.

Emanuel Löwy, we should keep in mind, was neither an Egyptologist nor a psychologist. What he said about Egyptian art was marginal to his interest; we should add that he did not study prehistoric art, and in fact had little use for the arts of the primitive societies of his own day. As he was not a psychologist, his use of psychological terminology may seem a little loose, and he certainly did not address himself to the professional scientist. Yet what he saw in early Greek art was not only of considerable significance for the general study of art, but it also had particular bearing on the explanation of Egyptian imagery and the study of the psychology of art. His thought, it has correctly been said, is "still suggestive for modern research and has a wider application than has been recognized."[16]

Löwy searched for the general principles for the depiction of nature in archaic art. That art represents nature was still for him an axiomatic truth.

He was concerned with a particular condition within that general truth: what happens when an *archaic* artist or culture undertakes to represent nature? He went beyond what psychologists had studied in prehistoric art, but also beyond what the Egyptologists were asking at the time. The representation of the human figure occupied a central part in his thought. He sought to understand how that projection of the human figure that we have encountered both in prehistoric and in Egyptian art came about.

In archaic cultures the artist's creative process begins with a "memory image." The term "memory image" (*Erinnerungsbild*) may seem to have been taken literally from the technical language of psychology, yet in Löwy's usage it had a different meaning, not mainly psychological. The impression of a fleeting moment, however distinctly retained in memory, was not a "memory image" in his sense. What he meant by the term was a cumulative image, distilled from many individual sense impressions. Moreover, the memory image was not the property of an individual mind. Löwy used the term to refer to collective images, known to larger groups of people, or to whole cultures, and handed down by tradition. The term was employed in this sense by artists. Without wishing to diminish the influence of psychology in the shaping of this notion, we can say, then, that the "memory image" pertained to cultural history no less than to psychology.

Löwy was not concerned with defining the memory image as such; he was interested in finding out how it worked in archaic art. The archaic artist made a strict selection. In rendering the human figure (or any other object), he forwent in advance the infinite variety of shapes and the abundance of movements that nature offered him, restricting himself to a few forms, those that he conceived as characteristic of the figure or object he was representing. These forms, furthermore, were cast in schematic patterns, mainly linear ones. These two qualities—typical forms and schematic patterns—determined the general character of the archaic memory image, as they determined the character of the work of archaic art.

Other qualities of the archaic memory image applied to specific aspects of the figure. The archaic artist gave pride of place to outline. His creative process began with, and focused on, the figure's outline. This was true regardless of whether the artist was making, or the spectator looking at, a mere line drawing or an area depicted in a solid color, as in vase painting or painted Egyptian reliefs. The significance of outline as distinguished from transitional shadows or color patches, was a subject of which art historical research and aesthetic reflection were well aware, especially in Löwy's Vienna around 1900.[17] Outline, it was generally accepted, was the rational and

abstract element in the comprehensive economy of the picture or the statue. It is in this context, I think, that we should see Löwy's emphasis on outline in the archaic memory image. It showed once again that his "memory image" was far removed from what we actually remember from our real experience.

Color was not Löwy's main concern; he was primarily interested in sculpture.[18] But in Greek archaic art painting played a well-known part, and so Löwy also discussed color. In the archaic memory image as well as in the art resulting from it, he said, color was applied without gradation, as a solid surface. Here the hiatus between the archaic memory image, as Löwy understood it, and the painter's attempt to evoke optical illusion was clearly revealed. The gradation of color and the shadow, as is well known, are what create the sense of volume, roundness, and depth in the flat picture, and these are the factors that create optical illusion. The solid surfaces of archaic painting showed that this art did not seek to create optical illusion.

Another feature Löwy discerned in the archaic image was particularly topical in the context outlined in the present chapter. The archaic artist, said Löwy, tried to show every limb or part of the body represented in its broadest view. This feature, of course, evoked particular interest among Egyptologists, but also among students of prehistoric art. The projection of a figure composed of different views, as we have seen, fascinated scholars dealing with works of Egyptian art. Most of them agreed that the Egyptian artists looked for the "typical" features of a figure. How do we get at these typical features? They are the broadest views of any limb or part of the figure, said Löwy. This principle, if accepted, would provide the sculptor in the workshop with a simple rule of thumb. It should also be stressed that this feature precluded illusion, and further enhanced the abstract character of both the memory image and the art derived from it.

A final feature also obstructed the creation of optical illusion, and thus further illustrated the abstract character of the memory image. Löwy noted that archaic art tended to reduce overlapping to a bare minimum or to prevent it altogether. It was inclined to spread out the composition on a flat surface, without creating the sense of space that extends into depth, and thus, once more, to deny the very basis of an illusionary art.

To sum up Löwy's contribution to the theme of the present essay. The initial stage of art, he claimed, was not the observation of nature, but a pattern we carry in our minds, or a "memory image" to which nothing in nature corresponds exactly. "The artist," he wrote in his widely read book, "does not approach nature in order to allow her impressions to act freely

upon him. He brings with him the image of his object already finally formed in his mind, and asks nature only for details...."[19]

NOTES

1. See Heinrich Schäfer, *Von ägyptischer Kunst, besonders der Zeichenkunst: Eine Einführung in die Betrachtung ägyptischer Kunstwerke* (Leipzig, 1919), pp. 167 ff. To Schäfer and his work we shall shortly return. See below, pp. 433 ff.

2. The student of art will find concise information and stimulating analyses in Rudolf Wittkower, *The Impact of Non-European Civilizations on the Art of the West* (Cambridge, 1989).

3. See Barasch, *Modern Theories of Art, 1,* pp. 263 ff.

4. Gaston Maspero, *Archéologie Egyptienne* (Paris, 1887), pp. 159 ff. References to page numbers in Maspero's work will be given, in parentheses, in the text.

5. See above, part 2, chapter 15.

6. See Barasch, *Modern Theories of Art, 1,* pp. 113, 217.

7. With regard to the canon of proportions new finds have changed our views. See mainly E. Iversen, *Canon and Proportion in Egyptian Art* (London, 1955). See also the brief but important remarks in Panofsky's study, "The History of the Theory of Human Proportions as a Reflection of the History of Styles," in Erwin Panofsky, *Meaning in the Visual Arts* (Chicago, 1955), pp. 55–107, especially pp. 64 ff.

8. See Barasch, *Modern Theories of Art, 1,* pp. 295 ff.

9. See Boime, *The Academy and French Painting,* pp. 78 ff., especially pp. 81, 87.

10. Schäfer, *Von ägyptischer Kunst.* References to page numbers of this work will be given in the text, in parentheses.

11. Maspero, *Archéologie Egyptienne,* pp. 170ff., 178 ff.

12. See Adolf Erman, *Aegypten und aegyptisches Leben im Altertum* (Tübingen, 1885, 1886). An English translation appeared in London, in 1894. I use the second edition of the German original (Tübingen, 1923).

13. It is interesting to note that even a scholar of Erman's stature was not free from the constraints and prejudices of his time. The toes were not represented, he says (p. 479), because of the difficulty of depicting them. This, one should remember, was said by a scholar who was well aware of the great ability of Egyptian artists.

14. See above, chapter 19.

15. See Emanuel Löwy, *Die Naturwiedergabe in der ältern griechischen Kunst* (Rome, 1900), translated into English by John Fothergill as *The Rendering of Nature in Greek Art* (London, 1907).

16. See the dense page on Löwy in Meyer Schapiro's essay on style. I use the reprint in Morris Philipson, ed., *Aesthetics Today* (New York, 1961), pp. 81–113. See esp. p. 99. And see also Gombrich, *Art and Illusion,* p. 22.

17. See below, chapter 26, pp. 590–93.

18. Emanuel Löwy's popular book, *Die griechische Plastik*, I 3d ed. (Leipzig, 1920), shows this particularly clearly. It also contains interesting observations on the nature of "type."

19. Löwy, *Die griechische Plastik*, I, p. 9. Translations by present author.

21

Gauguin

Among the artists who in the late nineteenth century proclaimed the value of primitive art Gauguin is the best known. He was a truly seminal figure. Perhaps no other artist had such an extensive role in disseminating the gospel of the primitive, including primitive art. His message, whether conveyed in images or in words, transmitted directly or by his many advocates, reached not only art lovers, but also large sections of the western world with little knowledge of art and perhaps even less use for it. For almost a century, whenever the subject of primitivism in art was discussed, his name came up almost instantly.

Since Gauguin's message and influence are so well known, we may be permitted, I hope, to treat his "doctrine" more briefly than that of less well-known artists and critics. On the other hand, since his influence encompasses so many fields (and is thus so diverse), it is necessary for us to set out as clearly as possible what we are looking for in the present chapter. Two questions arise: first, what did Gauguin say about primitive art, and about the life of the primitive in general; and second, what was it that gained him not only the eye, but also the ear and mind, of so great an audience in Europe?

I shall not attempt to discuss his artistic work; rather, I shall concentrate on his written legacy. Gauguin, it goes without saying, was not a professional writer, nor was he a systematic and articulate thinker. We cannot expect to find a well-ordered set of ideas in his writings, which consist of fragmentary notes and letters; none of his formulations should be considered a well-thought out, precise articulation of his thought. What is important is their general trend, even the intellectual climate that they reflect. In these utterances, I believe, he reflected the ideas of primitivism current in Europe more fully and more clearly than did most of the artists and critics I have discussed in this section.

It will probably be useful for our purposes to present Gauguin's views under two different headings: first, his ideas about primitive man, society,

and way of life in general; and next his thoughts about primitive art in particular, and what primitive life and art could do for the art of his own time in western Europe. Now, it is easy to see that a clear line of demarcation between the two domains, life and art, is not simple to trace; there is no watertight frontier between reflections on primitive life and on primitive art. But a presentation under two different headings not only helps us define Gauguin's historical position more clearly, it also gives us an insight into what it was that attracted him and his audiences to the primitive, and thus lays bare an important aspect of primitivism in the late nineteenth century.

Let us begin with the more general subject. Gauguin's journeys to distant islands have become canonized legends of the modern world. Gradually becoming ill at ease in his urban surroundings, he spent some time in rural Brittany (where he was able to "live as a peasant"), and then tried to leave Europe, at first unsuccessfully. In 1891 he finally sailed away to live like a "savage" in Oceania. Returning from Tahiti to France for a relatively short time (1893–95), he then moved to the Marquesas in the South Pacific, where he remained until the end of his life in 1903.

Gauguin escaped from France and from the big modern city to real islands, but his true quest, it is safe to say, was for a mythical land and a life belonging to the Golden Age. In the autumn of 1890, before taking off for Tahiti, he wrote: "As for me, my mind is made up, I am going soon to Tahiti. ... I want to forget all the misfortunes of the past ... the Tahitians ... happy inhabitants of the unknown paradise of Oceania, know only sweetness of life. To live, for them, is to sing and to love. . . ."[1]

In using such time-honored labels as the "Golden Age" we should, of course, be careful. Gauguin's primitivism, Kirk Varnedoe has recently reminded us, was "concerned neither with a lost original state of nature nor with its possible future counterpart."[2] It is true that Gauguin did not escape into books or into literary daydreaming. "He was instead attracted to places where the deep past seemed to survive in the present." But this does not negate the fact that he continued a venerable utopian tradition, even if he did so by traveling to distant places instead of writing or dreaming of them. In fact, even when he went to exotic, yet real islands, his thinking was informed and shaped by the concepts and images which this tradition had developed. A letter Gauguin wrote to Strindberg contains the following well-known passage:

> Civilization is what you suffer from; to me barbarism is a rejuvenation. Perhaps the memories of your selection have evoked [for you] a painful past

when confronted with the Eve of my choice, which I have painted in the forms and colors of another world. This world, which neither a Cuvier nor a botanist would probably recognize, will be a paradise of which I alone have made a rough draft. And from the rough draft to the realization of this dream is far. But what matter! To catch a glimpse of blessedness, is not that a fore-taste of *nirvana*?[3]

Reading this and similar statements one sees how deeply traditional utopian wishes and time-honored ideas were interwoven in Gauguin's dreams and actions. In the utopian traditions attempting to describe such mythical islands, two images prevailed: in one bliss and joy distinguished life in those abodes from life in our world; in the other it was the knowledge of the original nature of things, the cognition of primeval "truth" that did so. For Gauguin it was clearly the first image that counted. In the primitive world he looked for, and saw, happiness first and foremost.

Gauguin's utopian vision, however, was not altogether radiant. It has been pointed out that while the Tahitians and the Maori, as he called them, were archetypes of untarnished innocence and timeless bliss for him, his mental picture also included sinister features of barbarity and violence, and even plainly satanic, diabolical connotations.[4] The sensation of a nightmare crept into the dream of happiness.

In reading Gauguin's journals one comes across repeated descriptions or suggestions of superstition, of sexual promiscuity, and even of violence. They betray an underlying implicit attitude that tinged everything he said about the primitives. But while some of the individual notes can still be seen as more or less "objective" observations of what was happening around him, there are some more general statements, made by other people, with which he obviously agreed. Thus, Achille Delaroche, a critic whose review Gauguin copied into his journal, said:

Here a fantastic orchard offers its insidious blossoms to the desire of an Eve, whose arms are extended timorously to pluck the flower of evil. . . . Here it is the luxuriant forest of life and spring; wandering figures appear, far away, in a fortunate calm that knows no care . . . but the fateful axe of the woodcutter breaks in. . . . Idyllic children sing at their pastoral flutes in the infinite hap-piness of Eden, while at their feet, quiet, charmed like evil genii watching, lie the heraldic red dogs.[5]

Delaroche's statement suggests the atmosphere of Gauguin's paradisal vision. It would be mistaken to assume that Gauguin's vision of primitive

society and life was determined mainly by images of violence; but neither would it be true to see it as an optimistic vision, either full of nostalgia for a lost Garden of Eden or inspired by the hope that it would prove to be a reality of unmixed bliss. His image of primitive life, though overtly full of admiration for the Tahitian or Maori, remained ambivalent.

The interweaving of the paradisal dream with hidden diabolical urges—the reminder that in the Garden of Eden there lurks the serpent—is a romantic concept, a typical feature in the Romantics', or Neoromantics', approach to primitivism. In adopting these views Gauguin revealed at least some of his spiritual sources.

But the structure of Gauguin's attitude to primitivism was derived not only from the literary heritage; it was deeply influenced by his experience in, and disappointment with, the highly "civilized" world of western Europe. In our present context it should be stressed that Gauguin projected onto the primitive what he found lacking in the urban society he had left. Some of the features with which he endowed his primitive may have been consciously meant to shock the western, modern culture he so violently rejected. His defense of sexual promiscuity, and even of cannibalism, are good illustrations of this point. More important, I believe, was his emphasis on some general, underlying characteristics of primitive life and the primitive mind. Of particular significance was his belief that the primitive islanders were morally and spiritually superior to Europeans because they lived in a permanent, unchanging state of mind and society. Extolling the virtue and intrinsic value of static permanence was manifestly a criticism of the idea of progress that dominated intellectual life in Europe around the turn of the century, of the latter's permanent cultural flux and its belief in the ever increasing perfection of social and spiritual values. As against all these Gauguin set up the perfection of a culture and life in which supposedly nothing dramatic happened.

We turn from these brief comments on Gauguin's primitivism in general to our specific subject, namely, his views on art, and his impact on the development of those reflections we now call the "theory of art." Assessing his contribution to the development of art theory is more difficult than might appear at first glance. Given the complexity of Gauguin's views, it is useful to distinguish between what he said about the concrete works of tribal art he saw in the Oceanian islands, and what he believed primitive life and culture could do for the "civilized" art of western Europe. While no sharp dividing line can be drawn between the two groups of questions, we shall see that there are significant differences between them.

The experiences through which modern European artists (and their audiences) acquainted themselves with primitive art greatly differed from each other. In the following chapters we shall briefly discuss how, in the first years of the twentieth century, some of the best-known artists of our time encountered works of tribal art, sometimes under rather unusual conditions. The artists, impressed and attracted by the mysterious expressiveness of primitive objects, later saw in these encounters the origin of their turn to the "primitive." Gauguin's way to primitive art seems to have been completely different. It was in an encounter with specific tribal objects that the artistic value and intrinsic power of primitive art were revealed to him. Before he left for the Polynesian islands he must have seen some African and Oceanian objects in the Trocadero collections in Paris, or in the International Exhibition of 1889. He also had some acquaintance with anthropological literature, including some reproductions of idols and fetishes. Yet none of the individual objects he might have seen before he undertook his journey to the islands left a deep and distinct impression on him; certainly they were not "revelations" of far-reaching and lasting influence. What stimulated him to break away from traditional aesthetics and the norms of European painting was his own internal development. Such a development, it hardly needs emphasizing, forms the background to any artist's conversion to the primitive. In Gauguin's case there was no single experience, no encounter with a primitive fetish or tribal idol, that marked a turning point in his development. We can go even further. Even while he lived in the South Sea Islands, surrounded by objects of tribal art, the crucial turns in his intellectual and theoretical development were not stimulated by such objects.

Gauguin's intellectual world, as has been pointed out quite frequently, was to some extent eclectic; he was influenced by various traditions of art as well as of thought. When we see him combining the impact of such heterogeneous traditions of art as oriental, mainly Japanese, prints, images that reached him from South America, and even some influences from Egyptian or early medieval art in Europe, we cannot help asking: what did these images and arts have in common?

We can see what they shared as soon as we compare them with the main tradition of European, "high" art. This, indeed, was how Gauguin saw them: together they formed an alternative to the great art of Europe. This may also explain the relative dearth of observations on the art he found in Martinique, Tahiti, and the Marquesas. No careful reader can help being struck by how little Gauguin had to say about the specific character of the

art on each island, and about what distinguished the artistic production of one culture from another. What distinguished Tahitian idols from, say, early medieval pieces of sculpture? Gauguin said next to nothing about these differences. What distinguished these arts from one another, that is, their individual character, was clearly less important to him than that they offered an alternative to the great European tradition, that is, the tradition that followed the classical Greek model.

Gauguin was well aware of this. At the height of his intellectual and artistic development, shortly after he left Paris definitively for the Oceanian islands, he wrote (in October 1897): "Have before you always the Persians, the Cambodians, and a little of the Egyptian. The great error was the Greek, however beautiful it may be."[6] It was characteristic that, while in Tahiti and only a few years before moving to the Marquesas, Gauguin evoked in his mind the Persians, the Cambodians, and even a little of the Egyptian. Clearly, it was the non-European, or the "primitive," that was uppermost in his mind.

Gauguin often defined the European art tradition not only as an "error," but, much more pointedly, as a corruption. "The Western world is corrupt and whoever is a Hercules can obtain new strength by touching the soil over there, like Antaeus."[7] Moreover, "There is no longer any doubt, today, that the different arts, painting, poetry, music, after having followed their long and glorious courses, have been seized with a sudden malaise that has made them burst their dreary, time honored traditions, too narrow today. . . ."[8] Observations such as these, whatever their intellectual value or lack thereof, betray a deep-seated disappointment with the western tradition, and the desire to return to a past preceding the Greek "error."

When Gauguin wanted to transcend the European tradition, where did he go? "I have gone far back," he said, "farther than the horses of the Parthenon . . . as far back as the Dada of my babyhood, the good rocking horse."[9] It was, then, to the child as a primitive, taking his rocking horse quite seriously, that he wanted to revert. The image of the child as a primitive, I need hardly say, is ages old; it gained special strength and significance in the eighteenth and early nineteenth centuries.[10] In modern reflections on art the cult of childhood reached a climax in the decade after Gauguin's death, particularly in the work and thought of Paul Klee. But already in the early years of the twentieth century children's drawings were being opposed to the patterns underlying the great European tradition. We have seen that psychologists and students of prehistoric art turned to children's drawings to get a better understanding of cave paintings.[11] In 1902, a year before Gau-

guin's death, Paul Klee noted, "I want to be as though new born, knowing absolutely nothing about Europe, ignoring poets and fashions, to be almost primitive."[12] To be "newborn," a child, and to know nothing about Europe—these ideas were merged together. Clearly the image of the child as a primitive was very much in the air.

To conclude, it was easier to say what primitive art was *not*, what its proponents sought to replace through it, than what it was. Yet in considering Gauguin's ideas about the primitive, one can distinguish certain values that he seems to have seen as leading and formative. I shall briefly indicate some of them, selecting those that are of particular significance in our context. This brief list, it goes without saying, is not exhaustive in any sense.

Let me begin with the central problem of the artist's attitude to nature, a complex of questions central to the European tradition that also occupied Gauguin's mind. What he preached was directly opposed to most of what the venerable tradition had taught us. He saw the problem from a workshop vantage point: what should be the painter's attitude to the "model" who poses in front of him? He rejected the artist's dependence on his model. For a young man, he said, it may be useful to follow his model. As a rule, however, "it is better to paint from memory, for thus your work will be your own; your sensation, your intelligence, and your soul will triumph over the eye of the amateur."[13] Of himself he testified: "My artistic center is in my brain and nowhere else, and I am strong because I am never led astray by the others and because I make what is in me."[14] Among "the others," one feels, he included nature as well. He related the old story that God took some clay and formed of it the world we know, and derived from this tale the conclusion that the artist, who is like God, should not imitate nature but create something new.[15]

In this spirit Gauguin set himself off not only from the age-old tradition that explained art as an imitation of nature, but also from the impressionists who considered painting a record of visual perception. It is not surprising that these ideas emerged in the context of a search for the primitive in art. Both primitive and prehistoric art were seen as an affirmation of the view that art begins with a mental image rather than with a sense perception, and that the work of art is a projection rather than the record of an impression.[16] The student looking at these texts from the vantage point of the late twentieth century notes, with some astonishment how manifold and intricate were the paths leading to what we now know as the Abstract.

Another value to which Gauguin believed the artist should aspire was calm, stillness, and tranquility. Once again one is not surprised that this notion should arise in discussions of primitivism. We are familiar with the utopian image of the primitive who presumably lives in serene quietude. A long tradition of western utopists saw this state as a relief from the troubles, restlessness, and tensions characteristic of the modern world.

The longing for quiet played a significant role in the theory of art. Johann Winckelmann, later claimed as the prophet of Classicism, had in 1755 sketched his half-mythical image of Greek art by stressing "noble greatness and quiet simplicity" as its essential features.[17] It was an important feature of Gauguin's reflections on art that he made quiet and stillness a central value in painting. "Let everything about you breathe the calm and peace of the soul. Avoid motion in a pose. Each of your figures ought to be in a static position."[18] Note that he was not preaching quiet in general. He gave it a practical interpretation: the avoidance of bodily movement. Preaching a "static position" was one of the specific points on which the artist around 1900 differed from the author of 1755.

In a more general way let us recall that in Gauguin's thought the expression of a particular emotion was not at issue: for example, manifesting in painting the feeling or experience of tranquility. For centuries Raphael was admired for doing precisely this, yet no artist or critic would have doubted that the Renaissance master expressed the emotion of calm and tranquility by depicting figures in movement, or at least figures that convinced the spectator that they were capable of movement. Such movement, beholders of Raphael's works throughout the centuries believed, showed that the figures he depicted had both soul and body. What Gauguin saw in his mind seems to have been something else: it was a painting in which there was no dimension of passion and movement, and perhaps not even of time.

This issue of motionless figures, although seemingly specific, is not a marginal one; it has a comprehensive significance, and shows how profound and concrete was Gauguin's wish to free himself from the European tradition. For centuries western reflections on art were dominated by what may be called a rhetorical tradition. From Leone Battista Alberti in the early fifteenth century to Le Brun at the height of the French Academy and Jacques Louis David in the early nineteenth century the representation of movement was seen as the ultimate achievement of painting.[19] Movement was understood as having both an inner dimension, that is, as emotions and passions, and an outer one, comprising the motions of the body and,

more vaguely, the unceasing flow of time. Narrative painting—*istoria*—embodied both, and it was therefore taught in academies and appreciated by critics and audiences.

What Gauguin believed he had found in primitive art was the very opposite of this tradition. Where for centuries artists were taught to depict figures in movement, he suggested that the painter depict motionless figures. It was a new ideal that he presented here, not only for humanity in general but also quite specifically for the painter's scale of values.

It is not for us to decide whether Gauguin was correct in his descriptions of works of primitive art. Did the art he found on the islands, or saw in the Trocadero or at some exhibition, really mean to convey the sense of timelessness and lack of passion, and did it try to do this by depicting motionless figures? Whatever the answer of the contemporary student, this was how Gauguin understood primitive art, and this was the sermon he preached to the western artist of his time. In so doing he indicated an attitude typical of what many modern artists seem to have felt when they looked at works of primitive art: they were strongly attracted by something they could not fully define in terms of their own inherited tradition. In the same way, as we shall see shortly, Parisian artists in the first years of the twentieth century, mainly Vlaminck and Braque, were deeply moved by the mysterious expressiveness of African sculptures, without being able to say what precisely it was these figures expressed.[20]

It goes without saying that setting out alternative values shows that one is not free of the values from which one seeks to escape. On the contrary, if one wishes to replace something this only shows how deeply involved one is with what one seeks to replace. This was obviously true for Gauguin and his immediate followers. His projection of the primitive, in life as well as in art, was in many respects the true obverse of the modern artist's real experiences and anxieties.

We need not dwell on the details of what Gauguin thought about primitive art. These ideas were not systematically developed, and they are not essential for our understanding of the main subject of his thought, namely, what the primitive, aboriginal cultures and arts should mean to us. In many respects anthropologists will probably not agree with the image of primitive society and primitive art that he drew. Gauguin's crucial significance in the history of modern primitivism does not consist in how he pictured primitive art as much as in the very fact that he gave powerful expression to the western longing for the primitive in art.

NOTES

1. Quoted from Herschel Chipp, ed. *Theories of Modern Art* (Berkeley, 1968), p. 79. And see also F. S. Connelly, *The Origins and Development of Primitivism in Eighteenth and Nineteenth Century European Art and Aesthetics* (Ann Arbor, Mich., 1990), p. 104. Robert Goldwater's *Primitivism in Modern Art* (Cambridge, Mass., 1986), although originally published more than half a century ago (New York, 1938), is still valuable. See especially pp. 63–85.

2. See Kirk Varnedoe's article on Gauguin in the exhibition catalog *"Primitivism" in Twentieth-Century Art*, II (New York, 1984), pp. 179–209. The quotation may be found on p. 182, as also the next quotation I adduce.

3. Quoted by Jean de Rotonchamp, *Paul Gauguin 1848–1903* (Paris, 1925), p. 152. The English translation is taken from C. E. Gauss, *The Aesthetic Theories of French Artists* (Baltimore and London, 1966), p. 54.

4. Connelly, *Primitivism*, pp. 104 ff., especially pp. 107 f.

5. Quoted from van Wyck Brooks, ed., *Paul Gauguin's Intimate Journals* (Bloomington, Ind., 1965), p. 53. And see Connelly, *Primitivism*, p. 107.

6. See *Lettres de Paul Gauguin à Georges-Daniel de Montfried* (Paris, 1920), p. 187. The English translation is taken from Goldwater, *Primitivism*, p. 66.

7. See H. R. Rookmaaker, *Gauguin and Nineteenth-Century Art Theory* (Amsterdam, 1972), p. 322.

8. A quotation from Delaroche, with whom Gauguin fully agreed. See Brooks, *Gauguin's Intimate Journals*, pp. 49 ff. Quoted from Connelly, p. 169.

9. See Brooks, *Gauguin's Intimate Journals*, p. 22. Here quoted from Goldwater, *Primitivism*, p. 68.

10. See George Boas, *The Cult of Childhood* (London, 1966).

11. For some observations of the psychologist Max Verworn on children's drawings and their application to the analysis of cave paintings, see chapter 19 above.

12. See *The Diaries of Paul Klee*, ed. Felix Klee (Berkeley, 1964), p. 266. And see Goldwater, *Primitivism*, p. 199.

13. See Brooks, *Gauguin's Intimate Journals*, pp. 68 ff.

14. See M. Malingue, *Lettres de Gauguin à sa femme et à ses amis* (Paris, 1946), letter 127. I take the translation from Rookmaaker, *Gauguin*, p. 322.

15. Paul Gauguin, *Avant et àpres* (Paris, 1923), p. 35.

16. See chapter 19 above.

17. See Barasch, *Modern Theories of Art, 1*, pp. 115 ff.

18. Gauguin, *Avant et àpres*, p. 67.

19. See Barasch, *Theories of Art*, pp. 131 ff.

20. See chapter 22 below, pp. 482–86.

22

African Art

The sudden appearance of African art, primarily of African sculpture, on the horizon of the European art world and of aesthetic thought at the beginning of the twentieth century is probably the most famous single event in the history of modern primitivism, at least as far as the visual arts are concerned. For the modern mind it came to epitomize that large and complex process, the search for and discovery of the primitive and the aboriginal, and the almost messianic hopes that it would have a miraculous impact on the European mind. In the present chapter I shall briefly relate the story of the discovery of African sculpture, and then ask how the figures, masks, and other objects that came from black Africa were understood by those artists and critics who first saw them.

The discovery of African sculpture is well known; it is a story that has become something of a modern secular myth, even assuming some of the features commonly found in mythical narratives, such as sudden appearances and the "illumination" of those converted. Though the historian is aware that some questions still remain open, the general lines of the story are common knowledge. In recording the discovery of African art I may therefore be permitted to disregard most of the details, and to concentrate on trying to understand the motives for the search for the primitive, and the meanings attributed to it.

The story of how African art was discovered in Europe, no matter how briefly told, should begin by emphasizing two distinct features of particular significance in our context. First, this discovery was primarily the achievement of artists, particularly of artists belonging to the avant-garde. We shall soon return to this important fact. Second, African art was discovered at the very same time in two different places, quite independently of one another.

The term "discovery," commonly employed in telling our story, also requires some qualification. It does not mean that the objects themselves were made available for the first time, that they were unearthed, as it were,

and could now be seen. Rather, certain works of sculpture, which were known to have been "present," that is, available, were now seen in new light, considered in a new context, and differently appreciated. It is worth listening to an early witness of the movement. In 1926 Paul Guillaume and Thomas Munro wrote:

> Scarcely twenty years ago, negro sculpture was known only to an occasional missionary, who would write home with horror of the "hideous little idols" of the savages, and to a few explorers and ethnologists, who collected it among other phenomena of African life, without suspecting that it might ever be taken seriously as art. If any artist happened to notice one of the figures, it was no doubt with a feeling of complacency, that civilized art had gone so far ahead of these clumsy, misshapen attempts at reproducing the human form.[1]

The story of how black sculpture was discovered by modern artists is best known in the version told by Maurice Vlaminck in his autobiography. Vlaminck recalled, a quarter of a century after the event, that he saw two small Negro statuettes in a Paris *bistro* placed among the bottles behind the counter.[2] He was so moved by their expression that he bought them for two liters of aramon which he shared with the customers present. Vlaminck told this story in 1929, but by then he was apparently not certain as to the exact timing of this humble event. Historians of modern art have made great efforts to establish the precise date, which must have been either in 1904 or 1905. Later Vlaminck was also not sure about how many figures he saw. When in 1943 he again wrote his recollections, he placed the event in 1905, and described three, not two, statuettes: two from Dahomey, painted red, yellow, and white; and one all black, from the Ivory Coast.

It is worth noting that the statuettes in the *bistro* were not the first African sculptures Vlaminck had ever seen. He used to visit the Trocadero, but he had thought of the Negro sculptures he saw there as "barbaric fetishes." This reminds me of a literary or narrative motif well known in the history of religions: in Vlaminck's story we have all the elements of a "conversion in the *bistro*."

Be that as it may, the event was not an isolated one. From a friend of his father's Vlaminck received two more Ivory Coast figures and a large white Congo mask. Derain, then closely associated with Vlaminck, saw the sculptures and was profoundly impressed by them, especially by the mask. He bought it and hung it in his own studio, and it was here that both Picasso and Matisse first saw it. Derain, as we know, went on collecting African art.

In his collection he placed Negro sculpture in a conceptual context, without articulating a single word of theoretical reflection. In addition to African sculpture, he also accumulated contemporary folk art and works of archaic art from both East and West. It was an artist's private collection of primitive art in all its major aspects.

Independently of what was going on within the narrow circle of avant-garde artists in Paris, and without any knowledge of these sudden conversions, another group of painters was groping toward a "discovery" of primitive art, especially of African sculpture. This was the German group that came to be known as *Die Brücke*. Ernst Ludwig Kirchner was probably the first among the Dresden group to discover African and Oceanian art. This time the "discovery" did not take place in some remote *bistro*, but in the well-endowed Ethnological Museum in Dresden. The year was perhaps 1904, as Kirchner suggested in his brief *Chronik der Brücke*, which appeared in 1913. Scholars have voiced some doubts as to whether it was really at such an early date that the primitive was fully acknowledged and began to exert its influence on artists' work.[3]

However that may be, by the end of the first decade of the twentieth century primitivism, and particularly African tribal art, had become a significant component of the German art scene and of reflection on art. This can best be seen in the *Blaue Reiter* group in Munich. Thus Wassily Kandinsky later related that his ethnographic interests arose from "the shattering impression made on me by Negro art, which I saw in the Ethnographic Museum in Berlin." Goldwater has suggested, convincingly to my mind, that Kandinsky's closer acquaintance with African art as seen in the Berlin Museum, dates from 1907.[4] Another artist of the same group, Franz Marc, who also came under the spell of primitive art, wrote in January 1911: "I spent some very productive time in the Ethnographic Museum in order to study the artistic methods of 'primitive people.' I was finally caught up, astonished and shocked, by the carvings of the Cameroon people. . . ."[5] Shortly after receiving Franz Marc's letter, August Macke compared European painting to African decoration. "What we hang on the wall as a painting is basically similar to the carved and painted pillars in an African hut."[6] And two years later, Emil Nolde, the expressionist painter who joined a German imperial mission to New Guinea (in 1913–14), was carried away by his admiration of the primeval forces in the art of tribal societies: "the primeval power of all primitive people is germinal, is capable of future evolution. Everything which is primeval and elemental captures my imagination. . . ."[7] Though African art does not appear as exclusively in the impressions and

thoughts of the German groups as among the Parisian painters, here too it plays a central part. In European thought, African art came to be considered the prototype of tribal art in general.

As already mentioned, the story of how tribal art came to be known to the young artists of western Europe is well known. The few events related and quotations adduced above should suffice to remind us of that famous process that to a considerable extent shaped the course of modern art— the influence of African art on the fabric of European painting. We turn now to the questions this chapter tries to answer. At first glance the question is a simple one: what was it that so attracted avant-garde artists to African art? To make my question clear I should point out that I do not refer to the hidden motives and subconscious wishes or desires (to use fashionable concepts) that made European artists so attentive to the "crude fetishes" brought from Africa. These motives, it goes without saying, were an important component of the general process we are here describing, and we shall have to analyze them as far as we can. But first we must see what artists in France and Germany, the groups around Vlaminck and Derain, the *Brücke* and the *Blaue Reiter*, themselves thought and said they found in works of tribal art. Did they assume that they had found entirely unknown objects, or did they believe that they were suddenly understanding new meanings or seeing new aspects in objects previously available to them? In a simple and straightforward sense, what did their "discovery" mean?

To attempt to answer these questions, if only in outline, we must go back in time to the years preceding the "discoveries" by Vlaminck and Kirchner and their friends. We shall have to ask whether, and to what extent, African and other tribal art objects were available in western Europe. Could such objects be seen by the public, and to what extent were artists and critics, literary men, and intellectuals in general, aware of the existence and nature of the products of tribal art? The history of the ethnography, and of ethnographic collections and museums, has already been outlined.[8] Here I shall only briefly mention a few data, confining myself to what is better known, in order to place our questions and such answers as we shall be able to provide in proper perspective.

Within the general panorama of European cultural awareness, the interest in and the collection of tribal art, especially African, was a marginal issue. To be sure, even if we limit our attention to France and Germany (thus leaving aside England which played an important role in making the world beyond Europe better known) we find that for a long time a trickle

of African objects did reach Europe. The selection of objects, however, was random and did not raise any questions in art theory or general aesthetic reflection.[9] In the last two decades of the nineteenth century this trickle intensified somewhat both in the number of African and other tribal objects brought to Europe and shown there, mainly in Paris, and in the amount of interest they received. The great World Exhibitions, held at more or less regular intervals, tended to bring the diverse customs and products of societies in distant parts of the world to public attention; they thus helped undermine the Eurocentric opinions commonly encountered in France, England, and Germany.

In France one of the important results of the World Exhibitions, at least as far as our present subject is concerned, was the establishment of the Trocadero Museum. The actual foundation was stimulated by the World Exhibition of 1878, held in Paris, but the plan for a museum of *geographie et voyage* goes back to the middle of the century, and was, of course, linked to France's imperialist enterprises. Occasionally, though probably very rarely, private collections were formed. One such, a collection of African gems, was put up for auction as early as 1887.[10] And in 1912 Guillaume Apollinaire spoke of collectors who, "wishing to be up to date on the annals of curiosity, have started to collect the sculptures and all the works of art in general of those African and Oceanian peoples who are usually called savages."[11]

German colonial activity started late, but it proceeded fast. This at least is the impression one gets from surveying the dates and holdings of the collections of African and Oceanian objects in German museums. As early as 1886 the Museum für Völkerkunde in Berlin held almost ten thousand African objects, most of them gathered by German expeditions sent out after the 1860s. Around the turn of the century German museums acquired one of the two most important collections of works from Benin. In the remains of the royal palace in Benin the record of an extraordinary technical mastery was soon discovered, a level of skill that surprised many European spectators. The casting technique puzzled experts, as the size of some of the works was "monumental" in a real sense of the word.[12] This was a "court art" comparable to what was known from the European past.

German collecting went together with much publicized expeditions of discovery, and with serious scholarly publication. G. A. Schweinfurth's *Artes Africanae* appeared as early as 1875. Despite its comprehensive title, it dealt mainly with African ornaments executed in two-dimensional media.[13] Though it was overshadowed by the author's many other publications on

the customs and social life of the African tribes rather than on their arti-facts, the very fact that it combined the two terms "arts" and "Africa" in its title makes this work by Schweinfurth noteworthy.

Such activities as those briefly noted here should not mislead us, how-ever. Concern with "primitive," particularly African, objects remained mar-ginal. Both the collection and treatment of such objects seem to have been devoid of visible significance, and were almost neglected in the lively intel-lectual life of Europe. Not only was the attention given to African and Oceanian objects limited in scope, but the categories employed in dealing with them did not belong to the conceptual framework of the discussion of art. They were believed to be the province of the ethnographer or the an-thropologist. To describe African sculpture people spoke of "fetishes," while the realm of primitive art as a whole was often denoted by the word "cu-riosities." This attitude was revealed even in the way the objects were arranged in the few museums where they were exhibited. No distinction was made between, say, harpoons and figural statues, between objects of everyday life and what we now call "art."

Scholarly awareness of the primitive as art and recognition of elements of art in African objects was also rather isolated. In 1903, the year in which Salomon Reinach published his article on the magical element in prehis-toric art,[14] another French scholar, Maurice Delafosse, drew some parallels between early Egyptian sculpture and the more recent sculpture of the Ivory Coast. Both, he said, were cast in a uniform mold. Basing himself mainly on the work of Gaston Maspero, Delafosse believed that both Egyptian sculpture and the Ivory Coast masks and fetishes were a "mixture of naive science and wishful awkwardness."[15]

However, a decade before Delafosse, a German scholar, A. R. Hein, who concentrated on the study of ornament, had pointed out the aesthetic as-pect and value of objects usually relegated to ethnologists. He lamented the art historians' and aestheticians' unwillingness to treat the primitive object by employing the categories of their fields of study. The level of a society's material culture, he said, need not determine its artistic achievement and the aesthetic quality of what it produced.[16]

Approaches like those of Hein and Delafosse, we must repeat, were iso-lated, and were disregarded both by serious students and the general pub-lic. In the cultural awareness of Europe, works of tribal art, to the rather modest degree to which they were noticed at all, remained documents of the life of strange peoples, objects that made possible a study of the soci-eties and cultures from which they came. Consequently they were relegated

to the ethnographer's attention. That they might reveal aesthetic values not related to their tribal origin, was not even considered.

Let me conclude this chapter with another quotation from Apollinaire's 1912 article, several years after artists in Paris, Dresden, and Munich had been converted to tribal art. Writing of the Trocadero Museum, he said:

> The ethnographic museum of the Trocadero deserves to be developed, not only from the ethnographic point of view, but above all from an artistic one. The museum should also be given more space, so that the statues and other works of art are not piled up haphazardly in glass cases, together with household utensils and old rags of no artistic interest.[17]

What are the conclusions to be drawn from this very general outline of developments before and during the "discovery" of primitive art objects by the painters who were to become the founders of twentieth-century art? Although obvious, it may be useful to formulate these conclusions once again.

First, objects of the kind that became a revelation to Vlaminck, Derain, and Picasso, to Kirchner, Franz Marc, and Macke were available to the public at the time. Though they were not at the center of public attention, a curious spectator could easily contemplate them, mainly in the ethnological museums of the great cities of western Europe, and sometimes also in private collections. A second conclusion, equally obvious at first glance, is that general opinion, both among artists and critics and the broad public, held that these carved and painted objects were the "savage" products of primitive societies and cultures rather than works of art.

Having outlined the background, we now come back to our question: what was it that so struck the young artists when they saw works of African tribal art? What did they themselves say it was that so affected them, and what do we believe were some of the underlying motives for their reaction?

In what follows, I shall break this question down into two parts. I shall first adduce, as far as possible, the artists' own initial reaction to the African and Oceanian sculptures and other objects that they encountered under various and sometimes unusual circumstances. Only after that shall I attempt to analyze the motives that shaped the nature and direction of their reaction. We turn first, then, to the original statements of the painters and their close friends among the critics.

For the art historian, what painters in Paris, Dresden, and Munich said about African sculpture is disappointing; their few sentences, brief and fragmentary, make it difficult to reconstruct a detailed picture of what that

encounter really looked like. The artists who played such an important part in the reception of African art in Europe were obviously not much given to detailed verbal articulation. Moreover, the subject itself was new, and they were probably not able to envisage the proportions it was to assume. Nevertheless, even these few documents, unclear as they are, are of great importance for our understanding of what struck the artists in the first place, and what hidden desires caused them to take a fresh look at the "barbaric fetishes."

For a reader familiar with the sophisticated explanations current in our day, the artists' statements about their encounter with tribal art in the first decade of the twentieth century may sound surprising: they say nothing about form or style, but they all stress one point—the expressiveness of African sculpture. Whether making a statement or describing the impact these objects had on them, they always voiced the same feelings. Vlaminck, whose experience of the small objects in a Parisian *bistro* became a modern myth, thought the African figures in the Trocadero "barbaric fetishes." But when he saw the little figures behind the counter in the *bistro*, he was "profoundly moved . . . sensing the power possessed . . . by the three figures."[18] In 1909 Guillaume Apollinaire said of Matisse that "he likes to be surrounded by antique and modern works of art, by precious fabrics, and by those sculptures in which the negroes of Guinea, Senegal, and Gabon have represented, with a rare purity, their most passionate fears."[19] Picasso's account of his visit to the Trocadero in 1907, although given thirty years later, reflects the same attitude. After describing how disgusted he was at the museum, he continued:"I wanted to get out of there. I didn't leave, I stayed." The sculptures he saw, mainly the masks, were "magical things," "mediators," "intercessors" between man and some obscure forces of evil.[20] When we disregard the impact of literary formulae, what remains is a strong expressive effect.

Another revolutionary painter who belonged to the same group, André Derain, recorded his impression in similar terms. In a letter the precise date of which is a matter of dispute among art historians (according to recent research it was written in 1906) Derain described his visit to the ethnographic collections of the British Museum (he called these collections *musée nègre*). The objects exhibited there, he said, were "amazing, disquieting in expression."[21]

In Germany the artists' reactions to African and Oceanian art were not essentially different. To be sure, in Germany the Romantic heritage was occasionally more prominent, particularly in verbal formulation; there was

more talk about "experience" and more attention given to other notions of a psychological nature. But when we look carefully at what the artists in Germany said about works of African art, we find a close resemblance to what the Parisian painters were saying. It was the forceful expressiveness of the work of primitive art that caught their attention. Kandinsky talked of "the shattering experience made on me by Negro art which I saw [in 1907] in the Ethnographic Museum in Berlin."[22] Franz Marc reported that "he was caught up, astonished and shocked by the carvings of the Cameroon people. . . ."[23]

In using the word "expression" in the present context, we should carefully consider what we mean by this term. The concept of expression, as is well known, has a venerable history in the European reflection on art, in the course of which the notion has acquired a certain well-defined meaning. Thought about pictorial expression was closely linked with the tradition of rhetoric in western culture. Possibly under the influence of this link, "expression" in painting and sculpture came to be understood primarily as the visual manifestation of distinct emotions such as sadness, joy, love, hatred, and so on. For centuries it was believed that the specific patterns expressive of the distinct emotions were codified (by nature or by man), and could be studied. The academies of art taught expression.

Now, when in the first decade of the twentieth century the young artists in Paris and Germany attested to the deep impact the expressiveness of African sculptures had on them, they obviously meant something other than the rhetorical forms we have mentioned. The African figures or masks do not seek to represent specific emotions or experiences. Nor did the European painters who were so impressed by these works look for distinct emotional expressions in the products of the "savages." The artists around Vlaminck and Matisse, or those around Kandinsky and Franz Marc, *were* indeed affected by their experience of African art, but it was not rhetorical expression that they found there. What was it, then, that they found so "disquieting"?

Expressive qualities are notoriously difficult to describe and define, particularly when the rhetorical categories of expression developed for this purpose do not apply. This makes our question—what did the artists in the early twentieth century mean when they spoke of the expressive effects of African sculpture—especially difficult to answer. I can therefore only offer some vague and general observations, not more than my impressions from a critical reading of the rather scanty remarks they made on the subject.

First one should note that Apollinaire or Kandinsky, and the artists around them, found in the African figures and masks only a general expressiveness, a power to excite the spectator, and perhaps to irritate and disquiet him. Their scattered comments indicate that they felt that these strange figures they were looking at with sudden admiration held a message which addressed the spectator with a certain mysterious urgency. However, they did not ask what this message was precisely. They must have felt that such a question would be inappropriate in the context.

Perhaps one qualification should be made here. Though it is true that the young avant-garde artists in modern Europe did not say what the African sculptures expressed specifically, several times a sense of fear, of an unnamed anxiety, is mentioned in their letters or memoirs. As we have just seen, Apollinaire found that the African sculptures expressed the "most passionate fears" of the societies that produced them, and Derain found the figures and masks "amazing, disquieting in expression." Consequently while the expressive power that European artists perceived in the African and Oceanian works was a general ill-defined one, these primitive artifacts also transmitted to them an intimation of a somewhat indistinct fearfulness and menace.

Contemporary students will devote their careful attention not only to what was said or suggested in such reactions to the African figures, but also to what does not appear in their records of these encounters. They will note that there is no reference to merely formal aspects or qualities. We cannot help concluding that reflections on purely formal aspects, considerations of mere form, were not part of the initial reaction to these primitive works of art. Contrary to some myths prevailing at the end of the twentieth century, the great pioneering artists in the first decade of the century seem to have been so deeply affected ("shattered," as one of them said) by the expressive power of the African pieces they were looking at that they did not think of the formal problems.

In the earliest phase of the twentieth century, mainly in its first two decades, African art, then, was not altogether unknown, though of course it was not "popular." Not only was it not considered high art, but it was not approached as art at all. The ethnographers and anthropologists who studied the "fetishes" we have now come to consider works of art perceived in them nothing more than visible embodiments of "savage" cultures. The poles, masks, and figurines brought from Africa were "illustrations." Some avant-garde artists, lacking any ethnological background,

were indeed strongly affected by the expressive power of these products. But the painters in Paris, Dresden, and Munich were verbally inarticulate. All they did was to testify vaguely to the strange expressive power of these figures.

Around 1910 new types of people began to concern themselves with African art products. These were critics and writers on sculpture, theoreticians of art. They attempted, perhaps for the first time, to discuss the masks and figures imported from Africa as works of art, and to analyze their specifically artistic nature and message. Not surprisingly, the criteria by which they measured African sculpture and the conceptual framework within which they tried to discuss African art were altogether different from what we have seen so far. With the appearance and early impact of these critics, the first phase of the European reception of African art came to a close.

One of the earliest interpreters of African sculpture was Carl Einstein, one of the most colorful and intellectually adventurous figures of an age that abounded in eccentric intellectual adventurers. Born in 1885, the son of a well-to-do Jewish family in Karlsruhe, Germany, he committed suicide in the Pyrenean mountains in 1940, like Walter Benjamin, fearful of being extradited to his Nazi persecutors. Carl Einstein was not an academic figure, and though his interpretation of different arts were of historic importance, he cannot be called a scholar. For most of his life he attached himself to groups of expressionists in Germany. He wrote a novel (called *Bebequin, or The Dilettantes of the Miracle*, 1912) that was widely read in the 1920s, and in 1926 he published a volume on twentieth-century art of the prestigious *Propylaen Kunstgeschichte*. He was a friend of Georges Braque, and collaborated with James Joyce. It is no exaggeration to claim that he was at the center of the intellectual and artistic avant-garde of Europe. He was also, perhaps not surprisingly, the first author to publish books on African sculpture.

Carl Einstein's work on Negro Sculpture (as he called it) marks a watershed in the European acquaintance with, and reception of, African art. Historians of art, of aesthetic thought, and of culture in general may well disagree about Einstein's precise place in this development. Some will see him as marking the end of its first stage, which began with an intuitive reaction to the African figures; others will consider him as initiating the next stage, in which African art was comprehensively, rationally analyzed. Whatever one's opinion, he marks a mutational change in Europe's coming to terms with the artistic domain of black Africa. I would like to end these comments

on the art theoretical reception of African images with a discussion of Einstein's contribution. I shall restrict myself, however, to his first study, *Negerplastik*,[24] which appeared in 1915, and shall disregard his many later writings.

In this slim book, the first one to be devoted to Negro sculpture, Einstein made two more or less implicit assumptions. Let us begin by presenting them in contemporary language, that is, in terms other than the author's expressionist parlance. The first assumption was that, in contemplating a work of African sculpture, we should detach it from its original context. We know little about African art, we cannot date the pieces, and since most tribes in black Africa are nomadic, we even cannot assign the objects they produced to certain locations. The traditional methods of art history cannot be applied. On the contrary, we should shed all concern for the conditions in which the works were made, and think of them simply as "shaped creations" (*Gebilde*). What we study in African art are works detached from their history.

The other assumption, only briefly indicated, was that, when looking at African sculpture, we cannot disregard, or "forget," modern art, by which Einstein of course meant the European art of his own generation. The presentation of African art, in his own words, cannot "free itself from the experience of recent art" (p. vi). Carl Einstein was the first theoretical author to see reflections on "recent art" as a conceptual framework appropriate to the analysis of African sculpture. This attitude had a profound and long-lasting effect on modern thought.

African art, Einstein said, was shaped by religion.[25] In the art historical literature of the early twentieth century such a statement was in no way unusual. Similar declarations were frequently made in discussions of, say, medieval art. But what Einstein understood by religion shaping art was different from what medievalists had in mind. He was not thinking of ecclesiastic institutions as patrons of artists, of an iconography based on some kind of scripture, or even of the attempt to evoke religious emotion, as were students of religious art in Europe. For Carl Einstein, religion gives us the knowledge or feeling of complete distance between our world and the divine. Therefore, the African maker of a god's figure produced his work as if it were the god himself or the container of the god, "that is, right from the beginning he has a distance to his work, since it is the god or contains him" (p. xiii). "As divinity the work is free and detached from everything; the maker as well as the adorer are in immeasurable distance to it."

Such understanding of religious art has implications for how the work of art is experienced and explained as well as for how it is made. Imitation, Einstein stressed, is altogether impossible as an explanation of African religious art, for imitation is the negation of that immeasurable distance that prevails between the god and the world. How, then, can we conceptually describe the religious art of Africa? Einstein correctly said that from the rejection of imitation there follows a "realism of transcendent" form as the leading principle in making the god's figure and explaining it. He also called it "religious realism" (p. xv).

Religious realism inspires in us the urge to make visible the divine powers that dominate the world, without identifying with the god. This drive to manifest the cosmic powers implies the rejection or at least the suppression of our own subjective selves. Einstein explained two forms of artistic activity, tattooing and masks, both characteristic of primitive man, as deriving from this urge.

Tattooing, so far as I know, had never been considered in the context of artistic activity until Einstein did so, if only briefly (pp. xxv f.). Accepting tattooing as a widespread and characteristic custom, he asked why primitive man tattooed his body, and how tattoos could help us understand African art. In Einstein's view, tattooing attests to primitive man's belief that his own body is an incomplete work. The tattooer surpasses nature and completes the human, as it were. Tattooing also has an additional meaning, namely, that of surrendering one's individual body and acquiring a general one. By being tattooed, the body of a particular man or woman was replaced by a *general* body. The suppression of one's individual self, which Carl Einstein believed to be characteristic of African religion, thus manifested itself in the primitive custom of having one's body tattooed.

The process of visibly surrendering one's individual self to the objective powers reached a peak in the wearing and shaping of a mask. The negro was less captivated by his individual self than western Europeans, and had a more profound respect for the objective powers than they had. By wearing the mask he transformed himself. If he wore the mask of a god or of the tribe, he became the god or the tribe; he incarnated them, as it were. Here the critical reader must add that in fact Einstein was speaking of the tribal man's conscious awareness, of what he and possibly the other people of the tribe thought and believed. But Einstein's formulation was such that one gets the impression of a real transformation, a matter of nonpsychological reality. Despite this logical confusion (a rather common occurrence in the

literature on art in that decade), what Einstein had to say about the character of the mask remains of great interest.

Since the mask showed man's transformation into a general being, or rather man transformed into such a being (a god or the tribe), it was appropriate that the mask should have no individual character and bear no trace of individual emotion. To describe man transcending his individual self Einstein used the Greek term "ecstasis," which originally had the sense of "a being put out of its place" (and if said of the mind, it meant trance). The mask, Einstein said, was "fixed ecstasy." Its stiffness and rigidity indicated the highest degree of intensity, in which individual emotions were altogether canceled.

So far we have seen that Einstein, presenting African sculpture to European artists and general readers, actually spoke about metaphysical ideas such as religion as the ultimate source of African art; he had little to say about problems of form in the more limited and precise sense of this term. The longish chapter "Cubic Space Vision" (pp. xvii–xxiv) was devoted to form, but here he also went beyond specific forms as materialized in individual works; what he wished to understand here was what he called the African sculptor's way of seeing, that is, certain general and comprehensive principles underlying African sculpture.

"Negro sculpture is a fixation of undiluted plastic seeing" (p. xvii). Such a sentence, central to Einstein's reading of African art, easily captivated the ear and mind of the early twentieth-century reader. But what did it mean precisely, or what did Einstein mean by it? It turns out that there is no simple answer to this question. What Einstein was looking for was not "something spatial, but the three-dimensional as form" (p. xvii). To the "naive person," on the other hand, sculpture—whose task it was to materialize the three-dimensional object—was self-evident (p. xvii), and was accepted without question.

Here Einstein juxtaposed African sculpture, which performed the task of "giving," that is, materializing, the three-dimensional, with sculpture in western Europe. There were of course European attempts as well to do just this, but "they all were evasions" (p. xvii). Frontality or silhouette were not sufficient. They depended on a spectator, and thus carried a subjective element. They *suggested* "cubic nature" rather than actually materializing it (p. xviii). Ever since the Renaissance efforts were made to suppress the three-dimensional, or the "cubic," as he called it, using a term popular at the turn of the century.[26] European art offered either a mixture of sculp-

ture and painting, as in the Baroque, or was strongly permeated by "pictorial surrogates" of sculpture (p. ix). Rodin, who was still alive and very famous when Einstein wrote his first book, "makes efforts to dissolve the plastic." In thus disregarding the three-dimensional, European sculpture dissolved the work of art at an ever increasing pace and turned it into "a scale of psychological excitations" (p. x). In the western audience's attitude to sculpture, the three-dimensional was replaced by the artist's "personal handwriting."

As against this subjective "fall" from sculptural purity that characterized western statues, at least since the Renaissance, African sculpture revealed the true nature of the art. It should be noted that when Einstein spoke of Negro sculpture, he had a highly spiritualized art in mind. When the African sculptor shaped the figure of a god, he was not informed by "the almost totemistic feeling of the natural-born stone carver," as Michelangelo's attitude was described, but rather by the wish to visualize in his form the pure structure of abstract space. Einstein emphasized the distinction between cubic space and material mass. The African sculptor was not concerned with mass, he was only concerned with space. "We emphasize," said Einstein in *Negerplastik*, "sculpture is not a matter of naturalistic mass, but of formal clarification of space" (p. xx). The sculptor's task was to show the structure of space, mainly the dimension of depth, without allowing the object of representation or the naturalistic mass in which the statue was carved to become prominent and distract our attention from what was essential, namely, the structure of space. It is obvious, Einstein said, that the cubic must be grasped at once, but without the suggestion of objects, or by means of themes. One perceives the voices of cubism when one reads that "the parts placed in three dimensions must be represented simultaneously, that is, the diffused space must be integrated into one field of vision" (p. xviii).

Einstein did not tell us how the African sculptor managed to manifest the structure of space, but not the nature of the matter—wood or stone, ivory or bronze—in which his work was carved. It is interesting, in fact, that he never even mentioned texture, although some of the objects in his book were made of various materials. African masks, to take an obvious example, were often constructed out of substances of widely differing kinds.[27] Concentrating on the visual and tactile experience of the different materials, Einstein seems to have thought, would only distract the reader or viewer from what was essential in sculpture—cubic space.

While Einstein disregarded many concrete questions, the way the religious origin of the African statue and its artistic purpose of making spatial structure manifest to the eye hung together in Einstein's mind was clear: both were shaped by the almost metaphysical character of distance and abstraction. The figure was religious precisely because it was completely removed from our subjective grasp and emotional identification. The cubic space was also removed from direct sensual experience. African sculpture, in Carl Einstein's reading, was an embodiment of emotional and sensual abstraction.

Surveying Einstein's statement, the critical reader cannot help having many doubts. Why is it that distance as such indicates the religious origin of the work? And how do we know that it was the primeval urge of the African artist to manifest the structure of space rather than the weight, volume, and physical nature of the matter in which the statue was carved? Einstein did not answer these questions. But as I have said earlier, he was not an academic scholar. His views of African art, if not "correct" and exhaustive in "scientific" terms, have elements of projection; they reveal what those avant-garde artists and critics who were so impressed by the black idols and masks expected of that art, and what they saw in it. African art, they hoped and believed, was a kind of primordial revelation.

NOTES

1. See Paul Guillaume and Thomas Munro, *Primitive Negro Sculpture, with Illustrations from the Barnes Collection* (New York, 1926), p. 1.

2. I am following the much more detailed record of the story given by Goldwater, *Primitivism*, pp. 86 ff.

3. See Donald E. Gordon's contribution to the catalog of the New York exhibition. See *"Primitivism" in Twentieth-Century Art*, II, pp. 369 ff.

4. Goldwater, *Primitivism*, p. 127.

5. The quotation is from a letter Franz Marc wrote to August Macke. See Franz Marc and August Macke, *Briefwechsel* (Cologne, 1964), pp. 39–41 (the whole letter).

6. See August Macke, "Masks," in Klaus Lankheit, ed., *The Blaue Reiter Almanac* (New York, 1974), p. 88.

7. See Chipp, *Theories of Modern Art*, p. 177. Quotation from William S. Bradley, *The Art of Emil Nolde in the Context of North German Painting and Völkish Ideology* (Ann Arbor, Mich., 1981), p. 150.

8. For a history of the arrival of African art objects into different European countries, see especially the excellent survey by Jean-Louis Paudrat in the catalog *"Primitivism" in Twentieth-Century Art*, 1, pp. 125 ff.

9. See H. H. Freese, *Anthropology and the Public: The Role of the Museum* (Leiden, 1960).

10. For the museums, especially in France, see the still valuable section in Goldwater, *Primitivism*, pp. 1 ff., and the entry by Paudrat in *"Primitivism" in Twentieth-Century Art*. For the private collection put up for auction, see Paudrat, p. 129.

11. See Breuning, *Apollinaire on Art*, p. 244. The article originally appeared in *Paris Journal*, September 12, 1912.

12. See Felix von Luschan, *Die Altertumer von Benin* (Berlin and Leipzig, 1919). Luschan, one of the best scholars of the subject in his generation, composed the text in 1910; the publication was postponed until 1919.

13. G. A. Schweinfurth, *Artes Africanae* (Leipzig, 1875). The author expressed his general views mainly in the introduction.

14. See above, part 3, chapter 19.

15. See Maurice Delafosse, "Sur les traces probables de la civilization egyptienne et d'hommes de race blanche a la Côte d'Ivoire," *L'Anthropologie* XI (1900), pp. 431–51, 543–68, 677–90. Cf. Goldwater, *Primitivism*, p. 22.

16. Hein published several studies, articles, and books, that should be considered in the history of taste as well as of ethnology. See especially A. R. Hein, *Die bildenden Kunste bei den Dayaks in Borneo* (Vienna, 1890).

17. Breuning, *Apollinaire on Art*, p. 245.

18. Quoted from Goldwater, *Primitivism*, p. 87.

19. Breuning, *Apollinaire on Art*, p. 56.

20. Quoted from Paudrat's entry in *"Primitivism" in Twentieth-Century Art*, p. 141.

21. For the text of the letter, see André Derain, *Lettres à Vlaminck* (Paris, 1955), pp. 196 ff. Goldwater, *Primitivism*, p. 89, thinks the letter was written after 1910. For the earlier date (1906), see Jack D. Flam, "Matisse and the Fauves," in *"Primitivism" in Twentieth-Century Art*, pp. 211–39, especially p. 217.

22. See Wassily Kandinsky, *Der Blaue Reiter*, in Kenneth C. Lindsay and Peter Vergo, eds., *Kandinsky: Complete Writings on Art* (New York, 1994), pp. 229–85. See Goldwater, *Primitivism*, p. 127, and Gordon in *"Primitivism" in Twentieth-Century Art*, p. 375.

23. Marc and Macke, *Briefwechsel*, pp. 39 ff.

24. I use the second edition. See Carl Einstein, *Negerplastik* (Munich, 1920). This edition is, however, a precise reprint of the first one. References to this book will be given, in parentheses, in the text.

25. Whether or not this was indeed the case, Einstein did not discuss, nor even attempt to adduce evidence. As I have already indicated, he completely disregarded what anthropology had to say on the subject (and this was not very much). But

since his statement seems to have been accepted as a fact, at least in the first decade of the twentieth century, we need not discuss of it further.

26. For this term, see chapter 24 below, pp. 539–40.

27. In plate 101 of *Negerplastik* Einstein reproduced such a mask, with a wooden face, a hairy beard, and a hat in the shape of a small figure, probably done in a different kind of wood. Nowhere in the book did he name the materials in which the works reproduced were executed. In a later publication, *Afrikanische Plastik* (Berlin, n.d.), he mentioned some materials in the list of illustrations, but again did not consider them in the text.

Abstract Art

23

Abstract Art
Origins and Sources

"Abstract art" has become a household word in our time. Few terms are so frequently used, and occasionally misused, as the adjective "abstract" in the discourse about the visual arts. The wide popularity of the term, however, does not ensure that we are clear as to its original meaning. Criticism, both artistic and philosophical, while enriching the meanings attached to the concept, has also burdened it with a variety of conflicting connotations that have blurred whatever outlines and clear contours it may possess. To some of these discussions we shall have to return in the course of this part.

The contemporary student, trying to grasp the proper meaning of the term "abstract," will ask what it meant to the artists and critics who coined the concept. In the following brief comments I do not propose any new definition of abstract art, nor do I intend to defend any old interpretation of this notion. I shall only attempt to describe briefly what, in the first decade of the twentieth century, was meant and implied by the term, and what the ideas were that originally nourished the thought of the founders of the movement that eventually became so famous.

Whatever else the concept may tell us now, in the early decades of the twentieth century "abstract art" was perceived, first of all, as a profound, some would say a complete, break with the age-old tradition that art is primarily a representation of visible reality. In the parlance of modern criticism this tradition was sometimes called "the Tyranny of the Object." Later in the century, as the work of Kandinsky became accepted, almost canonical, and the wide audiences visiting museums and exhibitions supported and furthered this view, abstract art came to be seen as the final break with all pictorial traditions, a fateful and decisive turn in the historical development of art.

Now, such a profound and explicit break with tradition, a turn of such momentous consequence, naturally has many facets and belongs to many

"worlds"; it is an event not only within the well-defined limits of the visual arts, particularly of painting, but it is also an occurrence of great significance in the world of intellectual reflection. Moreover, as is the case with other turning points in the history of art, it cannot be explained merely, or even primarily, as the result of internal developments within the workshop. To understand it and its impact over several generations, we must examine the broader forces—intellectual, emotional, and other—that brought about such a dramatic turnabout. Just as we look for the intellectual reasons that made linear perspective necessary and possible in the early fifteenth century, for example, so we must look for the intellectual and emotional needs and urges that in the early twentieth century called for, and made possible, the shift from an art seeking to create a correct and convincing illusion of nature to an "abstract," nondepicting art. What was it that inspired the creators of the new art? What were the intellectual sources and conditions that made it possible for Kandinsky to attempt to separate art from the images of the world that surrounds us? In this section I shall attempt to discuss, necessarily only in outline, the intellectual and emotional factors that motivated Kandinsky's revolution, and the conditions and the spiritual orientations under which this revolution took place.

Several trends of thought formed the background to, contributed to, and made possible the revolutionary ideas of abstract painting in the first decade of the twentieth century. These trends and conditions were different in nature from each other, and they originated in different fields of experience and exploration. The convergence of these diverse traditions and conditions at the same time and in the same cultural environment shows how deeply the new views of painting that struck many critics as so unusual, were in fact rooted in the great intellectual movements of the time.

The Impact of Science

It is one of the characteristics of our age that science, in addition to the pursuit of knowledge and understanding in whatever field it studies, also plays a complex and many-sided role in society and general culture, and even helps shape the imagination of the time. To the scientist this role may be altogether marginal, yet for art and culture it may be of great significance. The impact of science on the visual arts is encountered and can be seen on two different levels. We can speak of a direct and an indirect impact of science on art.

In earlier chapters in this book we have had occasion to study instances of the more or less direct impact of the scientist on painting. Such direct contributions were made mainly by bringing to full awareness some specific aspect of sensual experience of direct concern to the artist, such as the analysis of our perception of light and color. Occasionally, scientists even concerned themselves with technical problems emerging from, and directly significant to, the artist's work. An illuminating example of such direct influence is Helmholtz's discussion of light and color in painting. We have tried in earlier chapters to show the link between this discussion and the emergence of impressionist painting, perhaps even its immediate impact on the process.[1] Anthropology and the scientific exploration of prehistoric cultures provided a direct model for the so-called "primitive" trends in art by bringing to light prehistoric artifacts and by discussing the aesthetic aspects of tribal art.[2] The analysis of the prehistoric and primitive imagination, though often vague, also contributed to developing the theoretical categories for the perception and discussion of art in "primitivist" trends of painting and sculpture at the turn of the century. The student will also recall the direct contribution that some schools of experimental psychology made in the late nineteenth century to the work and thought of the artists who later came to be known as "expressionists."[3] These examples demonstrate that scientific developments exerted a more or less direct influence on some major trends both in art and in the theoretical reflection on it.

In many ages a direct impact by science on art can be discerned.[4] Such "direct" influence did not consist, of course, in the scientist instructing the artist on how to proceed in as yet unsolved questions that arose in the process of his work, although interactions of this kind may have taken place in an early Renaissance workshop. In the modern world, especially in the late nineteenth and early twentieth centuries, direct influence consisted in scientists' raising problems, making discoveries, and presenting materials that artists could more or less immediately use in their work.

Notwithstanding the examples I have just quoted, the *direct* influence of science on art remained the exception rather than the rule. In any case, it was not the major type of interaction between the two domains. The *indirect* impact of science on art and art theory was no less significant. By shaping the conceptual and emotional orientations of a period, science necessarily also affects the arts. Whether or not the scientist wants it, what he does contributes to the general spiritual tone of an age or culture. The artist, being shaped by (and, in turn, also shaping) the comprehensive

spiritual atmosphere prevailing in a society or a period, is thus influenced by science, even if there is no direct link between them. It goes without saying that the artist or the critic do not necessarily have to understand correctly and fully what the scientists have to say in their own fields in order to be indirectly affected by their findings. A misunderstood truth or cognition may be as, and perhaps even more, effective than a discovery properly understood and appreciated. Sometimes painters and writers believe they have found in science confirmation of what they themselves feel, even if they thereby completely distort the "scientific truth" involved. Such an impact forms the background to Kandinsky's theory of abstract art. It is an important instance in the study of the indirect influence of science on art.

At the turn of the nineteenth and the beginning of the twentieth centuries, a scientific discovery of crucial importance also exerted a profound and far-reaching influence on the general culture. This was what came to be known as the "dissolution of the atom." Whatever this concept may mean in scientific terms, in the imagination and general culture of the first years of the twentieth century it acquired an almost apocalyptic aura. To wide audiences, naturally also including many artists, this "dissolution" was understood as the disintegration of the solid material world. It was all the more shattering as scientists themselves "admitted" that this was what it meant. In the mental constitution and intellectual world of many nonscientists, disintegration called for a turn toward the spiritual. Kandinsky himself described concisely and evocatively what the "dissolution of the atom" could have meant to people who were far removed from the world of scientists. In *Rückblicke* (Reminiscences), written in June 1913, he traced the process by which his theory of abstract art crystallized. Naturally, he encountered many difficulties in the endeavor. But, he said,

> A scientific event removed one of the most important obstacles from my path. This was the further division of the atom. The collapse of the atom was equated, in my soul, with the collapse of the whole world. Suddenly, the stoutest walls crumbled. Everything became uncertain, precarious and insubstantial. I would not have been surprised had a stone dissolved into thin air before my eyes and become invisible. Science seemed destroyed; its most important basis was only an illusion, an error of the learned, who were not building their divine edifice stone by stone with steady hands, by transfigured light, but were groping at random for truth in the darkness and blindly mistaking one object for another.[5]

This passage has provoked some debate. While some critics regard it as testimony to Kandinsky's concern for science, to others it betrays a profound incomprehension, even ignorance, of matters scientific.[6] Now, the scientist may smile at Kandinsky's understanding, or rather lack of understanding, of what the "dissolution of the atom" really means. But even if his interpretation was completely mistaken, for the artist, who was then in the process of creating a new theory of painting, it was of crucial significance.

Like other artists and the public in general, Kandinsky was raised in the belief that art imitates material reality. Art's very claim to "correctness," advanced since the Renaissance, was based on the belief that material reality is thoroughly solid, measurable, and tangible. Once again, a modern philosopher may smile at the primitive nature of such popular notions, yet they were the essential foundation for certain developments and transformations in general culture, and particularly in the accepted doctrines of the visual arts. The dissolution of the atom shook the public's firm belief in the solidity of the material world, and this uncertainty about matter was reflected in reasoning about art. What point was there in rendering material reality if matter itself turned out to be a mere illusion? In Kandinsky's *On the Spiritual in Art*, written in 1911, we find distinct traces of the shock that the "dissolution of the atom" caused the painter, and his reflections upon the significance of this new scientific development for the theory of art. Speaking of the work that "boldly shakes the pinnacles that men have set up," he said:

> Here, too, we find professional intellectuals who examine matter over and over again and finally cast doubt upon matter itself, which yesterday was the basis of everything, and upon which the whole universe was supported. The electron theory—i.e., the theory of moving electricity, which is supposed completely to replace matter, has found lately many keen proponents, who from time to time overreach the limits of caution and perish in the conquest of this new stronghold of science.... (p. 142)

Later in the same work he reflected upon the pace of scientific development. Here, too, we perceive his emotional shock in realizing that matter dissolves into thin air. We also see the inference he made from scientific development to pure art:

> If, however, we consider that the spiritual revolution has taken on a new, fiery tempo, that even the most "established" basis of man's intellectual life, i.e., positivistic science, is being dragged along with it and stands on the thresh-

old of the dissolution of matter, then we can maintain that only a few "hours" separate us from this pure composition. (p. 197)

In the first decade of the twentieth century, then, what was called the "dissolution of the atom" had a profound effect on the artist's mood and imagination, and on the interpretation of art in general. Kandinsky was particularly affected by the unexpected realization that matter is not solid. The effect of this shock was compounded by the fact that scientists themselves, considered guardians of the unshakable stability of truth in the nineteenth century, accepted and even confirmed this seeming collapse of all tangible reality. Nonscientists, artists among them, read into this collapse a kind of hidden encoded message. But what was this message? What specifically was being conveyed? In the nonscientific culture of the early twentieth century, a great deal of intellectual confusion resulted from the discovery of radiation. Looking back at the intellectual and emotional reaction to the new and unexpected insights into the structure of the physical world from the distance of almost a century, the historian can distinguish two main threads that are significant in our context.

One type of reaction was a sense of apocalyptic doom. This was an essential component in the impact of science on the general culture of the time. Of course, artists were not the only ones to whom the new scientific insights announced an "end of the world." Christian apologists, spiritists, and sectarians of different shades focused on what the scientists had themselves "admitted." Such apocalyptic gloom constituted the general emotional background against which different spiritual movements emerged. It should also be kept in mind in any attempt to understand the revolution in the thinking about art.

Another type of reaction that did not exclude the general sense of apocalyptic anxiety, was more distinct and specific. The breakdown of solid material reality, readily admitted by scientists, announced to some people and groups that true reality was spiritual in nature, and that "matter" was only an external shell. Various kinds of occult groups interpreted the new scientific developments as a positive reflection on the "true" spiritual reality. These movements, though not *directly* linked to the emotional impact of recent scientific discoveries, flourished in the general atmosphere of crisis. One of these occult trends, "theosophy," was of direct concern to Kandinsky. The founders of abstract painting, Wassily Kandinsky and Piet Mondrian, were also directly concerned with it. Suffice it to say here that the "spiritual" interpretation of reality as a result of the "dissolution of the

atom" attracted various audiences. Kandinsky himself seems to have preserved a book review that appeared in a newspaper in April 1908. A passage of this review reads:

> It is something of an irony that it is precisely the sciences that have significantly contributed to make people believe in things hidden in heaven and earth, that in the meantime, and perhaps forever, scoff at the wisdom of the schools. Have not they [the representatives of the wisdom of the schools] shown to us that we are surrounded, on all sides, by secret, powerful forces that seem outright fantastic? In the end, where does the limit between nature and spirit lie?[7]

Kandinsky's new gospel of abstract art was a direct descendant of such writings.

Occult Doctrines

The desire to uncover the concealed layers of spiritual reality, to make manifest what is hidden behind the material world surrounding us, might have remained a vague and perhaps transient mood, and not have crystallized in art theory, had it not been for the impact of a particular and unusual cultural tradition in the modern world. This was the strange yet widespread phenomenon which goes by the name of "occultism." The occult movements that spread in western Europe during the second half of the nineteenth and the first decade of the twentieth centuries were an essential component in the emergence and articulation of the doctrine of abstract art. We cannot understand how the theory of abstract art came into being if we do not acquaint ourselves with the teachings of various occult groups that arose at this time. We shall therefore comment briefly on the occult movements in modern Europe and their teachings, before we return to the artists' attempt to create a doctrine of spiritual painting.

Occultism, that is, the belief in and study of those hidden forces in nature and in the cosmos that supposedly cannot be reached by regular human reason and particularly by science, is of course an age-old phenomenon. In one form or another, it may be found in practically every period and culture. It is thus fair to say that occultism is embedded in the intellectual and emotional texture of all societies. In the modern world, however, it stands out more markedly because it is in such obvious contrast to rationalism and the rule of science, which are the dominant cultural trends

of the period. Even though modern occultism may occasionally adopt a semiscientific terminology, in essence it is antiscientific and antirational. Dissatisfaction with the modern world and with its typical intellectual representative, science has often led to the emergence and diffusion of occult movements and beliefs.[8]

In the decades we are here concerned with, and in the areas of technical development in western Europe and the United States, there were mainly two major movements of modern occultism that demand our attention. They are those of the Theosophical Society and the Anthroposophical Society. The Theosophical Society was founded in 1875 in New York by a Russian lady, Madame Helena Petrovna Blavatsky, and the American Colonel Henry Steele Olcott. The doctrine of this movement was first formulated by Madame Blavatsky in her book *Isis Unveiled*, that appeared in New York in 1877. Madame Blavatsky continued and completed her theosophical doctrine in another work, *The Secret Doctrine*, published in New York in 1888. Though Madame Blavatsky later moved the headquarters of the Theosophical Society to India (and based her occult doctrine on supposedly Indian sources), the movement remained important in modern western culture.

The German wing of the movement, led by Rudolf Steiner, a philosopher and editor of Goethe's scientific writings in an important series (the *Deutsche National-Literatur*), broke away from the Theosophical Society in 1907. It was established and became widely known in central Europe as the Anthroposophical Society. Steiner was a very prolific author; his published work is voluminous. Of particular significance for our purpose were his books *Luzifer-Gnosis: Grundlegende Aufsatze* (Lucifer-Gnosis: Basic Studies), published in Berlin in 1908; *Theosophie: Einführung in die übersinnliche Welterkenntnis und Menschenbestimmung* (Theosophy: An Introduction to the Supersensual Knowledge of the World and the Destination of Man), published in Leipzig in 1908; and *Wie erlangt man die Erkenntnis der höheren Welten?* (How Does One Acquire the Knowledge of Higher Worlds?) published in Berlin in 1905.

The contemporary student may find it difficult to understand how creative artists in different fields, artists who have shaped the imagery and the aesthetic core of our modern age, could have joined these movements and believed in their teachings. There is no doubt, however, that these movements did indeed attract artists in many fields. Composers such as Alexander Scriabin and Igor Stravinsky were profoundly impressed by the Theosophical Society, and Arnold Schönberg is said to have drawn on Rudolf

Steiner's mystery plays in his *Jakobsleiter*. Piet Mondrian was for twenty years under the spell of the theosophic movement, and for more than a decade he was formally a member of the Theosophical Society.[9] Kandinsky, with whom we are mainly concerned here, wrote in his manifesto of abstract art, *On the Spiritual in Art*:

> This was the starting point of one of the greatest spiritual movements, which today unites a large number of people and has even given material form to this spiritual union through the Theosophical Society. This society consists of brotherhoods of those who attempt to approach more closely the problems of the spirit by the path of *inner* consciousness. Their methods, which are the complete opposite of those of the positivists, take their starting point from tradition and are given relatively precise form. (pp. 143–45)

In a note to the last sentence, Kandinsky explicitly referred to Steiner's work, especially the *Lucifer-Gnosis* essays (note to p. 145).

What seems to have appealed most to these artists was the message that true reality is spiritual, and that in our search for truth we have to go beyond the solid, tangible objects that has thus far seemed to encompass all of reality. The preachers of the sermon of the occult were also influenced by the intellectual crisis that in many minds was linked with the "dissolution of the atom." There was a clear link between the seeming disintegration of matter and occult leanings toward spiritualism. Rudolf Steiner proclaimed in a lecture delivered in 1907, with which Kandinsky was familiar, that the atom is "frozen electricity, frozen heat, frozen light."[10] Regardless of its naive image of reality, this was a proclamation that carried mystical connotations. The emotional message, understood even when not fully articulated in words, was that the hard shell of "matter" had now been pierced. What had been considered "hard" matter had turned out to be spirit. Everything we encounter in experience, theosophy and anthroposophy taught, should be understood as condensed spirit. In his lecture Steiner continued: "Matter relates to spirit as water relates to ice. If you dissolve ice, it becomes water. If you dissolve matter, it disappears as matter and becomes spirit. Everything that is matter is in fact spirit, it is the external appearance of the spirit." According to the occult movements, when we reach an appropriate level of insight we can see that the material world, seemingly so solid, is only an appearance of spiritual reality.

There were two reasons why occultism and the various esoteric doctrines were so appealing to the mind and culture of the fin-de-siècle. One of them, the doctrine of hidden spirituality, we have already briefly out-

lined. The other was altogether different. The occult movements that made such a deep and perhaps disturbing impression upon various circles, including artists, did not intend to confine themselves to theoretical doctrines. They meant to achieve some "practical results." It comes as no surprise that the question of how these results could be achieved played an increasingly dominant role in the thought of both theosophy and anthroposophy. A title such as *How Does One Acquire the Knowledge of Higher Worlds* was characteristic of their publications, and of the trend of thought that governed them. To understand the main direction of their thought we have to see how they believed they could achieve their ends. And this in turn was inextricably interwoven with their views on the cosmos and on man.

Man, Rudolf Steiner taught, is a citizen of three worlds; the physical, the psychic, and the spiritual. Through his body, he partakes of the physical world, a world he knows by means of his senses, and shares with other beings. Through his soul, he creates a world of his own, an individual, unique world that he juxtaposes with external reality. Through the spirit, man partakes of a supernatural reality, and it is in the spirit that a world superior to both others reveals itself to him.

For the painters and critics who became the founders of the doctrine of abstract painting the distinction between soul and spirit, the psychic and the spiritual, was of particular importance. In trying to understand what the occult movements had to offer these artists we have to keep this division in mind. The distinction between body and soul, between the material and the nonmaterial, understood as that which pertains to our soul, was of course accepted wisdom in all ages. In the modern period it also came increasingly to be identified with the distinction between, or the juxtaposition of, the objective and the subjective. But the division between soul and spirit preached by the esoteric doctrines was not common. Later in this part we shall ask why such a division between soul and spirit, between the psychic and something that was neither material nor "subjective," was so attractive to the artists and theoreticians of abstract painting. Here we shall only say that the occult movements emphasized it. Madame Blavatsky devoted a special chapter to "The distinction between soul and spirit."[11]

Steiner also stressed that the spiritual was not simply the "subjective," to use a common concept. It was not an aspect of personal human experience (*Erlebnis*), differing from person to person. The psychological was individual, shaped by the uniqueness of each person, and necessarily changed and modified by every single individual "experience." The spiritual, on the other

hand, was an "objective," superindividual reality. It did not change from person to person, nor was it subject to individual modification. Its structure, whatever it may be, was not transformed by one's experience. To emphasize this difference between the emotional experience that was the subject matter of psychology, and the spiritual being that the theosophic movements wanted to reach, Steiner spoke metaphorically of the "spiritual or aethereal body." "By 'body'," he said, "we designate what gives to a being of any kind 'shape' (*Gestalt*) and 'form.' By no means should it be confounded with the physical body."[12] The world of the spirit, then, was a supernatural, yet firmly structured, reality.

As I have noted before, the occult movements had "practical" goals. The major one they had in mind was knowledge of the spiritual. How can one perceive and apprehend spiritual reality? This was a crucial question for theosophists and anthroposophists. The teachers of the occult did not aim only at knowledge; they were not content with merely offering an intellectual doctrine; they wished to provide for their disciples, and for humanity at large, a "path" to the secret world of the spiritual. Despite the importance to them of this end, however, their means to achieving it remained vague. Neither theosophists nor anthroposophists explicitly taught any specific technique for reaching the yearned-for knowledge (such as yoga). Their writings do not propose any specific means to achieve the secret knowledge. But one way does emerge clearly from these writings: introspection. It is within ourselves that the secret knowledge is hidden, and it is from the depth of our beings that we have to bring it to light. An articulate concept of man forms the foundation for this method.

The question of how the secret knowledge was to be gained had a particular appeal for those artists who were so deeply impressed by the vision of the teachers of the occult. It was especially significant to them that both Madame Blavatsky and Rudolf Steiner described the cognition of the spiritual world mainly in visual metaphors, in terms of visual perception and experience. To *see* the spiritual, said Steiner, "one needs the awakened *spiritual eye*. Without it, one can for reasons of logic assume its existence; *seeing* it one can only with the spiritual eye, as one sees a color with one's physical eye."[13]

The transition from these ideas to an abstract art seemed easy. In his *Reminiscences* Kandinsky wrote:

I believe the philosophy of the future, apart from the existence of phenomena, will also study their spirit with particular attention. Then the atmos-

phere will be created that will enable mankind in general to feel the spirit of things, to experience this spirit, even if wholly unconsciously, just as people in general today still experience the external aspect of phenomena unconsciously, which explains the public's delight in representational art. Then, however, it will be necessary for man initially to experience the spiritual in material phenomena, in order subsequently to be able to experience the spiritual in abstract phenomena. And through this new capacity, conceived under the sign of the "spirit," an enjoyment of abstract [=absolute] art will come about.

My book On the Spiritual in Art and the Blaue Reiter [Almanac], too, had as their principal aim to awaken this capacity for experiencing the spiritual in material and in abstract phenomena, which will be indispensable in the future, making unlimited kinds of experiences possible. My desire to conjure up in people who still did not possess it this rewarding talent was the main purpose of both publications. (pp. 380–81)

We can summarize. First of all, it is obvious that the artists who were to become the founders of abstract art, mainly Kandinsky, were profoundly impressed by the occult movements. Theosophy was a significant factor in their intellectual world. Furthermore, what these artists found in theosophy and anthroposophy corresponded to their own specific questions.

Religious Heritage

In surveying the major intellectual and emotional sources that have shaped the theory of abstract art, we have so far called to mind processes and movements that were essentially "modern." They also had an orientation toward the doctrinal. We no not need to be reminded that the "dissolution of the atom"—both its discovery in physics and the shocked reaction of the general public at the time—was part and parcel of the modern world. Since the first announcements of the discovery of radiation (around the turn of the century) down to our own day the dissolution of the atom and its fateful effects on history have been focal points of our lives. But the occult movements we have briefly discussed, theosophy and anthroposophy, are also characteristic of what we call "the Modern." Not only do they belong to the modern age for simple chronological reasons; in their conceptual attitude they are also rooted in a world that came after the period in which traditional religion dominated spiritual life. The authority of traditional religion has become a hallmark of what is called "the past." On the contrary,

the theory of abstract art, influenced by such different sources—a scientific discovery and an occult doctrine—is firmly rooted in the very center of the modern world. However, other sources of a different nature also influenced and helped shape the character of abstract art. Once again it is primarily Kandinsky's writings that help us see these other sources clearly.

In the years in which the theory of abstract art took shape, Kandinsky was concerned with the position of the art he envisaged, "nonobjective painting," within the whole framework of the history of art, mainly its relationship to the art of the past. In his *Reminiscences*, written, we recall, in 1913, only two years after *On the Spiritual in Art*, he offered clear testimony to this concern. He was, of course, well aware of the revolutionary nature of nonobjective art, but he did not want it to be understood as a denial or destruction of traditional art. He did not participate in the rhetoric of total alienation from tradition that was widespread in avant-garde circles.[14] ". . . I have come to conceive of nonobjective painting not as a negation of all previous art, but as an uncommonly vital, primordial division of the one old trunk into two main branches of development, indispensable to the creation of the crown of the green tree" (p. 378). Employing the terms "new" versus "old" art, he said: "I have always been put out by assertions that I intended to overthrow the old [tradition of] painting" (p. 379).

The dialectical relationship of new and old art occupied his mind. The development of art (and here, Kandinsky said, it resembles religion)

> consists in moments of sudden illumination, resembling a flash of lightning, of explosions that burst in the sky like fireworks, scattering a whole "bouquet" of different-colored stars around them. This illumination reveals with blinding clarity new perspectives, new truths that are in essence nothing other than the organic development, the continuing organic growth of earlier wisdom, which is not cancelled out by the latter, but remains living and productive as truth and as wisdom. The new branch does not render the tree trunk superfluous: the trunk determines the possibility of the branch. (pp. 377–78)

It is significant that, in order to explain the complex connection between old and new art, Kandinsky turned to the religious heritage for a model of such a dialectical relationship. His heritage offered him a model; the ambivalent relationship between the Old and New Testaments is a central motif in Christian theology. This particular problem has occupied people's minds in all stages of Christian theology. It can be formulated simply: while the Christian message overcomes the message of Judaism, and the New Tes-

tament prevails over the Old, the new (Christian) message and gospel are also based on the old (Jewish) faith, and show that what was hidden in it is a prefiguration of the new. To use a formulation that has become famous in the course of centuries: the New Testament reveals what the Old Testament concealed. Kandinsky used this theme of traditional theology to clarify his own position regarding the artistic heritage of the past. In connection with the new nonrepresentational painting he said: "Christ, in his own words, came not to overthrow the old law. When he said, 'It was said unto you . . . and I say unto you,' he transformed the old material law into his own spiritual law" (p. 378) It was in light of this sublime model that Kandinsky explicitly saw the attitude of the new art, of which he was one of the founders, to the art of past ages.

We are used to seeing abstract art as part of the modern secular world, and at first sight the religious associations made by Kandinsky may seem rather strange. Yet the fact that Kandinsky, the founder of abstract art and also the originator of its theory, should have had recourse to theological imagery is not as surprising as it may seem. Kandinsky was familiar with Christian lore, and probably also with theological thought, both from personal experience and from the search for sources of artistic inspiration. In his youth (in 1889) he took part in an anthropological expedition to the province of Vologda in Russia in order to study pagan remains in the law and religion of the peasants. This experience, which he recalled in *Reminiscences*, must have called his attention to problems of religion. In his writings, particularly in *On the Spiritual in Art*, there were frequent references to the Bible and to theological thought.[15] We also know that he was profoundly impressed by, and attracted to, the painting of Russian icons, particularly at the time when nonobjective art emerged.[16]

We are not concerned with the fact that the heritage of religion provided Kandinsky with some metaphors and well-known models of comparison. We ask whether, and to what extent, this heritage carried a message of substance for the nature of his art and art theory. "Art in many respects resembles religion," wrote Kandinsky in *Reminiscences* (p. 377), repeating a traditional view. But when he emphasized the resemblance of art and religion, he did not do so for the sake of comparison. To him the similarity of these two major and complex phenomena suggested that by their very nature they had some essential common element. It seems to me that what he found in religion was of crucial importance for his views on art mainly in two respects. First of all, religion carried the message that a spiritual reality does indeed exist. This spiritual reality is neither fully identical with the re-

ality of material objects and bodies, nor fully exhausted in psychological experience. Second, and closely related to the certainty that a spiritual reality exists, religion, particularly the Christian creed with which he was so familiar, told him that the spiritual would be revealed on earth, and would eventually govern the world.

It was easy for Kandinsky to take the Christian prediction of redemption as a model for placing abstract painting in the overall framework of the history of art. Christ's second coming, the eventual redemption, would be the final empowerment of the spiritual in the world. In art, Kandinsky believed, the twentieth-century period was on the "threshold of the 'third' revelation" (p. 378). In Christian belief the third revelation is the final redemption. The first revelation was that given to Moses, the second was Christ's appearance on earth and crucifixion, the third would be the final revelation that would end history. Abstract art was comparable to the third revelation because it was a purely spiritual art.

We conclude this brief interpretation by saying that the Christian religious heritage was one of the significant components in the intellectual makeup of the founders of abstract painting. What these religious images and memories showed in addition was that abstract painting carried a psychic urgency that could be compared only to the religious message.

NOTES

1. See above, part 1, chapter 4.
2. See above, part 3, chapter 19.
3. See part 1, chapter 11.
4. For a survey of the subject, see Martin Kemp, *The Science of Art: Optical Themes in Western Art from Brunelleschi to Seurat* (New Haven and London, 1990). The author concentrates, however, on the physical sciences, mainly optics. As far as I know, we have no comparable survey for the impact of the social sciences (anthropology and psychology) on the reflection of art.
5. *Reminiscences* was published in the album *Kandinsky, 1901–1913* (Berlin, 1913). I use the English translation by Lindsay and Vergo in *Kandinsky: Complete Writings on Art*, p. 364. Further quotations from Kandinsky will refer to this translation; page references will be given, in parenthesis, in the text.
6. For a concise but good survey of the debate, see Sixten Ringbom, *The Sounding Cosmos: A Study in the Spiritualism of Kandinsky and the Genesis of Abstract Painting* (Acta Academiae Aboensis, Ser. A. vol. 38, nr. 2) (Abo, 1970), pp. 33 ff.
7. Quoted by Ringbom, *The Sounding Cosmos*, p. 36. My translation is from the German.

8. For an introduction to the problems of modern occultism, with an essential bibliography, see Mircea Eliade, "The Occult and the Modern World" reprinted in his *Occultism, Witchcraft, and Cultural Fashions: Essays in Comparative Religions* (Chicago, 1976), pp. 47–68.

9. For documentation, see Ringbom, *The Sounding Cosmos*, pp. 58 ff, 91, note 49.

10. Rudolf Steiner, *Die Erkenntnis der Seele und des Geistes*, published only in 1965, p. 59. See Ringbom, *The Sounding Cosmos*, p. 224.

11. H. P. Blavatsky, *The Key to Theosophy: A Clear Exposition, in the Form of Question and Answer, of the Ethics, Science, and Philosophy* (London, 1889; New York, 1893; reprinted Los Angeles, 1962), pp. 93–96.

12. Rudolf Steiner, *Theosophie: Einführung in die übersinnliche Welterkenntnis und Menschenbestimmung* (Stuttgart, 1922), p. 23. This is the twentieth edition of this work; it originally appeared in 1906. Translation by the present author.

13. Steiner, *Theosophie*, p. 23.

14. For a discussion of the overall rejection of tradition, see Renato Poggioli, *The Theory of the Avant-Garde* (Cambridge, Mass., and London, 1968), passim, esp. p. 127.

15. See pp. 130 (reference to Christ's parable of the talents) and 133 (reference to the "biblical 'days' of creation"). He also quoted N. Kondakov, *Histoire de l'art byzantin considéré principalement dans les miniatures* (Paris, 1886–91), a work that repeatedly took up theological matters in connection with art.

16. Max Bill, *Kandinsky* (Paris, 1951), p. 117.

24

The Subject Matter
of Abstract Painting

Having briefly outlined some of the major sources that nourished abstract painting and shaped the direction of its development, we can now turn to the actual theory behind it. Here again Kandinsky offers the student the major clues in his search, and provides some of the answers to the questions that arise. In turning to the theory of abstract painting, our first question is obvious: what is its subject matter? What does the painting that has no "object" (*Gegenstand*) represent? To what did the term "abstract" apply in the minds of the founders of abstract painting? Or quite simply: what did they mean when they spoke about "abstract" painting?

These questions are commonly asked. Listening to spectators at exhibitions of abstract art and in museums displaying works of this school, one often hears: what does this picture really represent? Frequently the tone of the question is one of bewilderment and confusion. Rather than discuss abstract painting in general, my aim here is more modest, namely, to understand how the founders of abstract painting formulated the doctrine of their movement. To a critical reader, some of the theses so ardently defended by the painters in their books explaining the aims of their work seem to contain profound logical contradictions. However, what interests us in the original theory of abstract painting is not so much its consistency as a philosophical statement or as a doctrine of aesthetics; rather, we value it for what it can tell us about the problems that concerned the founders of abstract painting and the direction of their thought. In such a context, even the contradictions may be indicative and revealing.

For decades the view has been widely accepted that so-called "abstract painting" aims primarily—some would say, exclusively— at creating about an aesthetic experience. Many admirers see it as "pure art." They understand such art as a creation that is fully exhausted in mere sensual experience. According to the artists and critics who hold to this view, the ques-

tion: what does the picture represent? should not be asked at all. Whatever a work of art may represent, it is an "object" that belongs to the world outside the picture, that is located beyond "art." Thus in saying that the abstract picture does not represent anything, they mean that it does not *refer* to anything beyond what one sees. In other words, the painting is a fully self-contained world, conceived as an end in itself. Such views have not only gained acceptance with wide audiences, but in one way or another they have also crept into the interpretations of students and critics. They are common, as I have said, in the latter part of the twentieth century. Were they also held around 1910? First, what were the views of the founders of "abstract painting" on this crucial issue?

From the very early stages of abstract painting and the formulation of its doctrine, the concept of abstraction in art was a matter of differing interpretation. It would be an exaggeration to say that there was a debate between the different interpretations of the concept of "abstraction" around 1910. At this stage, the conceptual attitudes of the artists who eventually became known as the founders of a major school in twentieth-century art, and of other interpreters of the trend, were too fuzzy, and sometimes even confused, for a real debate to be feasible. Yet looking back from the distance of close to a century we discern two main tendencies in the interpretation of what we now in a sort of shorthand call the "abstractness" of abstract art, that were present from the very beginnings of the movement. In the following comments we shall have to emphasize the differences between these two tendencies. We should keep in mind, however, that around 1910 these differences were not clearly articulated and therefore did not stand out as distinctly as they now do. It was later developments that shed light on these early formulations.

Although in the first two decades of the twentieth century the concepts pertinent to our discussion and the terms employed in discussing them were not yet distinctly formulated and their meaning was still fluid, close study of what was said and written at this early stage illustrates that the major problems, as well as the principal attitudes to them, appeared in fairly plain outline. Let us examine an article by Guillaume Apollinaire, published on February 1, 1912. Under the title "On the Subject in Modern Painting," Apollinaire wrote that "The new painters paint works that do not have a real subject, and from now on, the titles in catalogues will be like names that identify a man without describing him." Apollinaire was speaking of "nonobjective" painting, though the pictures had not yet fully achieved the degree of abstraction with which we are now familiar. But the

elimination of the represented object was not the only characteristic Apollinaire described. He also emphasized the "austere" character of the new art ("Today's art is austere . . .") and the far-reaching consequences of this austerity: "If the aim of painting has remained what it always was—namely, to give pleasure to the eye—the works of the new painters require the viewer to find in them a different kind of pleasure from the one he can just as easily find in the spectacle of nature."[1]

To a contemporary reader this article may be an inadequate description of an abstract art that is not mainly directed toward giving aesthetic pleasure. It is clear, however, that in addition to eliminating the "subject matter" in the traditional sense of this term, Apollinaire also rejected mere aesthetic pleasure as the purpose of art. Other artists and critics also formulated the "aesthetic" or "decorative" interpretation of abstractness. Kandinsky, for instance, was aware of the possibility that abstract painting might be seen as serving a merely aesthetic end. He dreaded such an interpretation, rejecting it as "a meaningless playing with forms" (p. 171).[2]

The discontent with mere aesthetic pleasure as the major end of art reinforced the significance of subject matter in painting. However the subject matter of a picture may be understood, the spectator dissatisfied with mere formal qualities will necessarily turn to the contents, to what it says. It is this dialectical interlocking of the rejection of an "object""to be represented, on the one hand, and the demand for contents and meaning, on the other, that is essential to the doctrine of abstract painting.

Kandinsky totally rejected a purely formalistic, aesthetic approach to art. At the beginning of *On the Spiritual in Art,* where he presented his reasons for abstract painting, we read:

> Art, which at such times leads a degraded life, is used exclusively for materialistic ends. It seeks in *hard material* the stuff of which it is made, for it knows no finer. Thus, objects whose portrayal it regards as its only purpose, remain the same, unchanged. The question "What?" in art disappears eo ipso. Only the question "How?"—How will the artist succeed in recapturing that same material object?—remains. This question becomes the artist's "credo." Art is without a soul. (p. 135)

One of the points Kandinsky made here has become popular and is commonly accepted, namely, his criticism of the view that art's main purpose is the representation of material objects that can be experienced in "nature." We shall shortly come back to this point. His other argument, however, seems to have been lost in many more recent readings. It is an im-

portant issue. The content of the painting was so important in Kandinsky's eyes that renouncing it could imperil the very value of art. Art without subject, without what he called "What?" was to him an "art without a soul." Subject matter in art, the contents or the "object" represented (whatever that may be), was not dead freight; it could not be discarded without far-reaching consequences; it was an essential component of true art and played a unique and central role in the very concept of art. "This 'What?' is that content which only art can contain, and to which only art can give clear expression through the means available to it" (p. 138). Without further assessing of the implications of Kandinsky's statement, we can say that this statement amounts to an explicit and complete rejection of a formalistic approach to art and to a painting whose purpose is merely aesthetic.

Moreover, Kandinsky saw the reason for the public's indifference to art in the very fact that artists concentrated on matters of form. Art, moving "forward on the path of 'How?' . . . becomes specialized, comprehensible only to artists." It was in this concentration on matters of form, on what Kandinsky called the "How?" that he saw the ultimate reason for the public's indifference to art. It is obvious that, like other thinkers of abstract painting, he saw the central function of art as conveying something (we necessarily say: some content) to the spectator. It is true that "[t]he spectator," to quote Kandinsky, "turns tranquilly away from the artist who cannot see the purpose of his life in a purposeless art, but has higher aims before him" (p. 131). But this purposeless art, though aesthetic, "conceals no future potentialities, . . . [it] is a castrated art." Kandinsky's disappointment with aestheticism was the foundation of his demand that the artist be "not only an echo, a mirror" of his period, but have "an awakening *prophetic power*." He likened connoisseurs who admired the mere ability of representation, or "technique," as he called it, to those who admired tightrope walking (p. 130). The artist endowed with prophetic power would necessarily turn away from merely playing with form, and turn toward the content which art could express and which the abstract painting should convey. "The artist must have something to say, for his task is not the mastery of form, but the suitability of that form to its content" (p. 213).

What, then, was the "content" of the new art? What precisely was the subject of abstract painting? An essential motif in the doctrine of abstract painting was the division between two types of content, between two categories of subject matter. One was the "natural object," or "nature." For centuries painting had aimed at representing the material reality surrounding us. This kind of subject matter consisted of tangible bodies and "hard ob-

jects," and its importance, of course, persisted to Kandinsky's own day. "Painting today," he said, "is still almost entirely dependent upon natural forms, upon forms borrowed from nature" (p. 155). "Abstraction," the rejection of the "object" in painting, was the rejection of *this kind* of subject matter. It was the task of abstract painting, we read in different versions, to liberate art from this type of subject matter, which Kandinsky called "materialistic." An art that was "nonobjective" sought to extricate itself from "materialistic" objects.

There was, however, another type of content, a different kind of subject matter, one that is difficult to grasp in a single term or to define in simple words. It was, Kandinsky said, "veiled in darkness" (p. 131), it was part of an "inner nature" (p. 153). Language and its means of naming, describing, and defining, failed to help us grasp it. It belonged to a level of reality that not everybody could directly experience, and that occasionally eluded even the select few. It was a hidden reality the very experience of which required insight and intellectual and psychic effort. Since it was "veiled" "inner nature" it was not familiar to us to the same degree that the regular physical reality around us was. Yet this did not make it any less of an "object," or any less the "content" of a work of art, than a representation of material reality.

Belief in this hidden reality was a crucial assumption underlying the reflections that eventually became the theory of abstract painting. It is no exaggeration to say that the whole theory of abstract painting as it emerged in the early twentieth century was based on the thesis that there *is* such a reality, and that it can serve as subject matter of works of art. The difficulty in experiencing it, we should repeat, did not cast any doubt on its very existence.

The significance of the belief in a purely spiritual subject matter (that was nevertheless not a matter of "feelings" or impressions), as well as the difficulties of perceiving it, is also apparent in the thought of Piet Mondrian, another painter of the same period. His criticism of cubism, though published and to some extent also formulated at a somewhat later stage, in the early twenties of the century, originated in the same period in which Kandinsky's theory was formed. Cubism represents, of course, a crucial step in the liberation of art from a dependence on material objects of depiction. But cubism, said Mondrian, did not follow its own discoveries through to their final conclusion. It did not carry abstraction "to its ultimate end, the expression of pure reality."[3] What was it that prevented cubism from arriving at that ultimate conclusion? First of all, it was of course a lingering attachment to the natural object. "In nature," he de-

clared, "all relationships are veiled by matter." As long as artistic creation employed specific "forms," it could not reveal pure relationships. For this reason Mondrian demanded that the new creation be free from any link to specific forms (p. 100). What he was looking for were "universals," elements that by their very nature were opposed to the unique, particular, and specific.

But Mondrian did not have any emotional conditions in mind. No less important than the liberation from material objects, bodies, and forms found in nature was the artist's freedom from emotions and psychic experiences. These experiences and emotional conditions had been at the heart of expressionism, the art that drew from and was based on the theory of empathy. In Mondrian's view, however, the representation of "pure reality" could be achieved only if the artist abandoned "subjective feeling and imagining" altogether. For a long time, he said, he had tried "to discover those particularities of form and natural color that evoke subjective conditions of mood and that tarnish pure reality." "Pure reality," then, was free from both natural form and emotional experience.

Liberation from the natural object and the emotional condition, however, did not mean that the subject matter of art lost anything of its severe "objectivity." Both Mondrian (p. 101) and Kandinsky stressed that the "pure shaping" (*reine Gestaltung*) which they saw as art's ultimate goal was not mere "decoration." By "decoration" they meant a free, arbitrary play with forms, and the experimental combination and recombination of shapes and shades. The ultimate purpose of these experiments was to please the spectator's eye. Decoration could not be true art precisely because of its arbitrariness. Decoration was fortuitous and lacking in the insuperable constraints that imposed a certain order on the artist.[4] The representation of pure reality could not be decoration because it did not allow for any arbitrary playing and shifting of forms or emotions. The representation of pure reality was, on the contrary, the very embodiment of the "unchangeable" (*das Unveränderliche*) (p. 101). The painter was not free to combine forms and colors at will. While he was not constrained by the need to be true to a natural object familiar to everybody, he had to follow a strict order or a firm pattern that, though not embodied in the material objects of our everyday experience, was no less structured than them.

Reading what both Kandinsky and Mondrian had to say about the subject matter of abstract painting one is constantly reminded of the well-known "struggle over the universals" in late medieval philosophy and

scholastic thought. While the so-called Nominalists stressed that "true reality" consists of only individual beings and distinct objects, the Realists claimed that the "universals," pure categories and ideas, were the true reality. The "universals," they proclaimed, come *before* (individual) things (*universalia ante res*); their opponents, the Nominalists, said that the universals come *after* things (*universalia post rem*). In philosophically somewhat primitive form this great theoretical discussion, alive in one form or another at least since Plato, reappeared within the orbit of reflection on art in the attempts of the founders of abstract painting to provide a theoretical foundation for their work.

How is that hidden reality to be perceived? This simple question that we now pose as a matter of course, is perhaps more modern and more critical than we think. More than eight decades ago, when young artists began to do "abstract painting," perhaps they did not make a sharp distinction between the insight that there *is* an invisible reality that the painter should depict, and the ways of getting to know that reality. To the practicing artist, however, the question of how we see a reality, let alone one that is invisible, is crucial. Though Kandinsky and Mondrian never asked this question explicitly, at least not in so many words, they obviously were concerned with the problem.

Once we ask how we get to know "inner reality," in Kandinsky's formulation, or "pure reality" in Mondrian's, we can instantly see what it was in the movements of the occult that so directly appealed to artists in the early twentieth century. As we have already said, these movements not only asserted the existence of a supernatural reality; they asked how one got the knowledge and the immediate experience of these transcendent worlds. Perhaps the most popular of Rudolf Steiner's books was the one entitled *How Does One Acquire the Knowledge of Higher Worlds? (Wie erlangt man die Kenntnis höherer Welten?)*. Readers may smile at this question today. However, once one accepts the basic assumption of the occult movements, namely, that there are worlds beyond that given to our regular experience, the desire for cognition of these worlds is logical, as is the question: how is the yearned-for knowledge to be achieved? To be sure, what theosophists and anthroposophists offered in terms of practical instruction was rather disappointing. While in some primitive societies various ecstatic techniques were proposed to facilitate the supposed cognition of a hidden world, what modern western occultists said was vague and fuzzy. But merely posing the question, and making an effort to attain such knowledge, captivated the artists' imagination.

What did these artists say about the ways of perceiving the hidden, sublime reality? And what guiding principles did they suggest to the painter who attempted to represent that invisible world? Although here, too, they were vague, and had little to say that was specific and distinct, they addressed two central problems. One focus may be described as the artist's experience, the other as what Kandinsky called the "inner necessity."

The first focus, centered around the artist's personal experience, comes very close to what we know as "introspection." By looking into himself, into the depth of his psyche, the painter could discover something of the sublime reality. In the introduction he wrote to the catalog of the exhibition of the *Neue Künstler-Vereinigung* in Munich that took place in 1910, Kandinsky said:

> One point of departure is the belief that the artist, apart from those impressions that he receives from the world of external appearances, continually accumulates experiences within his own inner world. We seek artistic forms that should express the reciprocal permeation of all these experiences—forms that must be freed from everything incidental, in order powerfully to pronounce only that which is necessary—in short, artistic synthesis. This seems to us a solution that once more today unites in spirit increasing numbers of artists. . . . (p. 53)

We may, of course, ask how such introspection relates to the traditional concept of the artist's inspiration. That the artist's inspiration is at least partially a process of introspection was part and parcel of the traditional doctrine of art. Suffice it to mention one of the most famous examples. "In order to paint a beautiful woman," wrote Raphael in a celebrated letter, ". . . I make use of a certain idea that comes into my head. . . . I try very hard just to have it [the idea]."[5] Now, what is this search for the idea that dwells in the artist's head but introspection? The forms in which inspiration appears are always changing, but the idea that inspiration comes by looking into oneself reappears time and again. In spite of all revolutionary intentions, the founders of abstract painting in the early twentieth century were continuing an age-old tradition.

The other focus of reflection concerning the experience and representation of "true" but hidden reality, is indicated by the concept of "inner necessity." In Kandinsky's and Mondrian's thought, "inner necessity" was a crucial concept. It was referred to in diverse contexts in their writings, and therefore even a careful logical analysis will not easily make plain what they meant precisely by this ambiguous term. The critical reader will necessar-

ily ask: the "inner necessity" of what? The artists give no straight answer to this question, nor do they spell out the constraints under which this necessity was manifested. I shall briefly discuss a few of the references, mainly from Kandinsky's *On the Spiritual in Art*, that will at least indicate some general trend.

One of the conditions that is described as an inner necessity is that the work of art touch the spectator. To put this rather general requirement in Kandinsky's specific terms: "Thus it is clear that the harmony of forms can only be based upon the purposeful touching of the human soul. This is the principle we have called the principle of internal necessity" (p. 165). That the work of art should move the spectator, or "touch the human soul," is found through the ages, though it is of greater significance in the modern age when the magical or ritual functions of the art object are replaced by a concern with affecting the spectator. The emphasis on the "purposeful touching of the human soul" is thus indicative of a modern trend. For our purpose it is important to note that Kandinsky contrasted "internal necessity" and moving the beholder with the mere aesthetic experience of the work of art. Form, he said, "is the expression of inner content" (p. 165). What moves the soul, it follows, is *what* the artist says, not the mere form.

Earlier in *On the Spiritual in Art*, in the discussion of color harmony, we learned that "The artist is the hand that purposefully sets the soul vibrating by this or that key. Thus it is clear that the harmony of colors can only be based upon the principle of purposefully touching the human soul. This basic secret we shall call the principle of internal necessity" (p. 160). Whose hand is the artist, and how can one be sure that he does indeed touch the spectator's soul? We will look in vain for clear answers to these questions. What is important is that Kandinsky's text shows, though not always distinctly, the goals toward which art and the reflection on art were striving.

Every period in the history of art and art theory has, of course, asked *how*, by what means, the spectator's soul is set vibrating, and whether there is some more or less proven way of achieving this end. Kandinsky faced the same question. It was in this context that he used Goethe's concept of a *Generalbass* (p. 162) in painting. What Kandinsky had in mind was an objective mode of notation and composition of colors and forms that would, at least in principle, assure the moving of the spectator's soul. As we shall see shortly, Kandinsky believed that in music such an objective key was given to the composer, and that it could also be found for the nonfigurative

painter. The discovery of such an objective key to perfect expression was surrounded by a messianic aura. It is worth recalling the concluding paragraph of *On the Spiritual in Art* which reads:

> In conclusion, I would remark that in my opinion we are approaching the time when a conscious, reasoned system of composition will be possible, when the painter will be proud to be able to explain his works in constructional terms. . . . We see already before us an age of purposeful creation, and this spirit in painting stands in direct, organic relationship to the creation of a new spiritual realm that is already beginning, for this spirit is the soul of the epoch of the great spiritual. (pp. 218–19)

The revelation of the perfect key to expressing hidden reality would signal the "great epoch of the spiritual."

The views on the problem of subject matter in abstract painting are vague and sometimes outright confused. They can, nevertheless, be summarized in four points. First, the belief that works of abstract painting do have subject matter was an essential component of the whole doctrine. It was because they had subject matter that the works of this school could convey a message and were not mere exercises in inconsequential aesthetic decoration. Second, the subject matter of abstract painting was not the object known in nature, but what was called "hidden" reality. Third, affecting the spectator, "touching" or moving the soul, was the final purpose of the work of art. Fourth, that end could be reached by the selection of proper subject matter. Though in fact nothing definite was said about what such proper subject matter was, the thesis that such specific subject matter was essential was maintained with much emphasis.

NOTES

1. The article was published in *Les Soirées de Paris*. I use the translation in Breuning, *Apollinaire on Art*, p. 197.

2. Kandinsky, *Complete Writings*, p. 171, translated the sentence as "meaningless formal game." What Kandinsky had in mind was not a "game, that can have firm rules which cannot be changed," but rather an unhampered, arbitrary, if inconsequential, playing with forms.

3. I quote from Walter Hess, *Dokumente zum Verständnis der modernen Malerei* (Hamburg, 1956), p. 100. Page references will be given, in parentheses, in the text.

4. Whether or not decorative art is indeed free of such constraints is, of course,

beyond the scope of the present investigation. On this subject, see Gombrich, *The Sense of Order*, pp. 65, 75.

5. I am using the translation in Panofsky, *Idea*, p. 60. Of course, this is not to deny the ever changing and shifting versions, and other conditions, in which the idea of inspiration reached by introspection is formulated.

25

Color

The theory of abstract art, unlike other trends in contemporary art, was directly and explicitly concerned with the basic "material" elements of painting, such as line, color, and certain aspects of composition. It is significant that among these basic building blocks of the art of painting, color held pride of place. The importance that the artists and writers who founded the school of abstract painting assigned to color is manifest in two ways: on the one hand, the sheer amount of reflection devoted to color sometimes far exceeds the attention devoted to line and composition; on the other hand, the effects and powers ascribed to color go beyond what at the time was commonly believed color could achieve.

It may be useful to begin with a text which has one of the most outspoken discussions of color in the programmatic and theoretical writings on abstract painting: the chapter called "Effects of Color" in Kandinsky's *On the Spiritual in Art* (pp. 156–60). Significantly Kandinsky opened the second part of *On the Spiritual in Art*, that devoted to "Painting," with this chapter. (The first part went under the title "General.") In it Kandinsky set out to describe and to explain the mystery of colors and the effect they can have on the spectator. He began with the search for "pure" colors, that is, colors divorced from the representation of any identifiable objects we know from other experiences. To imagine such pure colors, he evoked a painter's palette with unmixed colors laid out on it. What does the spectator who lets his eye wander over such a palette experience in his mind? This was the question Kandinsky asked himself. In a sense this is, of course, the question of what color is both to the artist and to the spectator looking at a painting.

Levels of Color Experience

In color experience Kandinsky distinguished two, or possibly three, levels. He also called these "effects," "results," or "consequences" of color. The very

terms he employed indicate where the true interests of the artist lay. He was less concerned with what color actually *is*, that is, with its material or scientific nature, as with what color *does*, that is, its effect on the spectator.

Kandinsky called the first level of color experience the "purely physical effect" (p. 156). But already the very first sentence of this chapter—the sentence in which he presented the term—shows that what he really had in mind went far beyond what we would today understand by "purely physical." In his usage, "physical" referred neither to the sensations on the retina nor to pure chromatic qualities, but to something else. In looking at these unmixed colors, he said, "There occurs a purely physical effect, i.e., the eye itself is charmed by the beauty and other qualities of color." And if this were not sufficiently clear, Kandinsky went on to emphasize the psychological, one should perhaps say, the expressive, effect of color experience. "Or the eye is titillated, as is one's palate by a highly spiced dish. It can also be calmed or cooled again, as one's finger can when it touches ice" (p. 156). The visual experience he referred to as the "purely physical" effect was thus presented both in terms of psychological conditions (the eye is charmed) and by synaesthetic descriptions and metaphors, by comparison with sensations of taste and touch. These experiences, the text reads, "are all physical sensations."

What does "physical" really mean here? The next sentences suggest that by "physical" he primarily meant something of short duration that left no permanent mark on the spectator. These physical sensations, we read, "are also superficial, leaving behind no lasting impression if the soul [of the spectator] remains closed. Just as one can only experience a physical feeling of cold on touching ice (which one forgets after having warmed one's finger again), so too the physical effect of color is forgotten when one's eyes are turned away." The "physical" was thus a transient and fleeting condition. Clearly, physical reality and experience were not highly regarded, and occupied a low place in the author's esteem. Whether or not this view of the physical realm derived from the traditional teachings of Eastern Christianity or was shaped by the anthroposophists' desire to go beyond mere material reality, it had an influence on Kandinsky's concepts of color.

Kandinsky explicitly defined the other level of color perception as "psychological." He placed this at a higher level of experience. "At a higher level of development, however, there arises from this elementary impression [the physical one] a more profound effect, which occasions a deep emotional response. In this case we have: (2) The second main consequence of the contemplation of color, i.e., the *psychological* effect of color" (p. 157). Now,

Kandinsky's use of the term "psychological" demands explanation no less than his use of the term "physical." By the "psychological effect" of color he meant primarily that color reaches the beholder and affects his emotions. He himself described the effect of color as a power. "The psychological power of color becomes apparent, calling forth a vibration from the soul." If we remember that "calling forth a vibration from the soul" of the spectator was the main purpose of art, we can assume that the principal value of color should be sought at this level. We shall return to what Kandinsky and the other founders of abstract painting thought about *how* colors work, how they affect the spectator's soul, and why this effect of color was a core issue in their new doctrines.

Here we continue with a possible third level of color experience. This level was occasionally suggested, but never explicitly described as a mandatory component of color doctrine nor systematically presented. A certain ambiguity, then, prevailed with regard to this third level. At the end of the chapter dealing with the "Effects of Color" in *On the Spiritual in Art*, Kandinsky referred to what he called "color therapy" (p. 159). Some of his views were accepted beliefs, at least in some circles, in the first decade of the twentieth century. Color, it was assumed, can have a therapeutic effect. Attempts were made to exploit the "power of color" in the treatment of nervous disorders; from these attempts Kandinsky learned about the effect of specific colors on the heart, the nervous system, and so on. He referred particularly to the activity and writings of a Dresden physician, Dr. Franz Freudenberg, who believed that he could restore a patient's disturbed inner balance by means of colors. At least in some cases of disturbed balance and harmony in the organism, the proper equilibrium could be reestablished by providing the missing colors. To this end chromotherapy made use of colored glass panes hung in the window, to which the patient suffering from such disorders was exposed.[1] Without going into the details of this theory, it is obvious that color played a semimagical role here. Kandinsky believed in these hidden powers of color, which it is necessary to recall in order to fully understand his doctrine of what color may mean to the painter.

While Kandinsky and the other abstract artists who were so concerned with the power of color did not literally follow any past models, their views were clearly influenced by their acquaintance (whether direct or indirect, through other students) with the history of color theory. Goethe's influence loomed particularly large; Kandinsky referred to him expressly (p. 162). Kandinsky might have found the important distinction between the "physical" and the "psychological" color experience in Goethe's monumental and

influential *Color Theory* (*Farbenlehre*). In Goethe's terminology these categories were called "Physiological Colors" and the "Sensual and Moral Effect of Color" (*sinnlich-sittliche Wirkung der Farbe*).[2] In his early writings on art, mainly in his *New Plastic* of 1917, Mondrian also referred to Goethe's views on color. In a note he quoted Goethe to the effect that "color is troubled light."[3] Goethe's high repute in late-nineteenth-century German culture would have ensured that the painters discussed here were acquainted with his color doctrine. In addition to his general popularity, however, anthroposophy, and particularly Rudolf Steiner's teachings, tended to make of Goethe a kind of sage, steeped in the esoteric teachings of the past and the secret lore of nature.

Line and Color

Before we take up some of the theoretical and even technical questions that were so conspicuously raised in the color theory of abstract painting, we should ask what the conceptual conditions for the painter's consideration of color were, particularly as shaped by history. I shall make a brief comment on those aspects that are significant for the understanding of the theory of abstract painting.

Whenever painters and critics reflected theoretically on the problems faced by the artist in the process of creating a picture, the relative significance of line and color were compared. What was more suggestive, what was less dependent on other factors—line or color? These questions surfaced repeatedly. They point to a history of "rivalry" between line and color throughout most stages of art theory.[4] Whatever the views of the different schools, both line and color were believed to have distinct, definite characters of their own. Their relative values were ranked on a hierarchic scale, and they were associated with different, sometimes contradictory, concepts of the arts and of the function of a picture.

In the aesthetic reflection of most periods there was a distinct preference for line as compared to color. Already Aristotle, who in his *Poetics* considered color the distinctive element of painting and believed that we could enjoy color even if we did not know the subject of the painting (1448 b 19), said that the most beautiful colors were less valuable than a clear outline (1450 b 2). Line assured the clarity of the whole scene depicted (being the very embodiment of it), and for Aristotle clarity was the highest value. The same preference for line persisted in the aesthetic thought of the High Mid-

dle Ages. Thomas Aquinas explicitly pointed to the superiority of line over color. The representation by line was clearer than that by color, he said. An object rendered in outline, but without color, would be perfectly legible; the same object rendered in color but without outline would look diffused and the spectator would not be able to identify it.

The Renaissance established the theoretical foundation for the supremacy of line. Leone Battista Alberti, the founder of art theory in the postmedieval world, opened his discussion *On Painting* with an analysis of line, or "circumscription" as he called it. He left no doubt that, in his view, line was superior to color. "No composition and no reception of lights [which includes color] can be praised where there is not also a good circumscription—that is, a good drawing—which is most pleasant in itself."[5] In the art theory of the High Renaissance the function of the line, that is, the clear representation of the figure depicted, was sometimes also fulfilled by shading and modeling. In such cases, modeling could be juxtaposed to color. It is interesting to listen to Leonardo da Vinci:

> Only painting presents a marvel to those who contemplate it, because it makes that which is not so seem to be in relief and to project from the walls; but colors honor only those who manufacture them, for in them there is no cause for wonder except their beauty, and their beauty is not to the credit of the painter, but of him who has made them. A subject can be dressed in ugly colors and still astound those who contemplate it, because of the illusion of relief.[6]

Line, and the kind of modeling that is related to line, provide, then, both the sense of material reality and the measurable clarity of the representation. In a famous letter to Benedetto Varchi, who inquired about the relative merits of the different elements of art, Benvenuto Cellini wrote that Michelangelo was the greatest painter who had ever lived. Michelangelo was so great "only because all that he knows of painting he derived from carefully studied methods of sculpture. Today, I know no one who comes nearer to such truth of art than the able Bronzino. I see the others drowned among nose-gays, and employing themselves with many varicolored compositions which can only cheat the simple."[7] We need not dwell any further on the history of the "rivalry" between line and color, to some extent an interesting, though imprecise, parallel to the "Quarrel between the Ancients and the Moderns." Suffice it to say that essentially the doctrines and attitudes that crystallized in the Renaissance were passed on to, and were generally fully accepted by, the schools of painters, academies of art, and the

pictorial traditions of the following centuries. In the nineteenth century this approach still dominated art and art theory.

Seen in this context, Kandinsky's emphasis on color, though certainly not unprecedented, acquires its true meaning. To be sure, neither Kandinsky nor Mondrian offered any explicit and systematically argued explanation for the great value they assigned to color in the visual arts. Though the founders of abstract painting clearly attached supreme value to color, they themselves never discussed the reasons for color's great significance. Careful study of their writings, however, makes it possible to discern at least some of these reasons. If I am not mistaken, there were two main reasons why they valued pictorial elements in general, and color in particular.

The first of these was that, among the elements constituting the art of painting, color is furthest removed from the representation of objects, figures, and external reality in general. As we have seen, in most periods it was well known that color is less suitable than line or modeling for the representation of an identifiable object. Being less strictly linked to the function of representing the outside world, color could be perceived as more fitting for the creation of mood and feeling, and eventually of nonobjective, "abstract" painting. It was color's relative detachment from the mimetic function of art that lay behind the abstract painter's many, often confused, statements about the value of color in those crucial years.

Time and again Kandinsky emphasized the *inner* character of color, that is, its power not so much to represent the reality of nature as to evoke a mood and stimulate inner experience, the objects of which were often unknown. Color was also a way of sensing the inner hidden reality behind the tangible objects we perceived in everyday experience. The more we advanced in our understanding of what was hidden behind the external appearance, the more we perceived its "inner sound." And he continued: "So it is with color" (p. 157). If one's spiritual development was at a lower stage, color would create only a superficial effect. "At a higher level of development, however, there arises from this elementary impression [of color] a more profound effect. . . ."

The traditional subject—which is more independent, line or color?—also emerged in the thought of abstract painters. Kandinsky's awareness that line has a higher degree of autonomy than color was an echo of this theme. To cite a famous example, it was this autonomy that made the image of a black man outlined in white chalk immediately intelligible, while his image executed only in dark colors would not be clear. Said Kandinsky: "That form alone, as the representation of an object, or as the purely ab-

stract dividing up of a space, of a surface, can exist *per se*. Not so color" (p. 162).

What, then, were the reasons for placing such great value on color? Color, Kandinsky believed, makes, or at least is able to make, a *direct, immediate* impact on the spectator. "In general," he wrote, concluding the chapter on the effects of color, "therefore, color is a means of exerting *direct* influence upon the soul" (p. 160, italics mine). Now, what does "direct" mean here? What Kandinsky had in mind was obviously the view that, in order to touch the soul of the spectator, color did not depend on the scenes, figures, or objects represented. In other words, since color was most removed from what we call "subject matter," it could speak directly to the beholder.

In reflecting about how color affected the beholder, Kandinsky had to come to terms with questions and doctrines of psychology. The need to do so was heightened by his desire to find a particular way of affecting the beholder, namely, what was called the "direct" way. Kandinsky therefore embarked upon a lengthy (though from a scientific point of view, not always successful) discussion of what some contemporary psychologists had to say about the problem. At first sight it seems odd that an artist, even one as intellectually inclined as Kandinsky, should have attempted to discuss in writing the doctrines of schools of empirical psychology. But he did so precisely in order to understand the *direct* affect color had on the spectator.

The doctrine known as Associationism was of particular interest to the founders of abstract painting. Associationism was one of the earliest theories to attempt to explain perception.[8] In our context what is important about Associationism is the view that items, including shapes and emotional qualities, become connected in one's mind after they have appeared together frequently, or when they resemble each other.[9] Our perception of an object or appearance will thus necessarily, or at least to some degree, be determined by the sediment of our previous experiences. The theory of Associationism, which has a long and illustrious history in English philosophy, was influential on the European continent around the turn of the century, and was also applied to some extent to the explanation of art, particularly by the then famous scholar and scientist, Wilhelm Wundt.

For theoreticians of abstract painting, and especially of its color doctrine, Associationism was of obvious significance, and had to be addressed. If color affects the spectator by reminding him of his former experiences, from the abstract painters' point of view this brought back the object of representation, even though its impact was indirect. The "subject matter"

was reintroduced, if only by the back door, because of its association with previous experiences. Not surprisingly, therefore, Kandinsky devoted great attention to this theory. His formulation was as follows: "Since in general the soul is closely connected to the body, it is possible that one emotional response may conjure up another, corresponding form of emotion by means of *association*. For example, the color red may cause a spiritual vibration like flame, since red is the color of flame" (p. 158; italics in the original).

It was natural, therefore, that Kandinsky should have rejected Associationism as a possible explanation for the emotional effect of color on one viewing a painting. "If association does not seem a sufficient explanation in this case, then it cannot satisfy the effect of color upon the psyche" (p. 159). The effect of color upon the spectator had to be a *direct* one, unaided by and independent of memories he may, or may not, have accumulated from former experiences. There was something inherent in color that affected the beholder. Invoking the findings of chromotherapy, Kandinsky concluded this passage by saying: "These facts [of chromotherapy] in any case prove that color contains within itself a little-studied but enormous power, which can influence the entire human body as a physical organism" (p. 159).

The conclusion the theoretician of abstract painting drew from all this was that color did not need the assistance of the object, either represented or only dimly remembered, in order to exert its vibrating influence on the beholder. The rejection of psychological associationism was thus part of the attempt to prove the feasibility of a "nonobjective," non-representational art that was nevertheless able to convey a distinct message.

Painting and Music

The direct effect that color, divorced from any representative function, exerts on the beholder brings us to another motif of great significance to the theory of abstract art: the affinity of color to sound, and, in a broader sense, of painting to music. It is by means of color that painting is related, and can be compared, to music. The comparison of painting and music occupies a prominent place in the theoretical reflections of the founders of this theory. In *On the Spiritual in Art* the explicit and distinct comparison of the two arts emerges time and again. Although in Mondrian's early writings, especially during the second decade of the twentieth century, the comparison was not articulately made, here too it played an important role.[10] In

Kandinsky's utterances, mainly in *On the Spiritual in Art*, this theme was so prominent that some critics believed his aim was the painting of music. A year or so after *On the Spiritual in Art* appeared in print, the painter-author had to publicly correct this mistaken interpretation of his purpose. In an autobiographical note dated January 1, 1913, he wrote: "It is fondly maintained that I paint music. The assertion comes from superficial readers of my book *On the Spiritual in Art*" (pp. 344–45). But although these readers were wrong in a literal sense (simply assuming that Kandinsky painted music), they did put their finger on a central theme in his art and reflections.

In the doctrines of abstract art, especially in the thought of Kandinsky, the comparisons and views concerning the possible ultimate identity of painting and music are a complex and many-sided conceptual structure. It was never systematically set forth, and hence it would be dangerous to regard it as a philosophical system with an intrinsically rigid logic. One should not make a philosopher of Kandinsky. Yet confused as these impressions often are, one wants to know what kinds of connotations these comparisons had. Sometimes they strike the reader as a mass of disconnected fragmentary reflections. Nevertheless, several layers of experience and meaning can be discerned. With these qualifications I tentatively suggest the distinction of the following strata.

In the general, distant, and indistinct background there was the floating assumption of some synaesthetic unity to the elements of art, particularly of color, and its inherent inclination to be translated into experience by the other senses. As we recall, the ultimate purpose of art was to make the spectator's soul vibrate. Some "highly sensitive people are like good, much played violins, which vibrate in all their parts and fibers at every touch of the bow," wrote Kandinsky in *On the Spiritual in Art* (p. 158). He continued:

> If one accepts this explanation, then admittedly, sight must be related not only to taste, but also to all the other senses. Which is indeed the case. Many colors have an uneven, prickly appearance, while others feel smooth, like velvet, so that one wants to stroke them. . . . Even the distinction between cold and warm tones depends on this sensation. There are also colors that appear soft . . . , others that always strike us as hard . . . , so that one may mistake them as already dry when freshly squeezed from the tube.

Here Kandinsky also mentioned "the scent of colors." This expression, he noted, was common usage, and the fact that it was used seemed to speak for its truth.

Before we come to Kandinsky's comparison of painting and music, we must ask what it was that endowed each sensual experience, and hence the elements and media of art, with the qualities of experience characteristic of the other senses. How can color be soft or have a scent? In some obscure, indefinite way, Kandinsky seemed to assume that there was an ultimate unity, a common substance behind different kinds of sensual experience and the different arts. Just what this common substance was precisely, we are not told, yet it was referred to in different ways. "Behind matter, within matter, the creative spirit lies concealed," Kandinsky wrote in 1912, a year after *On the Spiritual in Art*, in the *Blaue Reiter* (p. 235). This spirit, as we know, was what he was searching for.

Sometimes it seems that, at least at this stage in Kandinsky's development, he also believed in or reflected on an ultimate unity between the arts. His short essay of 1912, *On Stage Composition*, an important statement of his theory of art, began by saying that "Every art has its own language, i.e., those means which it alone possesses." After a few lines, however, we read: "*In the last essentials*, these means are wholly alike: the final goal extinguishes the external dissimilarities and reveals the inner identity" (p. 257; italics in the original). To the reader this sounds like the postulation of an ultimate unity *of the arts*. Only a few years after Kandinsky wrote these words, Piet Mondrian, in his *Dialogue on the New Plastic* of 1919, said that "fundamentally all art is one."[11] While Mondrian's statement was not as elaborate as Kandinsky's, the direction of his thought was obviously the same. Essentially, then, they both held the same view of the ultimate unity of all the arts, even if this idea remained vague and never became the subject of a detailed and explicit discussion.

What is it that bears this unity of the arts? Is this unity founded on "the spirit" we have heard of before? It may not be possible, and it is probably not very important, to get a definite answer. But we should keep in mind that the idea of some kind of unity of the arts lurks vaguely in the background of the theory of abstract art. It is a tendency that acts against the erection of insuperable barriers between the individual arts.

Against the background of this vague idea, the specific relationship of painting and music was explicitly discussed. There are, I think, three subjects that we have to consider here, though in the original treatises of abstract art they are not separated. They are: (a) the parallelism of the arts of music and painting; (b) the superiority of music over all the arts, including painting; and finally, (c) the imitation of music by painting. We shall briefly survey the thought of Kandinsky and his contemporaries under these three headings.

The Parallelism of Music and Painting

Time and again the individual color was compared to the individual sound. Both, it was stressed, are subject to the same laws. "As with color in painting, sound in music must be determined both by composition and by plastic means . . ." said Mondrian (Mondrian, p. 146). He spoke of the new reality created by art. "This new reality in painting is *a composition of color and noncolor*, in music, of *determined sound and noise*" (Mondrian, p. 150; italics in the original). A few years earlier, Kandinsky said in *On the Spiritual in Art* that "for every color there are four main sounds (Hauptklänge)" (p. 178). It is not always clear what makes painting and music similar, or even comparable. Is it that, as a picture is composed of individual colors, so a musical piece is composed of individual sounds? Or is it the fact that composition, that is, the balanced and proper combination of varieties, or even contrasts and dissonances, is the central law governing both arts? We shall shortly return to this question in a somewhat different form. Here it will suffice to say that for the founders of abstract art the parallelism between painting and music was a fundamental issue in their reflections. Says one interlocutor to the other in Mondrian's *Trialogue*: "I have called your *compositions 'symphonies'*; I can see music in them . . ." (Mondrian, p. 83; italics in the original).

Superiority of Music

While it may be difficult to say what it is about painting and music that makes them alike, and thus comparable, it is much easier to say in what the superiority of music consists. A recurrent motif in the aesthetic reflection of many ages has it that music is the most spiritual of the arts. Why sounds should be perceived as more spiritual, that is, as less sensual, than, say, color, is a question for psychologists to answer. The historian has to accept that this is what people thought and how they felt about the arts based on the respective senses. The old belief in the spirituality of music emerges vigorously as a pivotal, fundamental idea in the initial stages of the theory of abstract painting. The creative artist, said Kandinsky, "who wants to, and has to, express his inner world—sees with envy how naturally and easily such goals can be achieved in music, the least material of the arts today" (p. 154).

Sometimes the superiority of music over the other arts seems not to follow from the nonsensual, or less sensual, nature of music, but from sound being closer than all other fields of experience to the spirit and inner nature

of being. Kandinsky often tended to identify "spirit" with "sound." The sense of limitless freedom, he believed, "arises from the fact that we have begun to sense the spirit, the *inner sound* within every object" (p. 240). The "inner sound" thus became synonymous with the spirit. In the *Blaue Reiter* we find the jubilant conclusion: "*The World sounds. It is a cosmos of spiritually affective beings. Thus, dead matter is living spirit*" (p. 250; italics in the original).

The comparison of painting with music, and the emphasis on the latter's spirituality, impressed itself mainly upon theories of color. To be sure, a comparison with music could be made for painting of all styles, realistic and abstract alike. However, it had particular appeal for theories that moved toward nonobjective painting. Music was, to use the terms employed by painters, "nonobjective"; it did not have an object to "represent." Likening painting to music could, therefore, mean that the picture, too, could do without an "object," be nonrepresentative. The painter Adolf Hoelzel, who in the first decade of the twentieth century made the gradual transition from Realism to abstract art, said: "For the painting in a musical sense, that emerges only from the execution and treatment of the autonomous basic elements and that as an absolute work of art possesses the highest value, the object (*Gegenstand*) is no necessity."[12] "Painting in a musical sense" was, of course, primarily achieved by color.

The Imitation of Music by Painting

Painting, the founders of abstract art thought, should imitate music. Kandinsky found it "understandable" that the painter "may turn toward it [music] and try to find the same means in his own art." He did not reject the idea of one art learning from another, particularly of painting learning from music. Such learning should however be done correctly: "Comparing the resources of totally different arts, one art learning from another, can only be successful and victorious if not merely the externals, but also the principles are learned . . ." (p. 154). What were the principles to be understood and transferred to the new domain?

It should be kept in mind that the founders of abstract painting and of its theory, though they formed part of the same general trend, were not in contact with each other, or at best their links were limited and haphazard. As a result, they developed neither a common terminology nor a common framework of discourse. Thus a term or concept could have one meaning for one of them, but a different meaning for the other. There were also sig-

nificant differences between individual artists on specific artists, though they remained true to the same general direction. All this was particularly evident in connection with the question of how painting could attain the spirituality of music.

The founders of the doctrine of abstract painting were united in their desire to make color "spiritual." This also applied to the individual color. It was mainly Mondrian who wanted the single, individual color to be "spiritualized." He saw the need to liberate color from the impact or the residue of the object represented. To this end he demanded the "reduction of naturalistic color to primary color" (Mondrian, p. 36). Color, he said some years later (1925), was "necessary to annihilate the natural appearance of materials" (Mondrian, p. 197). When the painter applied color, there were differences of tone that made some parts of it appear closer to and others more distant from the spectator. There was, thus, a residue of spatiality, of depth, in the artist's color. This residue should be eliminated. A full "reduction of color to plane" would bring about what Mondrian sometimes called the "denaturalization" of color. Thus not only did color replace the "object" of representation, but it in turn had to be purified from any link to, and residue of, "materiality." Hoelzel looked for other means for the spiritualization of color and for overcoming its materiality, finding these mainly in the simultaneous contrasts that play a marvelous part in a painting.

The attempts to spiritualize or "denaturalize" the individual color did not, however, become a central theme in the doctrine of abstract painting. They remained marginal. The major way of making painting similar to music was not by concentrating on the individual hue. The main concern remained, of course, the relationships between the colors themselves. Here the abstract painters, primarily Kandinsky, employed two concepts borrowed from music and music theory. These were the concepts of "Thorough Bass" and "Leitmotiv."

Kandinsky started his chapter on "The Language of Forms and Colors" with quotations from Shakespeare and Delacroix, followed by a statement by Goethe. In a conversation with Riemer, Goethe pointed out that painting lacked theory. Painting, he said on 19 May 1807, "has long since lacked knowledge of any *Generalbass;* it lacks any established, accepted theory as exists in music." This prophetic utterance, said Kandinsky, "anticipates the situation in which painting finds itself today" (p. 162). The *Generalbass* Goethe referred to, what the Italians called *basso continuo*, translated into English as "figured bass" or "thorough bass," was "a system of musical notation according to which, mainly in Baroque music, the keyboard player

would reconstruct the cembalo part in conformity with a relatively elaborate convention."[13] What Kandinsky suggested by adducing Goethe's use of the musical concept of *Generalbass* was twofold: First, that painting was in need of a comprehensive theory, and second, that this theory should be patterned after the model of music theory.

The other concept, that of *leitmotiv*, was also borrowed from music. Here Kandinsky seems to have wanted to emphasize a certain issue not by telling a story, but purely by means of art.

> Richard Wagner achieved something similar in *music*. His famous *leitmotiv* is likewise an attempt to characterize the hero not by theatrical props, make-up, and lighting, but by a certain, precise *motif*—that is, by purely *musical means*. This motif is a kind of musically expressed spiritual ethos proceeding from the hero, which thus emanates from him at a distance. (p. 148)

Wagner's music, we should remember, played an important part in Kandinsky's artistic and intellectual development. In *Reminiscences* he wrote that a performance of Wagner's *Lohengrin* was one of the revolutionary experiences of his youth. His recollections of the opera are particularly significant because int allowed him to directly translate sounds into colors, and thus make a clear connection between music and painting. "The violins, the deep tones of the basses, and especially the wind instruments at that time embodied all the power of that pre-nocturnal hour," and its views and colors. "I saw all the colors in my mind, they stood before my eyes." It became quite clear to him, he wrote, "that painting could develop just such powers as music possesses" (p. 364).

No wonder, then, that Kandinsky referred specifically to Wagner's use of *leitmotiv*. But what did this particular concept mean to the painter? Once again, two characteristics should be mentioned. First, in pictorial theory the *leitmotiv* was understood as a compositional device, a means of distributing emphasis in the painting and endowing the whole work with one dominant tone. Second, these ends (the placing of emphasis, the unity of the whole work) were sought to be achieved by pictorial means alone, just as the composer achieved his aims by "purely musical means." In other words, here too we see the painter trying to do without the narrative dimension in the work of art, without "subject matter" in its traditional form.

Kandinsky's conclusion was that painting should imitate music, and that, in its "abstract" form, it was capable of being as spiritual as music. Perhaps the main agent in painting's ascent to spirituality was color.

Reading Color

Here we reach another part of Kandinsky's color theory, one to which he devoted a great deal of attention. How does the spectator understand the various colors? Or, to put it in terms closer to Kandinsky's, how is it that one color affects the spectator differently from another? To convey a specific message, to affect the beholder in a distinct way, there must be something in one color that distinguishes it from another. What are these differences?

In the spiritual world of the abstract painters, colors were seen in two ways—as parts of a complex interaction with each other, or as "harmonies," but also as individual hues. The founders of abstract painting suggested that one begin with the attempt to understand single colors. "One concentrates first upon *color in isolation*, letting oneself be affected by *single colors*," said Kandinsky (p. 177). A few years later, Piet Mondrian admitted that "in nature, as in art, color is always to some degree dependent upon relationships, but is not always governed by them" (Mondrian, p. 36) The single color, then, even if considered in isolation, retained a particular, distinct character.

The theory of abstract painting assumed that each individual color, even if seen in isolation, had a distinct character of its own, and that it conveyed this character to the spectator. Each color, said Kandinsky, had "a certain precise, and yet imprecise, mental image (*Vorstellung*), having a purely internal, psychological sound" (p. 162).[14] Remembering earlier stages in the history of color reading the student may feel that, at least in some respects, such a "purely internal, psychological sound" came fairly close to what former ages called the "meaning" of a color. This raises the question, what was the relationship of the doctrine of abstract painting to the tradition of conventional color meanings?

The system applied in this tradition may be described as the dictionary method of color interpretation. Each individual hue was considered to have, or convey, a distinct idea. Each color, we then say, has a specific discrete meaning. White means purity, red conveys love (or whatever else a cultural tradition may establish), black conveys sadness, and so forth. The question of whether or not such meanings are universal, or even clear-cut, need not detain us here. What is important in the present context is that in the history of European color interpretation the dictionary approach to hues and shades has long prevailed, and that the individual color was "understood" (that is, taken as a sign for what it was intended to convey) because we, the actors and audiences in these traditions, *knew* what the color

"meant." Most doctrines of color symbolism were essentially based on the dictionary approach. This was particularly the case in late Renaissance color emblematics,[15] and has persisted ever since.

In principle, Kandinsky accepted that each individual color had a specific, unique emotional or spiritual effect, yet he differed from the approach underlying the dictionary method. He did not ask for the "meaning" of colors in the traditional sense of that term. A sentence such as "yellow means envy"—a kind of statement that frequently appears in the literature of color emblematics—is not to be found in the writings of the founders of abstract painting. Kandinsky's conception of the link between color and emotional effect was different from that of the emblematic tradition. To him color was not a sign, understood because we know the conventional code by which meanings are assigned to colors. Rather he believed that there is an immediate link, some hidden partial identity, between the chromatic shade and its emotional effect, the state of mind it produces in the spectator. The emotional or spiritual effect of a color derives from some of its inherent properties. He attempted to trace the character or meaning of each color from some basic principles that he spelled out. These were the "warmth or coldness" of a color, and its "lightness or darkness" (p. 177).

Both color scales, from warm to cool and from light to dark, are well known in color traditions from ancient times. The first scale particularly, from warm to cool, is based on the spectator's intuitive perception of the color scale. The so-called "cold colors" seem to recede, to move away from the spectator and evoke a sense of distance; the "warm colors" seem to come close to the spectator and generate a sense of nearness. The warmth and coolness of a shade were traditionally also defined in chromatic terms. Kandinsky accepted this definition. "In the most general terms, the warmth or coldness of a color is due to its inclination toward yellow or toward blue" (p. 179).

What were Kandinsky's immediate sources, especially with regard to the scale from warm to cool colors? In a brief footnote (p. 179) Kandinsky said that "all these assertions [that he presented] are the result of empirical-spiritual experience and are not based upon any positive science." We do not know precisely how far Kandinsky was acquainted with the earlier literature on color. He only referred to Goethe's *Farbenlehre*, to which we shall immediately return. We do know, however, that he was familiar with the ideas of anthroposophy, and that he could have found speculations here based on "empirical-spiritual experience" concerning the nature and connection of colors. In these speculations the notion of distance played some

part. Rudolf Steiner devoted serious consideration to color in his programmatic work, *Theosophie*. In a sense his approach was close to Kandinsky's. Color was not only a physical experience, Steiner said, but also a spiritual reality. Therefore we can experience ideas in terms of color. "An idea born of a sensual instinct has a different coloring than an idea serving pure cognition, noble beauty, and the eternal good. The color corresponds to the character of the idea." Going beyond statements of general principle, Steiner discussed specific ideas and their colors. Thus, ideas that help us ascend to higher cognition appear in beautiful, bright yellow; ideas born of the sensual life carry shades of red in our minds. Ideas born of devoted love are of a marvelous pink color, and so forth.[16]

The juxtaposition of yellow and blue as the polar ends of a general expressive or emotional color scale was not new either. It appears not only in writings that Kandinsky may have regarded as esoteric, such as Renaissance color symbolism (though it should be noted that he was interested in esoteric teachings), but also in such famous, often quoted, and much discussed texts as Goethe's *Farbenlehre*. In a truly poetic approach Goethe said that yellow "is the color nearest to light.... in its highest purity it always carries with it the nature of brightness, and has a serene, gay, softly exciting character." At the other end of the scale there is blue. "As yellow is always accompanied with light, so it may be said that blue still brings a principle of darkness with it." Goethe conceived of two qualities in the emotional character of blue. Blue has "a peculiar and almost indescribable effect on the eye. As a hue it is powerful, but it is on the negative side," it is a stimulating negation, "a kind of contradiction of excitement and repose.... Blue gives us the impression of cold, and thus, again, reminds us of shade." The other quality of blue, following partly from its darkness, is the sense of remoteness it creates. Its cold and dark qualities create the feeling of distance: "a blue surface seems to recede from us." This does not mean, however, that blue loses its hold on the beholder. After stating that blue seems to recede, Goethe added: "But as we readily follow an agreeable object that flies from us, so we love to contemplate blue, not because it advances to us, but because it draws us after it."[17]

Kandinsky's color scale owed much to Goethe's poetic reading of a color's nature, and had a profound affinity with that poet's vision. However, this affinity did not necessarily show in specific colors. In his interpretation of individual colors, Kandinsky often differed from Goethe. Thus, in Kandinsky's view, "Yellow is the typical earthly color" (p. 181). Though it produced an effect of closeness to the spectator and came to the fore, as it

were, for Kandinsky it was not primarily the embodiment of light, as it was for Goethe. This example also shows how Kandinsky deviated from Rudolf Steiner. Kandinsky did not see yellow as leading to the "higher worlds," as Steiner taught. As for blue, while it receded and thus created a sense of distance, it did not carry in Kandinsky's mind the demonic character Goethe found in it; rather, he perceived it as "the typically heavenly color" (p. 182).

Explanations such as these may derive from a certain homemade set of associations. It is worth noting, however, that Kandinsky's understanding of color derived not only from scientific and literary sources; in his memory dwelled images of medieval, particularly Russian (or late Byzantine) art which played a part in his approach to color. Interestingly enough, he explicitly referred to a scholarly study of Byzantine art to explain the nature of yellow and blue. He quoted (p. 182) Nicolai Kondakov's then well-known *Histoire de l'art byzantin* to indicate that the distinction between earthly yellow and celestial blue could be observed in religious art, particularly in the representation of haloes. The haloes of emperors and prophets, that is, of mortal, if exalted, human beings, were golden, that is, based on yellow; the haloes of spiritual creatures, mainly those of angels who had no body in the regular sense, were depicted in blue. This was so because the former were terrestrial and the latter celestial, creatures.[16] Thus, for Kandinsky the images of Byzantine and old Russian art were an authoritative text that supported other inspired texts. In sum, then, the statement of a color's nature (yellow was terrestrial, blue was celestial), its expressive impact (yellow was close, while blue was distant and could elevate the mind), and its symbolic function (the haloes of terrestrial figures were yellow or golden, while those of celestial creatures were blue) came together.

So far we have considered individual colors. In painting, however, and perhaps in natural experience as well, mixed colors prevail. Mixtures are more complex and ambiguous in meaning. As far as I can see, the founders of abstract painting did not offer any systematic treatment of this question, but scattered remarks and select examples show that they were aware of it. Mondrian's request that shades be reduced to primary colors (Mondrian, p. 36) may well have derived, at least in part, from the desire to avoid ambiguity. The best way to see the ambiguities inherent in color mixtures is to consider examples.

I shall take a single example, the color green. As we know, yellow, being a warm color, "cannot be pushed very far into the depths." To make yellow move away from the spectator and recede into the depths of space, it has to

be mixed with blue. But such mixture, resulting in the color green, also produces distinct expressive results. Here is what Kandinsky said about such a seemingly technical issue:

> When [yellow is] made colder with blue it takes on . . . a sickly hue. If one compares it to human states of mind, it could have the effect of representing madness—not melancholy or hypochondria, but rather mania, blind madness, or frenzy—like the lunatic who attacks people, destroying everything, dissipating his physical strength in every direction, expending it without plan and without limit until utterly exhausted. (p. 181)

But green can also have an altogether different effect. Again it is worth our while to read Kandinsky's explanation in full:

> The ideal balance of these two colors [yellow and blue]—diametrically opposed in every respect—when they are mixed, produces green. The horizontal movement of one color cancels out that of the other. The movement toward and away from the center cancels itself out in the same way. Tranquility results. This logical conclusion can easily be arrived at theoretically. And the direct effect upon the eye and, finally, through the eye upon the soul, gives rise to the same result. (pp. 182–83)

Kandinsky emphasized the emotional quality of green through different metaphors. "This green," he said, is like a fat, extremely healthy cow, lying motionless, fit only for chewing the cud, regarding the world with stupid, lackluster eyes." And as if this were not enough, he stressed that "When tending toward light or dark, green still retains its original character of equanimity and peace . . ." (p. 183).

In sum, green, the mixed color par excellence, could be the color of blind madness and frenzy, but also of tranquility. This ambiguity was characteristic to some degree of all mixed colors.

The other color scale, from light to darkness or from white to black, was simpler than the scale leading from warm to cool. It was also better known in workshops, academies, and in other forms of art teaching. The system of "values," that is, the lighter and darker shades of the same color, was common usage, and there was nothing new in Kandinsky's doctrine of it. It is interesting, however, that he endowed even this scale with an expressive character. Its two ends, white and black, also embodied spiritual realities. "White, which is often regarded as a non-color . . . is like the symbol of a world where all colors, as material qualities and substances have disappeared" (pp. 183–85). We perceive white as a great silence. "Its inner sound is like the absence of sound, corresponding in many cases to pauses in

music. . . ." In terms that seem to announce the philosophical terminology of the next generation, Kandinsky described white as "a silence that is not dead, but full of possibilities" (p. 185). Black, on the other hand, "has an inner sound of nothingness bereft of all possibilities, a dead nothingness as if the sun had become extinct, an eternal silence without future, without hope" (p. 185).

These metaphors and similes were common, accepted phrases, and sometimes even well-known idioms. What was different in Kandinsky's usage was the scale of "values" leading from white to black was no less endowed with emotional or "spiritual" qualities than the other color scale from warm to cold tones.

Kandinsky's color theory leads to the general concept of harmony. Before we turn to harmony, however, we should consider the other formal aspect of his doctrine, line.

NOTES

1. See Ringbom, *The Sounding Cosmos*, pp. 92 ff.

2. I quote from *Goethe's Werke*, vol. 33, *Naturwissenschaftliche Schriften* (Berlin, 1879), pp. 14 ff., 148 ff. And see the English translation, *Goethe's Color Theory*, translated by Herbert Aach (New York, 1971), pp. 78 ff., 168 ff. By "sensual" (*sinnlich*) Goethe meant perceived by the senses.

3. Harry Holtzmann and Martin S. James, eds., *The New Art—The New Life: The Collected Writings of Piet Mondrian* (London, 1987), p. 36. Page references are given in the text, preceded by the name of Mondrian.

4. I have referred to the earlier stages of this rivalry, in bare outline, in Barasch, *Theories of Art*, pp. 12, 101.

5. Alberti, *On Painting*, p. 68. For a more detailed discussion and for further bibliography, see Moshe Barasch, *Light and Color in the Italian Renaissance Theory of Art* (New York, 1978).

6. da Vinci, *Treatise on Painting* # 108.

7. Cellini's famous letter was written in 1546. I use the translation in Holt, *A Documentary History of Art*, 2 vols., pp. 35 ff.

8. For a concise survey of the history of this doctrine, see Robert M. Young's entry "Association of Ideas" in Philip P. Wiener, ed., *Dictionary of the History of Ideas: Studies of Selected Pivotal Ideas* (New York, 1973), I, pp. 111–18, and its good bibliography.

9. The literature on Associationism in psychology is extensive and need not detain us here. For general information, see E. G. Boring, *A History of Experimental Psychology* (New York, 1942), p. 310 ff., and Daniel N. Robinson, *An Intellectual His-*

tory of Psychology (New York and London, 1981), passim. For its application to art, the studies by Rudolf Arnheim offer interesting insights.

10. See Mondrian's "Natural Reality and Abstract Reality: A Trialoguer (While Strolling from the Country to the City)," in Holtzmann and James, *The New Art— The New Life*, pp. 82 ff., especially pp. 83–84. This text was composed in 1919–20.

11. Holtzmann and James, *The New Art—The New Life*, p. 79.

12. "Für das Bild im musikalischen Sinne, das allein aus der Durchführung und Verarbeitung autonomer Grundelemente entsteht und als autonomes Kunstwork einen Höchstwert besitzt, ist der Gegenstand keine Notwendigkeit." Hess, *Dokumente*, pp. 96 ff. Hoelzel's written notes were not published at the time. It was only in 1935, almost twenty years after his death, that they were published in a catalog to an exhibition of his work. From 1906, however, he taught at the Academy of Art in Stuttgart, and so could have spread his ideas orally.

13. See Editor's note to Kandinsky's *Complete Writings on Art*, p. 874. See also Peter Vergo, "Music and Abstract Painting: Kandinsky, Goethe and Schoenberg," in *Towards a New Art: Essays on the Background to Abstract Art 1910–20*, Tate Gallery (London, 1980), pp. 41 ff.

14. I differ here from the translator whose text I use. The otherwise very good translation renders *Vorstellung* as "representation." While in a literal sense this may be more precise than "mental image," Kandinsky was referring here to what the spectator imagines in his mind. "Mental image," though literally less close to the wording of the original, seems to me in this case more faithful to Kandinsky's thought.

15. See the essay "Renaissance Color Conventions: Liturgy, Humanism, Workshop," in Moshe Barasch, *Imago Hominis: Studies in the Language of Art* (New York, 1975), pp. 172–79. For a later period, see Barasch, *Modern Theories of Art, 1*, pp. 265–74.

16. Steiner, *Theosophie*, pp. 145–47.

17. Goethe, *Farbenlehre*, pp. 148–51. I use the English translation by Aach, *Goethe's Color Theory*, pp. 168–70.

18. Kandinsky mentions the French edition of Kondakov's great work, *Histoire de l'art byzantin*.

26

Line

The other element in the painter's work, line, also played a significant part in the examination and reflection of the abstract artists in the first two decades of the twentieth century. To be sure, in purely quantitative terms line seems to have attracted less of their attention than color. Thus, while in *On the Spiritual in Art* Kandinsky devoted a whole chapter specifically to the "Effects of Color," he treated line mainly in a chapter called "The Language of Forms and Colors." Even in this chapter the main parts were, in fact, devoted to color rather than to line. As we shall see, a similar situation also obtains in the theoretical texts composed by Mondrian at this period. Evidently, the founders of abstract painting considered color as the more interesting, and in their specific context also the more important, feature of the two. Yet while they may in fact have devoted more intellectual effort to color, line was and remained a crucial problem for them. Understanding line was of the utmost urgency in the formulation of a theory of abstract painting. In this chapter I shall try to show that in fact line, rather than color, was a touchstone for the validity of "abstraction," as they understood it, in painting.

The specific question that arises here is easily seen. The conceptual upheaval in the doctrine of art brought about by the school of abstract painting affected the function of line perhaps more profoundly than any other basic element in the painter's craft. As noted in the previous chapter, for centuries line was considered the main foundation of the art of painting. The principal reason for this high regard was the assumption that line determined the general arrangement of figures and masses within the space of a painting. Line was thus the primary means by which composition, that is, the overall arrangement of the painting, was achieved.

The function of line as making composition possible and serving as its foundation is, however, inseparably linked with the traditional view of what art is, and what a picture should be. Line was essentially understood as the *out*line, the contour, or *contorno* in the language of the Renaissance

theory of art. In other words, line was the contour outlining the bodies, figures, and objects that we see in nature and that we represent in a painting. It was the arrangement of figures seen within the space of the picture that was marked by line. The overall arrangement of figures was called "composition," and the composition was represented by lines. In other words, when speaking about line, one actually had the combination of figures in mind. The structure of a "figurative" painting, representing natural figures and bodies, became, or began with, a configuration of lines.

But what happens to line when it ceases to be the outline of a figure or object? It is the essential characteristic of abstract painting that figures and objects of representation are eliminated. The elimination of figures and objects in the picture necessarily also eliminates their outlines. Does line continue to be a means of artistic creation? And if so, what function does it fulfill?

First of all we have to emphasize that line continued to be a central concern of the founders of abstract painting. To be sure, there was a certain conceptual fumbling and groping with regard to line in their theoretical writings, manifested particularly in the terminology they employed. The term "line," though used by both Kandinsky and Mondrian, occurs rather rarely. To appreciate the profound revolution that the theory of abstract painting brought about in terminology one should remember that in traditional art theory between the sixteenth and nineteenth centuries, the concept and term line were frequent; sometimes they were the central concept and term of a doctrine. The abstract painters, as we shall see, more frequently used certain equivalents that in many cases were vague or even of doubtful meaning. Thus sometimes, but not always, Kandinsky spoke of form where he seems to have been thinking of line. This terminological fluctuation naturally makes it difficult to define precisely the notion of line in the doctrine of abstract painting. Despite these difficulties, however, it is possible to discern the major levels on which line appears and the central functions it was believed to perform.

Strange and self-contradictory as this may seem at first glance, the concept of outline did not disappear from thought on abstract art. To be sure, since the depiction of material bodies was excluded from abstract painting, the line *as contour of material bodies* also disappeared. However, it survived as the outline of something other than a material body or object. In *On the Spiritual in Art*, for example, Kandinsky wrote: "Form in the narrower sense is nothing more than the delimitation of one surface from another" (p. 165). But what is such "delimitation" other than a contour? A few lines later

he added: "The external element of form, i.e., its delimitation . . . serves as a means."

Even before he wrote *On the Spiritual in Art*, Kandinsky had linked the concepts of form and line. "Form," he said in the essay "Content and Form," written in 1910 in Russian, "is that combination of linear surfaces determined by internal necessity" (p. 89). It is interesting that on the same page Kandinsky describes "line and extension" as a characteristic feature of architecture. Here he characterized each art by two elements: music by sound and time, literature by word and time, sculpture by extension and space, and painting by color and space. Architecture was singled out as having two completely different elements—line and extension. But shortly after this classification Kandinsky spoke of painting as a combination of linear surfaces. Now, what did he mean by "linear surface"? He seems to have been referring to a surface surrounded by a line. In other words, line was a contour.

Mondrian, too, conceived of line, at least to some extent, as an outline. In his early notes, of 1917, he particularly emphasized the function of line as contour, though he rarely used this term. "*Line* is actually to be seen as the *determination of (color) planes*, and is therefore of such great significance in all painting." (Mondrian, p. 72; italics in the original). A little later in the same essay he wrote: "If form is expressed through line, then the most tense line will determine color most strongly; when line has become a straight line, it will give color its greatest determination" (p. 73).

Mondrian also occasionally used another term (or concept) linked to "outline," though he never made the connection explicitly. This was what he called "closed form." A closed form was a special kind of contour: a contour that completely surrounded the shape of the object to be represented. Mondrian seems to have perceived of "closed form" as juxtaposed to, or at least differing from, open lines, or other kinds of line. But whatever his particular intention, "closed form" was the ideal outline. "So you see the importance of form," he said in the essay of 1917. "A closed form, such as a flower, says something other than an open curved line as in dunes, or something else again than the straight line of a church . . ." (Mondrian, p. 77). While the particular shape of the line (closed, open, curved, or straight) conveyed an expression (to which matter we shall immediately return), the idea of outline was also present in these patterns.

Outline, however, was only one function of line, and probably not the most important one. Line, like color, was primarily conceived as an entity in its own right, an agent of expression, as it were. In art, Kandinsky said,

"forms and colors of nature were treated not in a purely external way, but as symbols, and finally, almost as hieroglyphs" (p. 199). We should recall that in the early twentieth century, when Kandinsky wrote *On the Spiritual in Art*, the riddle of the hieroglyphs had, of course, long been solved, and this Egyptian script had lost the power of fascination it had exerted over centuries. The hieroglyph survived, however, as a literary metaphor, as a vague but nonetheless evocative image transmitted from ancient culture. As a metaphor, it referred essentially to a more or less independent, self-enclosed form, suggesting a reality that was not self-evident. As a visible configuration suggesting a reality beyond the reach of our senses it could, of course, serve as a simile for an artistic form whose main aim was expression. This was the sense in which Kandinsky employed the notion of hieroglyph.

What, then, were the functions, meanings, and types of line in painting? Here it is of interest to carefully consider Kandinsky's model of the unfolding of line as a means of artistic expression. In 1919 he published in Moscow, in Russian, *Little Articles on Big Questions*. The two short pieces in this publication dealt with Point (pp. 423–24) and Line (pp. 424–27). Though written in 1919, they were based on Kandinsky's major theoretical work, *On the Spiritual in Art*, written at the beginning of that decade, in 1911.

In the article "On Line" Kandinsky wrote: "At first, line is able to move along a straight path . . ." (p. 425). It can do so in various directions, to the right or the left, up and down. Most important for us, the straight line was considered the original line. Kandinsky placed the straight line at the very origin of the unfolding of forms. We find a somewhat similar idea in Mondrian's thought. While Mondrian did not speak of the history of line drawing or of an unfolding of forms in time, he too considered the straight line as the fundamental shape. "The "universal is plastically expressed as the absolute—in line by *straightness*, in color by *planarity* and *purity*, and in relationships by *equilibrium* . . ." (Mondrian, pp. 31–32)

It is interesting that to these artists, and particularly to Kandinsky, the straight line was the beginning of tracing lines in all their variety. Now, the straight line, it need hardly be emphasized, is an abstract shape; we do not observe it in nature. Thus underlying the belief that the simple straight line constitutes the beginning of all lines in chronological development as well as in theoretical structure was the assumption that human imagination begins with what we would now call an abstract pattern, not with the shapes actually seen in nature. Abstraction was not the final result of a long devel-

opment, but its original beginning. The artists who were of this view may not have been fully aware of its far-reaching philosophical implications, but they must have sensed that in their theory of art, here the theory of line, they were actually formulating a doctrine of how the creative faculties of man are set in motion.

That Kandinsky conceived of the character of the straight line as an image of the initial stage of human development can be seen in his comparison of "graphic language" with primitive peoples' attempts to learn a new language. It is worth quoting the whole paragraph in full:

> The graphic work that speaks by means of these forms [straight lines] belongs to the first sphere of graphic language—a language of harsh, sharp expressions devoid of resilience and complexity. This sphere of draftsmanship, with its limited means of expression, is akin to a language without declensions, conjugations, prepositions or prefixes—just as primitive peoples, when they first try to speak a foreign language, use only the nominative case and the infinitive mood. (p. 425)

Here an interesting difference of opinion between Kandinsky and Mondrian should be noted. In a dialogue between two imaginary interlocutors, the *Dialogue on the New Plastic*, that Mondrian wrote in 1919, the year in which Kandinsky composed the article "On Line," Mondrian represented the straight line as the most perfect expression of an almost absolute relationship. "*The plastic expression of immutable relations*," he said, is "*the relationship of two straight lines perpendicular to each other*" (Mondrian, p. 79; italics in the original). The perfectly straight line, meeting another straight line at a sharp angle, was not understood as a limitation, a dependence on the ruler, but rather as a sign of approaching absoluteness. Drawing a straight line, then, was not the hallmark of an initial stage—the lack of declensions, conjugations, and prefixes, to recall Kandinsky's formulation— but rather a fully purified expression reduced to its essentials. Let us stress that in describing the physiognomy of the straight line both artists were fully in agreement. They diverged in their evaluation of what it meant (perfect expression of the absolute, to the one; dependence on the ruler, to the other) and of its proper place in the historical development of art (final achievement, to the one; the initial stage, to the other).

Let us return to Kandinsky's vision of history. He understood the branching out of the original straight line into a multitude of variously shaped lines as a liberation. In the 1919 essay he imagined this transition as a kind of mythical event: "There then follows the line's first-ever liberation

from that most primitive of instruments, the ruler." The process he imagined suggested to him a kind of primordial upheaval. "The clatter of the falling ruler speaks loudly of total revolution" (p. 426). In this revolution "another unfamiliar being—the curved line" was born.

As Kandinsky saw it, the process of transforming the straight line into a variety of differently shaped lines was a kind of invented history, a mental re-creation of the wealth of forms in the human imagination and in art. The structure of such unfolding was only vaguely and briefly suggested. It is of great interest, however, both as a model of how Kandinsky saw the development of art, and as a list of the types of lines he visualized in his mind. After its liberation from the authority of the ruler the curved line emerged, first "in its schematic form, the semicircle or the parabola," later in more complex shapes (p. 426). But even at this stage, the line (and, one imagines, the drawing hand) was not altogether free, it was still subordinated "to the instrument." Instrumental control over line went a long way. The complex instruments that ruled curved lines made possible a great variety of different linear patterns. This was the domain of what Kandinsky called "the arabesque." The arabesque, he said in the article of 1919, consists of "a long series of new movements, angular and curved, not lacking in a certain capriciousness and unexpectedness." This domain "often seem[ed] deceptively like a world of total freedom." Behind this impression, however, was still hidden a "servile subordination to the more complex instrument." What Kandinsky had in mind in this definition of the linear arabesque was not so much the draftsman's actual use of an instrument as the fact that he was bound by an imposed regularity of shapes. "This language [of the arabesque] is like the official style of state documents, where strict limits of conventionality hamper freedom of expression" (p. 426).

At the turn of the century and in its first decades, ornament in general and the arabesque in particular attracted the attention of scholars and artists. One of the outstanding analyses of the arabesque as a form of decoration was Alois Riegl's *Stilfragen*,[1] a work that was discussed for many years. Riegl stressed that the arabesque, or the "frühsaracenische Rankenornamentik," as he called it, was not a mere play with form, but rather a strictly imposed order, a highly refined yet always conventional pattern of lines. The weavers and embroiderers, the workers in stucco and the vase decorators who employed arabesques in their products were not free to trace lines as their fancy suggested. The playful shapes they produced were, in fact, ruled by geometrical forms and rigid traditional conventions. Thus we conclude that Kandinsky's emphasis on the arabesque's "servile subor-

dination" to geometrical forms and complex instruments was very much in keeping with what was believed at the time.

In Kandinsky's vision of the line's history the stage of the arabesque was followed by what he called "the freedom of unconstrained expression." In picturing the history of the line as a path leading from enslavement (to the ruler and later to other instruments) to unrestrained freedom, Kandinsky revealed how deeply rooted he was in the cultural imagery of his time. That history is the unfolding of freedom was a concept widely current in intellectual circles at the turn of the century. Though the topic was understood mainly in political and social terms, it also had some implications for art. As far as I know, however, Kandinsky was the first artist to systematically apply this view to an element of art.

When Kandinsky spoke of the history of the line as a process of liberation, he had two different ideas in mind. The first was seemingly simple: it was the liberation of the line from the tyranny of the ruler, and of the instrument in general. But the freedom of the line, that is, of one of the central features in the painter's craft, could not be detached from another freedom, the freedom of the artist, and of man as embodied by the artist, from the tyranny of patterns and models imposed by tradition. The liberation of the line and the liberation of the drawing hand could not be separated from one another. "From the fateful paths of line the independent hand seizes the ultimate achievement of the ultimate freedom—the freedom of unconstrained expression" (p. 426).

Kandinsky conceived of the line as a direct, immediate record of the artist's emotions, reflecting even slight changes in his mental and psychic condition. "The line curves, refracts, presses forward, unexpectedly changes direction. No instrument can keep up with it. Now comes the moment of maximum potential, of a truly infinite number of means of expression. The slightest inflection of the artist's feeling is readily reflected in the slightest inflection of line" (pp. 426–27). The idea that line faithfully reflected a person's character and even his changing moods, was discussed and accepted in the intellectual environment of early abstract art.

In this context let us recall Ludwig Klages, a critic and theorist of expression, who made a connection between line in, say, a drawing and lines in handwriting. The first and influential version of his doctrine appeared in 1905, as an article dealing with the law he believed governed expressive movements.[2] That body movements reflect "movements of the soul" (*movimenti d'anima*, as one used to say in the Renaissance) had, of course, always been known. Additionally, Klages stressed that character and moods were

also reflected in handwriting, thus linking graphology with a study of expression.[3] To the theory he derived from his observations Klages added his borrowings from contemporary trends of irrational philosophy and an almost total rejection of all mechanical elements and tools derived from the industrial revolution, praising instead a rather vague "eternal domain of the soul." But whatever one may think of the scientific value of Klages's doctrine, there can be little doubt that he was influential and that his writings reflected ideas that were widely held in the first decades of the twentieth century, particularly in central Europe. Thus Kandinsky did not have to have first-hand knowledge of Klages's writings (as far as I can tell, he never mentioned him by name) to be familiar with the idea that the line we draw or write on paper immediately and faithfully reflects our psychic condition, the permanent as well as the changing.

We now return to Kandinsky's vision of the history of line. Branching out from the straight line, drawn with the help of a ruler, this history led, as we have seen, to "unconstrained expression." It was presented as a history of liberation. Here a simple question arises: Who or what was being liberated in this process? Was it the line as a kind of metaphysical being, or was it that man, that is, the artist, was now able to express himself freely? This question is not as purely philosophical and detached from the painter's work as it may at first seem. The difficulty is that Kandinsky did not offer a clear-cut answer, or perhaps he was not fully clear in his mind that such questions would arise.

Before we attempt to suggest (not always on sufficiently solid ground) how Kandinsky might have responded to our questions, we should keep in mind that, even more than color, he considered lines, and all the shapes represented by lines, as carriers of expression. "Form itself, even if completely abstract, resembling geometrical form, has its own inner sound ..." he wrote in *On the Spiritual in Art* (p. 163). The question, then, was not whether or not line intended to be expressive, but rather specifically what or whom it wanted to express.

In Kandinsky's writings we find rudiments or beginnings of two different views of what line may convey to the spectator. One view conceived of certain shapes and linear configurations as endowed with an expressive nature of their own, while the other brought line closer to the emotions as actually experienced by human beings. But it seems that, as in the discussion of color, the theory of abstract painting tended to the first view.

Kandinsky was rather explicit in his discussion of the expression conveyed by certain linear patterns. Such a linear pattern, he said, "is a spiritual

being possessing qualities that are identical with that form." What were those "spiritual beings"? Kandinsky gave some examples. "A triangle [without more detailed description as to whether it was acute, obtuse, or equilateral] is one such being, with its own particular spiritual perfume." The triangle was not the only geometrical form carrying an expression: "Likewise the circle, the square, and all other possible forms." In a note to the same page he added that the direction in which such a triangle, or another of these forms, pointed, "is of great importance for painting" (p. 163). It was, then, primarily the geometrical forms which were endowed with an expressive—or should we say, an emotional—character.

In a strange way, and probably without being fully aware of it, Kandinsky was following an age-old trend here. The cultural traditions of emblematics assigned, often deliberately, what they called "meaning" to geometrical forms. Some of these meanings were quite well-known, of others only professional students were aware. But in European culture a continuing, if vague and ill-defined, connection is made between certain abstract forms and specific meanings. Some of these forms are thinly veiled as objects or creatures found in nature. Among the more familiar examples is the image of the serpent, coiled in a circular shape, devouring its own tail, as an image of the universe.[4] Less known, but interesting in our context, is the explanation some sixteenth-century emblematists offered for the fact that the Egyptians constructed monuments in honor and memory of their kings (such as pyramids and obelisks) in the shape of triangles. According to one of the authors of emblematics, they did so because the triangle (probably an equilateral one) shows justice and fairness.[5]

It goes without saying that what the humanists understood by "meaning" in these emblems was different from what Kandinsky had in mind. But they accepted the idea of shapes as "abstract beings." Moreover, their concept was many-sided and ambiguous, and often included this particular evocation of emotions that we now call "expression." This is not to say that Kandinsky borrowed directly from the emblematic tradition, or even that he was aware of its very existence. It shows, however, that assigning partly emotional meanings to abstract geometrical forms was part of the cultural tradition to which Kandinsky belonged.

Similar ideas had a certain currency in the cultural environment closer to Kandinsky. Thus, a "moral" reading of geometrical shapes was known, and perhaps even taught, in the anthroposophical movement. When in 1923 Rudolf Steiner lectured on the "moral-psychic therapeutical effects" of certain patterns of physical movements, he was summing up ideas that

had been present in his teaching, albeit in scattered form, since the beginning. If one walks along following the pattern of an obtuse triangle, said Steiner, one conveys the impression of peacefulness, while doing so along the pattern of an acute triangle creates the impression of energy. The first pattern of movement was therefore called, a "peace dance," while the other was an "energy dance."[6] In such teachings Kandinsky may well have seen a legitimation of his own reading of the expressive character of geometrical shapes.

In reading the emotional character of line, Kandinsky went far beyond what the teachers of anthroposophy perceived. As we have noted, he came close to graphology. But here it becomes clear that he was not trying to understand the individual, the person tracing the line, even if this person was the artist. His theory of line and drawing did not reach a climax in a better understanding of man, but rather as nuanced perception and a distinct understanding of the manifestations of "spiritual beings." "There can and do exist," said Kandinsky, "cheerful lines, gloomy and serious lines, tragic and mischievous, stubborn lines, weak lines, forceful lines, etc. In the same way, musical lines, according to their character, are denoted as *allegro, grave, serioso, scherzando*" (p. 427).

In distinguishing different emotional modes and expressive directions, Kandinsky's theory of abstract line reached its final stage of development. In conclusion, two points should be emphasized. First, the expressive character of the line was now independent of a whole pattern. It was not only the geometrical figure (like the closed circle, or the obtuse or acute triangle) that conveyed a mood, but also the individual separate line, standing for itself. It did not have to be part of a figure to be expressive. Second, though the nature of the expression was borrowed from human experience (cheerful, gloomy, serious, mischievous, stubborn), it did not belong to a person but to a "spiritual being." As the subject matter of abstract painting was said to reveal an objective, but not a material, reality, so the individual line, while it did not represent a natural object, objectively showed a spiritual reality.

NOTES

1. For Alois Riegl, see above, Chapter 15. His *Stilfragen* was reprinted in Berlin in 1923, a few years after Kandinsky wrote his brief essay on line. For Riegl's discussion of the arabesque, see *Stilfragen*, pp. 302–46.

2. Ludwig Klages, "Das Grundgesetz des Bewegungsausdrucks." It is significant that it appeared in *Graphologische Monatshefte*. Frequently reprinted, it is most easily available in Ludwig Klages, *Zur Ausdruckslehre und Charakterkunde* (Heidelberg, 1927).

3. For a critical assessment of Klages's theory, see Karl Bühler, *Ausdruckstheorie*, pp. 152–94; for his doctrine in graphology, see 162 ff.

4. For the most important formulation of this motif, see *The Hieroglyphics of Horapollo*, translated by George Boas (New York, 1950, p. 57 (I, 2 of the *Hieroglyphica*).

5. Gabriello Symeoni, *Imprese heroiche et morali* (Florence, 1559). I quote from Ludwig Volkmann, *Bilderschriften der Renaissance* (Leipzig, 1923), p. 53.

6. Rudolf Steiner, *Eurythmie als sichtbare Sprache* (Dornach, 1927), pp. 211–40. The lecture that makes up this chapter is called "Moralisch-seelische Heilwirkung durch das Ausströmen der Menschenseele in Form und Bewegung, und deren Zurückwirken auf den ganzen Menschen." In the next chapter we shall return in greater detail to this work by Steiner.

27

Composition and Harmony

So far we have discussed the concepts and doctrines of color and line, and the particular problems they pose, separately. In this we were, in fact, following Kandinsky and Mondrian. But the founders of abstract painting and of its theory were profoundly aware that the work of art, quite particularly as they envisaged it, was not an accumulation of colors and lines; it was a unified whole. Adding color to line, even if both were expressive, was not sufficient to create a painting. As we have seen, the wholeness or totality of a picture is not defined and often not even clearly spelled out in the theoretical notes of the abstract painters. But the observations scattered in their writings enable us to reconstruct their main line of thought on this central subject.

But what do we mean when we say that the painting is a whole? A picture's wholeness obviously does not reside in its material integrity. We know of pictures by such masters as Rembrandt and Titian parts of which, in the course of time, have been crudely cut off (mainly at the margins), perhaps to make them fit the empty stretches of some late owner's crowded wall. Museum catalogs often tell us the sad story of how much and occasionally even when the original pictures were trimmed. Yet these pictures remain great works of art; the damage caused to their material completeness has obviously not destroyed their eminently artistic character. What, then, is it that makes the picture a whole, and how do we explain this wholeness?

Kandinsky and Mondrian did not concern themselves with questions that interest the art historian, such as when and where some great paintings were mutilated. Nor did they explicitly and systematically formulate the question when and under what conditions a picture could be described as "whole" or complete. But implicitly the problem of the painting's wholeness was always present in their deliberations; it formed the background to their reflections on art.

That this was so is perhaps best seen in their assertion that the individual shape and color are not perceived in isolation; they form part of a com-

plex differentiated totality which endows even the single individual form with its unique character. In *On the Spiritual in Art* Kandinsky said that pictorial composition has two tasks: "1. The composition of the whole picture. 2. The creation of the individual forms that are related to each other in various combinations, while remaining subordinate to the whole composition." The individual forms, he emphasized, are modified to make them compatible with the whole composition. Moreover, ultimately it is the overall totality that determines the specific character of the individual feature, either color or line. "The individual form is shaped in this particular way not because *its* own inner sound . . . requires it, but mainly because it is called upon to serve as a building block for this composition" (p. 167; italics in the original).

Mondrian expressed the supremacy of the whole linear composition over the individual line in a different way. In the introduction to his 1917 treatise, *The New Plastic in Painting*, he extolled the importance of duality, seeing art as the expression of the duality in man (Mondrian, p. 28). In nature we perceive completeness as the relationship between two opposites. In art this primordial duality is compressed into a specific motif, a particular linear pattern. "The abstract plastic of relationship expresses this prime relationship *determinately*—by the duality of position, the perpendicular. This relationship of position is the most equilibrated because it expresses the relationship of extreme opposition in complete harmony and includes all other relationships" (Mondrian, p. 30; italics in the original). Here the perpendicular stands for the harmony in nature, and the perpendicular pattern is obviously a composed motif, based on the meeting of shapes and directions moving in opposite directions.

The historian of symbolic imagery cannot help noting an interesting change in the graphic model for completeness here. In the course of millennia, different cultures have looked for a simple visual image to express the universe as a paradigm of totality, or of completeness in general. Almost without exception it was the circle that was considered the appropriate emblem for wholeness. The fully self-enclosed circle, complete in itself, a shape that has no beginning or end, made it the most fitting pattern to express totality. It was a great feat of original imagination when Mondrian suggested the perpendicular pattern, in many respects almost the very opposite of the circle, as the symbol and embodiment of completeness. In addition to this change in paradigm as a symbolic form, the perpendicular pattern also clearly demonstrates the preponderance of the whole over the part. It is obvious that a line, vertical or horizontal, can be-

come perpendicular only in special relationship to another line. Without this relationship, a line has no direction, and therefore is neither vertical nor horizontal.

Since it is clear, then, that the founders of abstract painting considered the whole work of art as of primary significance, we can return to the question with which we began this chapter, and ask how the image achieved "wholeness." At this stage we have to revert to an old concept often used in explaining and teaching the process of artistic creation. I refer to the concept of composition, a concept that acquired a new significance in the doctrines of abstract art.

Composition

Broadly speaking, by composition we refer to the overall organization or arrangement of shapes and colors in a work of art. Every artist, in all periods and artistic traditions, has in one way or another been concerned with composition, that is, with the arrangement of forms and the comprehensive pattern of the object or image he was making. Even the prehistoric cave painter who was not acquainted with the basic pattern of the "enframed area" and thus, in a literal sense, did not yet have the concept of a "picture," was selective about the spot on which he chose to paint his animal. By using a curve or bulge in the rock on which he painted, he often suggested, however vaguely, a relationship between the beast represented and what we would now call the "space" in which it was placed. The more developed the art, the more explicit and articulate the compositional relationships would become.

However, it was not until painting became a teachable "art" that the various terms for such an overall organizational framework emerged and a doctrine of composition was articulated. As far as we can judge, the term "composition" emerged in the workshop and art school rather than in critical writings. An early (perhaps the earliest) full definition of composition is found in Filippo Baldinucci's *Vocabolario Toscano dell' Arte del Disegno* (Florence, 1681), probably the first systematic dictionary of the terms used in the teaching and discussion of the visual arts. The entry *Composizione* refers the reader to another entry, *Accozzamento* (medley, mixture). Here we read: "A quality necessary to good painting, [which exists] when all things depicted on a canvas or board are so arranged that they result in agreement and in a harmonious unity."[1] Already in this early formulation

the two central issues of composition were highlighted: comprehensiveness and harmonious unity.

In the teaching of painting, especially in academies of art in the nineteenth century, the composition program played an important part in the artist's training.[2] It also became an everyday word in the language of art criticism. The well-known fact that impressionism was rejected by the criticism of the day because it presumably lacked composition[3] shows both how commonly accepted the term was and how highly the balanced and manifest ordering of the parts in a painting was valued.

In spite of this long history, the founders of abstract painting believed that their art revealed a new aspect of composition. In 1917 Piet Mondrian wrote:

> Although composition has always been fundamental to painting, all modern painting has been distinguished by a *new way* of being concerned with it. In modern art, especially in Cubism, composition comes to the forefront and finally, in consequence, abstract-real painting expresses *composition itself.* While in the art of the past, composition becomes real only if we abstract the representation, in the abstract-real painting composition is directly visible because it has truly *abstract* plastic means. (Mondrian, p. 39; italics in the original)

Kandinsky, too, saw in abstract painting the ultimate achievement of composition. In an article ("Painting as Pure Art") that appeared in 1913 in *Der Sturm*, he divided the history of modern painting into three periods: the period of "realistic painting," by which he meant mainly the art of the first half of the nineteenth century; the period of "naturalistic painting," particularly impressionism and other modern art movements, including cubism; and finally, "The third period of painting is beginning today— *compositional painting*" (p. 353). "In compositional painting, which we see today developing before our eyes, we notice at once the signs of having reached the higher *level of pure art,* where the remains of practical desire may be completely put aside, where spirit can speak to spirit in purely artistic language—a realm of painterly spiritual essences (subjects)" (p. 353; italics in the original). In light of these comments, it was not merely by chance or convention that some of the most important and revolutionary paintings Kandinsky created in those years were called "Composition."

Why did abstract painters endow composition with such particular significance? What did they find in pictorial composition that artists in other periods did not see? Why did they conceive of their own art specifically as

the art of composition? If I am not mistaken, there were mainly two reasons, connected to one another but not identical, why composition played such a crucial part in their reflections.

The first reason was perhaps best expressed by Mondrian. "In all art, it is through composition [as opposed to rhythm] that some measure of the universal is plastically manifested and the individual is more or less abolished" (Mondrian, p. 39). Composition was in its very essence the manifestation, even embodiment, of the universal, and thus opposed to the individual. At first glance, Mondrian's statement seems cryptic, perhaps even outright strange. Why should composition rather than any other element of painting be the manifestation of the universal? Why was it less individual than, say, color or drawing?

Kandinsky's presentation of his ideas on composition was involved and complex, and therefore in need of interpretation. He believed that "inner necessity," the guiding principle of all art, was composed of, or flowed from, three "mystical necessities." These were (1) the element of personality; (2) the element of style, particularly of the style prevailing in the artist's time; and finally (3) the element of the "pure and eternally artistic." In the present context we are concerned only with the third of these "necessities." The first and second elements, the artist's unique personality and his links with the time and world in which he lived were, as Kandinsky put it, "of a subjective nature." What he meant by this was that they were of a specific character and limited to, or reflected specific conditions. In history the specific is shed and the universal is achieved or realized. "The process of the development of art consists to a certain extent in the ability to free itself from the elements of personality and temporal style" (p. 174).

What Kandinsky envisages then, however vaguely, was the replacement of the individual and the local and/or temporal by some kind of "universal." By extolling the "pure and eternally artistic," he suggested, again only in dim outline, an ideal in which the artist becomes anonymous, receding behind the universally artistic (whatever one may understand by such a term). It was characteristic that in this context he mentioned the impact of Egyptian art on the modern spectator (pp. 173 f.). In the early twentieth century, let us recall, Egyptian art was considered the perfect model of a suprapersonal art, an art in which the impact of the individual artist was almost completely blotted out, leaving behind it only a supratemporal and supraindividual "universal."

But did this universal, the "pure and eternally artistic," have any particular affinity to composition? Kandinsky was not explicit about this, but

many an offhand observation suggests that he identified the spiritual in art to some extent with composition. I quote the last paragraph of the article "Painting as Pure Art," published in 1913:

> History teaches that the development of humanity consists in the spiritualization of many values. Among these values art takes first place. Among the arts, painting has set foot on the path that leads from the personally purposeful to the spiritually purposeful. From subject matter to composition. (p. 254)

Here composition is simply a synonym for the spiritual in art. This is very close in meaning to the way "composition" is used in the concluding paragraph of *On the Spiritual in Art*. Once again the whole paragraph should be read carefully:

> In conclusion, I would remark that in my opinion we are approaching the time when a conscious, reasoned system of composition will be possible, when the painter will be proud to explain his works in *constructional* terms (as opposed to the Impressionists who were proud of the fact that they were unable to explain anything). We see already before us an age of purposeful creation, and this spirit in painting stands in a direct, organic relationship to the creation of a new spiritual realm that is already beginning, for this spirit is the soul of the epoch of *the great spiritual*. (pp. 218–19; italics in the original)

This passage, close in spirit to Leonardo, is remarkable in many respects, and raises many questions. Here, however, we should emphasize just one point. What Kandinsky considered to be characteristic of artistic creation in that final epoch of the "great spiritual" was a reasoned "system of composition." It was the composition, then, that constituted the culmination of art. That the artist was able to explain his work in "constructional" terms, that is, in terms of the overall structure of his creation, also shows that the ultimate achievement of art was composition.

The Spiritual Origin of Composition

Kandinsky's and Mondrian's statements on the significance of composition, and art's ultimate realization in composition, raised a question that was of the utmost importance in the particular intellectual world of the early abstract painters. Was the artist's composition a matter of his own free invention, or was it in some unknown way prescribed by invisible but in-

escapable laws? In building up a composition, that is, a work as a whole, could the artist follow his fancy, combining shapes and colors as he wished, or was he forced to choose specific combinations?

That the compositional structure of a work of art is not a merely arbitrary combination of shapes has always been felt, though rarely articulated in terms of theory. Kandinsky knew that artists have always felt, more or less clearly, certain constraints in combining shapes and colors. To reveal the third element in the work of art, that is, the purely spiritual, he wrote in *On the Spiritual in Art*: "one must simply penetrate these first two elements with one's spiritual eye" (p. 173). In other words, when looking with a spiritual eye at the works of earlier periods, in which a personal manner and the style of a specific time prevail, one discovers in them too the purely and universally artistic. In other words, in paintings of all times we find some kind of "system of composition." In abstract painting, however, the "inner necessity" according to which composition is patterned is revealed.

This raises the question of how the artist arrives at such composition. Painters representing nature found a model for their compositions in the actual relationships prevailing among the objects and figures they were depicting, despite the fact that in nature the pure composition was obscured by the objects and the accident of their placement. The realistic painter, then, had to extract the composition from the reality around him, and purify what he extracted. But how did the abstract painter, an artist who did not follow external, visible nature, reach the knowledge and experience of composition? Since neither Kandinsky nor Mondrian believed that the artist "invented" the composition freely, the problem of origin became crucial. How, then, did the painter arrive at the cognition of the abstract "inner necessity"? This problem, while not explicitly raised, was an important feature in the background of the theory of abstract painting.

The critical reader, perusing the writings of the abstract painters with this question in mind, may discover two different answers hinted at. Not explicit theories, they are rather obscure and ambiguous statements. But they may adumbrate some orientations of thought. One such direction is the careful observation of the art of the past, always trying to peel off the personal and temporary, as it were, and bring to light the universal that is hidden beneath it. "And we see," wrote Kandinsky in *On the Spiritual in Art*, "that the common relationship between works of art, which is not weakened by the passage of millennia, but is increasingly strengthened, does not lie in the exterior, in the external, but in the root of roots—in the mystical

content of art" (p. 175). If we disregard historical and personal differences when looking at the great art of the past some common vision of the universally artistic will emerge before our eyes.

The other orientation, perhaps even less clearly formulated than the first, was the assumption that art has a pristine kernel. In the distant past, wrapped in a mythical mist, the knowledge of perfect composition was common knowledge. About a decade after the publication of *On the Spiritual in Art,* Kandinsky wrote another short systematic text, *Point and Line to Plane (Punkt und Linie zur Fläche),* published in Munich in 1926. In the introduction to this text he said:

> One may safely assume that painting was not always in such a helpless state as it is today, that there existed certain kinds of theoretical knowledge relevant not merely to purely theoretical questions, that the beginner could be and was taught a certain theory of composition, and in particular that a degree of knowledge about the nature and application of (pictorial) elements was taken for granted among artists. (p. 534)

This reads like a modern version of the myth of an original age of perfect wisdom lost in the course of history. Perhaps one could regain some of that secret knowledge and perfection by trying to extract it from the production of later periods, as it became increasingly obscured by the varieties of different styles. One could also try to attain it by some kind of direct introspection. Kandinsky was not alone in this view. A few years after Kandinsky, Mondrian also assumed two paths to the spiritual in art: "The path of doctrinal instruction or of direct exercise (meditation, etc.); and the slow and sure path of evolution."[4]

The affinity of these arguments to theosophical doctrines is evident . Both schools of theosophy taught both paths to recovering the original knowledge. The various theosophical trends assumed that the great religions of the world have an outer and an inner meaning. While the various religions differ from each other in outer appearance and formulation, their inner kernel or hidden core is always the same. If you are able to look through the outer shell and penetrate to the inner kernel, you will always find an identical truth. The true "Wisdom-Religion," said Madame Blavatsky, is esoteric in all ages. "The Wisdom-Religion was ever one, and being the last word of possible human knowledge, was, therefore, carefully preserved." As witnesses to this pristine wisdom she adduced "Buddha, Pythagoras, Confucius, Orpheus, Socrates, or even Jesus. . . ."[5] This was not mere syncretism, a jumbled mixture of the names of religious leaders.

Rather it was a deliberate and intentional way of stressing that the essence of religions is always the same.

Dwelling on the inner identity of religions lent urgency to the call to bring to light the truth behind all of them. One way of recovering that Wisdom-Religion was to penetrate the outer shell of the doctrines of these different teachers, and to reach their identical but hidden insight and truth. If you are able to get past the different teachings of, say, Confucius or Jesus, Buddha or Socrates, you will find that they say the same thing. A critical student of religion may have some serious doubts as to the validity of such sweeping statements, but among large audiences in the late nineteenth and early twentieth centuries these ideas were broadly accepted. Kandinsky explicitly referred to this as part of Madame Blavatsky's theory. Early in *On the Spiritual in Art* he wrote:

> Mrs. H. P. Blavatsky was perhaps the first person who, after years spent in India, established a firm link between these "savages" and our own civilization. This was the starting point of one of the greatest spiritual movements, which today unites a large number of people and has even given material form to this spiritual union through the Theosophical Society. This society consists of brotherhoods of those who attempt to approach more closely the problems of the spirit by paths of *inner* consciousness. (p. 143; italics in the original)

Kandinsky's reference to the "savages" is further evidence of his assumption that the "savage," that is, primitive man, possessed the knowledge that complex and progressive civilizations have lost. Another way of regaining this knowledge, therefore, may be to access the hidden and obscured primitive layers in our own person. The way to such introspection was even less explicitly formulated than the first way. This may be what Kandinsky had in mind when he wrote at the beginning of the chapter on "Art and Artist" in *On the Spiritual in Art*: "In a mysterious, puzzling, and mystical way, the true work of art arises 'from out of the artist'" (p. 210).

In this and other statements we see the impact of the theosophical doctrines on the origins of secret knowledge on the writings of the abstract painters. However we may judge the correspondence between the theories of abstract composition and theosophy, it is obvious that the modern "spiritual" movement, of which both Kandinsky and Mondrian were followers, served as model and source of inspiration to artists in the early twentieth century.

Harmony

So far we have seen that composition is the structure of the work of art as a whole. What is the expressive nature of that wholeness? What are the expressive features that dominate it?

The writings of the abstract painters answer this question with reference to the concept of harmony. This concept occurs frequently and occupies a central place and function in their writings. In Mondrian's *Dialogue on the New Plastic*, written in the form of a conversation between a singer (A) and a painter (B), we find the following remarkable passage:

> B. Painting has shown me that the equilibrated composition of color relationships ultimately surpasses naturalistic composition and naturalistic plastic—when the aim is to express equilibrium, harmony, as purely as possible.
>
> A. I agree that the essential of art is the creation of harmony. . . . (Mondrian, p. 79)

Earlier, in *On the Spiritual in Art*, Kandinsky described "the inner sound of color," perceived "amidst extremely rich and different combinations," as harmony (p. 191). A little later he wrote that composition consists of the juxtaposition of shapes that have an independent existence, each of them being derived from its "internal necessity." He added: "Only those individual constituents are essential . . ." (p. 193). The less well-known painter Adolf Hoelzel, whom we have already mentioned, also emphasized that in the combination of colors the painter had to follow the demands of harmony.[6] Harmony, then, was conceived of as a supreme value of the picture as a whole, as an aim of painting as an art.

At this stage of our discussion we should digress for a moment and briefly recall the meaning of harmony through history, and the connotations it carried. We should also make some comment on what the concept implied around the turn of the century, when the founders of abstract painting declared it to be "the essential of art."

As is well known, the history of the concept of harmony goes back to the dawn of civilization. It was part and parcel of theories central to the study and explanation of several fields, primarily (but not exclusively) of music and cosmology. Its original meaning—concord, agreement—refers mainly to musical theory and the structure of the cosmos, but it was also applied to the purification of the soul (Iamblichus, *Vita Pyth.* 110). The care of the

soul, we read in Plato's *Timaeus*, consists in bringing its modulations into harmony with the cosmic order. This particular combination of fields and connotations—aesthetic (musical), cosmological, and soul saving—was transmitted to the tradition of European culture.[7]

In the course of time, particularly in the modern world, the meaning of harmony became more limited, at least in the sense the term was widely employed. The "harmony of the spheres" was replaced by cosmological science. In the prevailing cultural consciousness the term "harmony" became, on the one hand, more closely connected with music and music theory than before, and, on the other, it acquired a more emotional, expressive quality (even when used with regard to nonhuman reality). Though some echoes of the ancient meanings of harmony probably reached the founders of abstract painting, it was, of course, in the modern sense that they used the term. It is therefore of interest to know what specific emotional connotations the concept of harmony carried in the nineteenth century.

The emotional character of harmony was understood then, as it still is today, primarily as the agreeable congruity of parts. More specifically, it was perceived as a pleasing combination of two or more tones in a chord, and a soft, smooth, and pleasing transition, mainly from one tone to the other. Harmony thus had a definite and distinct emotional quality, a quality believed to be founded in nature. The "music of the spheres" as the comprehensive basis for acoustic harmony was replaced by what was believed to be the physiological structure of our perception.

Hermann Helmholtz, the path-breaking physiologist whose influence on painting we have considered earlier in this volume,[8] evoked an interesting and famous controversy when he published his study on the physiological foundations of music, translated into English as *On the Sensations of Tone*. Speaking of the riddle of harmony, he said: "The ear resolves all complex sounds into pendular oscillations, according to the law of sympathetic vibration, and it regards as harmonious only such excitements of the nerves as continue without disturbance."[9] Helmholtz's theory gave rise to a heated discussion that had a significant impact on aesthetic theory in general.[10] He intended to provide a scientific foundation for the aesthetic theory of music, a task that appeared feasible because he assumed a parallelism between physiological structure and psychological reality. Whatever the current opinion of this theory, Helmholtz's work in music theory clearly shows that the emotional quality of harmony was perceived as the total lack of, and even complete opposition to, dissonance. This, in general lines, is how

Kandinsky and Mondrian must have perceived the prevailing connotations of harmony. What does harmony mean in their theories of painting?

The founders were not content with the prevailing view. Two separate reasons made them reject the concept of a smooth harmony. First, they were aware of how complex and problematic the perception of harmony (as well as of other formal orders endowed with emotional quality) is. The perception of concord and agreement could not be taken for granted. They were well aware of the impact of subjective deviations, even if they did not sufficiently explore these as a psychological phenomenon. Harmony, said Mondrian, "does not mean the same thing to everyone and does not speak to everyone *in the same way*" (Mondrian, p. 79; italics in the original).

But the subjective variability of harmony, the fact that not everyone perceives the same configurations as harmonious, or in the same way, as Mondrian put it, was not the main concern of the founders of abstract painting. The second reason for their rejecting the accepted characterization of harmony was more profound. They perceived of harmony not merely as existing in the realm of perception, as a serene mood induced by certain shapes. In their mind harmony had an "objective" nature, a structure that in some cases may induce in the spectator (or in the listener) a sense of what we call harmony, but that had a reality beyond individual perception and mood. This "mystical" reality, as they sometimes called it, was not correctly characterized as soft, smooth, peace-inducing. The objective reality of harmony, as they understood it, was a different one.

Once again it is best to listen carefully to Kandinsky. "It is perhaps with envy, or with a sad feeling of sympathy," he wrote, "that we listen to the works of Mozart. They create a welcome pause amidst the storms of our inner life, a vision of consolation and hope, but we hear them like the sounds of another, banished, and essentially unfamiliar age." Here musical harmony embodies or evokes the perfect bliss of a mythical, legendary age. But though such harmony was a mythical ideal, it was not the harmony the founders of abstract painting were seeking. In a tone suggesting that he was proclaiming the ultimate truth of abstract painting, Kandinsky continued: "Clashing discords, loss of equilibrium, 'principles' overthrown, unexpected drumbeats, great questionings, apparently purposeless strivings, stress and longing (apparently torn apart), chains and fetters broken (which had united many), opposites and contradictions—this is our *harmony*" (p. 193; italics in the original).

Obviously Kandinsky rejected out of hand the common view of smooth harmony. What he was aiming at was the manifestation of discord and con-

flict, but in an overall pattern that balanced the contradictions. "Of course, it is clear on the one hand that the incompatibility of certain forms and certain colors should be regarded not as something 'disharmonious,' but conversely as offering new possibilities—i.e. also [a form of] harmony," he wrote (p. 163).

The abstract painters' link to the crisis of traditional harmony is perhaps best illustrated by a biographical detail: Kandinsky's close connection to Arnold Schoenberg, the composer whose name became symbolic of one of the most radical revolutions in modern music. Kandinsky's interest in Schoenberg's music dated from the beginning of 1911, that is, before he started writing *On the Spiritual in Art*. He referred to an article Schoenberg published in 1910 and translated part of it into Russian. This was to become part of his *Harmonielehre* (*Theory of Harmony*). In his article Schoenberg emphasized that dissonances were no less important than consonances (pp. 91–95). In 1912, shortly after the publication of *On the Spiritual in Art*, Kandinsky again wrote about Schoenberg, mainly about the pictures the musician painted (pp. 221–26). Schoenberg's thoughts on harmony and dissonance, one can safely assume, were for Kandinsky a living reality, constituting the background against which his theory crystallized in his mind. His yearning for a new harmony was shared by some trends in music as well as in painting.

A few years later Mondrian also expressed similar ideas, and he too evoked the model of music. In his *Neo-Plasticism*, published in 1920, he wrote in a revolutionary mood:

> When we listen to modern musicians who have not broken radically with sentimental instrumentation, it seems indeed that our time is not yet mature. . . . *The old tonic scale, along with the usual instruments, must be banished from music if the new spirit is to be plastically expressed.* . . . As with color in painting, sound in music *must be determined* both by composition and by plastic means. Composition will achieve this through a *new, double harmony in neutralizing opposition.* (Mondrian, p. 146; italics in the original)

In 1924 Mondrian wrote a manifesto called "Down with Traditional Harmony!" that was obviously addressed to a Futurist audience. Presenting his Neo-Plastic doctrine he said: "When it speaks of equilibrated relationship, Neo-Plasticism does not mean symmetry but constant contrast" (Mondrian, p. 191). In the same manifesto he quoted what he himself had said a few years earlier: "This 'disharmony' (according to the old concep-

tion) will be fought and attacked everywhere in the new art so long as the new harmony is not understood."

The painters who founded abstract art were anxious not to confine their concept of a new harmony to the domain of the conceptual; they tried to translate it immediately into the painter's practice. What did this tense, dialectic harmony mean particularly to the painter? How did he realize the harmony of contrasts in his actual work? Such questions were a permanent concern of the artists who founded abstract painting. It was not a philosophical doctrine they wanted to proclaim, but mainly a theory for artists. Said Kandinsky: "*Composition on the basis of this* [new] *harmony is the juxtaposition of coloristic and linear forms that have an independent existence as such, derived from internal necessity, which create within the common life arising from this source a whole that is called a picture*" (p. 193; italics in the original). The new harmony, then, was the harmony of manifest contrasts.

Some Concluding Comments

The critical student will necessarily ask himself how the abstract painters' strivings toward harmony should be evaluated. What final conclusions should one who immerses himself in these artists' sometimes terse and emphatic texts draw from their thoughts and impulses?

Before entering a discussion summarizing our explorations we should emphasize once again that we are not dealing with a philosophical system. The criteria appropriate to evaluating a philosophical system, therefore, cannot be applied to a theory of art, particularly one such as that articulated by the founders of abstract painting. The value of such art theory does not lie in its consistency argument leading to the solution of a problem. Rather, its significance consists in showing the problems the abstract painters faced, their spiritual sources, and the goals that they were, or were not, able to achieve in their theoretical reflections.

The philosophical reader, judging the consistency and structure of the arguments that Kandinsky and Mondrian put forward, may perhaps conclude that, at a theoretical level, these painters were unable to show how a composition could convey both the sense of contrast and dissonance and the sense of a unified harmony. Considered merely in conceptual terms, the "new harmony" which both Kandinsky and Mondrian envisaged (sometimes they also called it "our harmony"), may be insufficiently explained. But what does this theory reveal to us of how they understood the art they

were creating, and what they wished their new art to be? We may summarize our answer, to these questions if only schematically, in two main points.

The first of these is the very need for harmony. Reading what these painters wrote about harmony, one cannot miss the tone of urgency in their expression. The matter was of the utmost significance to them for several reasons. First and foremost they felt the need to secure the unity and inner wholeness of the painting. While this demand is valid for all art, it is particularly striking in abstract painting. In traditional painting, the natural subject matter (the landscape, the interior, or the story represented) secured a basic unity. With the exclusion of such natural subject matter, the danger of losing the unity and cohesion of the work of art, of the painting "falling apart," became a problem. It is therefore not surprising that the need and importance of harmony was more emphatically emphasized in the theory of abstract art than in other contemporary trends of art and art theory.

Another reason, less easily pinpointed but not devoid of significance, pertains to the intellectual context and sources of abstract painting. The esoteric doctrines, mainly theosophy and anthroposophy, conceived of the "spiritual worlds" that man attempts to experience as worlds permeated with harmony. Their depiction of the spiritual world, it seems natural to conclude, was therefore the depiction of a harmonious whole.

Finally, the emphasis placed on harmony reveals the profound connection the abstract painters perceived between painting and music. We have seen in the preceding chapters how crucial was the link between painting and music to these artist-thinkers. But the significance of the connection between color and sound, between painting and music, went beyond that of an inner relationship between two specific arts. Ultimately it revealed a hidden layer, a unique spiritual reality which secures the unity of all the arts. In the essay "On Stage Composition," written in the winter of 1911–12, Kandinsky clearly formulated this view:

> Every art has its own language, i.e. those means which it alone possesses.
> Thus every art is something self-contained. Every art is an individual life. It is a realm of its own.
> For this reason, the means belonging to the different arts are externally quite different. Sound, color, words! . . .

In the last essentials, these means are wholly alike: the final goal extinguishes the external dissimilarities and reveals the inner identity. (p. 257; italics in the original)

This ultimate identity between the arts was revealed by the centrality of harmony. Harmony revealed the hidden identity of all the arts.

So far I have tried to summarize one point in the doctrine of harmony, namely, the intellectual urges that made harmony central to the abstract painters' understanding of art. The second point that should be discussed briefly is their insistence that clash and discord, conflict and dissonance should not be mitigated for the sake of, or in the process of achieving, harmony. There are several aspects to this insistence, and I will attempt to spell them out concisely.

The first aspect was clearly polemical, and obviously spoke to a specific condition in the arts of their time. The insistence on the depiction of dissonance, on not sacrificing conflict in order to attain harmony, was directed against tendencies that were trying to gloss over dissonance in order to achieve a harmonious unity. The insistence on presenting, without mitigation, incompatibilities and conflicts to the viewer of a painting may well have been influenced by—and from a historical distance should perhaps even be seen as forming part of—the protest of young revolutionary artists against what they often called "the insincerity" of established, accepted art. Now, "insincerity" is, at least in the present context, a rather problematic notion, and should be employed with care. But what the young artists meant by their protests is more easily established: that the art to which they objected was glossing over conflict in subject matter as well as in the system of forms, thus resulting in a spurious harmony. In rejecting this established art, the doctrine of abstract painting was part of a larger historical process.

A second aspect, specific to the abstract painters, was the belief that harmony should be built up of manifestations of discord and dissonance. In this respect, it is important to remember that the founders of abstract art differed from what was probably their main intellectual source. The esoteric movement represented by both theosophy and anthroposophy also longed for harmony. However, they preached that by ascending into the superior spheres with our minds, with our "cognition of superior worlds," to use Rudolf Steiner's formulation, we could go beyond the realm of discord and dissonance. These "superior worlds" were realities in which conflict and contradictions just did not exist. At this decisive stage, the painters diverged from their masters in spirituality. One of the factors behind their profound impact on modern art and thought was their belief in open discord within harmony.

It is obvious that the desire for expression was the artists' main motive in rejecting ` harmony devoid of conflicts. While Kandinsky and Mondrian

did not explicitly speak of "expression," in their view the main value of the work of art was that it conveyed a message or an idea (whatever they may have been). Kandinsky rejected the belief that art is "purposeless," that the work of art should exist for its own sake. Therefore he totally rejected *l'art pour l'art* (p. 212). Now, the opposite of art for its own sake is art as expression, and in order to express oneself one also has to show discord and dissonance. The abstract painters' concept of art as expression, particularly the expression of clash and conflict, was often rather vague. But the very urge that the paintings we look at reveal something (and that the something revealed not always be art itself) cannot be overlooked in their doctrines and in their way of writing.

In this respect, both in terms of what they achieved theoretically and in terms of what they articulated but could not solve conceptually, the theory of the abstract painters raised issues that had a crucial impact on art movements, and on artistic thought at large, in the course of the twentieth century. They still agitate the minds of critics today.

NOTES

1. Filippo Baldinucci, *Vocabolario Toscano dell' Arte del Disegno*, originally published by the Accademici della Crusca (Florence, 1681), and recently photographically reprinted (Florence, n.d.). I use the reprint. For the entries mentioned, see pp. 33 and 2–3.

2. Boime, *The Academy and French Painting*, pp. 43–47, even believes that "the most original innovation of the nineteenth-century Academic curriculum was the compositional programme." Yet while the study of composition was certainly of central significance, the slow reception of innovations may have made the study somewhat unexciting. See, in general, Nikolaus Pevsner, *Academies of Art: Past and Present* (Cambridge, 1940), especially chapter V.

3. See above, part 1, chapter 5.

4. Quoted from Ringbom, *The Sounding Cosmos*, pp.109 f.

5. Blavatsky, *The Key to Theosophy*, pp. 7–12.

6. Hess, *Dokumente*, p. 97.

7. Once again an important scholarly work should be mentioned: Spitzer, *Classical and Christian Ideas of World Harmony*. While Spitzer deals with what he calls "historical semantics," his discussions have a bearing on the study of many other fields, including a history of the visual arts.

A concise, useful survey of the pertinent ideas, and a good bibliography, may be found in the entry by Gretchen Ludke Finney, "Harmony of Rapture in Music," in Wiener, *Dictionary of the History of Ideas*, II, pp. 388–95.

8. See part 1, chapter 4.

9. Hermann L. F. Helmholtz, *On the Sensations of Tone as a Physiological Basis for the Theory of Music*, translated by Alexander J. Ellis (New York ,1930), p. 229.

10. Charles Lalo, *Esquisse d'une esthétique musicale scientifique* (Paris, 1908), esp. pp. 90 ff.

Bibliographical Essay

Scholarly studies on the art of the late nineteenth and early twentieth centuries abound. They are scattered in publications in different fields and of very different types, and are thus difficult to survey. The following bibliography, as that of the previous volume in this series, in no way aims at completeness; on the contrary, it is highly selective, and to a considerable extent personal. I have designed it to assist the reader who wishes to study the sources of the theories discussed, and to follow up on the problems raised in this volume. I should also like to record some of my major intellectual debts in the study of reflections on art during the four crucial decades to which this volume is devoted.

I have excluded all publications of a general nature—on the history, culture, and even the art of the period discussed in this volume—although interesting suggestions for our specific subject may be found in some of them, and have kept close to our theme, the main trends and developments in the *theory* of art.

Impressionism

The literature on impressionism, scholarly as well as popular, is large, but not always easy to use. Though many discussions, usually brief ones, on problems of impressionistic art theory are found in the various studies, there is no easily available comprehensive and systematic work devoted primarily to the theoretical foundations and the conceptual implications of this movement in art. In the present essay I can mention only a small sample of the literature.

John Rewald, *The History of Impressionism* (New York, 1973; original edition 1946; revised edition 1961) is essential not only for the study of impressionism as an art movement, but also for our specific subject, the theory of art. This work contains a great deal of texts (notes, letters, memoirs)

that reflect the theoretical views of impressionist painters and of critics linked with this movement. Rewald's work also has useful detailed bibliographies.

Exhibition catalogs are sometimes another important source for the study of art theories. The catalog of an exhibition held in Paris, London, and New York, *The New Painting: Impressionism 1874–1886* (Seattle and Oxford, 1986) documents the original exhibitions of the impressionists, and provides insights into the reaction of their audiences.

The social character of impressionism, its painters as well as its spectators, has attracted scholarly attention. Interesting analyses of the interaction of impressionistic painting and its public are found in Robert L. Herbert, *Impressionism: Art, Leisure, and Parisian Society* (New Haven and London, 1988). For an understanding of the social and historical context of impressionism, see also T. J. Clark, *The Painting of Modern Life* (New York and London, 1985). The essays by Meyer Schapiro on Courbet, Cezanne, and Seurat, some of them reprinted in Schapiro's *Modern Art: Nineteenth and Twentieth Centuries, Selected Papers* (New York and London, 1978) also make a contribution to the study of impressionistic theory. The old work by Arnold Hauser, *The Social History of Art* (New York, 1958), vol. 4, pp. 166–225, expresses an extreme position in a sociological interpretation of impressionism and the ideas it raised.

Broader historical and intellectual contexts have also been taken into consideration in the interpretation of impressionism. Francis Haskell, *Rediscoveries in Art* (London and Ithaca, N.Y., 1976) and Edward Lockspeiser, *Music and Painting: A Study in Comparative Ideas from Turner to Schoenberg* (London, 1973), although they deal with altogether different aspects, make interesting contributions by placing impressionism within a broader cultural background. For a study of wider aspects of art in the period discussed in the present volume, mainly for an understanding of the links between art and technology and social culture, see also Stephen Kern, *The Culture of Time and Space, 1880–1918* (Cambridge, Mass., 1983).

Texts by impressionist artists or critics or writers immediately linked with the movement are not many, and they are scattered in different publications. A useful collection of relevant literary sources is Linda Nochlin, ed., *Impressionism and Post-Impressionism 1874–1804: Sources and Documents in the History of Art* (Englewood Cliffs, N.J., 1978). Elizabeth G. Holt, ed., *From the Classicists to the Impressionists: A Documentary History of Art and Architecture in the Nineteenth Century*, 2 vols. (Garden City, N.Y., 1966), especially part VI, though very concise, is valuable to the student.

The reception of impressionism in England, including a discussion of the theoretical problems it raised, is well documented in Kate Flint, ed., *The Impressionists in England: The Critical Reception* (London, 1984).

Literary and intellectual movements in western Europe, contemporary with impressionism and sometimes linked with it, should also be considered in the study of the art theory of this pictorial school or tradition. Walter Pater's writings, frequently reprinted, and available in many editions, may shed light on some of our problems. For our purpose, his central text is *The Renaissance: Studies in Art and Poetry* (London, 1877). A well-balanced survey of the modern studies of Pater's work, also with some attention to his influence, is found in William E. Buckler's introduction to his edition of *Walter Pater: Three Major Texts* (New York and London, 1986). Buckler's interest is concentrated on Pater's views of literature, and therefore not much is said about the significance of the visual arts in his aesthetics. For a discussion of the philosophical problems underlying Pater's work, with some particular concern for the problems of impressionism, see Walter Iser, *Walter Pater: Die Autonomie des Aesthetischen* (Tübingen, 1960); there is also an English translation of this study. *Walter Pater: The Aesthetic Moment* (Cambridge, 1987).

The basic text for the aesthetic views of the brothers Goncourt is the *Journal des Goncourts. Mémoires de la vie littéraire* (Paris, 1989), frequently reprinted. The study of the Goncourts' aesthetic doctrine by Pierre Sabatier, *L'esthétique des Goncourts* (Paris, 1920; reprinted Geneva, 1970), is still classic. Erich Koehler, *Edmond und Jules de Goncourt: Die Begründer des Impressionismus* (Leipzig, 1912) is also useful.

Among late-nineteenth-century philosophical trends that are of significance for the understanding of impressionism is the philosophy of Henri Bergson. For a study of the history of ideas Bergson's impact on general culture was important. For our subject, his major works are *Matière et mémoire* (Paris, 1896), translated into English as *Matter and Memory* by Nancy Margaret Paul and W. Scott Palmer (London, 1911), *Essai sur les données immédiates de la conscience* (Paris, 1889), and *L'Evolution créatrice* (Paris, 1907).

Bergson's aesthetics have been studied several times. I should mention Arthur Szathmary, *The Aesthetic Theory of Bergson* (Cambridge, Mass., 1937), and recently Mark Antliff, *Inventing Bergson* (Princeton, 1993).

The interaction of science and art, with special emphasis on optics, is traced, in broadest outlines, by Martin Kemp in *The Science of Art: Optical Themes in Western Art from Brunelleschi to Seurat* (New Haven and London,

1990). Marshall H. Segall, Donald T. Campbell, and Melville J. Herskovits, *The Influence of Culture on Visual Perception* (Indianapolis, New York, and Kansas City, 1966), raises some general problems with which impressionism was concerned, and, though it does not deal with art, is of interest for our subject.

I am not aware of a detailed and comprehensive study of the interaction of science and art in impressionism. Recent analyses of the impact made by individual scientists on the culture of the age, though they do not usually pay much attention to painting, often yield interesting insights. For Mach, see recently John Black, ed., *Ernst Mach: A Deeper Look* (Dordrecht, 1992).

Helmholtz's writings on the interrelation of science and general culture have recently been published (or republished) in English. See Hermann von Helmholtz, *Science and Culture: Popular and Philosophical Essays* (Chicago, 1995). Also of interest for our purpose is the monograph by R. Steven Turner, *In the Eye's Mind: Vision and the Helmholtz-Hering Controversy* (Princeton, 1994), though it does not deal with painting.

For William James, see Olaf Hansen, *Aesthetic Individualism and Practical Intellect: American Allegory in Emerson, Thoreau, Adams, and James* (Princeton, 1990), chapter 6.

The style of impressionistic painting has been discussed frequently. Every study of impressionism necessarily also touches on the theoretical problems raised by this style. Once again, however, the theoretical issues have rarely been discussed independently, as subjects in their own right. Among art historical studies that pay special attention to theoretical issues, though without separating them from the actual painting, those by Fritz Novotny should be mentioned. See especially his *Cezanne und das Ende der wissenschaftlichen Perspektive* (Vienna, 1938) and the last part of his *Painting and Sculpture in Europe, 1780–1880* (Baltimore, 1960).

For the impressionists' attitude to color, see the stimulating studies by Meyer Schapiro, now collected in his *Modern Art: Nineteenth and Twentieth Centuries*. A good collection of statements on color made by modern painters, including impressionists, is Walter Hess, ed., *Das Problem der Farbe in den Selbstzeugnissen moderner Maler* (Mittenwald, 1981). I know of no comparable selection of statements on composition and line.

For the fragment as an art form, especially in sculpture, see the scattered observations in H. W. Janson, *Nineteenth-Century Sculpture* (New York, 1985). The different forms of the fragment, and its transformations in the course of history, are discussed from various points of view in J. A. Schmoll gen. Eisenwerth, *Das Unvollendete als künstlerische Form* (Bern and Mu-

nich, 1959). The observations by Thomas McFarland, *Wordsworth, Coleridge, and the Modalities of Fragmentation* (Princeton, 1981) are concerned only with literature, but raise some broad questions that may also be pertinent to the visual arts.

Empathy

The scholarly literature pertaining to the trend we call empathy is particularly difficult to lay hold of. Investigations of empathy are widely scattered and found in many disciplines, among them psychology, philosophy, literary theory, and musicology. While this wide diffusion of studies shows the central significance of the concept of empathy, it also explains the difficulties of a bibliographical survey of pertinent studies.

There is no comprehensive systematic study of the concept of empathy from the point of view of the visual arts. Some scholarly works deal with important general aspects of the notion of empathy in the late nineteenth and early twentieth centuries, and are thus of significance to this volume. For the general scientific background of the doctrine of empathy (without reference to art), see Edwin G. Boring, *Sensation and Perception in the History of Experimental Psychology* (New York and London, 1942). In the context of physiognomics, of the direct understanding of the expression of emotions both in life and in all forms of cultural creation, see the important study by Karl Bühler, *Ausdruckstheorie: Das System an der Geschichte aufgezeigt* (Jena, 1933). Though Bühler does not deal with art, his discussion is also significant for understanding the aesthetic aspects of the concept. Several of Rudolf Arnheim's studies illuminate the sources and background of empathy theories, sometimes as they are applied to the analysis of works of art. See especially his *New Essays on the Psychology of Art* (Berkeley, Los Angeles, and London, 1986), as well as other volumes of essays.

The works of the individual scholars and writers who contributed to the theory of empathy, as well as the most important monographic studies dealing with each of them, have been discussed in the chapters of part II. Here I shall mention only some of the most representative texts. Even for the contemporary reader, the scientist's approach to the problem is well presented by the still very readable work by Charles Darwin, *The Expression of the Emotions in Man and Animals*. Originally published in London in 1872, it is now available in many editions.

The slim brochure by Robert Vischer, *Über das optische Formgefühl: Ein Beitrag zur Aesthetik* (Leipzig, 1873) is a crucial document of the philosophical approach to empathy, and had a significant, if implicit, influence on Heinrich Woelfflin, and through him on modern "formal" approaches to art. An article by Robert Vischer's father, the philosopher Friedrich Theodor Vischer, entitled "Das Symbol," influenced Aby Warburg, and through him made a lasting impact on another central tradition in modern research on art. For the latter, see E. H. Gombrich, *Aby Warburg: An Intellectual Biography* (London, 1970).

The concept of empathy was defined by Theodor Lipps in his *Grundlegung der Aesthetik*, I (Hamburg and Leipzig, 1903). In English see his essay, "Empathy and Aesthetic Pleasure," in A. Aschenbrenner and A. Isenberg, eds., *Aesthetic Theories: Studies in the Philosophy of Art* (Englewood Cliffs, N.J., 1965). Victor Basch, *Essai critique sur l'esthétique de Kant* (Paris, 1896), and James Sully, *The Human Mind: A Textbook of Psychology* (London, 1892) show that as a psychological theory the doctrine of empathy was widely diffused in Europe during the late nineteenth century.

Ernst Dilthey, a German philosopher and historian of culture, applied the concept to literature. See his *Das Erlebnis und die Dichtung: Lessing, Goethe, Novalis, Hölderlin* (Leipzig, 1906). For Dilthey's application of empathy to the understanding of poetry, see René Wellek, *A History of Modern Criticism, 1750–1950*, vol. 4, *The Later Nineteenth Century* (Cambridge, 1983), and Kurt Müller-Vollmer, *Towards a Phenomenological Theory of Literature: A Study of Wilhelm Dilthey's Poetik* (The Hague, 1963). Though Dilthey did not study the visual arts, he had an impact on art theory.

The critic Konrad Fiedler developed a general theory implicitly based on the concept of empathy, which he also applied to the field of visual experience and creation. An important essay by Fiedler has appeared in English entitled *On Judging Works of Visual Art*, translated by Henry Schaefer-Simmern and Fulmer Mood, 2d ed. (Berkeley, 1957). On Fiedler, see Hermann Konnerth, *Die Kunsttheorie Conrad Fiedlers* (Munich and Leipzig, 1909) and Udo Kultermann, *Kunst und Wirklichkeit: Von Fiedler bis Derrida* (Munich, 1991), pp. 191–97. See also Michael Podro, "The Parallel of the Linguistic and Visual Formulation in the Writing of Konrad Fiedler," *Filosofia* XII (1961), pp. 287–310.

Adolf Hildebrand, sculptor and writer on art, made significant contributions to the conceptual framework of modern discussions on art. His theoretical writings are collected in his *Gesammelte Schriften zur Kunst,*

edited by Henning Bock (Cologne and Opladen, 1969). His central work, *Das Problem der Form in der bildenden Kunst* (Strasbourg, 1893), also appeared in an English translation by M. Meyer and R. O. Ogden, *The Problem of Form in Painting and Sculpture* (available as Garland reprint, New York and London, 1972). An informative discussion of Hildebrand's doctrines can be found in Bock's introduction to his edition of Hildebrand's writings on art.

The towering figure of Alois Riegl is now, nine decades after his death, the subject of an intense and important debate among both art historians and students of cultural history in general. His major works are *Stilfragen* (Berlin, 1893), recently published in English as *Problems of Style*, translated by Evelyn Kain (Princeton, 1992); *Die Spätrömische Kunstindustrie* (Vienna, 1901), now translated into English by Rolf Winkes as *Late Roman Art Industry* (Rome, 1985); and a collection of essays, *Gesammelte Aufsätze* (Augsburg and Vienna, 1929).

The analysis of Riegl's work and thought, and particularly of his concept of *Kunstwollen* (artistic volition), has been one of the most significant themes in the critical discussion of problems in art theory during the twentieth century. Among the most important contributions to these discussions are Erwin Panofsky, "Der Begriff des Kunstwollens," *Zeitschrift für Aesthetik und allgemeine Kunstwissenschaft* 14 (1920), pp. 321–39 (reprinted in Panofsky's *Aufsätze zu Grundfragen der Kunstwissenschaft*, edited by Hariolf Oberer and Egon Verheyen [Berlin, 1964], pp. 33–47). Edgar Wind's extensive study, "Zur Systematik der künstlerischen Probleme," *Zeitschrift für Aesthetik und allgemeine Kunstwissenschaft* 118 (1925), pp. 438–86, and 25 (1931), pp. 163–66, is to a large extent another attempt to understand Riegl's theory, especially the *Kunstwollen*. Otto Pächt, "Art Historians and Art Critics: Alois Riegl," *Burlington Magazine* 105 (1963), pp. 188–93, presents Riegl's doctrine sympathetically, if somewhat differently from other students. A critical attitude to Riegl as "Hegelian" is powerfully presented by E. H. Gombrich in many of his studies. See especially Gombrich's "In Search of Cultural History," reprinted in the author's *Ideas and Idols: Essays on Values in History and in Art* (Oxford, 1979), esp. pp. 43 ff. In the context of ornament and the decorative arts, the study of which was also important for Riegl, Gombrich analyzes Riegl's *Kunstwollen* in his *The Sense of Order: A Study in the Psychology of Decorative Art* (Oxford, 1979), pp. 195 ff. See also Michael Podro, *The Critical Historians of Art* (New Haven and London, 1982), pp. 71–97. Debate and interpretation of Riegl continue with undiminished vigor.

Wilhelm Worringer's *Abstraktion und Einfühlung: Ein Beitrag zur Stilpsychologie* (Munich, 1908) has been translated into English by Michael Bullock, and published (in paperback) as *Abstraction and Empathy: A Contribution to the Psychology of Style* (Cleveland and New York, 1967). For the theoretical implications of Worringer's views, see Arnheim's essay "Wilhelm Worringer on Abstraction and Empathy," originally published in *Confinia psychiatrica* X, 1 (1967), and republished in Rudolf Arnheim, *New Essays on the Psychology of Art* (Berkeley, Los Angeles, and London, 1986), pp. 50–62.

Discovering the Primitive

The discovery of the primitive in the decades discussed in this volume affected many disciplines and fields of research and thought. Scholarly investigations of the process by which European high culture came to know the primitive in its many variations are, therefore, found in different fields of study.

A classic work in the history of art is Robert Goldwater, *Primitivism in Modern Art* (Cambridge, Mass., 1938; enlarged edition, 1986). Though explicitly dealing with art alone, Goldwater in fact suggests a broad canvas of cultural movements. Goldwater's book will be useful in the study of almost all aspects of the nineteenth-century discovery of the primitive that have some connection to art. For a somewhat earlier period, see also F. S. Connelly, *The Origins and Development of Primitivism in Eighteenth and Nineteenth Century European Art and Aesthetics* (Ann Arbor, Mich., 1990).

For our purpose, the first scholarly discussion of primitive art is Gottfried Semper's *Der Stil in den technischen und tektonischen Künsten oder praktische Aesthetik*, 3 vols. (Munich, 1860–63). Among modern discussions of this work and its influence we should mention Heinz Quitzsch, *Die ästhetischen Anschauungen Gottfried Sempers* (Berlin, 1962). And see also Michael Podro, *The Critical Historians of Art* (New Haven and London, 1982), pp. 44–58.

The discovery and exploration of prehistoric art and culture have given rise to many important studies. Glyn Daniel, *The Idea of Prehistory* (Harmondsworth, 1962) provides a comprehensive and well-balanced history of the way the idea of prehistory came into being and influenced various specific investigations. It also provides a good selective bibliography. For the religion of prehistoric societies much can be learned from Johannes

Maringer, *The Gods of Prehistoric Man* (London, 1960). The original German edition appeared in 1958. For the impact of technology I found the interpretation of the well-known psychologist Leon Festinger, *The Human Legacy* (New York, 1983) of interest.

Since prehistoric art is so closely interrelated with ritual and religious belief, the subject has been frequently discussed. A pioneering study was an article by Salomon Reinach, "L'art et la magie," that originally appeared in *L'Anthropologie* in 1903, pp. 257–66, and is now easily available in Reinach's *Cultes, mythes et religions*, vol. 1 (Paris, 1922), pp. 125–36. The same subject, art and religion in prehistoric times, was also presented in Hermann Klaatsch, *Die Anfänge von Kunst und Religion in der Urmenschheit* (Leipzig, 1913). For more recent investigations, see Maringer's work cited above which is also significant for the study of prehistoric art.

Among early modern speculations about the origins of art, related to religion but also considering different influences, the book by Yrjö Hirn, *The Origins of Art: A Psychological and Sociological Study* (London, 1900), should be mentioned. Another early work on the same subject is Max Verworn, *Die Anfänge der Kunst* (Jena, 1909). Also of considerable historical interest in this context is Verworn's *Zur Psychologie der primitiven Kunst* (Jena, 1907). Here Verworn coined the term "ideoplastische Kunst" to describe the character of an art different from that of the western world. This concept exerted a wide and lasting influence on interpretations of prehistoric and primitive art.

The discovery of primitive and prehistoric art is also related to, and to some degree influenced, the study and interpretation of the early "high" cultures, that is, the cultures that preceded the Greek world and classical Antiquity. Naturally here we are concerned only with the nineteenth-century "discovery" of these ancient cultures, not with them in their own right, or with what we know of them today. Gaston Maspero, *Archéologie Egyptienne* (Paris, 1887) is an early attempt to interpret the emergence of Egyptian art, and particularly the "laws" governing it.

In central Europe, two scholars who made lasting contributions in their attempt to interpret Egyptian art as showing universal archaic patterns were Heinrich Schäfer and Emanuel Löwy. Though Schäfer's comprehensive publications appeared only in the first decades of the twentieth century, his study goes back to earlier stages. In his *Von ägyptischer Kunst* (Leipzig, 1919) Schäfer attempted to define the basic structures of Egyptian representations of space and the human figure. Emanuel Löwy also searched for "basic forms" in the archaic mind and imagination. In his *Die*

Naturwiedergabe in der ältern griechischen Kunst (Rome, 1900), translated into English by John Fothergill as *The Rendering of Nature in Greek Art* (London, 1907), Löwy introduced the concept of the "memory image" (*Erinnerungsbild*) that served as the primordial model of all archaic renderings of the human figure. For an appreciation of these early attempts, mainly of Löwy's, see Meyer Schapiro, "Style," originally published in A. L. Kroeber, ed., *Anthropology Today* (Chicago, 1953) and reprinted in Morris Philipson, ed., *Aesthetics Today* (New York, 1974), pp. 99 ff.

Paul Gauguin is, of course, the most famous of the artists who discovered the primitive world of forms and showed it to modern audiences. However, his *Intimate Journals* (in English translation, originally London, 1931, reprint Bloomington, 1965) and his letters, however, yield few explicit theoretical statements. For Gauguin's view of the primitive, see the chapter in Goldwater's *Primitivism in Modern Art*, pp. 63–85, and H. R. Rookmaaker, *Gauguin and Nineteenth-Century Art Theory* (Amsterdam, 1972). See also an earlier study by Rookmaaker, *Synthetist Art Theories: Genesis and Nature of the Ideas on Art of Gauguin and His Circle* (Amsterdam, 1959).

The discovery of African art by European audiences and the arrival of African works of art, mainly sculpture, in the larger cities was a major process in twentieth-century western culture. It is well described in Goldwater's *Primitivism in Modern Art*. For different aspects of the European response to African art, see also H. H. Freese, *Anthropology and the Public: The Role of the Museum* (Leiden, 1960).

Abstract Art

As opposed to the materials treated in the parts on Empathy (part 2) and on Discovering the Primitive (part 3), the basic documents of the trend known as Abstract Art are easily available, and most of them exist in satisfactory English translations.

Kandinsky's writings, collected in Kenneth C. Lindsay and Peter Vergo, eds., *Kandinsky: Complete Writings on Art* (New York, 1994), are basic texts. Of crucial significance is *On the Spiritual in Art* (originally *Über das Geistige in der Kunst* [Munich, 1911]), pp. 114–219, in *Kandinsky: Complete Writings on Art*. Also important for our subject are the notes in the *Blaue Reiter Almanach* (*Kandinsky: Complete Writings*, pp. 229–85).

Mondrian's writings composed in the years between 1917 and 1924 are another central source for the original theories of abstract art. They have

been collected, translated, and published in Harry Holtzman and Martin S. James, eds., *The New Art—The New Life: The Collected Writings of Piet Mondrian* (London, 1987), pp. 27–183.

The reflections of Adolf Hoelzel, which shed some light on ideas on art during the first decade of the twentieth century, have been published in the catalog of the memorial exhibition (Stuttgart, 1935).

The basic monographs about Kandinsky and Mondrian adduce some valuable material for the theory of abstract art, although they are primarily devoted to the pictorial work of the artists. For Kandinsky, see Will Grohmann, *Wassily Kandinsky: Life and Work* (New York, 1958) translated from the German original that appeared in the same year. For an introduction to Mondrian's world, artistic as well as theoretical, see H. L. C. Jaffe, *Piet Mondrian* (New York, 1970).

The sources of the esoteric theosophical doctrines that may have influenced these and other young artists in the formation of the theory of abstract art are also easily available. Of particular significance among Madame Blavatsky's writings are (in chronological order) her books: *Isis Unveiled: A Master-Key to the Mysteries of Modern Science and Theology*, vols. I–II (New York, 1877); *The Secret Doctrine*, which originally appeared in New York in 1888 and is now available in a two-volume facsimile edition (Los Angeles, 1947); *The Key to Theosophy* (London, 1889).

The works of Rudolf Steiner, who founded anthroposophy after splitting off from the theosophical movement, are numerous. Among the most popular (and also known to Kandinsky) were the articles published in 1904 and 1905 in the periodical *Luzifer-Gnosis* and now collected in the volume *Wie erlangt man Erkenntnisse der höheren Welten?* (How Does One Acquire the Knowledge of Higher Worlds?) (Dornach, 1961); *Theosophie: Einführung in die übersinnliche Welterkenntnis und Menschenbestimmung* (Theosophy: An Introduction to the Supersensual Knowledge of the World and of the Destination of Man) (Leipzig, 1906?). To this should be added Steiner's many public lectures and articles.

Among other esoteric writings that may have influenced the theories of abstract art are F. Marryat, *Die Geisterwelt* (The World of Spirits) (Leipzig, n.d. [1895]) and Albert de Rochas, *Les sentiments, la musique et le geste* (Grenoble, 1900).

Modern studies on abstract art are, of course, abundant, but they are mainly concerned with the development of the art rather than with the theory. An important work is that by the Finnish scholar Sixten Ringbom, *The Sounding Cosmos: A Study in the Spiritualism of Kandinsky and the Genesis*

of Abstract Painting (Abo, 1970). Ringbom investigates both art and art theory, and provides a good bibliography. See also his article "Art in the Epoch of the Great Spiritual: Occult Elements in the Early Theory of Abstract Painting," *Journal of the Warburg and Courtauld Institutes* 29 (1966), pp. 386–416. Also interesting in our context is L. D. Ettlinger, *Kandinsky "At Rest"* Charlton Lectures on Art (London, 1961). Of the many publications pertinent to Kandinsky's development I shall only mention Peg Weiss, *Kandinsky in Munich: The Formative Jugendstil Years* (Princeton, 1979), and Rose-Carol Washton Long, *Kandinsky: The Development of an Abstract Style* (New York and Oxford, 1980).

For a philosophical interpretation of Mondrian, see the thought-provoking essay by Meyer Schapiro, "Mondrian: Order and Randomness in Abstract Painting," now reprinted in Meyer Schapiro, *Modern Art: Nineteenth and Twentieth Centuries*, pp. 233–61. See also Kermit Champa, *Mondrian Studies* (Chicago, 1985). See also "Mondrian and Theosophy," in the catalog of the *Piet Mondrian Centennial Exhibition*, at the S. R. Guggenheim Museum in New York (New York, 1971), pp. 35–52. Mark Roskill, *Klee, Kandinsky, and the Thought of Their Time* (Urbana and Chicago, 1922), deals with a later period, but is interesting for our purpose as it explores the further development of theories of the abstract.

Name Index

Subject Index